no-sew
knits

20
flattering
finish-free
garments

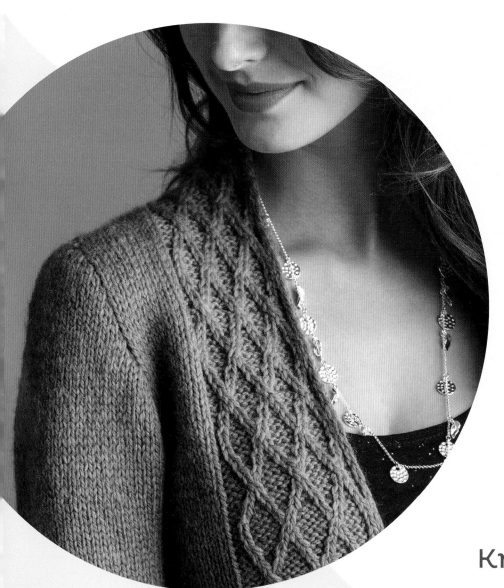

Kristen TenDyke

INTERWEAVE.
interweave.com

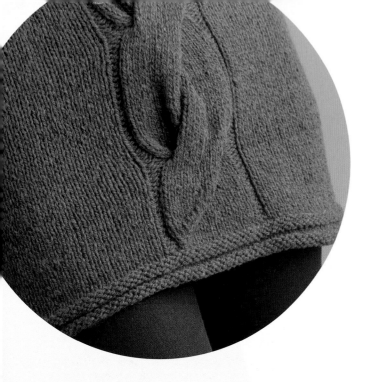

Acknowledgments

This book wouldn't have come to be if it wasn't for the enthusiasm and excitement from you knitters about my first book, *Finish-Free Knits*. I'm SO thankful for each of you and your presence at my book signings, your online presence and in yarn stores. The joy you express and your eagerness to knit my designs are what fuel me to keep going. Thank you!

I'd also like to thank everyone at Interweave who took all the bits and pieces and made them into something functional and beautiful—you all did such an amazing job!

Physically this book could not have been possible without the help of my dedicated and skillful knitters: Jessica Wright Lichter, Kim Haesemeyer, Candace Musmeci, and Jessica Johnston. You are all truly lifesavers!

And . . . my family! Your endless support is beyond value. Thanks to each of you for always being there for me, through all kinds of weather.

I bow,

Namasté,

EDITOR // Erica Smith

TECHNICAL EDITOR // Therese Chynoweth

PHOTOGRAPHER // Joe Hancock

STYLIST // Emily Smoot

HAIR & MAKEUP // Leilani Drum

COVER DESIGN // Kit Kinseth

INTERIOR DESIGN // Adrian Newman

PRODUCTION // Katherine Jackson

Interweave
A division of F+W Media, Inc.
4868 Innovation Drive
Fort Collins, CO 80525
interweave.com

Manufactured in China by RR Donnelley Shenzhen.

Library of Congress Cataloging-in-Publication Data
TenDyke, Kristen.
No-sew knits : 20 flattering, finish-free garments /
Kristen TenDyke.
pages cm
Includes index.
ISBN 978-1-62033-624-3 (pbk)
ISBN 978-1-62033-626-7 (PDF)
1. Knitting--Patterns. 2. Sweaters. I. Title.
TT825.T424 2014
746.43'2--dc23
 2014016302

10 9 8 7 6 5 4 3 2 1

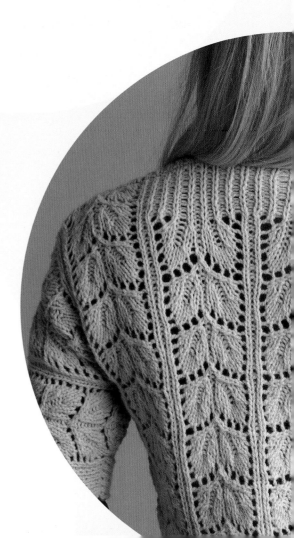

Contents

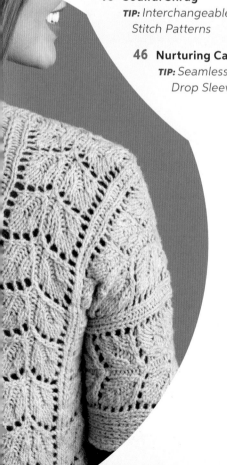

Introduction

After I completed knitting the sweaters and writing the patterns for my first book, *Finish-Free Knits* (Interweave, 2012), I was convinced I'd never want to make another book. Even with all the helpful knitters I have, it's a labor of love to write and knit twenty sweaters in less than a year. However, once the book was published and I began to experience the results of all that hard work, it all seemed worth it. So, here I am again with another twenty sweater designs that all focus on constructing handknit sweaters without needing to sew anything together.

No-Sew Knits was sparked by all the knitters who came to the *Finish-Free Knits* book signings. Their enthusiasm and excitement about the sweaters was so inspiring. The question I was asked most often was: "What is the easiest pattern?" There were a few simple designs in *Finish-Free Knits*, but I wanted to offer them more!

While designing the sweaters in *No-Sew Knits*, I kept their question in mind. Many of these patterns have customizable options, making the patterns simpler or more difficult depending on your skill level or what sorts of shaping, etc., you want for your sweater. I include detailed instructions for a hood and three different seamless pockets that can be added to practically any sweater; you can adjust sleeve length, and there are some places where short-rows are optional. There are lots of tips throughout the book!

This book is divided into chapters. It was my intention as I arranged the patterns that the easier chapters be toward the front of the book, with the easiest sweaters at the beginning of each chapter. However, the difficulty of each pattern can vary depending on how you choose to customize it. I've also included a list of techniques at the beginning of each pattern, so you can see which techniques are used in that pattern and which ones are optional before you cast on. I encourage you to try new things and expand your knitting toolbox. The glossary of this book includes all the techniques you'll need to complete the sweaters in this book.

About the Patterns

To the best of my ability, I kept the pattern instructions simple and straightforward. Whenever possible I avoided terms such as "and at the same time." Personally, I prefer when a pattern walks me through step by step rather than telling me to start something, then a little while later to start something else while continuing to do the first thing—that can be so confusing. So, these patterns are all written step by step to avoid that sort of confusion. Whenever there is shaping the instructions tell you exactly how many rows to work, and how many times to work them, and you'll be guided when to end after RS or WS rows.

The patterns have been extensively tech-edited and proofed. To the best of our knowledge, the information provided within these pages is correct, though sometimes things slip through the cracks. If mistakes are found, I will include the errata on my website *(kristentendyke.com)*, and Interweave will post them on theirs as well as update future printings of the book.

About the Charts

Charts and written instructions are included for the majority of the patterns in this book, with the exception of large charts. Unfortunately, the written instructions for those charts would take up so much space that it was decided to only include the charts.

When working from a chart, begin RS rows and rounds at the right edge of the chart and work from right to left. When working WS rows, work from left to right. The row numbers to the edges of the charts indicate RS and WS rows. Numbers to the right of the chart indicate RS rows, and numbers on the left indicate WS rows. If there are many rows in the chart, it may be useful to adhere highlighter tape to your chart to easily keep track of which row you're knitting.

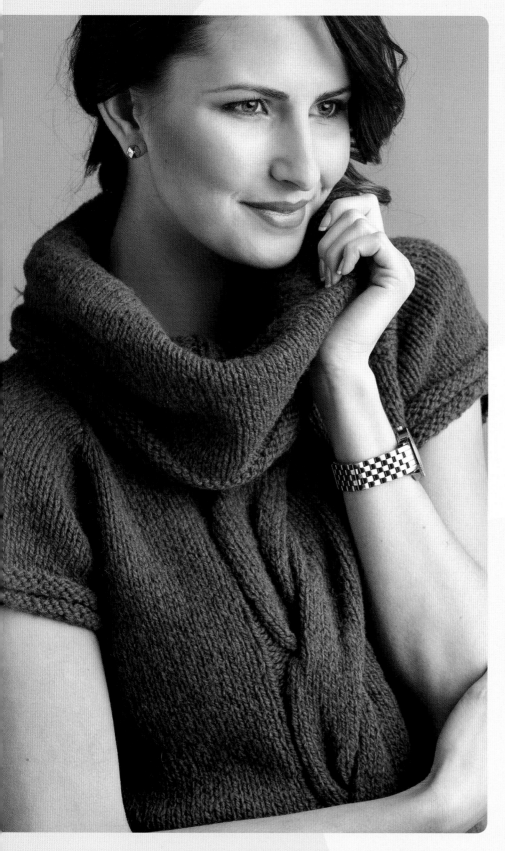

About the Schematics

The schematic drawing includes the measurements of the sweater while it's being blocked. It's recommended to block your sweater when instructed in the "finishing" by laying the sweater out to the measurements on the schematic. Blocking may be done by wet-blocking or steam-blocking (see Glossary) depending on your preference. I prefer to wet-block because I believe it lets me know how the sweater will look and feel after washing.

For many of the cardigans, the bust, waist, and hem measurements are given as the total completed measurement, with the width of the opening that will be at the center front for the front band. To block your sweater to match the correct finished measurement, divide the measurement on the schematic in half to indicate the width of the back. With the fronts overlapping the back, the opening between the fronts should match the indicated opening measurement on the schematic.

For example: The smallest size of the Unconditional Cardigan has a finished bust circumference of 30¼" (77 cm) with ¾" (2 cm) opening for the front band. To measure this sweater for blocking, divide the total 30¼" (77 cm) in half = 15⅛" (38.5 cm). Measure the bust of the sweater from underarm to underarm, adjusting the width of the fronts by moving them closer together or farther apart at the center front until your back measures the half-measurement (15⅛" [38.5 cm]). At this measurement, the fronts should have a ¾" (2 cm) opening between them at the center. When the front bands are worked, that opening will be filled in and the sweater will measure the total finished measurement.

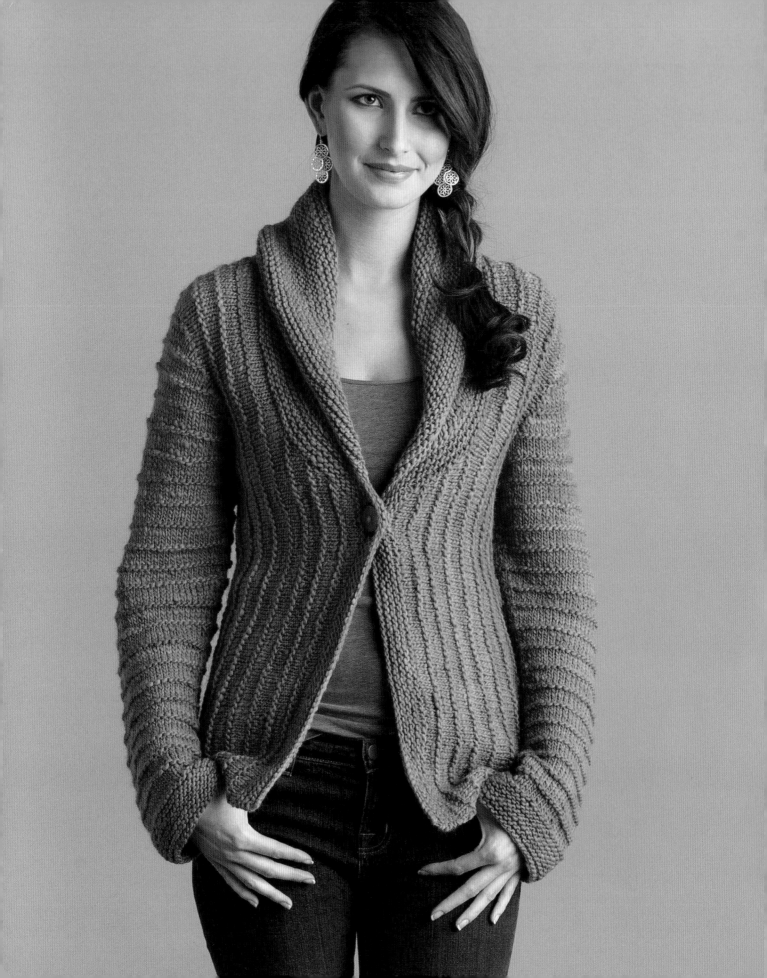

The Basics

In Chapter 1, there are four different types of sweater constructions that use familiar stitch patterns, such as stockinette, garter, and moss stitch. These sweaters are a great place to start seamless knitting.

The Heroic Vest is knit in the round from the bottom up with a seamless pouch pocket; the Dreamy Pullover is knit from the top down in stockinette stitch, with yoke shaping and a cozy collar; the Wholesome Coat is knit from side to side beginning at the center of the back with a provisional cast-on; the Unconditional Cardigan is knit from the top down in garter stitch, then the sleeve stitches are picked up around the armholes and knit down.

Using simple and familiar stitch patterns while learning a new construction can let you focus on the unique construction without needing to maintain much focus on keeping the stitch pattern intact.

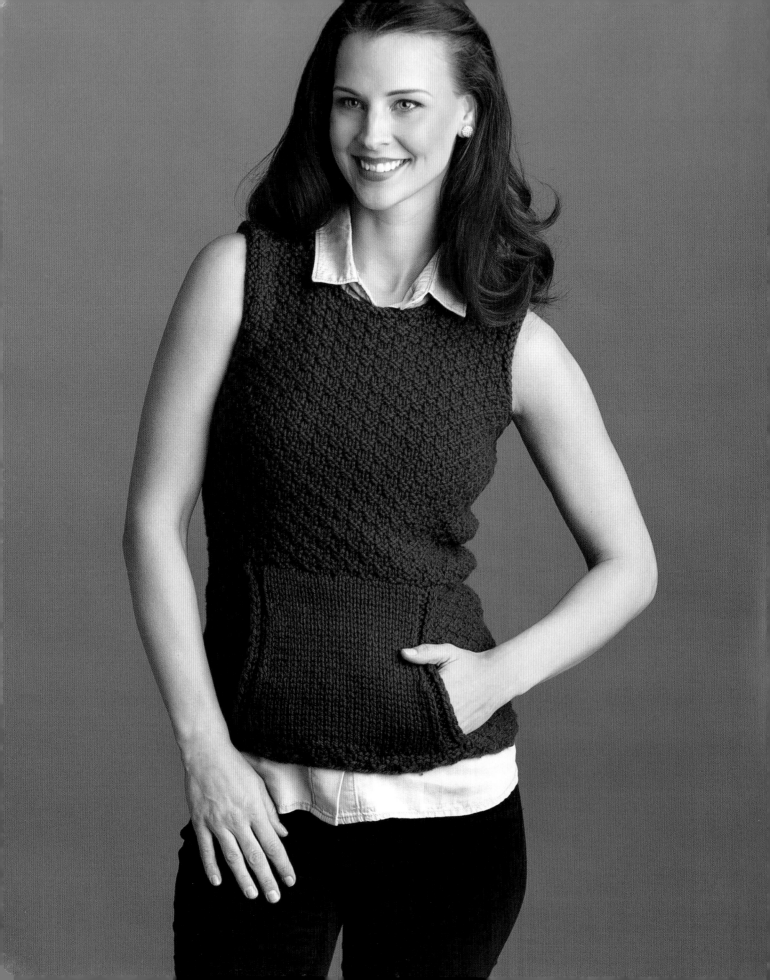

Heroic VEST

The Heroic Vest is knit in the round from the bottom up, with a seamless pouch pocket added to the front. Made in a bulky yarn, it knits up really quick for that feeling of instant gratification. The moss-stitch texture makes the vest extra cozy and fun to wear. I love sleeveless, bulky vests. They keep my core super warm, without overheating. Though, if you want sleeves, pick up stitches and shape the cap following the tips on page 32, then determine the sleeve length using the info on page 54.

Techniques
Circular knitting with circular needles and dpns

Seamless pocket

Picking up stitches

Three-needle bind-off

Using a stitch holder or waste yarn

Increasing and decreasing in pattern

Finished Size
About 29½ (34½, 39½, 44¼, 49¼, 54¼)" (75 [87.5, 100.5, 112.5, 125, 138] cm) bust circumference.

Vest shown measures 34½" [87.5 cm].

Yarn
Chunky weight (#5 Bulky).

Shown here: O-Wool, Legacy Bulky (100% certified organic merino, 106 yd [97 m]/100 g): #5625 ocean floor, 5 (6, 6, 7, 8, 9) skeins.

Needles
Body—Size U.S. 9 (5.5 mm): 29" (74 cm) circular (cir).

Trim—Size U.S. 9 (5.5 mm): 16" (40 cm) cir and set of 4 or 5 double-pointed (dpn).

Adjust needle size if necessary to obtain the correct gauge.

Notions
Markers (m); holder or waste yarn; tapestry needle.

Gauge
13 sts and 23 rnds = 4" (10 cm) in moss st; 14 sts and 19 rows = 4" (10 cm) in St st.

{ Picking Up Stitches }

In this pattern, the trim around the neck and armhole edges is worked after the vest is complete. To begin, stitches are picked up evenly along the edge, then a few rounds are worked outward and bound off. Picking up stitches along the edge of a piece of fabric is an easy way to add a finishing touch to the edge without knitting a separate piece and sewing it on.

When picking up stitches along a cast-on or bind-off edge, usually 1 stitch is picked up in each of the cast-on or bound-off stitches. These stitches are picked up by inserting the needle into the top-most stitch. There are two types of spaces that could be used to pick up the stitches: one is shaped like an *n*, the other is shaped like a *u*. When picking up stitches, insert the needle into the *n* stitch; this is the center of a stitch, and the stitches of the trim will therefore align with the stitches of the body. If you pick up the stitches in the *u*, the trim stitches will appear shifted by half a stitch. This shift isn't the end of the world, but I think it's nice to know how to align them if that's what you prefer.

When picking up stitches along a straight selvedge edge, you will usually pick up 3 stitches for every 4 rows. You do this because often there are more rows per inch (2.5 cm)

than there are stitches. An easy way to tell if 3 stitches over 4 rows would work for your project is to divide the stitch gauge of the body by the row gauge. The result is a fraction of a number. If that fraction is close to .75 (¾), then 3 stitches over 4 rows will work. If the fraction is closer to .5 (½), as it often is when working in garter stitch, pick up 1 stitch for every 2 rows.

As an example, the gauge for the Heroic Vest is 13 stitches and 23 rounds. When 13 is divided by 23, the result is .57, which is pretty close to .5. So picking up 1 stitch over 2 rows will result in the trim being close to the body measurement but a little tighter.

If too many stitches are picked up along an edge, the trim will be loose and pucker. If too few stitches are picked up along an edge, the trim will be tighter than the body and pull in.

When picking up the stitches along a selvedge edge, I often insert my needle into the space between the first and second stitches on the edge. I find that this gives a secure edge that will stay snug against the edge of the body. This is important if your pattern has buttonbands or

something that would tug on the pick-up edge. However, if the yarn is really bulky and the trim is narrow, I pick up only the outside half of the first stitch. This prevents the edge from being too bulky behind the trim. I suggest experimenting with your project to see what works best for you.

Picking up along a diagonal edge is similar to picking up along a selvedge edge; however, the ratio for how many stitches to pick up may change. A common ratio to use is 5 stitches over 6 rows. Sometimes I find that 3 stitches over 4 rows works fine along the diagonal. It depends on the project, so again, I suggest experimenting to see what works well for you.

Stitch Guide

Moss Stitch Worked in Rounds: *(multiple of 4 sts)*

Rnds 1 and 2: *K2, p2; rep from *.

Rnds 3 and 4: *P2, k2; rep from *.

Rep Rnds 1–4 for patt.

Moss Stitch Worked in Rows: *(multiple of 4 sts)*

ROW 1: (RS) *K2, p2; rep from *.

ROW 2: *P2, k2; rep from *.

ROW 3: *P2, k2; rep from *.

ROW 4: *K2, p2; rep from *.

Rep Rows 1–4 for patt.

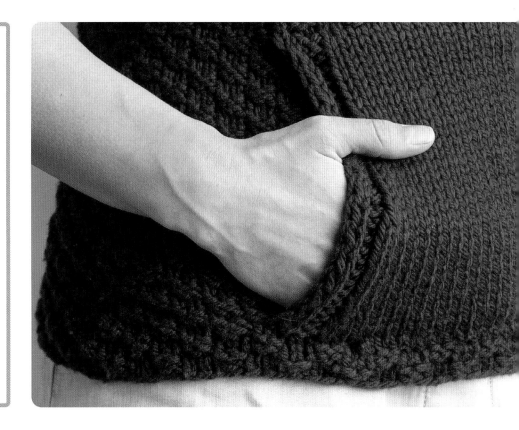

Note: *I suggest using a tapestry needle and waste yarn to hold stitches when dividing the pocket and lining stitches; this method is more flexible and makes working the row easier.*

Body

With longer cir needle, CO 96 (112, 128, 144, 160, 176) sts. Place marker (pm) and join for working in rnds, being careful not to twist sts.

Work 4 rnds in moss st.

Pocket

SET-UP RND: Work 6 (10, 10, 14, 14, 18) sts in patt, pm for pocket, [k1f&b (see Glossary)] twice, [p1f&b (see Glossary)] twice, [k1f&b 28 (28, 36, 36, 44, 44) times, [p1f&b] twice, k1f&b, k1,

pm for pocket, turn work leaving rem sts unworked—71 (71, 87, 87, 103, 103) sts between markers.

Sl the 60 (76, 84, 100, 108, 124) body sts outside the pocket m onto holder or waste yarn, keeping beg-of-rnd m but removing pocket m. Cont working back and forth divide sts as foll:

NEXT ROW: (WS) Sl 1 pwise wyf, move yarn to back, sl 1 to holder in front for lining, p1 for pocket, move yarn to back, [sl 1 to holder, k1] twice, [sl 1 to holder, p1, move yarn to back] 28 (28, 36, 36, 44, 44) times, [sl 1 to holder, k1] twice, [sl 1 to holder, p1, move yarn to back] twice, turn—36 (36, 44, 44, 52, 52) pocket sts, 35 (35, 43, 43, 51, 51) lining sts.

SET-UP ROW: (RS) Sl 1 pwise wyb, k1, p2, knit to last 4 sts, p2, k2.

NEXT ROW: (WS) Sl 1 pwise wyf, p1, k2, purl to last 4 sts, k2, p2.

Shape pocket

DEC ROW: (RS) Sl 1 pwise wyb, k1, p2, k2tog, knit to last 6 sts, ssk, p2, k2—2 sts dec'd.

Work 9 rows even, ending with a WS row.

Rep the last 10 rows 2 times—30 (30, 38, 38, 46, 46) sts rem. Pocket should meas about 6¾" (17 cm) from division.

Place sts onto holder or waste yarn for pocket.

Join the Body and Lining

Sl 60 (76, 84, 100, 108, 124) body sts and beg-of-rnd m to longer cir, then 35 (35, 43, 43, 51, 51) held lining sts to same cir needle behind pocket. Rejoin yarn with RS facing, to beg at lining sts—95 (111, 127, 143, 159, 175) sts.

NEXT RND: Beg at right edge of lining sts: M1, k16 (16, 20, 20, 24, 24), k2tog, k17 (17, 21, 21, 25, 25), M1, work 6 (10, 10, 14, 14, 18) sts in est patt, pm for side, work in est patt to beg-of-rnd m—96 (112, 128, 144, 160, 176) sts.

Work 2 rnds even in moss st over all sts.

Shape Waist

DEC RND: *K2tog (or p2tog to maintain patt), work in moss st to 2 sts before m, ssk (or ssp to maintain patt), sl m; rep from * once more—4 sts dec'd.

Work 8 rnds even.

Rep the last 9 rnds 3 times—80 (96, 112, 128, 144, 160) sts rem.

Join the Pocket and Body

Return 30 (30, 38, 38, 46, 46) held pocket sts to shorter cir needle.

JOINING RND: Work 5 (9, 9, 13, 13, 17) body sts, holding needle with pocket sts in front, k2tog (or p2tog to maintain patt) working 1 st from pocket and 1 st from body until all pocket sts have been joined, work in est patt to end of rnd—80 (96, 112, 128, 144, 160) sts.

INC RND: *RLI (see Glossary), work in moss st to next m, LLI (see Glossary), sl m; rep from * once more—4 sts inc'd.

Rep Inc rnd every 8 rnds 3 times—96 (112, 128, 144, 160, 176) sts.

Cont even until piece meas 18" (45.5 cm), ending with an even-numbered rnd. End last rnd 2 (3, 4, 5, 6, 7) sts before beg-of-rnd m.

Divide for Armholes

NEXT RND: BO 4 (6, 8, 10, 12, 14) sts removing the m, work in est patt to 2 (3, 4, 5, 6, 7) sts before m, BO 4 (6, 8, 10, 12, 14) sts, work to end of rnd—44 (50, 56, 62, 68, 74) sts rem each back

and front. Cont working back and forth on back sts only. Place front sts onto holder or waste yarn.

Back
Shape Armhole

Work 1 WS row even.

DEC ROW: (RS) K2tog (or p2tog to maintain patt), work in patt to last 2 sts, ssk (or ssp to maintain patt)—2 sts dec'd.

Rep the last 2 rows 1 (3, 5, 7, 9, 11) time(s), ending with a WS row—40 (42, 44, 46, 48, 50) sts rem.

Cont even until armholes meas 4¾ (5, 5½, 6¼, 7, 7¾)" (12 [12.5, 14, 16, 18, 19.5] cm) from divide, ending with a WS row.

Shape Neck

NEXT ROW: (RS) Work 9 (10, 10, 11, 11, 12) sts in est patt, join a second ball of yarn, BO 22 (22, 24, 24, 26, 26) sts, then work to end—9 (10, 10, 11, 11, 12) sts rem each side for shoulders.

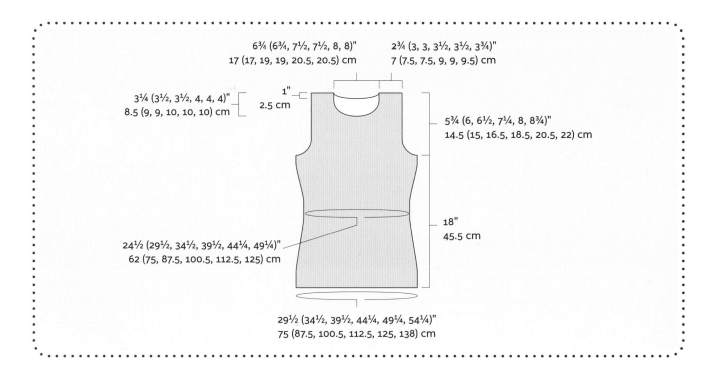

6¾ (6¾, 7½, 7½, 8, 8)"
17 (17, 19, 19, 20.5, 20.5) cm

2¾ (3, 3, 3½, 3½, 3¾)"
7 (7.5, 7.5, 9, 9, 9.5) cm

3¼ (3½, 3½, 4, 4, 4)"
8.5 (9, 9, 10, 10, 10) cm

1"
2.5 cm

5¾ (6, 6½, 7¼, 8, 8¾)"
14.5 (15, 16.5, 18.5, 20.5, 22) cm

24½ (29½, 34½, 39½, 44¼, 49¼)"
62 (75, 87.5, 100.5, 112.5, 125) cm

18"
45.5 cm

29½ (34½, 39½, 44¼, 49¼, 54¼)"
75 (87.5, 100.5, 112.5, 125, 138) cm

Cont each side separately until armhole meas 5¾ (6, 6½, 7¼, 8, 8¾)" (14.5 [15, 16.5, 18.5, 20.5, 22] cm) from divide, ending with a WS row. Break yarns and place sts onto holders or waste yarn.

Front

Return held 44 (50, 56, 62, 68, 74) front sts to needle. Rejoin yarn with WS facing.

Work as for back until piece meas 2½ (2½, 3, 3¼, 4, 4¾)" (6.5 [6.5, 7.5, 8.5, 10, 12] cm) from divide, ending with a WS row—40 (42, 44, 46, 48, 50) sts rem.

Shape Neck

NEXT ROW: (RS) Work 14 (15, 16, 17, 18, 19) sts in est patt, join a second ball of yarn, BO 12 sts, then work to end—14 (15, 16, 17, 18, 19) sts rem on each side.

Cont working both sides at the same time, using separate balls of yarn.

Work 1 WS row even.

DEC ROW: (RS) Work in est patt to 2 sts before neck edge, ssk (or ssp to maintain patt); on other side, k2tog (or p2tog to maintain patt), work to end—1 st dec'd on each side.

Rep Dec row every RS row 4 (4, 5, 5, 6, 6) times—9 (10, 10, 11, 11, 12) sts rem each side.

Cont even until armhole meas 5¾ (6, 6½, 7¼, 8, 8¾)" (14.5 [15, 16.5, 18.5, 20.5, 22] cm) from divide, ending with a WS row. Break yarns and place sts onto holders or waste yarn.

Finishing

Block to measurements.

JOIN SHOULDERS: Place held 9 (10, 10, 11, 11, 12) sts from right front shoulder onto dpn, then held 9 (10, 10, 11, 11, 12) sts from right back shoulder onto second dpn. Hold needles parallel with RS of knitting facing tog and use the three-needle method (see Techniques) to BO sts tog. Rep for left shoulder.

NECK TRIM: With shorter cir needle and RS facing, beg at right shoulder join, pick up and knit 32 (32, 34, 34, 36, 36) sts evenly across back neck, then 38 (40, 40, 44, 44, 44) sts evenly along front neck—70 (72, 74, 78, 80, 80) sts. Pm and join for working in rnds.

Purl 1 rnd.

BO all sts pwise.

ARMHOLE TRIM: With dpns and RS facing, beg at center of underarm, pick up and knit 25 (26, 28, 31, 35, 38) sts to shoulder join, then 25 (26, 28, 31, 35, 38) sts to center of underarm—50 (52, 56, 62, 70, 76) sts. Divide sts evenly over 3 or 4 dpn. Pm and join for working in rnds.

Purl 1 rnd.

BO all sts pwise.

Rep for second armhole.

Weave in loose ends.

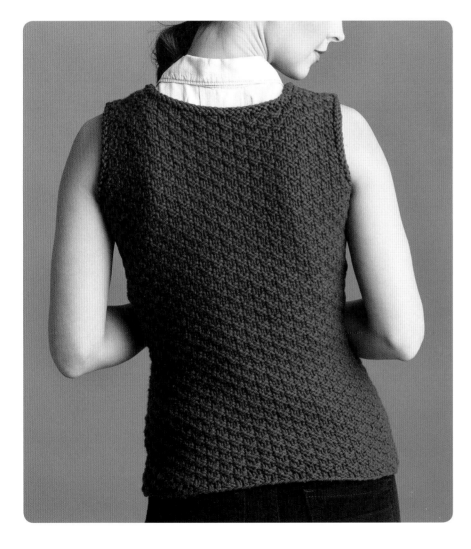

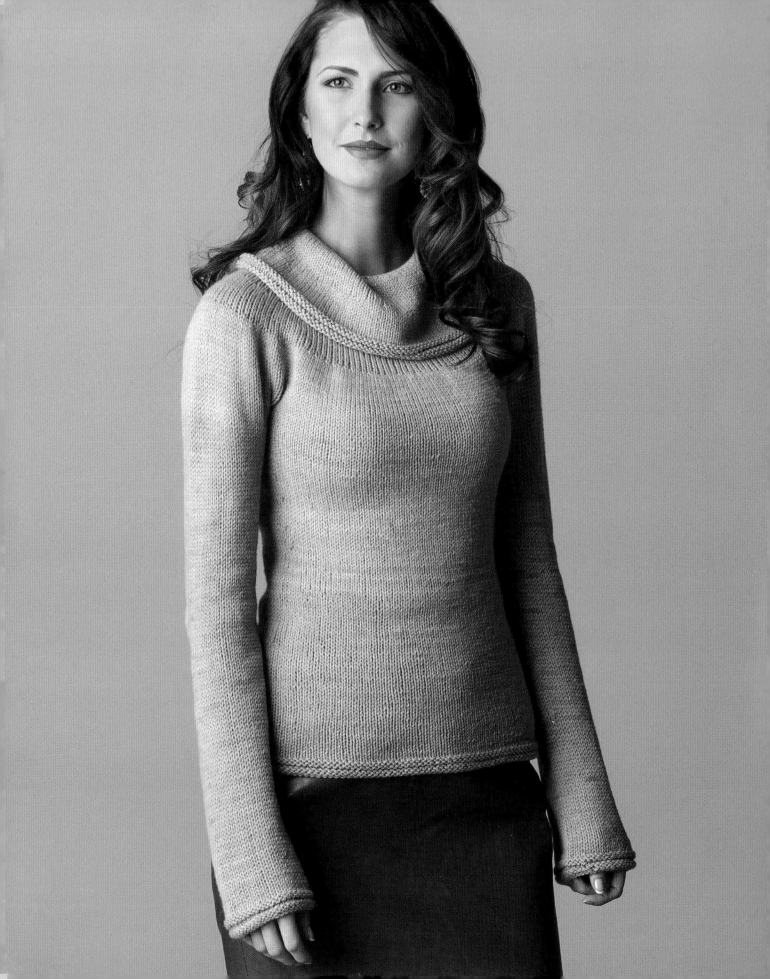

Dreamy PULLOVER

Part of the beauty of knitting an entire sweater in stockinette stitch is that it can show off the colorful texture of gorgeous hand-dyed yarns. Yet the pattern that is chosen for the edgings can be used to bring a bit of unique detail to the sweater and make it a little more interesting to knit. The Dreamy Pullover can be knit with the welt edging pattern, as shown, or with any range of edgings. I've included some ideas for other possible basic edgings that could substitute into this or many other patterns in this book. Also, check out the tip on page 152 about alternating skeins of hand-dyed yarns.

Techniques

Circular knitting with circular needles and dpns

Picking up stitches

Lifted increases

Using a stitch holder or waste yarn

Increases evenly along one round (a few times during the yoke)

Short-rows (optional)

Casting on stitches mid-row

Finished Size

About 30½ (34¼, 38, 42, 45¾, 49½, 53¼, 57)" [77.5 (87, 96.5, 106.5, 116, 125.5, 135.5, 145) cm] bust circumference and 22 (22½, 23, 23½, 23¾, 24¼, 24¾, 25¼)" (56 [57, 58.5, 59.5, 60.5, 61.5, 63, 64] cm) long.

Pullover shown measures 34¼" [87 cm].

Yarn

Worsted weight (#4 Medium).

Shown here: Swans Island, Natural Colors (100% certified organic merino wool, 250 yd [228 m]/100 g): early thyme, 5 (5, 6, 6, 7, 8, 8, 9) skeins.

Needles

Size U.S. 7 (4.5 mm): 16" (40 cm) and 32" (80 cm) circular (cir) needles, and set of 5 double-pointed (dpn). *Adjust needle size if necessary to obtain the correct gauge.*

Notions

Markers (m); holders or waste yarn; tapestry needle.

Gauge

17 sts and 27 rnds = 4" (10 cm) in St st, worked in rnds.

{ Why Use Edging? }

When a project is knit in stockinette stitch or reverse stockinette stitch, the edges may be prone to rolling, depending on the fibers used and the spin of the yarn. At the cast-on and bind-off edges, a stockinette stitch fabric will roll out toward the right side, so the purl bumps from the wrong side are showing. At the selvedge edges, a stockinette stitch fabric will roll in toward the wrong side, so the knit sides roll in. This can be used to your advantage if you want this look, but for many designs, it's important for the edges to lay flat when you're wearing them.

When you use an equal (or nearly equal) combination of knit and purl stitches together in an edging stitch pattern, the knits and purls work together to maintain a flat fabric. It's when one stitch dominates over the other that the fabric will roll.

Here are a few of my favorite basic edging patterns:

Garter Stitch

Worked back and forth: Knit all stitches every row.

Worked in the round: Knit 1 rnd, purl 1 rnd. Rep the last 2 rnds.

Garter stitch is the simplest of all these edgings. By knitting on every row (or alternating knit/purl while working in the round), you create an equal number of knit and purl ridges when viewing the piece from each side. This stabilizes the edge so it lays flat.

Advantages: It's the simplest pattern because it can be used over any number of stitches, and you don't need to adjust the stitch count at all for this to work.

Things to consider: It's possible for the edge to still roll even with a garter-stitch edge if you're working with a yarn that really wants to roll. The solution is to work MORE garter stitch because if it's still rolling, there isn't enough stability yet to keep it flat.

For example, a garment with ½" (1.3 cm) of garter stitch at the edge may roll, but if you add 1" (2.5 cm) to 1½" (3.8 cm) of garter stitch at that edge, instead of just ½" (1.3 cm), it may solve the rolling problem. The same is true at the side edge. If you work 3 stitches in garter stitch at the edge and your side edge is still rolling under, try working 6 stitches to make it lay flat.

Also, the gauge of garter stitch is often looser (fewer stitches per inch [centimeter]) than stockinette stitch. You may want to consider using a needle one size smaller than you used for stockinette stitch.

Seed Stitch

Worked back and forth:
(multiple of 2 sts)
ROW 1: *K1, p1; rep from * to end.

ROW 2: *P1, k1; rep from * to end.

Rep the last 2 rows.

Worked back and forth:
(multiple of 2 sts + 1)
All rows: K1, *p1, k1; rep from * to end.

Worked in the round:
(multiple of 2 sts + 1)
RND 1: K1, *p1, k1; rep from * around.

RND 2: P1, *k1, p1; rep from * around.

Rep the last 2 rows.

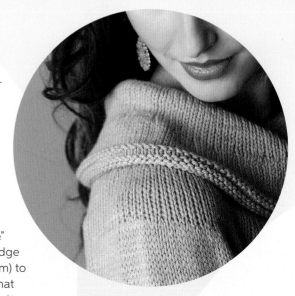

Seed stitch is another stitch pattern with an equal number of knit and purl stitches. By alternating knits and purls every other stitch and every other row/round, the texture of the pattern is elegant and very flat.

Advantages: When working seed stitch flat (back and forth in rows), it can be worked over any number of stitches, making it easy to adapt to any pattern.

Things to consider: When working seed stitch circular (in the round), the beginning of the round is less noticeable when the pattern is worked over an odd number of stitches. When working over an odd number of stitches, the first and last stitch of the round will be the same stitch (knit or purl). Beginning the second round with the opposite stitch will maintain the alternating stitch pattern.

Sometimes when working seed stitch on the same size needle as stockinette stitch, the seed-stitch gauge may be tighter (more stitches per inch [centimeter]) than the stockinette-stitch gauge. Therefore, it may be desirable to work the seed stitch with a needle one size larger than you used for the stockinette stitch.

Welts

Worked back and forth:
(any number of sts)
Note: These 3 rows will result in a 3-row welt.

ROW 1: Purl.

ROW 2: Knit.

ROW 3: Purl.

Rep Rows 1–3.

Worked in the round:
(any number of sts)
RNDS 1–3: Purl.

RNDS 4–6: Knit.

Rep Rnds 1–6.

At the moment, welts are one of my very favorite edge patterns. I've used this edging in a few of the patterns in this book. This edging pattern is very simple, much like garter stitch. The difference is that instead of knitting every row, forming 1-row garter ridges, you work 2 or more rows in both stockinette stitch and reverse stockinette stitch to make each garter ridge (welt) a little wider.

Advantages: It's a very simple pattern, just like working stockinette stitch and reverse stockinette stitch for a few rows each. It can be used over any number of stitches, and it adds a bit of fun to the edge. It's not very flat; there's usually a little bit of a bounce to it.

Things to consider: If using a thin yarn, I suggest working more rows per welt than if using a thick yarn. For example, with a sportweight yarn, I might work 4 rows of each stockinette stitch and reverse stockinette stitch per welt, whereas with a bulky yarn, I might only work 2 each. Always knit up a swatch to see what

the edging will look like with your intended number of rows per welt.

Ribbing

Worked back and forth:
(multiple of 4 sts + 2)
ROW 1: (WS) P2, *k2, p2; rep from * to end.

ROW 2: (RS) K2, *p2, k2; rep from * to end.

Worked in the round:
(multiple of 4 sts)
ALL RNDS: *K2, p2; rep from * around.

The overall direction of the stitch pattern used in the body of the sweater should be taken into consideration when choosing an edging to add. When working with a stitch pattern that already has some sort of vertical orientation, I like to use ribbing. The vertical nature of the ribs complements a sweater with cables or any other vertical stitch pattern better than garter stitch or welts. If you're ever questioning which edging would be best with the over-all stitch pattern of your sweater, I suggest swatching the two patterns together. It will take only a few minutes to knit up a tiny swatch to see if the stitch patterns are complementary or dissonant. If you're still unsure, swatch a few different options and hang them on the wall where you will see them throughout your day. Eventually one of them will scream out to you, "Pick me, pick me!"

Advantages: Ribbing can be knit so it will align with the stitch pattern of the sweater, so it almost seems like part of the pattern itself. If there is a chart that follows the ribbing, pull out some graph paper and see if you can align the ribbing pattern with the stitches in the chart. You even have creative freedom to break up the ribbing pattern from k2, p2 (or any other equal knit and purl pattern) to

k2, p1, k3, p2, k3, p1, k2 to line up with the chart. I do this often, and it really gives that little bit of extra detail to a sweater that you may not notice at first glance.

Things to consider: Depending on the fiber content and type of spin used for your chosen yarn, ribbing can either pull together at the purl stitches, making for a stretchy edge that draws in toward the body, or it will flatten out to where you can see both the knit and purl stitches laying flat. I suggest making a swatch and washing it to see what your yarn will do before determining if ribbing is the best edging for your sweater.

If your yarn creates ribbing that pulls in, but you want it to measure the same width as the sweater, don't fret—you can still use ribbing! Simply measure the gauge in the ribbing (after washing and drying) and multiply the stitches per inch (centimeter) by the width (or circumference) of the body on the schematic. This will tell you how many stitches in the ribbing you'll need to match that measurement. Then either increase or decrease between the ribbing and body to compensate.

When using ribbing, it's important to use a multiple of stitches that corresponds to that type of ribbing. For example, the k2, p2 ribbing pattern suggested uses a multiple of 4 sts plus 2, so there are knit stitches at each edge when laying flat.

- When working a cardigan with ribbing, you'll want to add the extra 2 (or whatever number corresponds to your ribbing) in order to make the ribbing look the same on each front.

- When working in the round, just work the multiple of stitches without the extra stitches.

Yoke

With shorter cir needle, and using the long-tail CO (see Glossary), CO 69 (75, 81, 83, 85, 87, 89, 91) sts. Place marker (pm) and join for working in rnds. Rnds beg at the center of the back neck.

Sizes 30½ (34¼, 38)" only:
Knit 1 rnd.

Sizes 42 (45¾, 49½, 53¼, 57)" only:
INC RND: K8 (7, 5, 7, 7), RLI (see Glossary), *k22 (10, 7, 5, 4), RLI; rep from * to last 9 (8, 5, 7, 8) sts, knit to end—87 (93, 99, 105, 111) sts.

All Sizes:
OPTIONAL: Raise Back Neck with Short-rows

Note: These short-rows (see Glossary) will raise the back neck so it is higher than the front neck. Working these short-rows will make the front neck fit a bit more comfortably than without them. However, though they are highly recommended, short-rows may be omitted if they are not within your comfort zone at this time.

SHORT-ROW 1: (RS) K17 (19, 20, 22, 23, 25, 26, 28) sts, wrap next st and turn piece with WS facing; purl to m, sl m, p17 (19, 20, 22, 23, 25, 26, 28) sts, wrap next st and turn piece with RS facing.

SHORT-ROW 2: (RS) Knit to m, sl m, k24 (26, 27, 29, 30, 32, 33, 35) sts knitting the wrapped st tog with the st it wraps, wrap next st and turn piece with WS facing; purl to m, sl m, p24 (26, 27, 29, 30, 32, 33, 35) sts purling the wrapped st tog with the st it wraps, wrap next st and turn piece with RS facing.

SHORT-ROW 3: (RS) Knit to m, sl m, k28 (30, 31, 33, 34, 36, 37, 39) sts knitting the wrapped st tog with the st it wraps, wrap next st and turn piece with WS facing; purl to m, sl m, p28 (30, 31, 33, 34, 36, 37, 39) sts purling the wrapped st tog with the st it wraps, wrap next st and turn piece with RS facing. Knit to m.

NEXT RND: Knit to end, knitting wrapped sts tog with the st they wrap as they appear.

[END OPTIONAL SHORT-ROWS]

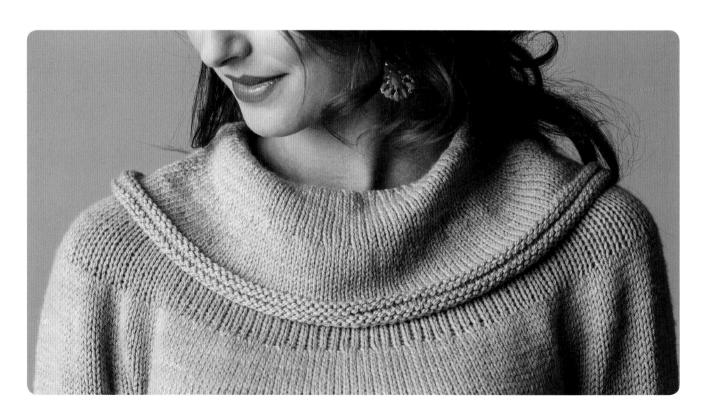

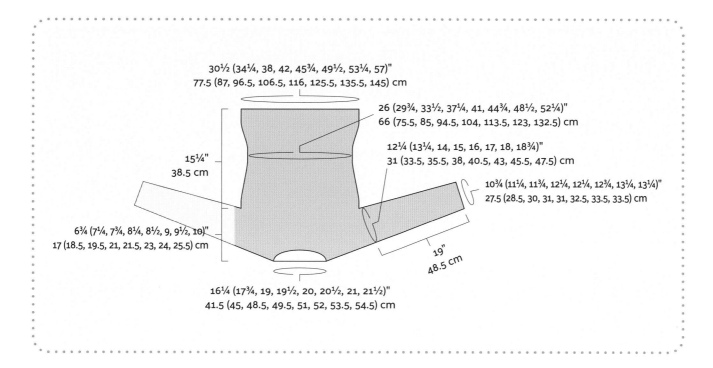

30½ (34¼, 38, 42, 45¾, 49½, 53¼, 57)"
77.5 (87, 96.5, 106.5, 116, 125.5, 135.5, 145) cm

26 (29¾, 33½, 37¼, 41, 44¾, 48½, 52¼)"
66 (75.5, 85, 94.5, 104, 113.5, 123, 132.5) cm

12¼ (13¼, 14, 15, 16, 17, 18, 18¾)"
31 (33.5, 35.5, 38, 40.5, 43, 45.5, 47.5) cm

15¼"
38.5 cm

10¾ (11¼, 11¾, 12¼, 12¼, 12¾, 13¼, 13¼)"
27.5 (28.5, 30, 31, 31, 32.5, 33.5, 33.5) cm

6¾ (7¼, 7¾, 8¼, 8½, 9, 9½, 10)"
17 (18.5, 19.5, 21, 21.5, 23, 24, 25.5) cm

19"
48.5 cm

16¼ (17¾, 19, 19½, 20, 20½, 21, 21½)"
41.5 (45, 48.5, 49.5, 51, 52, 53.5, 54.5) cm

Cont even in St st (knit every rnd) until piece meas ¾ (1, 1, 1, 1, 1, 1¼, 1¼)" (2 [2.5, 2.5, 2.5, 2.5, 2.5, 3.2, 3.2] cm) from beg along center of front.

Shape Yoke

Note: *Change to longer cir needle when sts no longer fit comfortably on shorter cir needle.*

INC RND 1: *K3, RLI (see Glossary); rep from * around—92 (100, 108, 116, 124, 132, 140, 148) sts.

Cont even in St st until piece meas 1¾ (1¾, 2, 2, 2¼, 2¼, 2½, 2½)" (4.5 [4.5, 5, 5, 5.5, 5.5, 6.5, 6.5] cm) from beg along center of front.

INC RND 2: *K2, RLI; rep from * around—138 (150, 162, 174, 186, 198, 210, 222) sts.

Cont even in St st until piece meas 3½ (3¾, 3¾, 4¼, 4¼, 4½, 4¾, 5)" (9 [9.5, 9.5, 11, 11, 11.5, 12, 12.5] cm) from beg along center of front.

INC RND 3: *K2, RLI, k1, RLI; rep from * around—230 (250, 270, 290, 310, 330, 350, 370) sts.

Cont even in St st until piece meas 6¾ (7¼, 7¾, 8¼, 8½, 9, 9½, 10)" (17 [18.5, 19.5, 21, 21.5, 23, 24, 25.5] cm) from beg along center of front.

DIVIDE SLEEVES AND BODY: Work 32 (35, 39, 42, 46, 49, 53, 56) sts for the right half of the back, slip the next 51 (54, 57, 60, 63, 66, 69, 72) sts onto holder or waste yarn for sleeve, use the backward-loop method (see Glossary) and CO 1 (2, 3, 4, 5, 6, 7, 8) sts for underarm, work 64 (71, 78, 85, 92, 99, 106, 113) sts for front, slip the next 51 (54, 57, 60, 63, 66, 69, 72) sts onto holder or waste yarn for sleeve, CO 1 (2, 3, 4, 5, 6, 7, 8) sts for underarm, knit to end of rnd. Remove beg-of-rnd m—130 (146, 162, 178, 194, 210, 226, 242) sts rem.

NEXT RND: K30 (34, 38, 42, 46, 50, 54, 58), pm, k5 (4, 5, 4, 5, 4, 5, 4), pm, k60 (69, 76, 85, 92, 101, 108, 117), pm, k5 (4, 5, 4, 5, 4, 5, 4), pm for new beg of rnd.

Body

Work even in St st until piece meas 1"
(2.5 cm) from divide.

Shape Waist

DEC RND: *K2tog, knit to 2 sts before
next m, ssk, sl m, knit to next m, sl m;
rep from * once more—4 sts dec'd.

Work 5 rnds even.

Rep the last 6 rnds 4 times—110 (126,
142, 158, 174, 190, 206, 222) sts rem.

INC RND: *RLI, knit to next m, LLI (see
Glossary), sl m, knit to next m, sl m;
rep from * once more—4 sts inc'd.

Work 10 rnds even.

Rep the last 11 rnds 4 times—130
(146, 162, 178, 194, 210, 226, 242) sts.

Cont even until piece meas 14½"
[37 cm] from divide.

Purl 2 rnds. Knit 2 rnds. Purl 2 rnds.
BO all sts pwise.

Sleeves

Place held 51 (54, 57, 60, 63, 66, 69, 72)
sts from one sleeve onto 3 dpns, with
4th dpn, beg at gap between held sts
and underarm CO sts, with RS facing,
pick up and knit 1 st in gap between
held sts and underarm CO sts, 1 st in
each CO st, and 1 st in gap between
CO sts and held sts, knit to last st of
held sts, ssk last st with first picked-up
st, k1 (2, 3, 4, 5, 6, 7, 8), k2tog—52 (56,
60, 64, 68, 72, 76, 80) sts.

NEXT RND: K51 (54, 58, 61, 65, 68, 72,
75), pm, k1 (2, 1, 2, 1, 2, 1, 2), pm for
beg of rnd.

Work even in St st until piece meas 1"
(2.5 cm) from underarm.

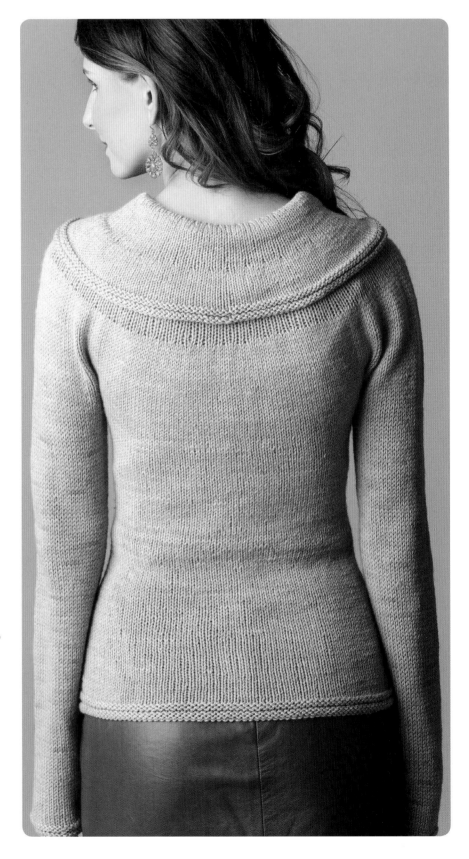

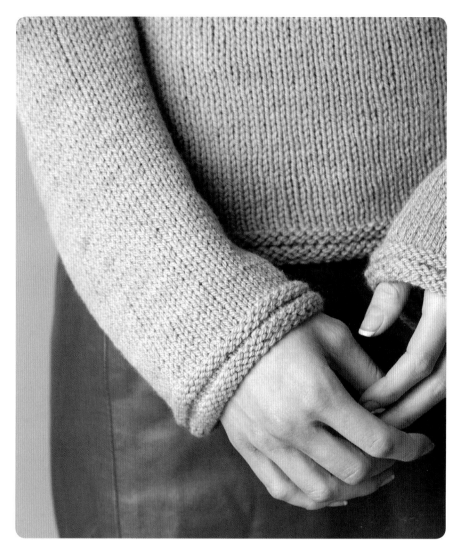

Shape Sleeves

DEC RND: K2tog, knit to 2 sts before next m, ssk, sl m, knit to end—2 sts dec'd.

Work 31 (23, 18, 15, 11, 10, 9, 7) rnds even.

Rep the last 32 (24, 19, 16, 12, 11, 10, 8) rnds 2 (3, 4, 5, 7, 8, 9, 11) more times—46 (48, 50, 52, 52, 54, 56, 56) sts.

Cont even in St st until piece meas 18¼" [46.5 cm] from underarm.

Purl 2 rnds. Knit 2 rnds. Purl 2 rnds. BO all sts pwise.

Work second sleeve same as first.

Finishing

Block to measurements.

Cowl

Turn piece with WS facing. With shorter cir needle, beg at center of back neck, pick up and knit 1 st in each CO st around—69 (75, 81, 83, 85, 87, 89, 91) sts. Pm and join for working in rnds with WS of body facing (the RS of cowl will face when turned down).

Knit 1 rnd. Purl 2 rnds. Knit 2 rnds. Purl 2 rnds.

Cont in St st (knit every rnd) until piece meas 2" (5 cm) from pick-up rnd.

INC RND 1: *K2, RLI; rep from * to last st, k1—103 (112, 121, 124, 127, 130, 133, 136) sts.

Cont even in St st until piece meas 4½" (11.5 cm) from pick-up rnd.

INC RND 2: *K3, RLI; rep from * to last st, k1—137 (149, 161, 165, 169, 173, 177, 181) sts.

Cont even in St st until piece meas 6½" (16.5 cm) from pick-up rnd.

Purl 2 rnds. Knit 2 rnds. Purl 2 rnds. Loosely BO all sts pwise.

Weave in loose ends.

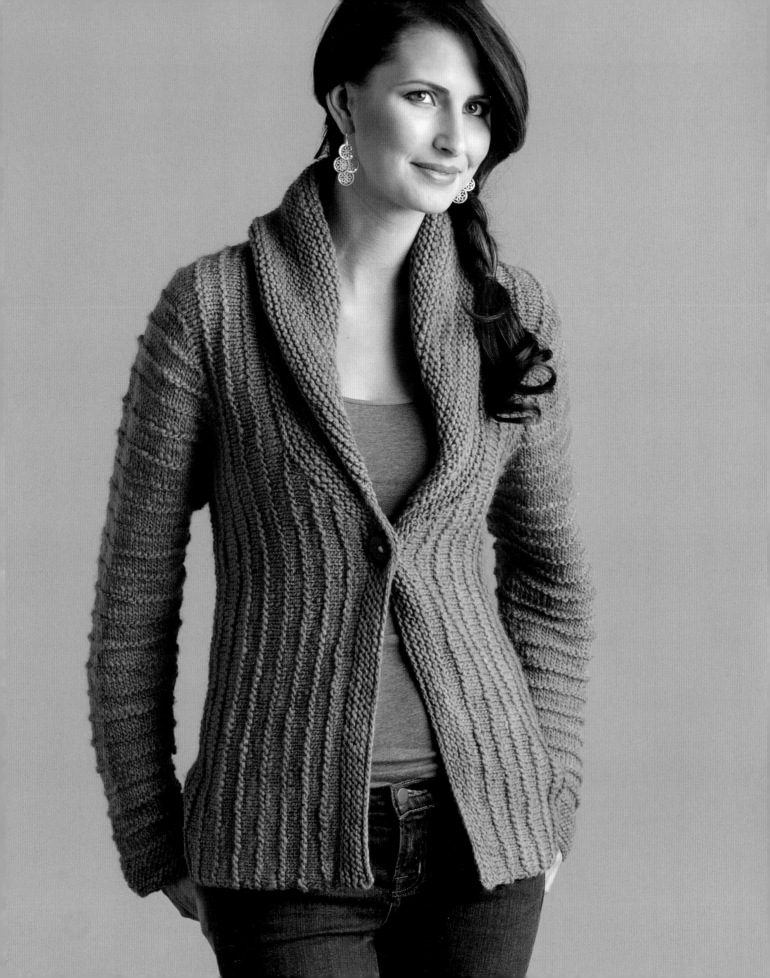

Wholesome COAT

This side-to-side cardigan includes some of my favorite fundamental seamless-knitting techniques: a provisional cast-on, three-needle bind-offs, and short-rows. For someone new to short-rows, the sleeve cap short-rows are optional; however, the short-rows on the collar are not if you want the shawl collar.

The difference between these two sets of short-rows is that on the optional sleeve cap short-rows the wrapped stitch needs to be hidden by working the wrap together with the stitch it wraps; but the necessary shawl collar short-rows are much easier! When working short-rows in garter stitch, the wrap doesn't need to be hidden because it blends into the stitch pattern. So if short-rows are something new to you, feel free to omit the sleeve cap short-rows, but I suggest giving the collar short-rows a try. If you're unsure, try swatching some short-rows in garter stitch, following the collar instructions, to see how they feel before getting started on the sweater.

Techniques

Provisional cast-on

Casting on stitches mid-row

Short-rows

Three-needle bind-off

Using a stitch holder or waste yarn

Buttonholes

Circular knitting with dpns

Finished Size

About 33½ (38½, 42½, 46½, 51, 55, 60)" (85 [98, 108, 118, 129.5, 139.5, 152.5] cm) bust circumference buttoned with 1" (2.5 cm) overlapping buttonband and 25¾ (26¼, 26¾, 27, 27½, 28, 28¼)" (65.5 [66.5, 68, 68.5, 70, 71, 72] cm) long.

Coat shown measures 38½" (98 cm).

Yarn

Chunky weight (#5 Bulky).

Shown here: Manos del Uruguay, Wool Clasica (100% wool, 138 yd [126 m]/100 g): #28 copper, 8 (9, 10, 10, 11, 12, 13) skeins.

Needles

Size U.S. 8 (5 mm): 32" (80 cm) circular (cir) and set of 4 or 5 double-pointed (dpn). *Adjust needle size if necessary to obtain the correct gauge.*

Notions

Markers (m); waste yarn and size U.S. H-8 (5 mm) crochet hook for provisional CO; holders or waste yarn; one 1¼" (32 mm) button; tapestry needle.

Gauge

14 sts and 28 rows = 4" (10 cm) in garter ridge patt; 14 sts and 31 rows = 4" (10 cm) in garter st.

{ The Amazing Provisional Cast-on }

The provisional cast-on method is one of my favorite methods of casting on when there will be live stitches at the cast-on edge to knit in the opposite direction. Another option would be to use any ol' cast-on method, then pick up and knit the stitches to knit in the other direction. Both are possibilities, but they are entirely different in both form and function. A regular cast-on is useful when stability is needed at the cast-on, such as at the back neck of a sweater or along the edge of a buttonband. But when that sort of stability is not necessary and it's more desirable to have a flexible and invisible cast-on, the provisional cast-on can work magic.

For the Wholesome Coat, there is a provisional cast-on worked at the center of the back. The left half of the sweater is worked from the center back outward toward the sleeve cuff. When that half is complete, the provisional cast-on stitches are placed onto the needle and the right half of the sweater is knit from the center back outward toward the right sleeve cuff. The flexible and invisible cast-on is important in this pattern to avoid an obvious vertical line down the center of the back. As you can see in the photo (page 29), the stitch pattern appears to blend seamlessly all the way across the back!

The glossary includes detailed instructions for how to work a provisional cast-on. If you've never tried it, I suggest knitting a little swatch using two different colors of yarn. With waste yarn, cast on 10–15 stitches and use one color of yarn to knit a few inches (centimeters) before binding off. Then carefully remove the waste yarn from the provisional cast-on and place the same number of stitches that you cast on onto the needle. Knit a few inches (centimeters) and bind off on that side. It's truly amazing to see how virtually invisible this cast-on is.

Stitch Guide

Garter Ridge Pattern Worked Back and Forth: *(any number of sts. See chart on page 27.)*

ROWS 1 AND 3: (RS) Knit.

ROW 2: (WS) Purl.

ROWS 4 AND 5: Knit.

ROW 6: Purl.

Rep Rows 1–6 for patt.

Garter Ridge Pattern Worked in Rounds: *(any number of sts)*

RNDS 1–3: Knit.

RND 4: Purl.

RNDS 5–6: Knit.

Rep Rnds 1–6 for patt.

Note: *Circular needle is used to accommodate large number of sts. Do not join; work back and forth in rows.*

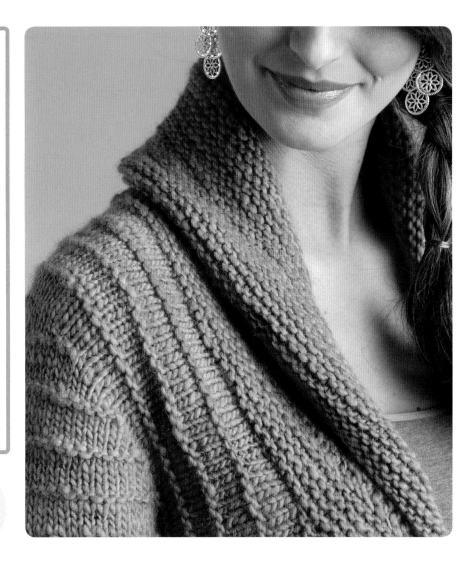

Left Back

With cir needle, using provisional method (see Glossary), CO 87 (89, 90, 91, 93, 95, 96) sts. Do not join; work back and forth in rows.

Work in garter ridge patt for 10 (12, 12, 14, 14, 16, 16) rows, ending with Row 4 (6, 6, 2, 2, 4, 4) of patt.

Shape Neck

INC ROW: (RS) K1, M1L (see Glossary), work to end—1 st inc'd.

Work 1 WS row even in garter ridge patt.

Rep the last 2 rows 3 times—91 (93, 94, 95, 97, 99, 100) sts.

Back should meas 2½ (2¾, 2¾, 3¼, 3¼, 3½, 3½)" (6.5 [7, 7, 8.5, 8.5, 9, 9] cm) to here.

Break yarn. Place sts onto holder or waste yarn.

Left Front

With longer cir needle, CO 52 (53, 54, 55, 57, 59, 61) sts. Do not join; work back and forth in rows.

Purl 1 WS row.

Shape Neck

INC ROW: (RS) Work in garter ridge patt to last st, M1R (see Glossary), k1—1 st inc'd.

Work 1 WS row even in garter ridge patt.

Rep the last 2 rows 5 (6, 6, 7, 7, 8, 8) times—58 (60, 61, 63, 65, 68, 70) sts.

Front should meas 1¾ (2, 2, 2¼, 2¼, 2½, 2½)" (4.5 [5, 5, 5.5, 5.5, 6.5, 6.5] cm) to here.

Left Body

NEXT (JOINING) ROW: (RS) Work to end of left front sts, turn piece with WS facing and using cable method (see Glossary), CO 33 (33, 33, 32, 32, 31, 30) sts, place marker (pm) for shoulder, turn piece with RS facing and place left back sts onto left end of cir needle, work to end of row—182 (186, 188, 190, 194, 198, 200) sts.

Work 3 (5, 5, 5, 5, 7, 7) rows in garter ridge patt, ending with a WS row.

Shape Shoulder

DEC ROW: (RS) Work to 3 sts before m, ssk, k1, sl m, k1, k2tog, work to end—2 sts dec'd.

Rep Dec row every 4 (6, 6, 6, 6, 8) rows 2 times—176 (180, 182, 184, 188, 192, 194) sts rem.

Back should meas 4½ (5½, 5½, 6, 6, 6¾, 7¼)" (11.5 [14, 14, 15, 15, 17, 18.5] cm) to here; front should meas 4¼ (4¾, 4¾, 5½, 5½, 6, 6)" (11 [12, 12, 14, 14, 15, 15] cm) to here.

OPTIONAL: Sleeve Cap Short-rows

Note: The following short-rows (see Glossary) are optional; they require wrapping and turning and also working the wraps together with the stitches they wrap. These short-rows shape the cap so the sleeve gently curves over the shoulder. For the best fit, I suggest working them, but if short-rows simply aren't something you want to do, feel free to omit them.

SHORT-ROW 1: (RS) Work to shoulder m, sl m, work 5 sts, wrap next st and turn piece with WS facing; (WS) work to shoulder m, sl m, work 5 sts, wrap next st and turn piece with RS facing.

SHORT-ROW 2: (RS) Work to wrapped st from previous row, work wrap together with the st it wraps, work 2 sts, wrap next st and turn piece with WS facing; (WS) work to wrapped st from previous row, work wrap together with the st it wraps, work 2 sts, wrap next st and turn piece with RS facing.

Rep the last short-row once more.

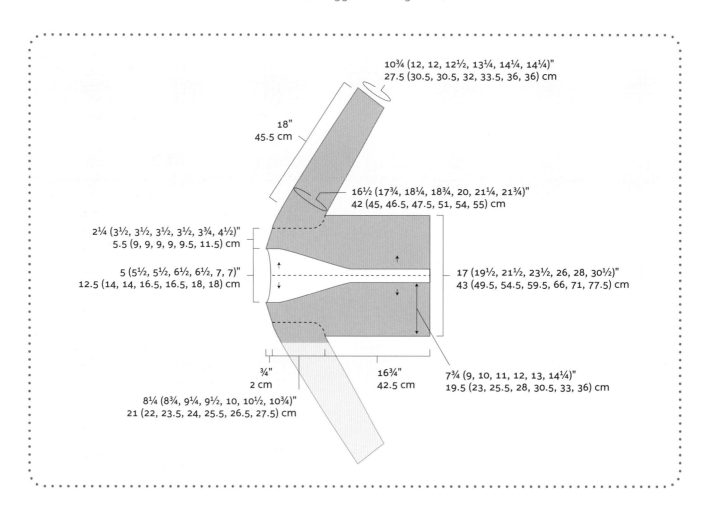

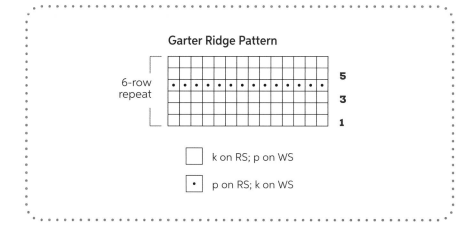

Garter Ridge Pattern

6-row repeat

5
3
1

☐ k on RS; p on WS

⊡ p on RS; k on WS

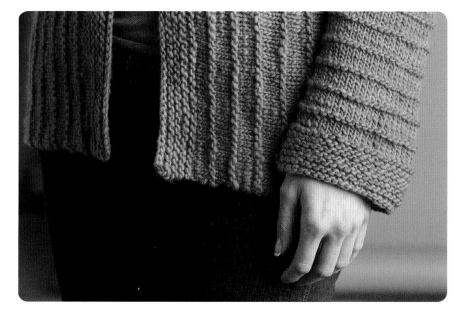

SHORT-ROW 3: (RS) Work to wrapped st from previous row, work wrap together with the st it wraps, work 1 st, wrap next st and turn piece with WS facing; (WS) work to wrapped st from previous row, work wrap together with the st it wraps, work 1 st, wrap next st and turn piece with RS facing.

Rep the last short-row 2 (2, 2, 2, 3, 3, 3) times.

SHORT-ROW 4: (RS) Work to wrapped st from previous row, work wrap together with the st it wraps, wrap next st and turn piece with WS facing; (WS) work to wrapped st from previous row, work wrap together with the st it wraps, wrap next st and turn piece with RS facing.

Rep the last short-row 6 (6, 6, 6, 8, 8, 8) times.

NEXT 2 ROWS: Work to end, hiding the wrap as it appears, ending with a WS row.

[END OPTIONAL SHORT-ROWS]

Cont working as est for 23 (21, 29, 33, 41, 45, 47) rows, ending with a RS row.

Note: If you skipped the short-row cap shaping, add 2 rows here.

Back should meas 8 (8¾, 10, 11, 12¼, 13½, 14¼)" (20.5 [22, 25.5, 28, 31, 34.5, 36] cm) to here; front should meas 7¾ (8, 9¼, 10½, 11¾, 12¾, 13)" (19.5 [20.5, 23.5, 26.5, 30, 32.5, 33] cm) to here, measured along the selvedge edges.

MARK ARMHOLE: (WS) Work 59 sts, pm, work 58 (62, 64, 66, 70, 74, 76) sts, pm, work rem 59 sts.

JOIN SIDE BODY: Holding needles parallel with RS of knitting facing together, and being careful not to twist the work, use the three-needle method (see Glossary) to join 59 sts from each end of the cir needle together for the body side "seam," remove markers, BO 1 more st from the front needle, then slip that st back to the front needle in your left hand—58 (62, 64, 66, 70, 74, 76) sts rem. Turn piece with RS facing.

Sleeve

Change to dpn. Pm and join for working in the rnd. With RS facing, work even in est patt until piece meas about 1" (2.5 cm) from body join, ending after any rnd except Rnd 3.

Shape Sleeve

DEC RND: K1, k2tog, knit to last 3 sts, ssk, k1—2 sts dec'd.

Rep Dec rnd every 6 rnds 9 (9, 10, 10, 11, 11, 12) times—38 (42, 42, 44, 46, 50, 50) sts rem.

Cont even until piece meas 16¼" (41.5 cm) from body join, ending with Rnd 2 of patt.

[Purl 1 rnd, knit 1 rnd] 6 times. BO all sts pwise.

Right Front

With longer cir needle, CO 52 (53, 54, 55, 57, 59, 61) sts. Do not join; work back and forth in rows.

Purl 1 WS row.

Shape Neck

INC ROW: (RS) K1, M1L, work in garter ridge patt to end—1 st inc'd.

Rep the last 2 rows 5 (6, 6, 7, 7, 8, 8) times—58 (60, 61, 63, 65, 68, 70) sts.

Break yarn. Place sts onto st holder or waste yarn.

Right Back

Carefully remove waste yarn from left back provisional CO and place 87 (89, 90, 91, 93, 95, 96) sts onto cir needle. Do not join; work back and forth in rows. Join yarn to beg with a RS row.

Work in garter ridge patt for 10 (12, 12, 14, 14, 16, 16) rows, ending with a WS Row 4 (6, 6, 2, 2, 4, 4) of patt.

Shape Neck

INC ROW: (RS) Work to last st, M1R, k1—1 st inc'd.

Work 1 WS row even.

Rep the last 2 rows 3 times—91 (93, 94, 95, 97, 99, 100) sts.

Right Body

NEXT (JOINING) ROW: (RS) Work to end of right back sts, turn piece with WS facing and using cable method, CO 33 (33, 33, 32, 32, 31, 30) sts, pm for shoulder, turn piece with RS facing and place held right front sts onto left end of needle, work to end of row—182 (186, 188, 190, 194, 198, 200) sts.

Work 3 (5, 5, 5, 5, 7, 7) rows even in est patt, ending with a WS row.

Work shoulder, sleeve cap, and sleeve shaping same as for left body.

Finishing

Block to measurements.

Collar

With cir needle and RS facing, beg at lower edge of right front, pick up and knit 52 (53, 54, 55, 57, 59, 61) sts evenly along right front CO edge to beg of neck shaping, pm for buttonhole placement, pick up and knit 44 sts evenly along neck edge to shoulder, 28 (30, 30, 32, 34, 36, 36) sts along back neck edge, 44 sts along left front neck edge to the beg of neck shaping, pm, then 52 (53, 54, 55, 57, 59, 61) sts along left front CO sts—220 (224, 226, 230, 236, 242, 246) sts.

Knit 3 rows, ending with a WS row.

NEXT (BUTTONHOLE) ROW: (RS) Knit to 7 sts before m, work one-row buttonhole (see Glossary) over 3 sts, knit to end.

Knit 3 rows, ending with a WS row.

Shape collar

SHORT-ROW 1: (RS) Knit to first m, sl m, k63 (65, 65, 67, 69, 71, 71), wrap next st and turn piece with WS facing; k10 (12, 12, 14, 16, 18, 18), wrap next st and turn piece with RS facing—52 sts rem unworked between the wrapped st and the marker on each side.

SHORT-ROW 2: Knit to gap formed by the wrap on the previous row, k2, wrap next st and turn piece with WS facing; knit to gap formed by the wrap on the previous row, k2, wrap next st and turn piece with RS facing.

Rep the last short-row 6 times—31 sts rem unworked between the last wrap and marker on each side.

SHORT-ROW 3: Knit to gap formed by the wrap on the previous row, k1, wrap next st and turn piece with WS facing; knit to gap formed by the wrap on the previous row, k1, wrap next st and turn piece with RS facing.

Rep the last short-row 4 times—21 sts rem unworked between the last wrap and marker on each side.

SHORT-ROW 4: Knit to gap formed by the wrap on the previous row, wrap next st and turn so WS is facing; knit to gap formed by the wrap on the previous row, wrap next st and turn so RS is facing.

Rep the last short-row until you wrap the st just before the marker on each side.

NEXT ROW: (RS) Knit to end.

BO all sts kwise.

Block collar flat.

Sew button to left front opposite buttonhole and weave in loose ends.

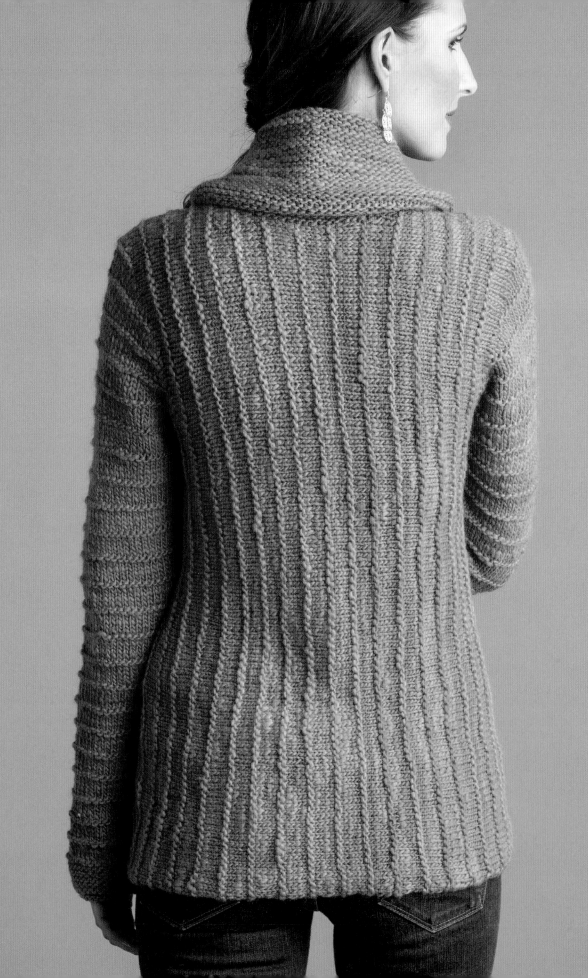

Unconditional
CARDIGAN

The body of the Unconditional Cardigan is knit from the top down, making it easy to try on as you go and adjust the length to fit your body. The sleeve stitches are picked up around the armhole edges and knit from the top down, while working some short-rows to shape the caps. Really detailed instructions for the cap shaping are included, so you can take this technique beyond this sweater and use it in any other sweater pattern! This sweater is a great foundation on which to try many of the customizable techniques in this book, such as adding bust darts (page 112), pockets (page 80), or a hood (page 64).

Techniques
Provisional cast-on at shoulders (optional)

Short-rows for shoulder shaping (optional)

Short-rows for sleeve caps

Casting on stitches mid-row

Picking up stitches

Circular knitting with dpns

Buttonhole

Finished Size
About 30¼ (34¼, 37¾, 41¼, 45¼, 49¼, 52¾)" (77 [87, 96, 106, 115, 125, 134] cm) bust circumference and 25½ (26, 26¾, 27, 27¼, 27¾, 28)" (65 [66, 68, 68.5, 69, 70.5, 71] cm) cm) long.

Cardigan shown measures 34¼" (87 cm).

Yarn
Worsted weight (#4 Medium).

Shown here: Peace Fleece, Worsted (75% merino, 25% mohair, 200 yd [183 m]/4 oz): Anna's grasshopper (MC), 6 (7, 7, 8, 8, 9, 9) skeins; Baikal superior green (CC), 1 skein.

Needles
Size U.S. 8 (5 mm): straight, 32" (80 cm), circular (cir), and set of 4 or 5 double-pointed needles (dpn). *Adjust needle size if necessary to obtain the correct gauge.*

Notions
Markers (m); holders or waste yarn; tapestry needle; seven 1" (2.5 cm) buttons.

Gauge
15 sts and 30 rows = 4" (10 cm) in garter st, worked flat; 16 sts and 21 rnds = 4" (10 cm) in St st, worked in the rnd.

{ Seamless Set-in Sleeve Caps }

The Unconditional Cardigan has "set-in" sleeve shaping. This means the armhole edges are indented from the edge of the body, and a curved cap helps the sleeve fold over the shoulder for a flattering fit. The armhole shaping is similar to "modified drop" shaping (see page 48), except that a modified drop armhole has only a single set of bound-off stitches. With a set-in armhole, there may be more than one set of bound-off stitches, and there are often many rows of gradual decreases that occur before the armhole shaping is complete. This curve at the underarm, in conjunction with the curved sleeve cap, creates a flattering shape and prevents fabric from bunching up under the arm.

There are many seamed sweater patterns where the sleeves are knit separately from the body, from the bottom up, with a curved cap that is set in to the armhole while sewing it together. The seamless construction I'm about to share is similar to that, except it's knit from the top down, and instead of seaming, you begin by picking up stitches around the armhole. The curve of the sleeve cap is created by working short-rows back and forth across the center of the sleeve.

Pick up stitches

To begin, determine how many stitches you'll need for the under-arm circumference of your sleeve. This will be the total number of stitches you'll need to pick up around your armhole. Divide that number in half to know how many stitches are needed from the center of the underarm to the shoulder on each side. For the sample size of the Unconditional Cardigan, I needed 52 stitches. Divided in half, that's 26 stitches on each half.

Start at the center of the under-arm stitches, pick up and knit 1 stitch for each bound-off stitch, then pick up and evenly knit the remaining number of stitches needed for the first half of your sleeve to the shoulder. I picked up 2 bound-off stitches then an additional 24 stitches to the shoulder.

Place a marker at the shoulder—you'll need this on the first short-row to establish the center of the sleeve. Pick up and knit the same number of stitches on the other side. Place a marker for the beginning of the round. While working the cap shaping, you'll work back and forth in short-rows, but you'll start using the beginning of the round marker once the cap shaping is complete.

Determine the shape of the cap

Now that your stitches are picked up, you have some choices to make. The shape of the cap can determine a lot about how well the sweater will fit and whether it's more formal or casual. A tall, narrow cap is more formal and has a snugger fit. A short, wide cap is more casual and has a looser fit. The charts below show the differences between these two types of caps. For the Unconditional Cardigan, I chose to go a little in between but closer to casual.

On the first short-row, work to the marker at the shoulder, then knit some more stitches. The number of stitches knit here will be a huge deciding factor in how tall and narrow or how short and wide your cap will be. If you knit a lot of stitches here, you'll have a short and wide cap, but if you knit just a few, your cap will be tall and narrow. (As you can see in the charts on page

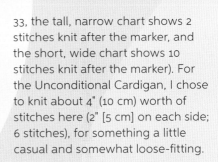

33, the tall, narrow chart shows 2 stitches knit after the marker, and the short, wide chart shows 10 stitches knit after the marker). For the Unconditional Cardigan, I chose to knit about 4" (10 cm) worth of stitches here (2" [5 cm] on each side; 6 stitches), for something a little casual and somewhat loose-fitting.

SHORT-ROW 1: (RS) Knit to shoulder marker, remove m, knit your decided number of stitches (I knit 6), wrap next st and turn piece with WS facing; purl your decided number of stitches times 2 (I purled 12), wrap next st and turn piece with RS facing.

Determine cap height

Before continuing, determine how many stitches remain unwrapped on each side of your wrapped stitches, then subtract the number of bound-off underarm stitches. Knowing this number will help you see the tallest height your sleeve cap can be.

For the sample, I have 19 stitches remaining on each side. There are a total of 4 bound-off underarm stitches (2 on each side), so I subtract 2 from the 19 for a remaining number of 17 stitches on each side for the short-row shaping. The 17 stitches on each side can be worked into 34 rows (17 × 2) for the tallest cap

height possible. To determine the total height of my cap, I add 3 rows (for the RS and WS rows worked from Short-row 1, and for 1 additional row worked at the end) to 34 and divide it by the row gauge.

34 + 3 = 37

37 ÷ 5.25 rows per inch (2.1 rows per cm) = 7" (17.5 cm)

With my armhole depth at about 7½" (19 cm), a 7" cap is really tall and not exactly what I'm looking for with this design. I want something shorter.

Adjust cap height

I could either knit more stitches for Short-row 1, or I could work a few short-rows where there is 1 knit stitch between the wrap from the previous short-row and the wrap on this row. This uses up 2 stitches per side per short-row. I'm choosing to work a few of these short-rows so there is a curve at the top of the cap. If the cap shaping goes directly from knitting stitches to wrapping and turning every stitch, the top of the cap will be a bit boxy. Working a few of these short-rows with 1 stitch between the wraps helps prevent that.

The more short-rows that are worked with 1 stitch worked between the wraps (Short-row 2), the shorter the cap will be. I usually work only a few of these.

To decide how many of these short-rows to work for the ideal cap height, subtract 2 rows from your total rows (figured above) for each Short-row 2 that you'll work.

In my sample, I figured that I have 37 rows if I worked all the following short-rows with wraps every stitch. If I work Short-row 2 three times, it will use up 6 stitches (the knit stitch between the wrap and the wrapped st for each rep) and will subtract 6

Example of a short, wide sleeve cap: casual and loose-fitting

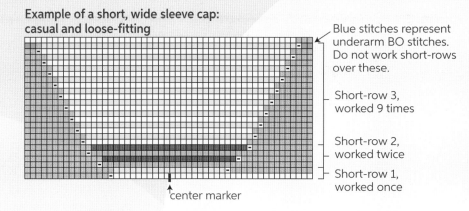

center marker

Blue stitches represent underarm BO stitches. Do not work short-rows over these.

Short-row 3, worked 9 times

Short-row 2, worked twice

Short-row 1, worked once

Example of a tall, narrow sleeve cap: formal and snug-fitting

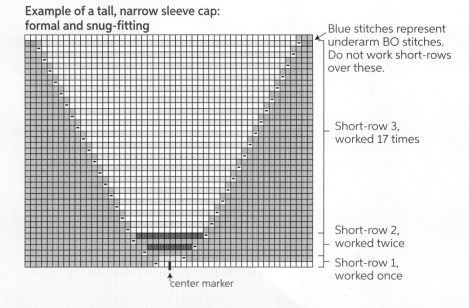

center marker

Blue stitches represent underarm BO stitches. Do not work short-rows over these.

Short-row 3, worked 17 times

Short-row 2, worked twice

Short-row 1, worked once

Size 34¼" (87 cm) sleeve cap

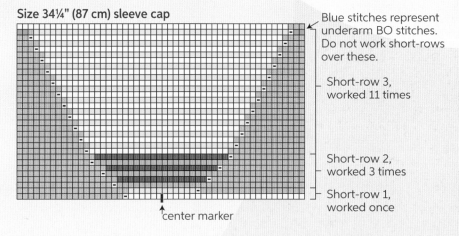

center marker

Blue stitches represent underarm BO stitches. Do not work short-rows over these.

Short-row 3, worked 11 times

Short-row 2, worked 3 times

Short-row 1, worked once

rows from the total. If I divide 31 rows by the row gauge, I get an updated cap height of 6" (15 cm), and I'll have 11 stitches remaining to be wrapped.

A 6" (15 cm) sleeve cap for a 7½" (19 cm) armhole is somewhat more casual and comfortable than a 7" (18 cm) sleeve cap. So, I like it. Let's keep going.

SHORT-ROW 2: (RS) Knit to wrapped st from previous row, knit wrap together with st it wraps, k1, wrap next st and turn piece with WS facing; purl to wrapped st from previous row, purl wrap together with st it wraps, p1, wrap next st and turn piece with RS facing.

Work the last short-row as many times as determined. I worked it a total of 3 times.

SHORT-ROW 3: (RS) Knit to wrapped st from previous row, knit wrap together with st it wraps, wrap next st and turn piece with WS facing; purl to wrapped st from previous row, purl wrap together with st it wraps, wrap next st and turn piece with RS facing.

Rep the last short-row until only the underarm BO stitches remain unworked at each edge of the cap. I worked it a total of 11 times and had 2 stitches remaining on each side.

NEXT ROW: (RS) Knit to end of rnd, working wrap tog with the st it wraps as you come to it. Join to work in the round and continue working your sleeve from the underarm to the cuff.

Alter seamed patterns

I believe it's possible to knit set-in sleeves seamlessly for many patterns that instruct you to knit separate sleeves. Simply flip the sleeve cap shaping around and work it backward, from the top down instead of the bottom up. You may want to get out some graph paper and draw out the cap shaping as it's written in your seamed pattern before beginning, as that will help you see at a glance what you'll need to do to knit it from the top down. Some fudging may be required, but if you've got the basic outline on your graph paper, you can play around with it until it works with the three sets of short-rows above.

Right Back Shoulder

With straight needles and using provisional method (see Glossary) or your favorite CO method, CO 9 (10, 11, 12, 13, 14, 15) sts.

With MC, knit 1 WS row.

OPTIONAL:
Shape Shoulder with Short-rows

SHORT-ROW 1: (RS) K3 (3, 4, 4, 4, 5, 5), wrap next st and turn piece with WS facing; knit to end.

SHORT-ROW 2: (RS) K6 (6, 8, 8, 8, 10, 10), wrap next st and turn piece with WS facing; knit to end.

(END OPTIONAL SHORT-ROWS)

NEXT (INC) ROW: (RS) K1, M1, knit to end—10 (11, 12, 13, 14, 15, 16) sts.

Knit 1 WS row even.

Keep sts on needle. Break yarn and set aside.

Left Back Shoulder

With empty straight needle, using provisional method, or your favorite method, CO 9 (10, 11, 12, 13, 14, 15) sts.

With MC, knit 1 WS row.

Knit 1 RS row.

Note: *if you choose not to work the following short-rows, inc 1 st at end of this row by knitting to the last st, then M1, k1.*

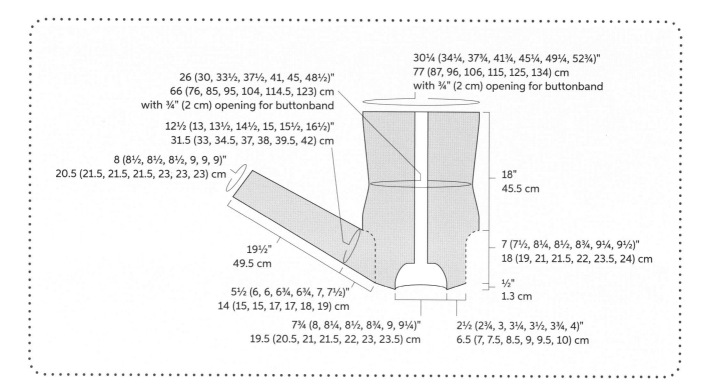

26 (30, 33½, 37½, 41, 45, 48½)"
66 (76, 85, 95, 104, 114.5, 123) cm
with ¾" (2 cm) opening for buttonband

30¼ (34¼, 37¾, 41¾, 45¼, 49¼, 52¾)"
77 (87, 96, 106, 115, 125, 134) cm
with ¾" (2 cm) opening for buttonband

12½ (13, 13½, 14½, 15, 15½, 16½)"
31.5 (33, 34.5, 37, 38, 39.5, 42) cm

8 (8½, 8½, 8½, 9, 9, 9)"
20.5 (21.5, 21.5, 21.5, 23, 23, 23) cm

18"
45.5 cm

19½"
49.5 cm

7 (7½, 8¼, 8½, 8¾, 9¼, 9½)"
18 (19, 21, 21.5, 22, 23.5, 24) cm

½"
1.3 cm

5½ (6, 6, 6¾, 6¾, 7, 7½)"
14 (15, 15, 17, 17, 18, 19) cm

7¾ (8, 8¼, 8½, 8¾, 9, 9¼)"
19.5 (20.5, 21, 21.5, 22, 23, 23.5) cm

2½ (2¾, 3, 3¼, 3½, 3¾, 4)"
6.5 (7, 7.5, 8.5, 9, 9.5, 10) cm

OPTIONAL:
Shape Shoulder with Short-rows

SHORT-ROW 1: (WS) K3 (3, 4, 4, 4, 5, 5), wrap next st and turn piece with RS facing; knit to end.

SHORT-ROW 2 (INC): (WS) K6 (6, 8, 8, 8, 10, 10), wrap next st and turn piece with RS facing; knit to last st, M1, k1—10 (11, 12, 13, 14, 15, 16) sts.

(END OPTIONAL SHORT-ROWS)

Knit 1 WS row even.

Back

NEXT (JOINING) ROW: (RS) Knit to last st of left back shoulder, M1, k1, turn piece with WS facing and using cable method (see Glossary), CO 25 (26, 27, 28, 29, 30, 31) sts, turn piece with RS facing and work right back shoulder sts as foll: k1, M1, knit to end—47 (50, 53, 56, 59, 62, 65) sts.

Cont even in garter st (knit every row) until piece meas 6 (5¾, 5¾, 5½, 5½, 5¼, 5¼). (15 [14.5, 14.5, 14, 14, 13.5, 13.5] cm) from shoulder along side edges, ending with a WS row.

Shape Armholes

INC ROW: (RS) K1, M1, knit to last st, M1, k1—2 sts inc'd.

Knit 3 rows.

Rep the last 4 rows 0 (1, 2, 2, 2, 3, 3) time(s)—49 (54, 59, 62, 65, 70, 73) sts.

[Work Inc Row, then knit 1 WS row] 2 (3, 3, 5, 6, 7, 8) times—53 (60, 65, 72, 77, 84, 89) sts.

Place all sts onto cir needle. Break yarn and set aside.

Right Front

With straight needles, carefully ravel waste yarn from provisional CO and place 9 (10, 11, 12, 13, 14, 15) sts onto

needle. Join yarn to beg with a WS row, or if you used a different CO, beg at armhole edge of right back shoulder, and with MC, pick up and knit 1 st in each CO st—9 (10, 11, 12, 13, 14, 15) sts.

OPTIONAL:
Shape Shoulder with Short-rows

SHORT-ROW 1: (WS) With MC, k3 (3, 4, 4, 4, 5, 5), wrap next st and turn piece with RS facing; knit to end.

SHORT-ROW 2: (WS) K6 (6, 8, 8, 8, 10, 10), wrap next st and turn piece with RS facing; knit to end.

(END OPTIONAL SHORT-ROWS)

Knit 2 rows even, ending with a RS row.

Shape Neck

Knit 1 WS row even.

INC ROW: (RS) Knit to last st, M1, k1—1 st inc'd.

Rep the last 2 rows 9 (10, 10, 11, 10, 11, 11) times—19 (21, 22, 24, 24, 26, 27) sts.

Using the backward-loop method (see Glossary), CO 3 (3, 3, 3, 4, 4, 4) sts—22 (24, 25, 27, 28, 30, 31) sts.

Cont even until piece meas 6 (5¾, 5¾, 5½, 5½, 5¼, 5¼). [15 (14.5, 14.5, 14, 14, 13.5, 13.5) cm] from shoulder, meas along side edges, ending with a WS row.

Shape Armholes

INC ROW: (RS) K1, M1, knit to end—1 st inc'd.

Knit 3 rows.

Rep the last 4 rows 0 (1, 2, 2, 2, 3, 3) time(s)—23 (26, 28, 30, 31, 34, 35) sts.

[Work Inc Row, then knit 1 row] 2 (3, 3, 5, 6, 7, 8) times—25 (29, 31, 35, 37, 41, 43) sts.

Place all sts onto holder or waste yarn. Break yarn and set aside.

Left Front

Beg at neck edge of left back shoulder, with MC, pick up and knit 1 st in each CO st—9 (10, 11, 12, 13, 14, 15) sts.

Knit 1 WS row.

OPTIONAL: Shape Shoulder with Short-rows

SHORT-ROW 1: (RS) K3 (3, 4, 4, 4, 5, 5), wrap next st and turn piece with WS facing; knit to end.

SHORT-ROW 2: (RS) K6 (6, 8, 8, 8, 10, 10), wrap next st and turn piece with WS facing; knit to end.

(END OPTIONAL SHORT-ROWS)

Knit 2 rows even, ending with a WS row.

Shape Neck

INC ROW: (RS) K1, M1, knit to end—1 st inc'd.

Knit 1 WS row.

Rep the last 2 rows 9 (10, 10, 11, 10, 11, 11) times—19 (21, 22, 24, 24, 26, 27) sts.

Using the backward-loop method, CO 3 (3, 3, 3, 4, 4, 4) sts—22 (24, 25, 27, 28, 30, 31) sts.

Cont even until piece meas 6 (5¾, 5¾, 5½, 5½, 5¼, 5¼). [15 (14.5, 14.5, 14, 14, 13.5, 13.5) cm] from shoulder, meas along side edges, ending with a WS row.

Shape Armholes

INC ROW: (RS) Knit to last st, M1, k1—1 st inc'd.

Knit 3 rows.

Rep the last 4 rows 0 (1, 2, 2, 2, 3, 3) time(s)—23 (26, 28, 30, 31, 34, 35) sts.

[Work Inc Row, then knit 1 WS row] 2 (3, 3, 5, 6, 7, 8) times—25 (29, 31, 35, 37, 41, 43) sts.

Body

NEXT (JOINING) ROW: (RS) With cir needle and MC, knit to end of left front sts, using the backward-loop method, CO 2 (2, 3, 3, 4, 4, 5) sts, pm for side, CO 2 (2, 3, 3, 4, 4, 5) sts, place back sts onto empty end of cir needle and knit to end, CO 2 (2, 3, 3, 4, 4, 5) sts, pm for side, CO 2 (2, 3, 3, 4, 4, 5) sts, place right front sts onto empty end of cir needle and knit to end—111 (126, 139, 154, 167, 182, 195) sts.

Work even until piece meas 1½" (3.8 cm) from underarm, ending with a WS row.

Shape Waist

DEC ROW: (RS) *Knit to 4 sts before side m, ssk, k2, sl m, k2, k2tog; rep from * once more, knit to end—4 sts dec'd.

Knit 9 rows, ending after a WS row.

Rep the last 10 rows 3 times—95 (110, 123, 138, 151, 166, 179, 196) sts rem.

INC ROW: (RS) *Knit to 2 sts before side m, M1R, k2, sl m, k2, M1L; rep from * once more, knit to end—4 sts inc'd.

Knit 11 rows, ending after a WS row.

Rep the last 12 rows 3 times—111 (126, 139, 154, 167, 182, 195, 212) sts rem.

Cont even until piece meas 18" (45.5 cm) from underarm, ending with a RS row. BO all sts kwise.

Sleeves

With dpns, beg at center of underarm CO sts, with MC, pick up and knit 2 (2, 3, 3, 4, 4, 5) sts along CO sts, then pick up and knit 23 (24, 24, 26, 26, 27, 28) sts evenly along armhole edge to shoulder, pm, pick up and knit 23 (24, 24, 26, 26, 27, 28) sts evenly along armhole edge to the other side of the underarm CO sts, pick up and knit 2 (2, 3, 3, 4, 4, 5) sts along rem CO sts—50 (52, 54, 58, 60, 62, 66) sts. Divide sts evenly over 3 or 4 dpn. Pm for beg of rnd.

Shape Sleeve Cap with Short-rows

SHORT-ROW 1: (RS) Knit to shoulder marker, remove m, k6, wrap next st and turn piece with WS facing; p12, wrap next st and turn piece with RS facing.

SHORT-ROW 2: (RS) Knit to wrapped st from previous row, knit wrap together with st it wraps, k1, wrap next st and turn piece with WS facing; purl to wrapped st from previous

row, purl wrap together with st it wraps, p1, wrap next st and turn piece with RS facing.

Rep the last short-row 2 times—12 (13, 14, 16, 17, 18, 20) sts rem unwrapped at each end of center wrapped sts.

SHORT-ROW 3: (RS) Knit to wrapped st from previous row, knit wrap together with st it wraps, wrap next st and turn piece with WS facing; purl to wrapped st from previous row, purl wrap together with st it wraps, wrap next st and turn piece with RS facing.

Rep the last short-row 9 (10, 10, 12, 12, 13, 14) times—2 (2, 3, 3, 4, 4, 5) sts rem unwrapped at each end of center wrapped sts.

NEXT ROW: (RS) Knit to end of rnd, working wrap tog with the st it wraps as you come to it. Cont working St st (knit every rnd) until piece meas 1" (2.5 cm) from underarm, hiding the last wrap on the first rnd.

Shape Sleeve

DEC RND: K2, k2tog, knit to last 4 sts, ssk, k2—2 sts dec'd.

Work 10 (10, 9, 7, 7, 7, 6) rnds even.

Rep the last 11 (11, 10, 8, 8, 8, 7) rnds 0 (0, 1, 5, 5, 2, 3) time(s)—48 (50, 50, 46, 48, 56, 58) sts rem.

[Work Dec Rnd, then knit 8 (8, 7, 5, 5, 5, 4) rnds] 8 (8, 8, 6, 6, 10, 11) times—32 (34, 34, 34, 36, 36, 36) sts rem.

Cont even until piece meas 19" (48.5 cm) from underarm.

Change to CC.

Knit 1 rnd. Purl 1 rnd. Knit 1 rnd.

BO all sts pwise.

Work second sleeve same as first.

Finishing

Block to measurements.

Buttonband

With CC and cir needle, beg at neck edge of left front, pick up and knit 76 (76, 78, 78, 80, 82, 82) sts evenly along left front edge. Knit 6 rows, ending with a RS row. BO all sts kwise.

Buttonhole Band

With CC and cir needle, beg at lower edge of right front, pick up and knit 76 (76, 78, 78, 80, 82, 82) sts evenly along right front edge.

Knit 3 rows, ending with a WS row.

NEXT (BUTTONHOLE) ROW: (RS) K4 (4, 5, 5, 2, 4, 4), work one-row buttonhole (see Glossary) over 3 sts, *k7 (7, 7, 7, 8, 8, 8), one-row buttonhole over 3 sts; rep from * to last 2 (2, 3, 3, 2, 2, 2) sts, knit to end.

Knit 2 rows, ending with a RS row. BO all sts kwise.

Neck Trim

With CC and cir needle, beg at right front edge, pick up and knit 21 (22, 22, 23, 23, 24, 24) sts to shoulder, 31 (32, 33, 34, 35, 36, 37) sts along back neck, then 21 (22, 22, 23, 23, 24, 24) sts along left front edge—73 (76, 77, 80, 81, 84, 85) sts.

Knit 2 rows. BO all sts kwise.

Sew buttons to buttonband opposite buttonholes.

Weave in loose ends.

Interchangeable Stitch Patterns

In Chapter 2, there are six different patterns that each use a stitch pattern with the same multiple of stitches, making all six stitch patterns interchangeable with all six sweaters!

So, in Chapter 2 alone, there are thirty-six possibilities for sweaters. Mix and match your favorite stitch pattern with your favorite sweater shape for a unique creation.

Take a look at the tip box on page 42 for some tips on substituting the stitch patterns.

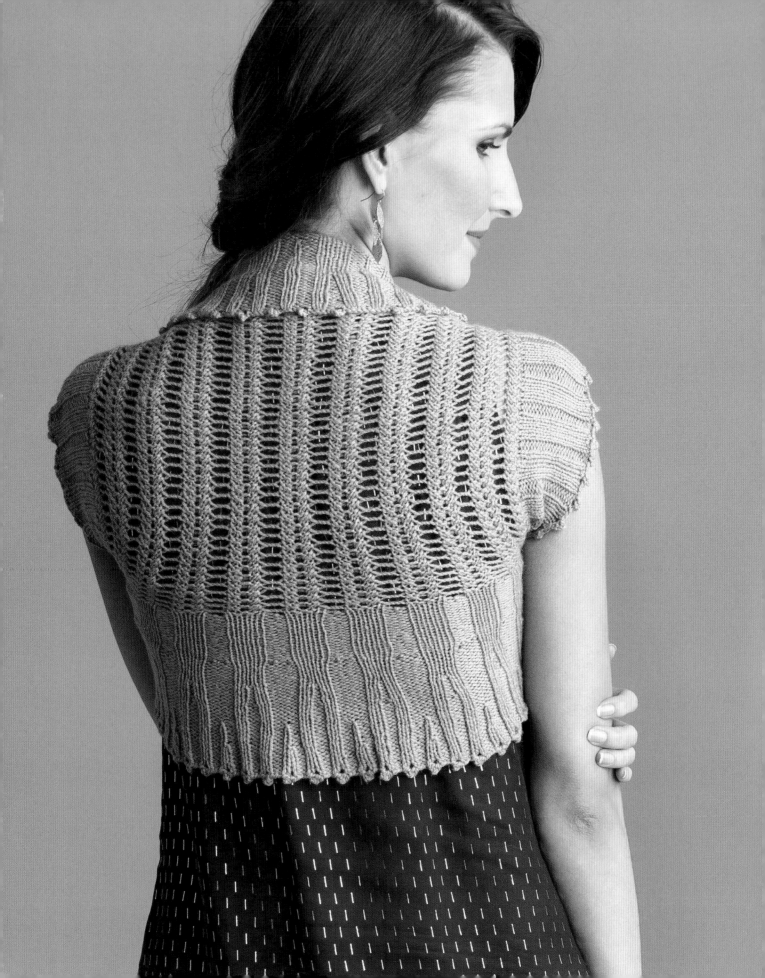

Soulful SHRUG

The Soulful Shrug is a great small project that's perfect for on-the-go knitting. Not only is it small and quick to knit, the stitch pattern can be interchanged with the stitch patterns used in the other five patterns in this chapter! Falling in love with this shrug construction won't get boring when you have so many options. It can be knit over and over with many different results. Also, play with different combinations of the main stitch pattern and the edging. See page 16 for alternate edging options.

See page 16 for alternate edging options.

Techniques
Circular knitting on circular needles and dpns

Casting on stitches mid-row

Lace

Provisional cast-on

Finished Size
About 11¾ (13, 14¼, 15½, 16¾, 18, 19¼)" (30 [33, 36, 39.5, 42.5, 45.5, 49] cm) across back shoulders.

Shrug shown measures 13" (33 cm).

Yarn
Sport weight (#2 Fine).

Shown here: Imperial Stock Ranch, Tracie Too (100% wool, 395 yd [361 m]/4 oz): #302 rain, 1 (1, 1, 2, 2, 2, 2) skein(s).

Needles
Size U.S. 5 (3.75 mm): straight, 24" (60 cm) circular (cir) and set of 4 or 5 double-pointed (dpn). *Adjust needle size if necessary to obtain the correct gauge.*

Notions
Waste yarn and size U.S. F-5 (3.75 mm) crochet hook for provisional CO; marker (m); tapestry needle.

Gauge
19 sts and 28 rows = 4" (10 cm) in shrug lace pattern, worked in rows.

17 sts and 32 rnds = 4" (10 cm) in k4, p2 ribbing, worked in rnds.

{ Interchangeable Stitch Patterns }

The Soulful Shrug, Nurturing Cardigan, Majestic Tie Cardigan, Tender Hoodie, Sunshine Pullover, and Merci Hoodie all use stitch patterns that are multiples of 6 stitches plus 2 edge stitches when worked flat or a multiple of 6 stitches when worked in the round. This means that these six stitch patterns may be used for any of the six patterns in this chapter!

When choosing which stitch pattern to use for your sweater, consider how functional that stitch pattern will be. For example, the Majestic Tie Cardigan and the Merci Hoodie both use stitch patterns as edging. The knit and purl combinations help prevent the edges from rolling, so using a stitch pattern that is primarily knit stitches—as in the Nurturing Cardigan—might result in a rolling edge.

Below is an alternative version of the lace pattern used in the Nurturing Cardigan, where the lace is worked over garter stitch, instead of St st, making the edging more stable.

Read more about what to consider when choosing edgings on page 16 (Dreamy Pullover).

Also, when knitting the pockets in the Merci Hoodie, I personally wouldn't choose to use a lace pattern over the pocket because the airy holes may not keep my hands warm and may allow items to fall through. If you love the idea of using a lacy pattern in the Merci Hoodie, consider omitting the pockets. Or, work the pockets in the lace pattern but close up the eyelets by knitting them through the back loop.

Nurturing Cardigan
Lace Pattern Worked Back and Forth

└─ 6-st rep ─┘

Nurturing Cardigan
Lace Pattern Worked in Rounds

└─ 6-st rep ─┘

☐ k on RS; p on WS	╲ ssk
• p on RS; k on WS	╱ k2tog
○ yo	ᘒ k1-tbl on RS, p1-tbl on WS

⋁ sl 1 pwise wyb	
☐ pattern repeat	

Stitch Guide

Shrug Lace Pattern Worked Back and Forth:
(multiple of 6 sts + 2)

ROW 1: (RS) K1, *k2tog, k1, [yo] twice, k1, ssk; rep from * to last st, k1.

ROW 2: (WS) K2, *p2, k1, p1, k2; rep from *.

Rep Rows 1–2 for patt.

Shrug Lace Pattern Worked in the Round:
(multiple of 6 sts)

RND 1: *K2tog, k1, [yo] twice, k1, ssk; rep from *.

RND 2: *P1, k2, p1, k1, p1; rep from *.

Rep Rnds 1–2 for patt.

Picot BO: *(multiple of 6 sts)*

BO 2 sts in patt, place rem st on right needle onto left needle tip, use the knitted method (see Glossary) to CO 2 sts, BO 2 sts by knitting tbl, *BO 4 sts in patt, place rem st on right needle onto left needle tip, CO 2 sts, BO 2 sts by knitting tbl; rep from * around, BO 2 sts in patt. Fasten off.

Notes

This shrug only uses the Shrug Lace Pattern Worked Back and Forth. The Shrug Lace Pattern Worked in Rounds is given so it may be used for other patterns in this chapter.

To determine which size would fit you best, measure across your upper back from one shoulder to the other. Choose the size closest to that measurement.

Shrug Lace Pattern Worked Back and Forth

2 ... 1
6-st rep

Shrug Lace Pattern Worked in Rounds

1
6-st rep

- ☐ k on RS; p on WS
- • p on RS; k on WS
- ╱ k2tog
- ╲ ssk
- ○ yo
- ☐ pattern repeat

Back

With straight needles and using a provisional method (see Glossary), CO 56 (62, 68, 74, 80, 86, 92) sts. Knit 1 WS row. Work Rows 1–2 of shrug lace patt until piece meas 11½ (12¼, 13½, 14¼, 15½, 16¼, 17½)" (29 [31, 34.5, 36, 39.5, 41.5, 44.5] cm) from CO, ending with a WS row and complete patt rep.

Collar

Change to cir needle.

SET-UP RND: (RS) K3, p2, (k4, p2) to last 3 sts, k3, using backward-loop method (see Glossary), CO 4 sts, carefully remove waste yarn from provisional CO and place sts onto an empty needle with RS facing, k3, p2, (k4, p2) to last 3 provisional CO sts, k3, CO 4 sts—120 (132, 144, 156, 168, 180, 192) sts. Place marker (pm) and join for working in rnds.

NEXT RND: K3, p2, *k4, p2; rep from * to last st, k1.

Cont in est patt until rib meas 1½" (3.8 cm).

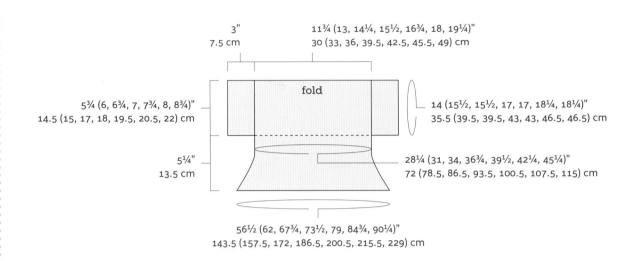

3"
7.5 cm

11¾ (13, 14¼, 15½, 16¾, 18, 19¼)"
30 (33, 36, 39.5, 42.5, 45.5, 49) cm

fold

5¾ (6, 6¾, 7, 7¾, 8, 8¾)"
14.5 (15, 17, 18, 19.5, 20.5, 22) cm

14 (15½, 15½, 17, 17, 18¼, 18¼)"
35.5 (39.5, 39.5, 43, 43, 46.5, 46.5) cm

5¼"
13.5 cm

28¼ (31, 34, 36¾, 39½, 42¼, 45¼)"
72 (78.5, 86.5, 93.5, 100.5, 107.5, 115) cm

56½ (62, 67¾, 73½, 79, 84¾, 90¼)"
143.5 (157.5, 172, 186.5, 200.5, 215.5, 229) cm

Shape Collar

INC RND 1: *K3, LLIP (see Glossary), p2, RLPI (see Glossary), k1; rep from *—160 (176, 192, 208, 224, 240, 256) sts.

NEXT RND: *K3, p4, k1; rep from *.

Rep last rnd 4 times.

INC RND 2: *K1, M1P, k2, p4, k1; rep from *—180 (198, 216, 234, 252, 270, 288) sts.

NEXT RND: *K1, p1, k2, p4, k1; rep from *.

Rep last rnd 4 times.

INC RND 3: *K1, p1, M1P, k2, p4, k1; rep from * around—200 (220, 240, 260, 280, 300, 320) sts.

NEXT RND: *K1, p2, k2, p4, k1; rep from * around.

Rep last rnd 4 times.

INC RND 4: *K1, p2, k2, p2, M1, p2, k1; rep from * around—220 (242, 264, 286, 308, 330, 352) sts.

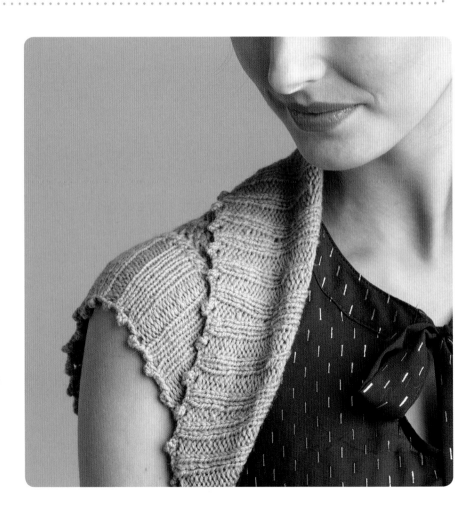

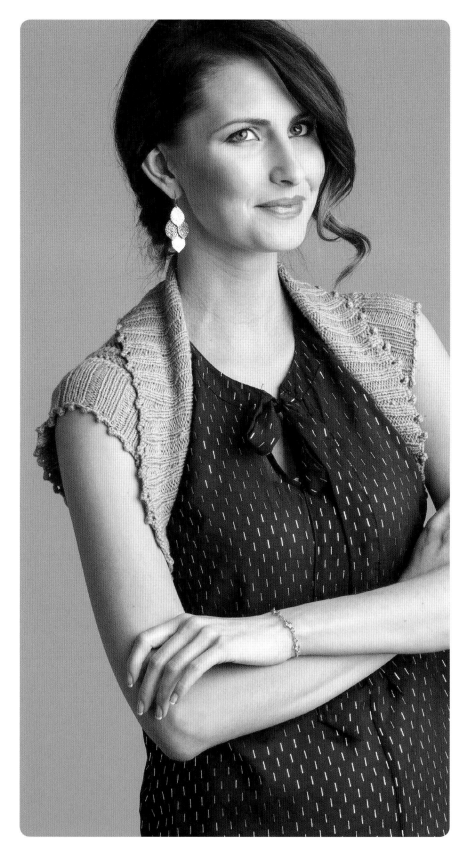

NEXT RND: *K1, p2, k2, p2, k1, p2, k1; rep from * around.

Rep last rnd 4 times.

INC RND 5: *K1, p2, k2, p2, k1, M1, p2, k1; rep from * around—240 (264, 288, 312, 336, 360, 384) sts.

NEXT RND: *K1, p2, k1; rep from * around.

Rep last rnd 4 times, ending last rnd 2 sts before end of rnd.

BO using picot BO (see Stitch Guide).

Sleeves

With dpns, beg at center of collar CO sts, pick up and knit 2 sts along CO sts, 56 (62, 62, 68, 68, 74, 74) sts along selvedge edge of back, then 2 sts along rem CO sts—60 (66, 66, 72, 72, 78, 78) sts. Divide sts evenly over 3 or 4 dpn. Pm and join for working in rnds.

RND 1: *P1, k4, p1; rep from * around.

Rep last rnd until sleeve meas 3" (7.5 cm).

BO using picot BO.

Work second sleeve same as first.

Finishing

Weave in loose ends. Block to measurements.

Nurturing
CARDIGAN

The Nurturing Cardigan is a simple boxy sweater designed as a cozy top layer. The body is worked in one piece straight up to the underarms. Underarm stitches are bound off, then the back and fronts are worked separately to the shoulders where they are joined with a three-needle bind-off.

There is no complex shaping in the body, making it easy to work a lace pattern. The modified-drop sleeve caps are picked up around the armhole edge, shaped with a few short-rows, then the sleeve is worked in the round from the underarm to the cuff, decreasing along the way. Both the lace and the ribbing are established in multiples of six stitches plus two, so they can be interchanged with any of the stitch patterns used in this chapter. The possibilities for this sweater are endless.

Techniques
.
Circular knitting on dpns

Lace

Using a stitch holder
or waste yarn

Short-rows

Three-needle bind-off

Picking up stitches

Finished Size
About 29 (33½, 38½, 43, 48, 53, 57½)" (73.5 [85, 98, 109, 122, 134.5, 146] cm) bust circumference and 18¾ (19¼, 19¾, 20¼, 20¾, 21¼, 21¾)" (47.5 [49, 51, 51.5, 52.5, 54, 55] cm) long.

Cardigan shown measures 38½" (98 cm).

Yarn
DK weight (#3 Light).

Shown here: Blue Sky Alpacas, Skinny Cotton (100% organic cotton, 150 yd [137 m]/65 g): #30 birch, 6 (7, 8, 9, 10, 11, 12) skeins.

Needles
Size U.S. 6 (4 mm): 32" (80 cm) circular (cir) and set of 4 or 5 double-pointed (dpn). *Adjust needle size if necessary to obtain the correct gauge.*

Notions
Markers (m); holders or waste yarn; tapestry needle.

Gauge
20 sts and 31 rows = 4" (10 cm) in lace patt; 25 sts and 30 rnds = 4" (10 cm) in k4, p2 ribbing when stretched slightly.

{ Seamless Modified-Drop Sleeve Caps }

The Nurturing Cardigan has "modified-drop" sleeve caps. This means the armhole edges are indented from the edge of the body, unlike "drop" sleeve caps where the armhole edges are not indented. With a drop sleeve, no sleeve cap is necessary, as the sleeve stitches are simply picked up around the armhole and worked to the cuff. However, for a modified drop, some sleeve fabric needs to be added over that armhole indentation to get to the edge of the body before joining the sleeve to work in the round down to the cuff.

Modified-drop sleeve caps are a little easier to work than set-in sleeve caps and are a good choice for a casual sweater design. I discuss more about set-in sleeve caps on page 32 (Unconditional Cardigan).

The shape of the armhole for a modified-drop sleeve cap is pretty boxy. There is usually a single set of bound-off stitches at each underarm for armhole shaping. See the dashed line on the schematic as an example.

Stitches are picked up evenly around the armhole, beginning at the center of the underarm bind-off as follows: Pick up half the total number of underarm bound-off stitches (1 stitch for each bound-off stitch; these stitches will all be decreased as you shape the cap). Pick up and knit 1 additional stitch at the corner, place a marker dividing the underarm stitches from the armhole stitches, then pick up a predetermined number of stitches along the selvedge edge of the armhole from the bound-off stitches to the shoulder, then the same number of stitches along

the other side. The number of stitches picked up on each side should be half the number needed for the desired underarm circumference.

For example, on the sample size of the Nurturing Cardigan, I needed a total of 92 stitches. I chose 92 stitches because it is a multiple of 6 stitches plus 2, to match the k4, p2 ribbing stitch pattern and because 92 stitches divided by the stitch gauge for the ribbing is about 14¾" (37.5 cm), the underarm measurement I wanted (double the armhole depth).

The corner stitches (picked up on the other side of the marker) are included in this stitch count, so to determine how many stitches to pick up between the bound-off stitches and the shoulder on each side of the armhole, the 2 corner stitches are subtracted, then the number is divided in half: 92 - 2 = 90 sts; 90 ÷ 2 = 45 sts on each side.

Place a second marker dividing the armhole and underarm stitches on the other side. Pick up and knit one more corner stitch then the other half of the underarm bound-off stitches (1 stitch for each bound-off stitch). Place a marker for the beginning of the round (I suggest using a different color than the other two markers) and work the first short-row (see Glossary) while establishing a stitch pattern over the stitches between the markers, if necessary, as follows:

SHORT-ROW 1: (RS) Knit to 2 sts before m, k2tog, sl m, establish your stitch pattern between the two markers,

sl m, ssk, turn (do not wrap)— 2 sts dec'd.

Between the markers, your stitch pattern is established, and this should not change as you continue to decrease the underarm stitches outside the markers. Work the following 2 short-rows until only 2 stitches remain at the underarms (1 st each side of the beg-of-rnd marker, before the other markers).

SHORT-ROW 2: (WS) Sl 1 st pwise wyf, sl m, work as est to next m, sl m, p1, sl next st pwise wyf, turn (do not wrap).

SHORT-ROW 3: (RS) K2tog, sl m, work as est to next m, sl m, ssk, turn (do not wrap)—2 sts dec'd.

When only 2 stitches remain between the markers (with the beg-of-rnd marker between them), remove all m except beg-of-rnd m.

You'll now have the desired number of stitches needed to get your underarm circumference measurement. Join to work in the round and continue working your sleeve in the round from the underarm to the cuff.

Stitch Guide

K4, P2 Ribbing Worked Back and Forth: *(multiple of 6 sts + 2)*

ROW 1: (WS) K2, *p4, k2; rep from * to end.

ROW 2: (RS) P2, *k4, p2; rep from * to end.

Rep Rows 1–2 for patt.

K4, P2 Ribbing Worked in Rounds: *(multiple of 6 sts)*

RND 1: *K2, p2, k2; rep from * around.

Rep Rnd 1 for patt.

Lace Pattern Worked Back and Forth: *(multiple of 6 sts + 8)*

ROW 1: (RS) K2, *yo, ssk, k2tog, yo, k2; rep from * to end.

ROW 2: Purl.

ROW 3: K2, *k2tog, [yo] twice, ssk, k2; rep from * to end.

ROW 4: *P4, p1-tbl, p1; rep from * to last 2 sts, p2.

ROW 5: K1, k2tog, *yo, k2, yo, ssk, k2tog; rep from * to last 5 sts, yo, k2, yo, ssk, k1.

ROW 6: Purl.

ROW 7: K1, yo, *ssk, k2, k2tog, [yo] twice; rep from * to last 7 sts, ssk, k2, k2tog, yo, k1.

ROW 8: P7, *p1-tbl, p5; rep from * to last st, p1.

Rep Rows 1–8 for patt.

Lace Pattern Worked in Rounds: *(multiple of 6 sts)*

RND 1: *K1, yo, ssk, k2tog, yo, k1; rep from *.

RND 2: Knit.

RND 3: *K1, k2tog, [yo] twice, ssk, k1; rep from *.

RND 4: *K3, k1-tbl, k2; rep from *.

RND 5: *K2tog, yo, k2, yo, ssk; rep from *.

RND 6: Knit.

RND 7: *[Yo] twice, ssk, k2, k2tog; rep from *.

RND 8: Remove m, sl 1 st pwise wyb, replace m, *k1-tbl, k5; rep from *.

Rep Rnds 1–8 for patt.

Notes

This cardigan only uses the Lace Pattern Worked Back and Forth. The Lace Pattern Worked in Rounds is given so it may be used for other patterns in this chapter.

If using this stitch pattern along an edge, see the charts on page 42 for an alternate version to prevent the pattern from rolling.

Body

With cir needle, CO 122 (146, 170, 194, 218, 242, 266) sts. Do not join; work back and forth in rows.

Work in k4, p2 ribbing until piece meas 1½" (3.8 cm) from beg, ending with a WS row.

Work in lace patt until piece meas 12½" (31.5 cm) from beg, ending with a RS row.

Divide for Armholes

NEXT ROW: (WS) Work in patt for 20 (26, 32, 32, 38, 38, 44) sts for left front, BO 10 (10, 10, 22, 22, 34, 34) for armhole, work in patt until 62 (74, 86, 86, 98, 98, 110) sts are on right needle for back, BO 10 (10, 10, 22, 22, 34, 34) sts for armhole, work in patt over rem sts for right front—20 (26, 32, 32, 38, 38, 44) sts rem for each front, and 62 (74, 86, 86, 98, 98, 110) sts rem for back.

Place sts for back and left front onto holders or waste yarn.

Right Front

Cont even in lace patt over right front sts until armholes meas 6¼ (6¾, 7¼, 7¾, 8¼, 8¾, 9¼)" (16 [17, 18.5, 19.5, 21, 22, 23.5] cm) from divide, ending with a WS row. Break yarn and place sts onto holder or waste yarn.

Back

Place 62 (74, 86, 86, 98, 98, 110) held back sts onto cir needle. Cont even in lace patt until armholes meas 6¼ (6¾, 7¼, 7¾, 8¾, 9, 9¼]" (16 [17, 18.5, 19.5, 21, 22, 23.5] cm) from divide, ending with a RS row, 1 row less than right front.

Shape Neck

NEXT ROW: (WS) Work 20 (26, 32, 32, 38, 38, 44) sts, BO 22 sts for neck, work in patt over rem sts—20 (26, 32, 32,

38, 38, 44) sts rem for each shoulder. Place sts onto holders or waste yarn. Do NOT break yarn.

Left Front

Place 20 (26, 32, 32, 38, 38, 44) held left front sts onto cir needle. Cont even in lace patt until armholes meas 6¼ (6¾, 7¼, 7¾, 8¼, 8¾, 9¼)" (16 [17, 18.5, 19.5, 21, 22, 23.5] cm) from divide, ending with same WS row as right front.

Join Shoulders

Place 20 (26, 32, 32, 38, 38, 44) held left back sts onto empty tip of needle or second cir needle. Hold needles parallel with RS of knitting facing tog and use the three-needle method (see Glossary) to BO sts tog. Place 20 (26, 32, 32, 38, 38, 44) held sts for right front and right back onto cir needle and join using the three-needle BO method.

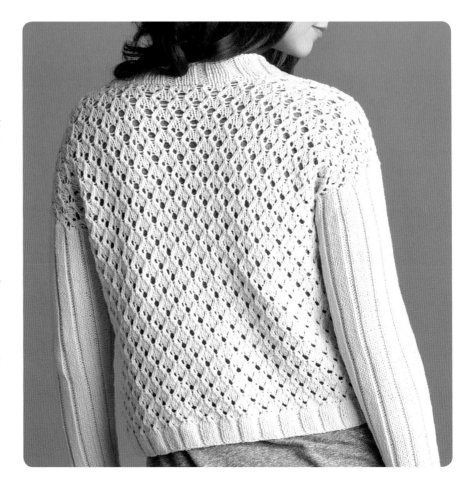

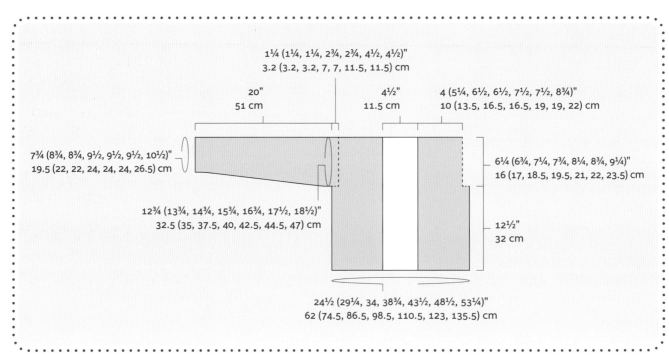

1¼ (1¼, 1¼, 2¾, 2¾, 4½, 4½)"
3.2 (3.2, 3.2, 7, 7, 11.5, 11.5) cm

20"
51 cm

4½"
11.5 cm

4 (5¼, 6½, 6½, 7½, 7½, 8¾)"
10 (13.5, 16.5, 16.5, 19, 19, 22) cm

7¾ (8¾, 8¾, 9½, 9½, 9½, 10½)"
19.5 (22, 22, 24, 24, 24, 26.5) cm

6¼ (6¾, 7¼, 7¾, 8¼, 8¾, 9¼)"
16 (17, 18.5, 19.5, 21, 22, 23.5) cm

12¾ (13¾, 14¾, 15¾, 16¾, 17½, 18½)"
32.5 (35, 37.5, 40, 42.5, 44.5, 47) cm

12½"
32 cm

24½ (29¼, 34, 38¾, 43½, 48½, 53¼)"
62 (74.5, 86.5, 98.5, 110.5, 123, 135.5) cm

Lace Pattern Worked Back and Forth

Lace Pattern Worked in Rounds

☐ k on RS; p on WS	☒ k1-tbl on RS, p1-tbl on WS
☐o yo	☐v sl 1 pwise wyb
☐\ ssk	☐ pattern repeat
☐/ k2tog	

Sleeves

With dpn, beg at center of underarm BO sts, pick up and knit 5 (5, 5, 11, 11, 17, 17) sts along BO sts (1 st in each BO st), 1 st in corner, pm, pick up and knit 39 (42, 45, 48, 51, 54, 57) sts evenly along selvedge edge of armhole to shoulder, 39 (42, 45, 48, 51, 54, 57) sts evenly along selvedge edge to underarm, pm, pick up and knit 1 st in corner, then 5 (5, 5, 11, 11, 17, 17) sts along rem BO sts—90 (96, 102, 120, 126, 144, 150) sts. Divide sts evenly over 3 or 4 dpn. Place marker (pm) for beg of rnd.

Shape Sleeve Cap with Short-rows

SHORT-ROW 1: (RS) Knit to 2 sts before m, k2tog, sl m, k2, p2, *k4, p2; rep from * to 2 sts before next m, k2, sl m, ssk, turn (do not wrap)—2 sts dec'd.

SHORT-ROW 2: (WS) Sl 1 st pwise wyf, sl m, work in est patt to next m, sl m, p1, sl next st pwise wyf, turn (do NOT wrap).

SHORT-ROW 3: (RS) K2tog, sl m, work in est patt to next m, sl m, ssk, turn (do NOT wrap)—2 sts dec'd.

Rep the last 2 short-rows 3 (3, 3, 9, 9, 15, 15) times—80 (86, 92, 98, 104, 110, 116) sts rem. Remove all m except beg-of-rnd m.

Join for working in rnds. Cont even in est patt for 1" (2.5 cm).

Shape Sleeves

DEC RND: K1, k2tog (or p2tog to maintain patt), work to last 3 sts, ssk (or ssp to maintain patt), k1—2 sts dec'd.

Work 7 (7, 6, 6, 5, 4, 4) rnds even.

Rep the last 8 (8, 7, 7, 6, 5, 5) rnds 15 (15, 18, 18, 21, 24, 24) times—48 (54, 54, 60, 60, 60, 66) sts rem.

Cont even until sleeve meas 20" (51 cm) from underarm. BO all sts in rib.

Work second sleeve same as first.

Finishing

Block to measurements.

Neckband

With cir needle and RS facing, beg at lower edge of right front, pick up and knit 100 (103, 106, 109, 112, 115, 118) sts evenly along right front edge, 24 sts along back neck (1 st in each BO st, plus 1 at each corner), then 100 (103, 106, 109, 112, 115, 118) sts evenly along left front edge—224 (230, 236, 242, 248, 254, 260) sts.

Work in k4, p2 ribbing for 2" (5 cm). BO all sts loosely in ribbing.

Weave in loose ends.

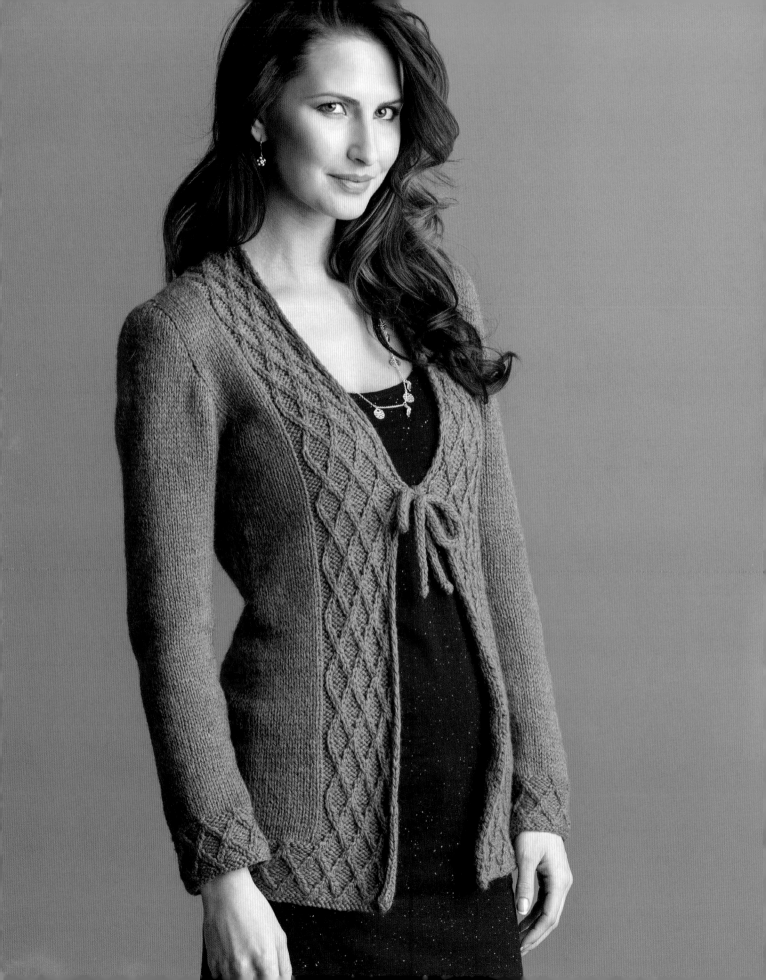

Majestic Tie
CARDIGAN

Knit from the top down, the Majestic Tie Cardigan can be tried on and customized as you go. It begins at the center of the back collar with a provisional cast-on (or your favorite cast-on method; see page 24 for information on how to use a different cast-on method). The back collar is knit, then stitches are picked up for the body and sleeves. They are worked together from the top down, while working set-in sleeve shaping. The body has some elegant waist shaping, and there are two options for the sleeves—long or short! Also, be sure to check out page 80 and consider putting a pocket onto each front.

Techniques

Provisional cast-on

Short-rows

Multiple stitch patterns at the same time (lattice pattern and stockinette stitch)

Casting on mid-row (at underarms)

Using a stitch holder or waste yarn

Lifted increases

Picking up stitches

I-cord

Finished Size

About 31 (34¾, 38¼, 41¾, 45¼, 49, 52½)" [78.5, 88.5, 97, 106, 115, 124.5 133.5) cm] bust circumference, tied closed, and 25½ (27½, 27½, 27¾, 29½, 29¾, 29¾)" (65 [70, 70, 70.5, 75, 75.5, 75.5] cm) long.

Cardigan shown measures 34¾" [88.5 cm].

Yarn

Worsted weight (#4 Medium).

Shown here: Cascade, Eco + (100% Peruvian Wool, 478 yd [437 m]/250 g): #9451 Lake Chelan heather, 2 (3, 3, 3, 3, 3, 4) skeins.

Needles

Size U.S. 7 (4.5 mm): 32" (80 cm) circular (cir) needles and set of 4 or 5 double-pointed (dpn). *Adjust needle size if necessary to obtain the correct gauge.*

Notions

Waste yarn and size U.S. G-6 (4 mm) cro-chet hook for provisional CO; markers (m); cable needle (cn); holders or waste yarn; tapestry needle.

Gauge

18 sts and 22 rows = 4" (10 cm) in St st.

{ Adjusting Sleeve Length to Fit You! }

Sometimes the sleeve length in a pattern isn't exactly the right length for your body. Here's how to adjust it to make sure the sweater fits just right! I've included some samples in () and some blank spaces for you to write your numbers.

Begin by measuring the underside of your arm from your underarm to the bend of your wrist. This measurement is a great starting point from which you can adjust the measurement if you want the sleeves to hang longer over your hands or if you want to make them bracelet- or three-quarter length.

My arms measure 18½" (47 cm) from my underarms, and I like long, full-length sleeves, so I usually knit my sleeves between 18½" (47 cm) and 19" (48.5 cm) long. Some designs call for shorter sleeves, though. For example, when a sleeve is wide at the cuff edge, I prefer it to be shorter, so it's not hanging into whatever I'm trying to do, such as cook dinner. In that case, I'd likely make it a three-quarter-length sleeve, which is about 6"–7" (15–18 cm) shorter than arm length. Or, if the cuff is nice and snug, I'll make it bracelet length, which is 1"–2" (2.5–5 cm) shorter than arm length. I sometimes put a short sleeve on warm-weather knits or on a woolen sweater to be worn over long sleeves (I think that's just the cutest look); these sleeves would be only 3"–4" (7.5–10 cm) in length.

WHAT IS YOUR DESIRED SLEEVE LENGTH?
_____ (17½" [44.5 cm]) (use pencil, so you can reuse this worksheet)

If you opt to keep the cuff circumference the same as the underarm circumference, changing the sleeve length is *really* easy. Just knit to the length you want without increasing or decreasing.

If you wish to change the cuff circumference, measure the circumference of your arm where you want the sleeve to end. This will give you a starting point for the minimum size of the cuff. You'll want it at least wide enough to fit your hand through, so hold your measuring tape in a circle at that measurement and make sure your hand can fit through.

WHAT IS THE DESIRED CIRCUMFERENCE OF YOUR SLEEVE CUFF? _____
(8" [20.5 cm])

Multiply this number by your stitch gauge per inch (centimeter) to determine how many stitches you'll need at the cuff to obtain this measurement.

- Take a look at the stitch count at the underarm to see if it is an even or odd number. Adjust the cuff stitch count so it is even or odd to match the underarm stitch count.

- Also take into consideration stitch patterns. If your pattern calls for a certain stitch multiple, adjust the number of stitches to match that multiple to maintain the stitch pattern. For example, if your measurement and gauge give you 40 stitches, but you need a multiple of 6 stitches to maintain the stitch count, use 42 or 36 stitches instead, depending on if you want your cuff a little larger or smaller than what you originally determined.

In this case, my stitch gauge per inch is 5, so 8 × 5 = 40 stitches.

HOW MANY STITCHES WILL YOU HAVE AT YOUR CUFF? _____ (40)

HOW MANY STITCHES ARE AT THE UNDERARM? _____ (62)

WHAT IS THE DIFFERENCE BETWEEN THEM? _____ (22)

There are 2 increases (if working from the cuff to the underarm) or 2 decreases (if working from the underarm to the cuff) per shaping row. Determine the difference between the underarm stitches and cuff stitches and divide in half. This tells you how many times to work a shaping row.

HOW MANY TIMES TO WORK A SHAPING ROW? _____ (11)

If the pattern you're editing has cap shaping, the shaping is designed to fit into that size armhole, so let's not fuss with that. Instead, you'll use the underarm circumference given in the pattern and adjust only the length and cuff circumference.

DETERMINE ROWS FOR SHAPING

To figure out how many rows are available for shaping, first subtract the length of the edging (if there is any) from the total length of the sleeve. You will want all the shaping to be worked in the main part of the sleeve, so the stitch pattern is not interrupted in the edging.

WHAT'S YOUR LENGTH SANS EDGING?
_____ (15½" [39.5 cm])

Multiply this length by your row gauge per inch (centimeter) to determine how many rows you have for your shaping. Round this to the nearest even number.

In this case, my row gauge per inch is 7, so 15½ × 7 = 108.5, which is rounded to 108.

HOW MANY ROWS FOR SHAPING?
_____ (108)

NOW COMES THE FUN PART: HOW OFTEN ARE THESE SHAPING ROWS WORKED?

STEP 1: Take the number of rows available for the shaping and divide it by the number of times you will be working a shaping row: _____ (108 ÷ 11 = 9.818181)

If you get a number that is between 1 and 2, see ** below.

STEP 2: Determine the two even numbers closest to this number. In this case, they are 8 and 10. I set them up as in diagram A to keep things consistent. These numbers represent the row spans you will be using; in this example, you will increase every 8 rows/rnds so many times, then every 10 rows/rnds so many times. Now, figure out how many times for each of the increases.

STEP 3: Multiply the larger of these two numbers (for example: 10) by the number of times you need to increase (11): _____ (10 × 11 = 110)

STEP 4: From this number, subtract the total number of rows available for shaping: _____ (110 - 108 = 2)

STEP 5: Then divide that number in half: _____ (2 ÷ 2 = 1)

Place that number beside the smaller of your two numbers (see diagram B).

STEP 6: Now take the total number of rows available for shaping and subtract the number you're left with in Step 5: _____ (11 - 1 = 10). Place this number beside the larger of your two numbers in your diagram (see diagram C).

STEP 7: To double-check all this, multiply the number on the left by the number on the right for both the smaller number and the larger number: _____ (8 × 1 = 8 rows)

_____ (10 × 10 = 100 rows) (see diagram D).

Add the two numbers: 8 + 100 = 108 rows! Yay, the rows are right!

Now, check the number of shaping rows. Add the two right-side numbers: 1 + 10 = 11 times (see diagram E). That's right, too! Amazing!

This translates to working a shaping row every 8 rows/rnds 1 time then every 10 rows/rnds 10 times.

**If, in Step 1 above, you get a number that is between 1 and 2, choosing the even numbers above and below that number won't work, as the lower number would be 0. In this case, use 1 and 2 rather than two even numbers. You may run into this if you are increasing a lot of stitches in fewer rows.

I'm going to pick random numbers as a second example. Let's use 20 rows to shape 13 times. So, 20 divided by 13 = 1.53846. You'll use 1 and 2 for your numbers.

STEP 1: Set up your diagram as before, with the smaller number (1) on the top and the larger number (2) on the bottom (see diagram F).

STEP 2: Subtract the number of shaping rows from the number of total available rows: 20 - 13 = 7. Insert that number beside the larger number (see diagram G).

STEP 3: Subtract the number from Step 2 from the total number of increase times: 13 - 7 = 6. Insert that number beside the smaller number (see diagram H).

STEP 4: Double-check everything as in Step 7 above (see diagrams I and J).

This translates to working a shaping row every row/rnd 6 times, then every 2 rows/rnds 7 times.

A $\dfrac{8}{10}$

B $\dfrac{8}{10}\ \ 1$

C $\dfrac{8}{10}\ \begin{matrix}\times & 1 \\ \times & 10\end{matrix}$

D $\dfrac{8}{10}\ \begin{matrix}\times & 1 & = 8 \\ \times & 10 & = 100\end{matrix}$
8 + 100 = 108 rows

E $\dfrac{8}{10}\ \begin{matrix} & 1 \\ + & 10\end{matrix}$
= 11 increase times

F $\dfrac{1}{2}$

G $\dfrac{1}{2}\ \ 7$

H $\dfrac{1}{2}\ \begin{matrix}6 \\ 7\end{matrix}$

I $\dfrac{1}{2}\ \begin{matrix}\times & 6 & = 6 \\ \times & 7 & = 14\end{matrix}$
6 + 14 = 20 rows

J $\dfrac{1}{2}\ \begin{matrix} & 6 \\ + & 7\end{matrix}$
= 13 increase times

Stitch Guide

LPT (LEFT PURL TWIST): Sl 1 st onto cn and hold in front, p1, k1 from cn.

LT (LEFT TWIST): Sl 1 st onto cn and hold in front, k1, k1 from cn.

RPT (RIGHT PURL TWIST): Sl 1 st onto cn and hold in back, k1, p1 from cn.

RT (RIGHT TWIST): Sl 1 st onto cn and hold in back, k1, k1 from cn.

Lattice Pattern Worked Back and Forth: (multiple of 6 sts + 2)

ROW 1: (WS) K3, *p2, k4; rep from * to last 5 sts, p2, k3.

ROW 2: (RS) *P2, RPT, LPT; rep from * to last 2 sts, p2.

ROW 3: K2, *p1, k2; rep from *.

ROW 4: P1, RPT, p2, *LPT, RPT, p2; rep from * to last 3 sts, LPT, p1.

ROWS 5 AND 7: K1, p1, *k4, p2; rep from * to last 6 sts, k4, p1, k1.

ROW 6: P1, k1, p4, *RT, p4; rep from * to last 2 sts, k1, p1.

ROW 8: P1, LPT, p2, *RPT, LPT, p2; rep from * to last 3 sts RPT, p1.

ROW 9: Rep Row 3.

ROW 10: *P2, LPT, RPT; rep from * to last 2 sts, p2.

ROW 11: Rep Row 1.

ROW 12: P3, LT, *p4, LT; rep from * to last 3 sts, p3.

Rep Rows 1–12 for patt.

Lattice Pattern Worked in Rounds: (multiple of 6 sts)

RND 1: *P1, RPT, LPT, p1; rep from *.

RND 2: *P1, k1, p2, k1, p1; rep from *.

RND 3: *RPT, p2, LPT; rep from *.

RNDS 4 AND 6: *K1, p4, k1; rep from *.

RND 5: Sl 1 st pwise wyb, *p4, RT; rep from * to last 5 sts, p4, sl last st onto cn and hold in back, remove beg-of-rnd m, k1, replace beg-of rnd m, place st from cn onto left needle.

RND 7: *LPT, p2, RPT; rep from *.

RND 8: Rep Rnd 2.

RND 9: *P1, LPT, RPT, p1; rep from *.

RNDS 10 AND 12: *P2, k2, p2; rep from *.

RND 11: *P2, LT, p2; rep from *.

Rep Rnds 1–12 for patt.

Notes

Circular needle is used to accommodate a large number of stitches. Do not join yoke or body; work back and forth in rows.

The first stitch at the center front edge of every row is slipped purlwise with the yarn in the back on RS rows and the yarn in the front on WS rows.

Piece is worked from the top down, beginning with the center back of the collar and then the front shoulders. The back shoulders and neck stitches are picked up along the fronts and collar then shaped. The front and back are joined together by picking up stitches along the sides of the shoulders for the sleeve caps. Then all the body and sleeve stitches are worked together while shaping the caps and underarm. Body and sleeve stitches are then divided and worked separately to the desired length.

Right Collar

With dpn and using a provisional method (see Glossary), CO 21 sts. Do not join.

Knit 1 RS row.

SET-UP ROW: (WS) Sl 1 pwise wyf, work Row 1 of lattice patt worked back and forth to end.

NEXT ROW: Work Row 2 of lattice patt to last st, k1.

Work in est patt for 23 more rows, ending with a WS row.

Right Front Shoulder

Change to cir needle.

NEXT ROW: (RS) Using cable method (see Glossary), CO 8 (10, 11, 13, 15, 16, 18) sts for right shoulder, knit 8 (10, 11, 13, 15, 16, 18) sts just CO, place marker (pm), work next row of lattice patt to last st, k1—29 (31, 32, 34, 36, 37, 39) sts.

OPTIONAL: Shape Shoulder with Short-rows

SHORT-ROW 1 (SEE GLOSSARY): (WS) Work in est patt to m, sl m, p4 (5, 5, 6, 7, 8, 9), wrap next st and turn piece with RS facing; work to end in est patt.

(END OPTIONAL SHORT-ROWS)

NEXT ROW: (WS) Work in est patt, working wrap from short-row together with the st it wraps.

Work 2 rows even, ending with a WS row. (Take note of which row of the lattice patt is worked last.)

Slip all sts and marker to holder or waste yarn. Break yarn.

Left Collar

Carefully remove waste yarn from provisional CO sts and place 21 sts onto dpn. Join yarn to beg with a WS row.

SET-UP ROW: (WS) Work Row 1 of lattice patt worked back and forth to last st, p1.

NEXT ROW: Sl 1 pwise wyb, work Row 2 of lattice patt to end.

Work in est patt for 24 more rows, ending with a RS row.

Lattice Pattern Worked Back and Forth

Lattice Pattern Worked in Rounds

6-st rep

□ k on RS; p on WS
· p on RS; k on WS
RPT (see Stitch Guide)
LPT (see Stitch Guide)
RT (see Stitch Guide)
LT (see Stitch Guide)

V sl 1 pwise wyb

RT; at end of last rep, work as foll: sl 1 st onto cn and hold in back, remove m, k1, replace m, place st on cn onto left needle to beg next rnd

□ pattern repeat

Left Front Shoulder

Change to cir needle.

NEXT ROW: (WS) Using cable method, CO 8 (10, 11, 13, 15, 16, 18) sts for left shoulder, purl 8 (10, 11, 13, 15, 16, 18) sts just CO, pm, work next row of lattice patt to last st, p1—29 (31, 32, 34, 36, 37, 39) sts.

OPTIONAL: Shape Shoulder with Short-rows

SHORT-ROW 1: (RS) Work in est patt to m, sl m, k4 (5, 5, 6, 7, 8, 9), wrap next st and turn piece with WS facing; work to end in est patt.

(END OPTIONAL SHORT-ROWS)

NEXT ROW: (RS) Work in est patt, working wrap from short-row together with the st it wraps.

Work 1 row even, ending with the same WS row of lattice patt as right front shoulder.

Slip all sts and marker to holder or waste yarn. Do NOT break yarn.

Back Shoulder

Rotate work to begin picking up sts at the left shoulder CO edge and with the RS facing. With cir needle and a new ball of yarn, pick up and knit 8 (10, 11, 13, 15, 16, 18) sts along left shoulder CO sts, pick up and knit 42 sts evenly along side edge of collar, then pick up and knit 8 (10, 11, 13, 15, 16, 18) sts along right shoulder CO sts—58 (62, 64, 68, 72, 74, 78) sts.

Shape Shoulders and Neck

SHORT-ROW 1: (WS) P8 (10, 11, 13, 15, 16, 18), wrap next st and turn piece with RS facing.

SHORT-ROW 2: K4 (5, 5, 6, 7, 8, 9), wrap next st and turn piece with WS facing.

SHORT-ROW 3: P7 (8, 8, 9, 10, 11, 12) working the wrap together with the stitch it wraps, wrap next st and turn piece with RS facing.

SHORT-ROW 4: Knit to end of row, working the wrap together with the st it wraps.

SHORT-ROW 5: Purl to last 4 (5, 6, 7, 8, 8, 9) sts, wrap next st and turn piece with RS facing.

SHORT-ROW 6: K4 (5, 6, 7, 8, 8, 9), wrap next st and turn piece with WS facing.

SHORT-ROW 7: Purl to end of row, working the wrap together with the st it wraps.

SHORT-ROW 8: K11 (13, 14, 16, 18, 19, 21) sts, working the wrap together with the st it wraps, wrap next st and turn piece with WS facing.

SHORT-ROW 9: Purl to end of row.

Keep sts on needle. Break yarn.

Yoke

Note: *Working around the sleeve stitches for the first few rounds is a tad awkward. To make this a little easier, you can pull the cord of your circular needle through the sleeve stitches on the needle, as if working the magic-loop technique (see Glossary).*

Slip the sts from the left and right shoulders onto the corresponding

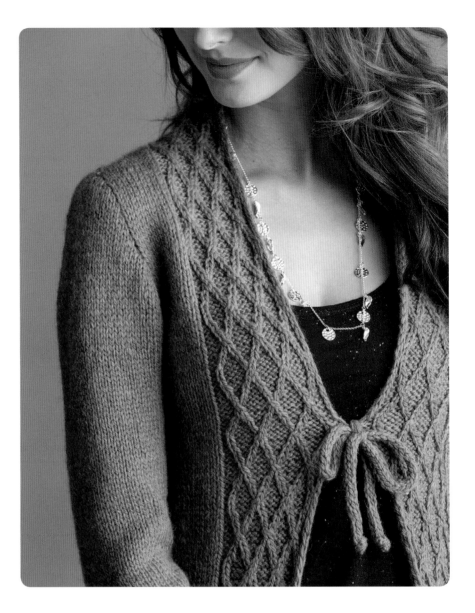

tips of the circular needle with the back sts. They should be arranged as foll: left front, gap, back, gap, right front. Cont working with yarn at collar edge of left front.

SET-UP ROW: (RS) Work in est patt to collar m, sl m, work in St st to end of left front, pm for sleeve, pick up and knit 8 sts evenly along side edge of shoulder to back sts for left sleeve, pm, work in St st across back sts working the wrap together with the st it wraps, pm for sleeve, pick

up and knit 8 sts evenly along side edge of shoulder to back sts for right sleeve, pm, work in St st to collar m, sl m, work in est patt to end—132 (140, 144, 152, 160, 164, 172) sts.

Shape Sleeve Cap

SLEEVE INC ROW 1: (WS) *Work in est patt to sleeve m, sl m, LLPI (see Glossary), purl to next m, RLPI (see Glossary), sl m; rep from * once more, work as est to end of row—4 sts inc'd.

SLEEVE INC ROW 2: (RS) *Work in est patt to sleeve m, sl m, LLI (see Glossary), knit to next m, RLI (see Glossary), sl m; rep from * once more, work as est to end of row—4 sts inc'd.

Rep the last 2 rows 2 times—156 (164, 168, 176, 184, 188, 196) sts total; 21 sts for each collar, 8 (10, 11, 13, 15, 16, 18) sts for each front, 20 sts for each sleeve, and 58 (62, 64, 68, 72, 74, 78) sts for back.

Work 1 WS row even.

Rep Sleeve Inc Row 2—4 sts inc'd.

Rep the last 2 rows 2 (1, 0, 0, 1, 1, 1) time(s)—168 (172, 172, 180, 192, 196, 204) sts total; 21 sts for each collar, 8 (10, 11, 13, 15, 16, 18) sts for each front, 26 (24, 22, 22, 24, 24, 24) sts for each sleeve, and 58 (62, 64, 68, 72, 74, 78) sts for back.

Rep Sleeve Inc Row 1—4 sts inc'd.

Rep Sleeve Inc Row 2—4 sts inc'd.

Rep the last 2 rows 6 (7, 8, 9, 9, 9, 10) times—224 (236, 244, 260, 272, 276, 292) sts total; 21 sts for each collar, 8 (10, 11, 13, 15, 16, 18) sts for each front, 54 (56, 58, 62, 64, 64, 68) sts for each sleeve, and 58 (62, 64, 68, 72, 74, 78) sts for back.

Shape Underarm

BODY INC ROW 1: (WS) *Work in est patt to sleeve m, RLPI, sl m, purl to next m, sl m, LLPI; rep from * once more, work as est to end of row—4 sts inc'd.

BODY INC ROW 2: (RS) *Work in est patt to sleeve m, RLI, sl m, knit to next m, sl m, LLI; rep from * once more, work as est to end of row—4 sts inc'd.

Rep the last 2 rows 1 (2, 3, 4, 5, 6, 7) more time(s)—240 (260, 276, 300, 320, 332, 356) sts total; 21 sts for each collar, 12 (16, 19, 23, 27, 30, 34) sts for each front, 54 (56, 58, 62, 64, 64, 68)

sts for each sleeve, and 66 (74, 80, 88, 96, 102, 110) sts for back.

DIVIDE FOR BODY AND SLEEVES: (WS) *Work as est to sleeve m, remove m, slip the next 54 (56, 58, 62, 64, 64, 68) sleeve sts onto holder or waste yarn, remove m, using the backward-loop method (see Glossary) and CO 2 (2, 3, 3, 3, 4, 4) sts, pm for side, CO 2 (2, 3, 3, 3, 4, 4) sts; rep from * once more, then work as est to end of row—140 (156, 172, 188, 204, 220, 236) sts.

Body

Working underarm sts in St st, cont even until piece meas 1" (2.5 cm) from divide, ending with a WS row.

Shape Waist

DEC ROW: (RS) *Work in est patt to 3 sts before side m, ssk, k1, sl m, k1, k2tog; rep from * once more, then work as est to end of row—4 sts dec'd.

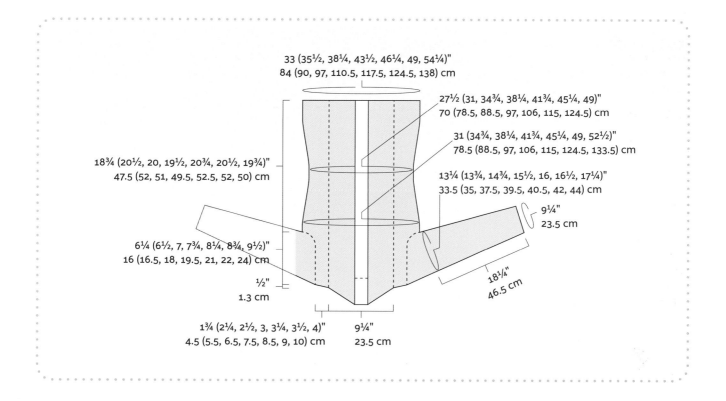

33 (35½, 38¼, 43½, 46¼, 49, 54¼)"
84 (90, 97, 110.5, 117.5, 124.5, 138) cm

27½ (31, 34¾, 38¼, 41¾, 45¼, 49)"
70 (78.5, 88.5, 97, 106, 115, 124.5) cm

31 (34¾, 38¼, 41¾, 45¼, 49, 52½)"
78.5 (88.5, 97, 106, 115, 124.5, 133.5) cm

18¾ (20½, 20, 19½, 20¾, 20½, 19¾)"
47.5 (52, 51, 49.5, 52.5, 52, 50) cm

13¼ (13¾, 14¾, 15½, 16, 16½, 17¼)"
33.5 (35, 37.5, 39.5, 40.5, 42, 44) cm

9¼"
23.5 cm

6¼ (6½, 7, 7¾, 8¼, 8¾, 9½)"
16 (16.5, 18, 19.5, 21, 22, 24) cm

18¼"
46.5 cm

½"
1.3 cm

1¾ (2¼, 2½, 3, 3¼, 3½, 4)"
4.5 (5.5, 6.5, 7.5, 8.5, 9, 10) cm

9¼"
23.5 cm

Work 7 rows even, ending with a WS row.

Rep Dec row every 8 rows 3 times—124 (140, 156, 172, 188, 204, 220) sts rem.

INC ROW: (RS) *Work in est patt to 1 st before side m, RLI, k1, sl m, k1, LLI; rep from * once more, then work as est to end of row—4 sts inc'd.

Work 7 (9, 11, 7, 9, 11, 7) rows even, ending after a WS row.

Rep the last 8 (10, 12, 8, 10, 12, 8) rows 5 (4, 3, 5, 4, 3, 5) times—148 (160, 172, 196, 208, 220, 244) sts rem. Remove side markers.

Work even until piece meas about 16 (17¾, 17¼, 16¾, 18, 17¾, 17)" (40.5 [45, 44, 42.5, 45.5, 45, 43] cm) from divide, ending with Row 3 of lattice patt.

Lattice Edging

NEXT ROW: (RS) Sl 1 pwise wyb, work Row 4 of lattice patt to collar m, remove m, purl to next collar marker, remove marker, work in est patt to end of row.

Note: On the next row only, replace the 4th RT with an LT so the existing lattice pattern line from the collar remains on top of the new lines created for the lower edging. Work all the following rows in lattice patt as charted/written.

SET-UP ROW: (WS) Sl 1 pwise wyf, work Row 5 of lattice patt to last st, k1.

NEXT ROW: (RS) Sl 1 pwise wyb, work Row 6 of lattice patt to last st, p1.

Work in est patt for 12 more rows, ending with Row 6 of patt.

BO all sts kwise on WS.

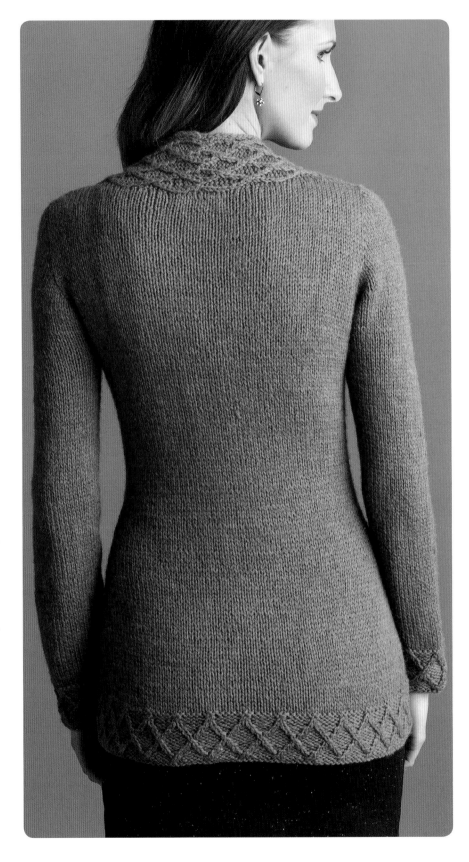

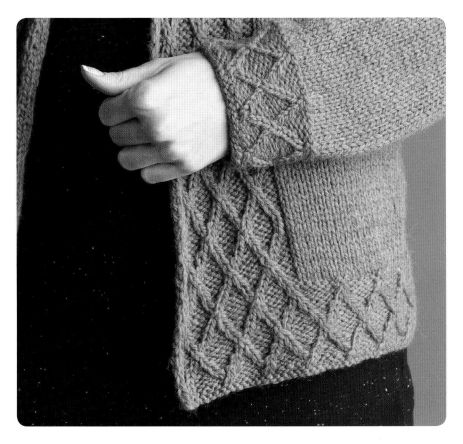

[Work dec rnd, then 7 (6, 5, 4, 4, 3, 3) rnds even] 1 (1, 6, 7, 13, 4, 14) time(s)—42 sts rem.

Cont even until sleeve meas 16" (40.5 cm) from underarm.

Lattice Edging

Purl 1 rnd.

Beg with Rnd 11, work 13 rnds in lattice patt worked in rounds, ending with Rnd 11.

BO all sts pwise.

Work second sleeve same as first.

Finishing

Block to measurements.

TIES: Try on the sweater and place removable markers in each front at the desired location for the ties. The sample sweater has the ties 3½" (9 cm) lower than the armholes. Use a dpn to pick up and knit 3 sts at edge of one front as follows: Pick up and knit 1 st, yo, pick up 1 in next st. Work I-cord (see Glossary) until piece meas 13" (33 cm) from pick-up row. Break yarn leaving about 4" (10 cm) tail. Thread tail through all sts twice, pull tight to close end, then pull tail to inside of I-cord. Tie an overhand knot at the end of the tie. Make a second tie on the other side front opposite first.

Weave in loose ends.

Sleeves

Divide held 54 (56, 58, 62, 64, 64, 68) sleeve over 3 dpn. With empty dpn, beg at center of underarm CO sts, pick up and knit 2 (2, 3, 3, 3, 4, 4) sts along underarm CO sts, 1 st in gap between CO sts and sleeve sts, knit sleeve sts, pick up and knit 1 st in gap between sleeve sts and underarm CO sts, then 2 (2, 3, 3, 3, 4, 4) sts along rem CO sts—60 (62, 66, 70, 72, 74, 78) sts. Pm and join for working in rnds.

(**Customize:** *Make this short-sleeved by working a decrease round, decreasing 6 (2, 6, 4, 6, 2, 6) sts evenly around, so you have a multiple of 6 sts: 54 (60, 60, 66, 66, 72, 72) sts. Then skip ahead to lattice edging.*)

Long Sleeves

DEC RND: K2 (2, 3, 3, 3, 4, 4), k2tog, knit to last 4 (4, 5, 5, 5, 6, 6) sts, ssk, knit to end—58 (60, 64, 68, 70, 72, 76) sts rem.

Work even in St st until sleeve meas 1" (2.5 cm) from underarm.

Shape Sleeve

DEC RND: K1, k2tog, knit to last 3 sts, ssk, k1—2 sts dec'd.

Work 8 (7, 6, 5, 5, 4, 4) rnds even.

Rep the last 9 (8, 7, 6, 0, 5, 5) rnds 6 (7, 4, 5, 0, 10, 2) times—44 (44, 54, 56, 68, 50, 70) sts rem.

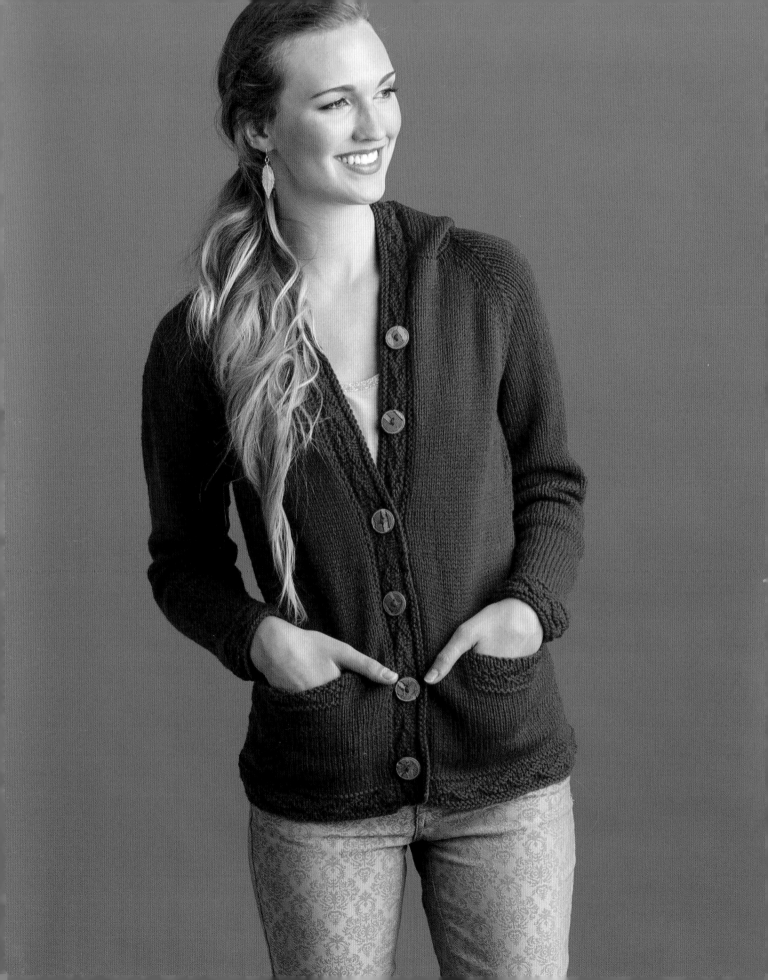

Tender HOODIE

The Tender Hoodie is a super-cozy hoodie, with some simple seamless pockets. This is the perfect sweater to curl up with a cup of tea and a good book. The hood has some beautifully comfortable shaping that fits nicely around your head. Like the other sweaters in this chapter, the textured leaf pattern can be interchanged with any of the others, making this sweater uniquely your own. Or, if you're more on the busty side, the stockinette-stitch body lends perfectly to adding some bust dart shaping (see page 112).

Techniques

Circular knitting on dpns

Lifted increases

Buttonholes

Three-needle bind-off

Picking up stitches

Short-rows on hood (optional)

Using a stitch holder or waste yarn

Seamless pockets

Multiple stitch patterns at the same time

Finished Size

About 29¾ (33½, 37¼, 41, 44¾, 48¾, 52½)" (75.5 [85, 94.5, 104, 113.5, 124, 133.5] cm) bust circumference, buttoned with 1½" (3.8 cm) overlapped buttonband, and 22¼ (22¾, 23¼, 23½, 23¾, 24, 24½)" (56.5 [58, 59, 59.5, 60.5, 61, 62] cm) long.

Hoodie shown measures 33½" (85 cm).

Yarn

Worsted weight (#4 Medium).

Shown here: Quince & Co., Lark (100% American wool, 134 yd [123 m]/50 g): gingerbread, 11 (12, 13, 14, 15, 16, 16) skeins.

Needles

Body—Size U.S. 8 (5 mm): 40" (100 cm) circular (cir) needle and set of 4 or 5 double-pointed (dpn).

Pocket Lining—Size U.S. 7 (4.5 mm) or one size smaller than needle used for the body: set of 4 or 5 double-pointed (dpn).

Adjust needle sizes if necessary to obtain gauge.

Notions

Markers (m); holders or waste yarn; waste yarn for pocket placement; seven 1" (2.5 cm) buttons; tapestry needle.

Gauge

19 sts and 29 rows = 4" (10 cm) in St st with larger needles.

{ Adding a Hood to Any Sweater }

There are many different ways to knit a hood onto a sweater. Over the last few years, I've been experimenting with different styles, and I've finally settled on one that works great every time—at least I think it does. This hood can be added to practically any sweater, but it works best on sweaters that have no front neck shaping, where the edge of the front comes all the way up to the shoulders or to the same height as the back. So, if you're considering adding this hood to a sweater that has neck shaping, it would work best if you omit the neck shaping and simply bind off the neck stitches at the top of the sweater or leave them on a stitch holder.

Begin with stitches picked up around the whole neck—front and back—and if it's a raglan, pick up stitches over the top edges of the sleeves, too. The number of stitches picked up will vary depending on your sweater (see page 10). Place markers to each side of the center 4"–5" (10–12.5 cm) worth of stitches. For example: If your total hood measures 16" (40.5 cm) wide, 5" (12.5 cm) in the center of the hood would leave 5.5" (14 cm) on either side of the center 5" (12.5 cm), marking the hood into 3 sections. These center stitches will run along the back then over the top of the hood. If you want a narrow, snug-fitting hood, err toward fewer stitches in the center; if you want a wider, more loose-fitting hood, err toward more stitches in the center.

Work in the stitch pattern to match your sweater until the hood measures about 1"–2" (2.5–5 cm) from the pick-up row.

The markers placed at the center of the hood will now be used for increasing. Each increase row has 4 stitches increased: one at each selvedge edge and one on the outside of each of the center markers. The number of stitches between the center markers will never change. The increased stitches shape the hood for the head. Stitches are added to the center to add depth for the back of the head, and stitches are added to the selvedge edges to add depth for the front of the head, so the hood doesn't feel like it's sitting too far back. It should fall comfortably beside the cheeks.

Determine the width of the hood

Determining the number of times the increase row is worked and how often requires us to do a little bit of measuring and some math. First, using a flexible measuring tape, measure at eye level from the outside edge of one eye around the back of the head to the outside edge of the other eye. I measure from the edges of the eyes because it's nice to be able to see when wearing a hood. If a hood is too large, peripheral vision is blocked; if it's too small, it just feels funny. My head measures about 18" (45.5 cm), so this is the measurement I use for the sample hoods I knit.

Next, you'll want to take your front band width into consideration. If the sweater has a 1" (2.5 cm) band that goes around the hood, I use the exact measurement of my head as a guide for how large I want the hood. If the band is wider, then I'll make the hood measurement smaller than what I measure; if the band is narrower, I'll make the hood measurement larger. I like the hood, including the front bands, to measure about 3"–4" (7.5–10 cm) larger than the head measurement, from eye to eye. So for me, the ideal hood measurement is 21"–22" (53.5–56 cm). If my band width is 2" (5 cm) on each side of the hood, I increase the hood to a width of 17"–18" (43–45.5 cm); 21 or 22 - 4 = 17 or 18.

How many increase rows?

Multiply the width you'll need by your stitch gauge to determine about how many stitches you'll need after you increase, then determine the number of stitches between this number and the number of stitches you have on your needle. This is the number of stitches that needs to be increased for your desired hood width. Round this number to the nearest multiple of 4 stitches. Rounding up will make your hood a little wider; rounding down will make it a little narrower. You need a multiple of 4 stitches because 4 stitches are increased on each increase row. Divide your total number of increased stitches by 4; the result is the number of times your increase row needs to be worked.

In this example, the gauge is 5½ stitches per inch, and the row gauge is 7 rows per inch. I've picked up 88 stitches evenly around the neck and knit for 2" (5 cm). The desired hood width is about 18" (45.5 cm).

18" × 5½ stitches per inch = 99 stitches.

Subtract 88 stitches from 99 stitches and the result is 11 stitches. Round up to the nearest multiple of 4, which is 12. That will give me 100 stitches (88 + 12). If I divide 100 by the 5½-stitch gauge, the result is the hood width, which will be 18¼" (46.5 cm). This sounds good to me; it's just ¼" (6 mm) larger, so no biggie. To find the instances of the increase row, divide 12 by 4 for 3 instances of the increase row.

How often to work the increase row?

I prefer to have all my increases completed by the time the hood measures 7"–8" (18–20.5 cm) from the pick-up row. To determine how many rows are needed between each increase row, you first need to figure out how many rows total you have to work with.

At the bottom of the hood, I knit to 1" (2.5 cm) or 2" (5 cm) before beginning the increases. If there are many increases needed, I'll often only knit to 1" (2.5 cm), but if there are only a few increases, as in the example, I'll knit to 2" (5 cm) before increasing.

Subtract the measurement you plan to knit to before increasing from 7" (18 cm) to determine the space you have available for the increasing. In this example, 7" - 2" = 5".

Multiply that measurement by your row gauge to see how many rows you have to work with. In this example, 5" × 7 rows/inch = 35 rows. Round this number to the nearest multiple of

the number of times you'll be increasing. For example, I need to increase 3 times, and the nearest multiple of 3 to 35 is 36. 36 ÷ 3 = 12. That means I'll increase every 12 rows.

But, let's say that I need to increase 4 times in 35 rows: 36 is also a multiple of 4; however, 36 ÷ 4 = 9, which means I'd increase every 9th row. It's ideal to be increasing every even-numbered row, so the increases always fall on the RS row. In this case, I could round up to 40, to increase every 10th row or down to 32, to increase every 8th row. Increasing every 10th row would give me 40 rows, making my hood a little longer than 7" (18 cm). That's likely to be okay since the desired measurement is between 7" (18 cm) and 8" (20.5 cm). To double-check, divide 40 by the row gauge: 40 ÷ 7 = 5¾". Add this to the measurement before increasing: 5¾" + 2" = 7¾". Perfect.

Shaping the Top of the Hood

From here, you have some options. The easiest path is to continue knitting evenly until the hood measures about 13" (33 cm) from the pick-up row, divide your stitches in half, and join the two halves of the hood using a three-needle bind-off. It's simple and creates a hood. But heads aren't shaped like that. I believe a hood should be much more fitted and comfortable than what that technique can provide. The following is what I suggest for a really comfortable and well-fitted hood.

Adding More Depth to the Back of the Hood

The back of the head is often higher than the front of the head, so for a really comfortable fit, it's nice to raise up the back of the hood while keeping the front of the hood a little lower. To do this, I use short-rows.

I'm going to keep the front of the hood close to the measurement that it's at after the increases, but I'll raise the back of the hood about 2" (5 cm). Determine about how many rows are needed to work 2" (5 cm) by multiplying the row gauge by 2": 7 rows/inch × 2" = 14 rows.

Two of those rows will be worked over the whole hood, so subtract 2 from that number and divide the result by 2 to determine how many short-rows you'll need worked over the back (center) of the hood; in this example, 14 - 2 = 12 and 12 ÷ 2 = 6, so I'll have 6 short-rows.

Work the first short-row as follows:

SHORT-ROW 1: (RS) Knit to second m, sl m, k1, wrap next st and turn piece with WS facing, p1, sl m, purl to next m, sl m, p1, wrap next st and turn piece with RS facing.

The following short-rows work knit stitches between the wrap from the previous short-row and the current short-row. You'll need to determine how many stitches to knit here so you'll have enough stitches for all your short-rows. I like to work about ¾" (2 cm) worth of stitches between each of the wraps. At the 5½-stitches/inch gauge, that would be about 4 stitches between the wraps. When the wrapped stitch is added to that, it means there are 5 additional stitches worked on each edge each time a short-row is worked. To be sure there are enough stitches to each side of the markers, I multiply 5 short-rows by 5 stitches, then add 1 more stitch (for the first short-row wrap). As long as there are more than 26 stitches to each side of the center markers, this will work. If there are fewer stitches, reduce the number of stitches between the wraps and double-check again.

This is how the following 5 short-rows are worked in this example:

SHORT-ROW 2: (RS) Knit to wrapped st, knit wrap together with the st it wraps, k4, wrap next st and turn piece with WS facing; purl to wrapped st, purl wrap together with the st it wraps, p4, wrap next st and turn piece with WS facing.

Rep the last short-row 4 times.

NEXT 2 ROWS: Work to wrapped st, work wrap together with the st it wraps, work to end.

Curve the Top

The back of the head is curved, so to avoid a really square hood (unless that's what you want), I like to decrease the center back over a few rows before finishing off the top.

DEC ROW: (RS) Knit to 2 sts before m, ssk, sl m, work to next m, sl m, k2tog, knit to end—2 sts dec'd.

Work 1 WS row even as est.

Rep the last 2 rows 2 or 3 times. The more times these 2 rows are worked the more curved the back of the hood will be and the longer it will be. Alternatively, decreases could be worked every row over the same number of rows to make it more curved without adding length. Either way will work depending on how you want your finished hood to look.

Shape Top of Hood with Short-rows

You've made it to the last step! Now you'll decrease the stitches to the outsides of the markers, leaving the center stitches remaining on holders to be worked with the front band. This step uses a few simple short-rows.

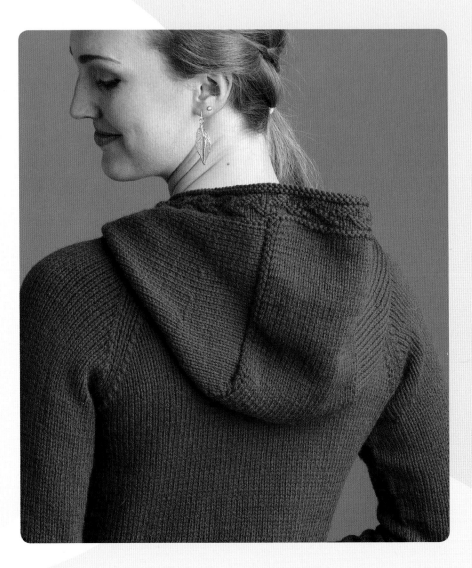

To start, work the following short-row once:

SHORT-ROW 1: (RS) Knit to first m, sl m, work to second m, sl m, k2tog, turn piece (do not wrap) with WS facing; slip 1 st pwise wyf, sl m, work to next m, sl m, ssp, turn piece (do not wrap) with RS facing—2 sts dec'd.

Then repeat the following short-row until only 1 stitch remains outside the markers.

SHORT-ROW 2: (RS) Sl 1 st pwise wyb, sl m, work to m, sl m, k2tog, turn piece (do not wrap) with WS facing; slip 1 st pwise wyf, sl m, work to m, sl m, ssp, turn piece (do not wrap) with RS facing—2 sts dec'd.

Place your remaining stitches onto a stitch holder and work your front band to finish off the edge of the hood. Voilá!

Stitch Guide

Leaf Pattern Worked Back and Forth: (multiple of 6 sts + 2)

ROW 1: (RS) Purl.

ROW 2: Purl.

ROW 3: P1, knit to last st, p1.

ROW 4: P1, *k3, p3; rep from * to last st, p1.

ROW 5: P2, *k3, p3; rep from *.

ROW 6: P1, *k1, p3, k2; rep from * to last st, p1.

ROW 7: P1, *k2, p3, k1; rep from * to last st, p1.

ROW 8: *P3, k3; rep from * to last 2 sts, p2.

ROW 9: P1, *p3, k3; rep from * to last st, p1.

ROW 10: Purl.

ROW 11: P1, knit to last st, p1.

ROW 12: Knit.

Work Rows 1–12 for patt.

Leaf Pattern Worked in Rounds: (multiple of 6 sts)

RND 1: Purl.

RNDS 2 AND 3: Knit.

RND 4: *K3, p3; rep from *.

RND 5: *P1, k3, p2; rep from *.

RND 6: *P2, k3, p1; rep from *.

RND 7: *K2, p3, k1; rep from *.

RND 8: *K1, p3, k2; rep from *.

RND 9: *P3, k3; rep from *.

RNDS 10 AND 11: Knit.

RND 12: Purl.

Work Rnds 1–12 for patt.

Note: *Circular needle is used to accommodate large number of stitches. Do not join; work back and forth in rows.*

Sleeves

With larger dpns, CO 36 (36, 36, 42, 42, 42, 48) sts. Divide sts evenly over 3 or 4 dpn. Place marker (pm) and join for working in rnds (see Glossary).

Knit 1 rnd.

Work Rnds 1–12 of leaf patt worked in rnds.

Change to St st (knit every rnd), and work until piece meas 2" (5 cm) from beg.

Shape Sleeve

INC RND: K1, LLI (see Glossary), knit to last st, RLI (see Glossary), k1—2 sts inc'd.

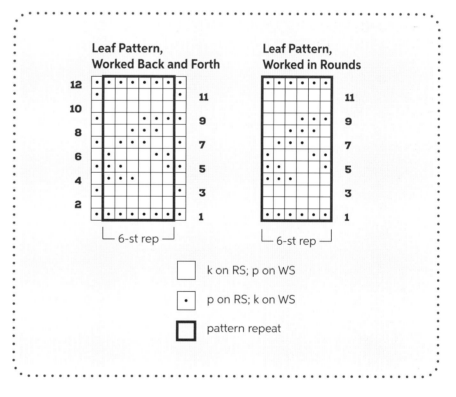

Leaf Pattern, Worked Back and Forth

Leaf Pattern, Worked in Rounds

6-st rep

6-st rep

□ k on RS; p on WS

• p on RS; k on WS

□ pattern repeat

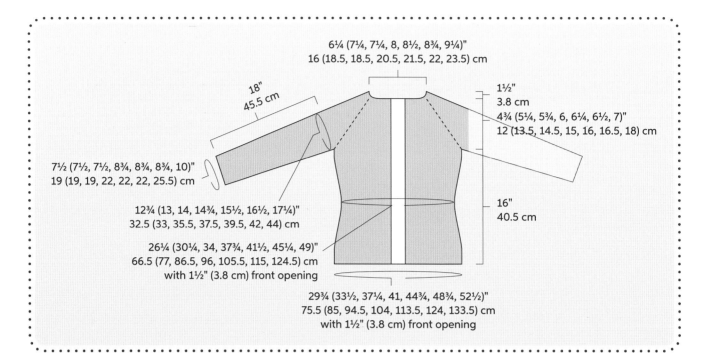

Knit 8 (7, 6, 7, 6, 5, 5) rnds.

Rep the last 9 (8, 7, 8, 7, 6, 6) rnds 5 (3, 7, 12, 15, 14, 7) times—48 (44, 52, 68, 74, 72, 64) sts.

[Rep inc rnd, then knit 9 (8, 7, 8, 0, 6, 6) rnds] 6 (9, 7, 1, 0, 3, 9) times—60 (62, 66, 70, 74, 78, 82) sts.

Work even in St st until piece meas 18" (45.5 cm) from beg.

DIVIDE FOR UNDERARM
Remove beg-of-rnd m, k3 (4, 5, 6, 7, 8, 9), sl the last 6 (8, 10, 12, 14, 16, 18) sts onto holder or waste yarn for underarm. Place the rem 54 (54, 56, 58, 60, 62, 64) sts onto a separate holder or waste yarn for sleeve. Break yarn and set aside.

Make second sleeve same as first.

Body

With cir needle, CO 134 (152, 170, 188, 206, 224, 242) sts. Do not join; work back and forth in rows.

Purl 1 WS row.

Work Rows 1–12 of leaf patt worked back and forth.

Change to St st (knit RS rows, purl WS rows) and work until piece meas 2" (5 cm) from beg, ending with a RS row.

PM FOR SIDES: (WS) P32 (36, 41, 45, 50, 54, 59) sts for left front, pm, p70 (80, 88, 98, 106, 116, 124) sts for back, pm, p32 (36, 41, 45, 50, 54, 59) sts for right front.

Shape Waist

Note: *Read the following instructions carefully before cont: pocket is established before waist decreases are completed.*

DEC ROW: (RS) * Work as est to 3 sts before m, ssk, k1, sl m, k1, k2tog; rep from * once more, knit to end—4 sts dec'd.

Work 11 rows even as est, ending after a WS row.

Rep the last 12 rows 3 times—118 (136, 154, 172, 190, 208, 226) sts rem.

At the same time, when piece meas 6" (15 cm) from beg, end with a WS row.

EST POCKET: (RS) Work 9 (11, 13, 15, 17, 19, 21) sts, pm for pocket, work Row 1 of leaf patt worked back and forth over next 20 sts, pm, work to last 29 (31, 33, 35, 37, 39, 41) sts, pm for pocket, work Row 1 of leaf patt over next 20 sts, pm, work to end of row.

Cont in est patt for 11 more rows, ending with last row of leaf patt.

NEXT ROW: (RS) *Knit to first pocket m, remove m, k20 with waste yarn, slip 20 sts from right needle to left needle, then knit the 20 waste yarn sts with working yarn, remove second m; rep from * once more, knit to end.

Cont in St st, purl 1 WS row.

INC ROW: (RS) *Knit to 1 st before m, RLI (see Glossary), k1, sl m, k1, LLI (see Glossary); rep from * once more, knit to end—4 sts inc'd.

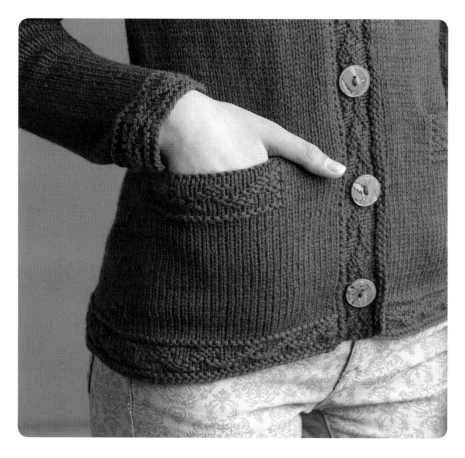

Rep Inc row every 10 rows 3 times—134 (152, 170, 188, 206, 224, 242) sts.

Work even until piece meas 16" (40.5 cm) from beg, ending with a WS row.

DIVIDE FOR UNDERARMS: (RS) *Knit to side m, remove m, k3 (4, 5, 6, 7, 8, 9), place the last 6 (8, 10, 12, 14, 16, 18) sts worked onto holder or waste yarn; rep from * once more, knit to end of row—29 (32, 36, 39, 43, 46, 50) sts rem for each front, and 64 (72, 78, 86, 92, 100, 106) sts rem for back.

Yoke

JOINING ROW: (WS) P29 (32, 36, 39, 43, 46, 50) front sts, pm for raglan, return held 54 (54, 56, 58, 60, 62, 64) sts from one sleeve to left needle and purl across, pm for raglan, p64 (72, 78, 86, 92, 100, 106) back sts, pm for raglan, return held 54 (54, 56, 58, 60, 62, 64) sts from second sleeve to left needle and purl across, pm for raglan, p29 (32, 36, 39, 43, 46, 50) front sts—230 (244, 262, 280, 298, 316, 334) sts.

Shape Raglan

DEC BODY AND SLEEVES ROW: (RS) *Knit to 3 sts before raglan m, ssk, k1, sl m, k1, k2tog; rep from * 3 times, knit to end—8 sts dec'd.

Purl 1 WS row.

Rep the last 2 rows 13 (17, 19, 19, 19, 18, 18) times—118 (100, 102, 120, 138, 164, 182) sts rem; 15 (14, 16, 19, 23, 27, 31) sts for each front, 26 (18, 16, 18, 20, 24, 26) sts for each sleeve, and 36 (36, 38, 46, 52, 62, 68) sts for back.

Sizes 29¾ (33½)" only:
Rep Dec body and sleeves row—8 sts dec'd.

DEC SLEEVES ROW: (WS) *Purl to next m, sl m, p1, ssp, purl to 3 sts before next m, p2tog, p1, sl m; rep from * once more, purl to end—4 sts dec'd.

Rep the last 2 rows 2 (0) more times—82 (88) sts total; 12 (13) sts for each front, 14 sts for each sleeve, and 30 (34) sts for back.

Sizes 37¼ (41, 44¾, 48¾, 52½)" only:
Rep Dec body and sleeves row—8 sts dec'd.

DEC BODY ROW: (WS) *Purl to 3 sts before raglan m, p2tog, p1, sl m, purl to next m, sl m, p1, ssp; rep from * once more, purl to end—4 sts dec'd.

Rep the last 2 rows 0 (1, 2, 4, 5) more time(s)—90 (96, 102, 104, 110) sts rem; 14 (15, 17, 17, 19) sts for each front, 14 sts for each sleeve, and 34 (38, 40, 42, 44) sts for back.

All sizes:
BO all sts kwise.

Finishing

Block to measurements.

Hood

With cir needle and RS facing, beg at right front neck edge, pick up and knit 1 st in each BO st along neck edge—82 (88, 90, 96, 102, 104, 110) sts. Do not join; work back and forth in rows.

Work even in St st until piece meas 1½" (3.8 cm) from pick-up row, ending with a RS row.

NEXT ROW: (WS) P28 (31, 32, 35, 38, 39, 42), pm, p26, pm, purl to end.

Shape hood
INC ROW: (RS) K2, LLI, knit to 1 st before m, RLI, k1, sl m, knit to next m, sl m, k1, LLI, knit to last 2 sts, RLI, k2—4 sts inc'd.

Work 11 (11, 11, 11, 17, 17, 17) rows even.

Rep the last 12 (12, 12, 12, 18, 18, 18) rows 2 (2, 2, 2, 1, 1, 1) time(s)—94 (100, 102, 108, 110, 112, 118) sts.

Hood should meas about 7" (18 cm) from pick-up row.

Shape back of hood with short-rows as foll:
SHORT-ROW 1: (RS) Knit to second m, sl m, k1, wrap next st and turn piece with WS facing, work p1, sl m, purl to next m, sl m, p1, wrap next st and turn piece with RS facing.

SHORT-ROW 2: (RS) Knit to wrapped st, knit wrap together with the st it wraps, k4, wrap next st and turn piece with WS facing; purl to wrapped st, purl wrap together with the st it wraps, p4, wrap next st and turn piece with WS facing.

Rep the last short-row 4 times.

NEXT 2 ROWS: Work to wrapped st, work wrap together with the st it wraps, work to end.

DEC ROW: (RS) Knit to 2 sts before m, ssk, sl m, work to next m, sl m, k2tog, knit to end—2 sts dec'd.

Work 1 WS row even as est.

Rep the last 2 rows 3 times —86 (92, 94, 100, 102, 104, 110) sts rem; 26 sts in the center, and 30 (33, 34, 37, 38, 39, 42) sts at each side.

Shape top of hood with short-rows as foll:
SHORT-ROW 1: (RS) Knit to first m, sl m, work to second m, sl m, k2tog, turn (do not wrap) so WS is facing; slip 1 st pwise wyf, sl m, work to next m, sl m, ssp, turn (do not wrap) so RS is facing—2 sts dec'd.

SHORT-ROW 2: (RS) Sl 1 st pwise wyb, sl m, work to m, sl m, k2tog, turn (do not wrap) so WS is facing; slip 1 st pwise wyf, sl m, work to m, sl m, ssp, turn (do not wrap) so RS is facing—2 sts dec'd.

Rep the last short-row 27 (30, 31, 34, 35, 36, 39) times—28 sts rem; 26 sts in the center, and 1 st at each side.

Slip all sts onto holder. Break yarn and set aside.

Buttonband
Place removable markers along edge of right front edge to indicate buttonhole placement. The first buttonhole is 2" (5 cm) from the neck edge BO, the last buttonhole is 1½" (3.8 cm) above the bottom edge, and the rem 5 are spaced evenly between.

With cir needle and RS facing, beg at lower right edge, pick up and knit 131 (134, 137, 140, 140, 143, 143) sts evenly along right front and hood edge to held sts, place 28 held hood sts onto left needle tip and knit across, pick up and knit 131 (134, 137, 140, 140, 143, 143) sts evenly along left hood and front edge—290 (296, 302, 308, 308, 314, 314) sts

Purl 1 WS row.

Work Rows 1–5 of leaf patt worked back and forth.

BUTTONHOLE ROW: (WS) *Work Row 6 of leaf patt as est to buttonhole m, work one-row buttonhole (see Glossary) over 3 sts; rep from * 6 times, work to end in est patt.

Work Rows 7–12 of leaf patt.

BO all sts pwise on RS.

Sew buttons to left front opposite buttonholes.

Pocket Lining
With RS facing, carefully remove waste yarn from one pocket and sl sts onto 3 smaller dpns: 1 dpn for 20 lower body sts and 2 dpns for upper 21 sts, picking up 1 st at each end of opening—43 sts.

Note: There is one extra st on upper body needle.

Work in St st until piece meas 5" (12.5 cm) from pick-up rnd.

DEC RND: Knit to last 2 sts, k2tog—42 sts.

Turn piece with WS facing, carefully insert one dpn at a time through the pocket opening. Join with three-needle BO (see Glossary).

Work second pocket lining same as first.

Weave in loose ends.

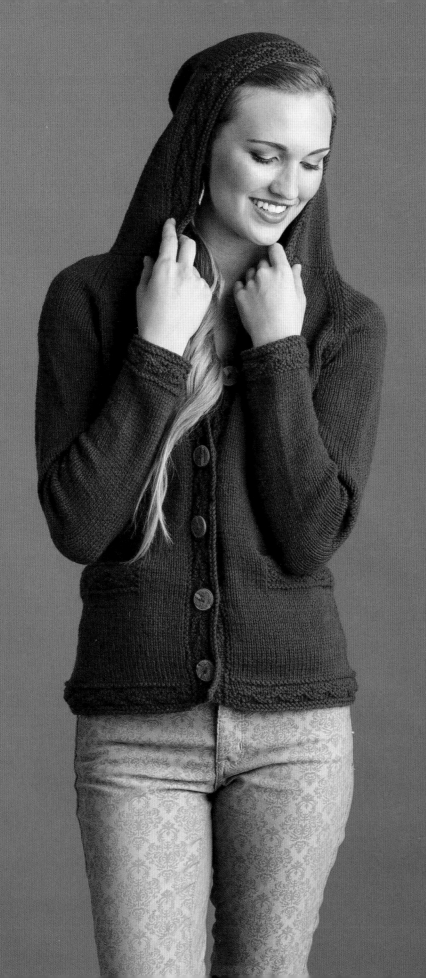

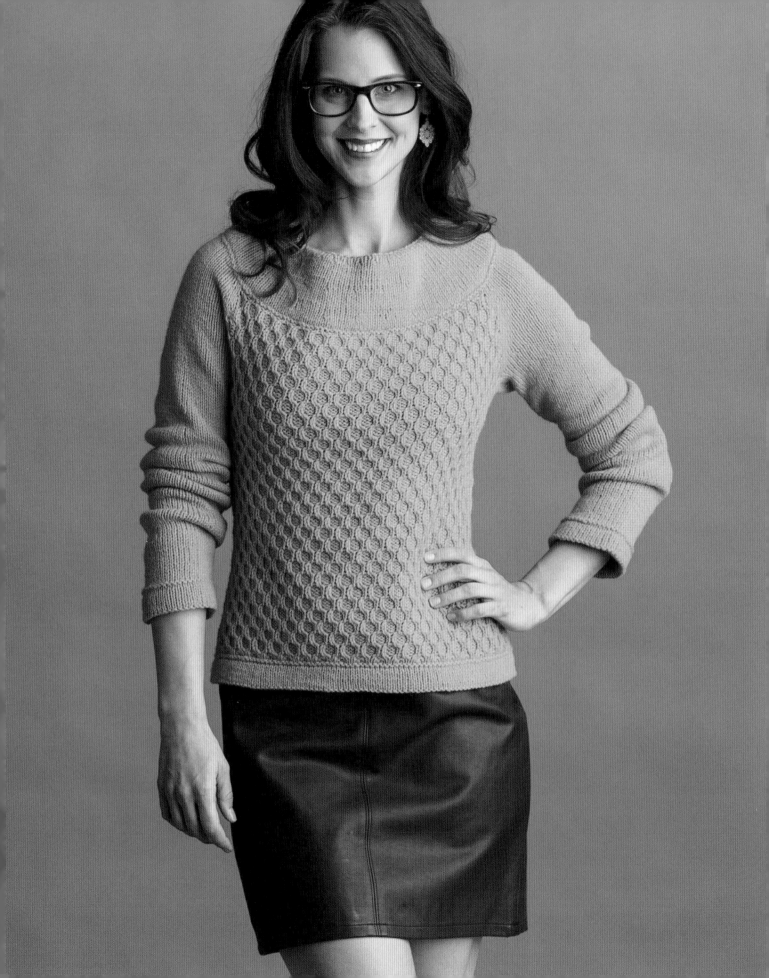

Sunshine PULLOVER

The Sunshine Pullover is knit from the top down with seamless hems worked at the yoke, sleeve cuff, and lower edges. Double-layered hems are worked at each edge of this sweater, using two different techniques for the cast-on or bind-off edges. The hems and sleeves are knitted in stockinette stitch, and the honeycomb pattern is worked in a multiple of six stitches plus two, which can interchange with the other stitch patterns in this chapter! This sweater would look great in a lacy pattern and short sleeves. See page 54 for more info on adjusting sleeve length.

Techniques

Circular knitting with circular needles and dpns

Provisional cast-on

Seamless hem

Lifted increases

Using a stitch holder or waste yarn

Multiple stitch patterns at the same time

Increasing and decreasing in pattern

Casting on stitches mid-row

Finished Size

About 32¼ (36, 39¾, 43½, 47, 50¾, 54½, 58¼)" (82 [91.5, 101, 110.5, 119.5, 129, 138, 148] cm) bust circumference and 19¾ (20¾, 20¾, 21¾, 21¾, 21¾, 21¾, 22¾)" (50 [52.5, 52.5, 55, 55, 55, 55, 58] cm) long.

Pullover shown measures 36" (91.5 cm).

Yarn

DK weight (#3 Light).

Shown here: O-Wool, Legacy DK (100% organic merino, 130 yd [119 m]/50 g): #4198 gamboge, 10 (12, 13, 14, 15, 16, 17, 18) skeins.

Needles

Body—Size U.S. 4 (3.5 mm): 29" (74 cm) circular (cir) and set of 4 or 5 double-pointed needles (dpn).

Inner Hems—Size U.S. 3 (3.25 mm): 29" (74 cm) circular (cir) and set of 4 or 5 double-pointed needles (dpn).

Adjust needle size if necessary to obtain the correct gauge.

Notions

Markers (m); cable needle (cn); holders or waste yarn; size U.S. E-4 (3.5 mm) crochet hook and smooth waste yarn for provisional cast-on; tapestry needle.

Gauge

21½ sts and 27 rnds = 4" (10 cm) in St st with larger needles; 26 sts and 32 rnds = 4" (10 cm) in honeycomb patt with larger needles.

Knitting Seamless Hems

Hems can be knit seamlessly at the cast-on or bind-off edges. The benefit of knitting hems is that you can have the appearance of stockinette stitch all the way to the edge of the fabric without the nuisance of curling. It also creates a double layer of fabric, which can be useful for extra warmth.

Cast-on Edge

When working a hem on the cast-on edge, the initial stitches are cast on using a provisional method. The inner (invisible) portion of the hem fabric is knit first, a turning row (or round) is worked by making a purl ridge, then the outer (visible) portion of the hem fabric is knit. When the inner and outer portions are the same length from the turning row/round, the stitches from the provisional cast-on are placed onto a second needle, the hem fabric is folded so the needles are held parallel, then 1 stitch from each needle is knit together as the row/round is worked.

Bind-off Edge

When working a hem on the bind-off edge, the outer (visible) portion of the hem fabric is knit first, a turning row (or round) is worked by making a purl ridge, then the inner (invisible) portion of the hem fabric is knit. The inner portion is folded to the inside of the sweater with the stitches still live on the needle. To join and bind off the inner hem stitches, determine which row on the wrong side of the outer portion of the hem aligns with the row on the inside portion. Often, the inner and outer hem portions will have the same number of rows. *Insert the left needle tip into the row on the wrong side of the outer

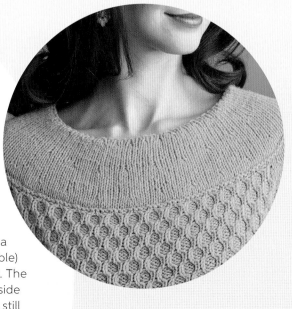

portion, picking up the loop for the stitch that aligns with the first stitch on the left needle. Knit the picked up stitch together with the live stitch on the left needle. Repeat from * as you work across, binding off the stitches loosely as you go.

Stitch Guide

T3F: (TWIST 3 FRONT) Sl 1 st onto cn and hold in front, p2, p1 from cn.

T3B: (TWIST 3 BACK) Sl 2 sts onto cn and hold in back, k1, p2 from cn.

Honeycomb Pattern, Worked Back and Forth: (multiple of 6 sts + 2)

ROW 1: K1, *T3F, T3B; rep from * to last st, k1.

ROWS 2 AND 4: P1, *k2, p2, k2; rep from * to last st, p1.

ROW 3: K1, *p2, k2, p2; rep from * to last st, k1.

ROW 5: K1, *T3B, T3F; rep from * to last st, k1.

ROWS 6–8: Rep Rows 2–4.

Rep Rows 1–8 for honeycomb patt.

Honeycomb Pattern, Worked in Rounds: (multiple of 6 sts)

RND 1: *T3F, T3B; rep from *.

RNDS 2–4: *P2, k2, p2; rep from *.

RND 5: *T3B, T3F; rep from *.

RNDS 6–8: Rep Rnds 2–4.

Rep Rnds 1–8 for honeycomb patt.

Note: *This pullover only uses the Honeycomb Pattern Worked in Rounds. The Honeycomb Pattern Worked Back and Forth is given so it may be used for other patterns in this chapter.*

Inner Yoke Hem

With smaller cir needle, using provisional method (see Glossary), CO 204 (208, 212, 216, 220, 224, 228, 232) sts. Place marker (pm) and join for working in rnds.

Knit 2 rnds.

DEC RND 1: *K5, k2tog; rep from * to last 1 (5, 2, 6, 3, 0, 4, 1) st(s), knit to end—175 (179, 182, 186, 189, 192, 196, 199) sts rem.

Knit 9 rnds even.

DEC RND 2: *K4, k2tog; rep from * to last 1 (5, 2, 0, 3, 0, 4, 1) st(s), knit to end—146 (150, 152, 155, 158, 160, 164, 166) sts rem.

Knit 9 rnds even.

DEC RND 3: *K1, k2tog; rep from * to last 2 (0, 2, 2, 2, 1, 2, 1) st(s), knit to end—98 (100, 102, 104, 106, 107, 110, 111) sts rem.

Knit 1 rnd even.

DEC RND 4: *K8, k2tog; rep from * to last 8 (0, 2, 4, 6, 7, 0, 1) st(s), knit to end—89 (90, 92, 94, 96, 97, 99, 100) sts rem.

Knit 1 rnd even.

Outer Yoke Hem

NEXT (TURNING) RND: Purl.

Change to larger cir.

Knit 1 rnd.

INC RND 1: *K9, RLI (see Glossary); rep from * to last 8 (0, 2, 4, 6, 7, 0, 1) st(s), knit to end—98 (100, 102, 104, 106, 107, 110, 111) sts.

Knit 1 rnd even.

INC RND 2: *K2, RLI; rep from * to last 2 (0, 2, 2, 2, 1, 2, 1) st(s), knit to end—146 (150, 152, 155, 158, 160, 164, 166) sts.

Knit 9 rnds even.

INC RND 3: *K5, RLI; rep from * to last 1 (5, 2, 0, 3, 0, 4, 1) st(s), knit to end—175 (179, 182, 186, 189, 192, 196, 199) sts.

Knit 9 rnds even.

INC RND 4: *K6, RLI; rep from * to last 1 (5, 2, 6, 3, 0, 4, 1) st(s), knit to end—204 (208, 212, 216, 220, 224, 228, 232) sts.

Knit 2 rnds even.

Yoke

NEXT (JOINING) RND: Carefully remove waste yarn from provisional CO and place 204 (208, 212, 216, 220, 224, 228, 232) sts onto smaller cir needle. Fold hem at turning rnd with WS of knitting facing tog. Holding the 2 needles parallel, and using larger cir, *knit tog 1 st from each needle; rep from *

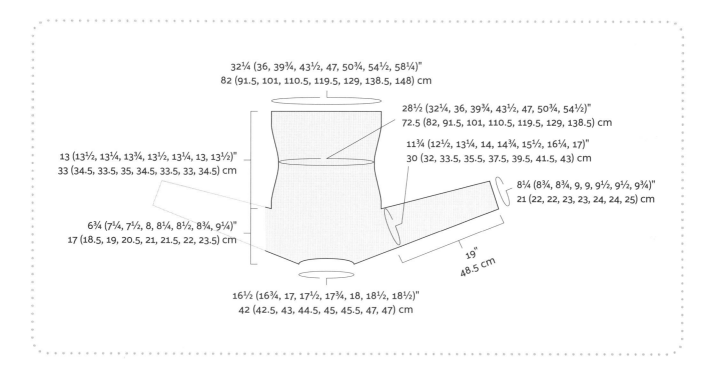

32¼ (36, 39¾, 43½, 47, 50¾, 54½, 58¼)"
82 (91.5, 101, 110.5, 119.5, 129, 138.5, 148) cm

28½ (32¼, 36, 39¾, 43½, 47, 50¾, 54½)"
72.5 (82, 91.5, 101, 110.5, 119.5, 129, 138.5) cm

11¾ (12½, 13¼, 14, 14¾, 15½, 16¼, 17)"
30 (32, 33.5, 35.5, 37.5, 39.5, 41.5, 43) cm

13 (13½, 13¼, 13¾, 13½, 13¼, 13, 13½)"
33 (34.5, 33.5, 35, 34.5, 33.5, 33, 34.5) cm

8¼ (8¾, 8¾, 9, 9, 9½, 9½, 9¾)"
21 (22, 22, 23, 23, 24, 24, 25) cm

6¾ (7¼, 7½, 8, 8¼, 8½, 8¾, 9¼)"
17 (18.5, 19, 20.5, 21, 21.5, 22, 23.5) cm

19"
48.5 cm

16½ (16¾, 17, 17½, 17¾, 18, 18½, 18½)"
42 (42.5, 43, 44.5, 45, 45.5, 47, 47) cm

around—204 (208, 212, 216, 220, 224, 228, 232) sts.

Cont with larger cir needle.

Purl 1 rnd. Knit 1 rnd.

INC RND 5: *Work 44 (42, 40, 38, 36, 34, 32, 30) sts in St st for right sleeve, pm for raglan, [k2, M1P, p2, M1P] 14 (15, 16, 17, 18, 19, 20, 21) times, k2 for front, pm for raglan; rep from * once more for left sleeve and back—260 (268, 276, 284, 292, 300, 308, 316) sts total; 44 (42, 40, 38, 36, 34, 32, 30) sts for each sleeve, and 86 (92, 98, 104, 110, 116, 122, 128) sts each for back and front.

SET-UP RND: *Work in St st to raglan m, sl m, k1, work Rnd 1 of honeycomb patt to 1 st before next m, k1, sl m; rep from * once more.

Shape Raglan

INC RND: *K1, M1L (see Glossary), work in est patt to 1 st before next raglan m, M1R (see Glossary), k1, sl m; rep from * 3 times—8 sts inc'd.

Work 3 rnd even as est.

Rep the last 4 rnds 4 (4, 3, 3, 2, 1, 0, 0) time(s), working sts on front and back into honeycomb patt as sts become available—300 (308, 308, 316, 316, 316, 316, 324) sts total; 54 (52, 48, 46, 42, 38, 34, 32) sts for each sleeve, and 96 (102, 106, 112, 116, 120, 124, 130) sts each for back and front.

[Rep raglan Inc rnd, then work 1 rnd even] 1 (3, 6, 8, 11, 14, 17, 19) time(s)—308 (332, 356, 380, 404, 428, 452, 476) sts total; 56 (58, 60, 62, 64, 66, 68, 70) sts for each sleeve, and 98 (108, 118, 128, 138, 148, 158, 168) sts each for front and back.

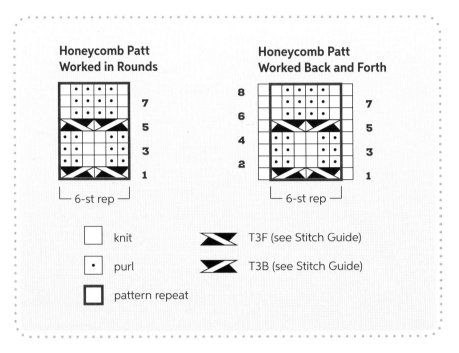

Honeycomb Patt Worked in Rounds

7
5
3
1

6-st rep

Honeycomb Patt Worked Back and Forth

8
6
4
2

7
5
3
1

6-st rep

☐ knit

· purl

☐ pattern repeat

◣ T3F (see Stitch Guide)

◢ T3B (see Stitch Guide)

Divide Sleeves and Body

NEXT RND: Remove m, sl the 56 (58, 60, 62, 64, 66, 68, 70) sleeve sts onto holder or waste yarn, remove m, using backward-loop method (see Glossary), CO 3 (4, 5, 6, 7, 8, 9, 10) sts for underarm, pm for beg of rnd, CO 4 (5, 6, 7, 8, 9, 10, 11) sts, work 98 (108, 118, 128, 138, 148, 158, 168) front sts in est patt, remove m and sl 56 (58, 60, 62, 64, 66, 68, 70) sleeve sts onto holder or waste yarn, remove m, CO 3 (4, 5, 6, 7, 8, 9, 10) sts for underarm, pm for side, CO 4 (5, 6, 7, 8, 9, 10, 11) sts, work 98 (108, 118, 128, 138, 148, 158, 168) back sts, then cont in est patt to beg-of-rnd m—210 (234, 258, 282, 306, 330, 354, 378) sts.

Body

SET-UP RND: *P1 (faux seam st, p1-tbl on all following rnds), k1, work next rnd of honeycomb patt to 1 st before next m, k1, sl m; rep from* once more.

Shape Waist

Work 7 rnds even.

DEC RND: *P1-tbl, ssk, work in est patt to 2 sts before next m, k2tog; rep from * once more—4 sts dec'd.

Rep the last 8 rnds 5 times—186 (210, 234, 258, 282, 306, 330, 354) sts rem.

Work 5 rnds even.

INC RND: *P1-tbl, k1, M1 (or M1P to maintain patt), work in est patt to 1 st before m, M1 (or M1P to maintain patt); rep from * once more—4 sts inc'd.

Rep the last 6 rnds 5 times—210 (234, 258, 282, 306, 330, 354, 378) sts.

Cont even until piece meas about 11¼ (11¾, 11½, 12, 11¾, 11½, 11¼, 11¾)" (28.5 [30, 29, 30.5, 30, 29, 28.5, 30] cm) from divide, ending with Rnd 1 of honeycomb patt.

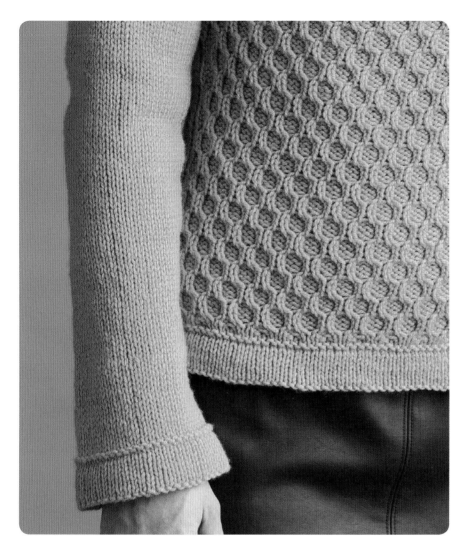

(5, 6, 7, 8, 9, 10, 11) sts along rem CO edge—63 (67, 71, 75, 79, 83, 87, 91) sts. Divide sts evenly over 3 or 4 dpn. Pm and join for working in rnds.

Work even in St st until piece meas 1" (2.5 cm) from pick-up rnd.

Shape Sleeve

DEC RND: K2tog, knit to last 3 sts, ssk, k1—2 sts dec'd.

Work 11 (9, 7, 7, 5, 5, 5, 3) rnds even.

Rep the last 12 (10, 8, 8, 6, 6, 6, 4) rnds 6 (3, 3, 8, 3, 7, 15, 0) times—49 (59, 63, 57, 71, 67, 55, 89) sts rem.

[Rep dec rnd, then knit 13 (11, 9, 9, 7, 7, 7, 5) rnds] 2 (6, 8, 4, 11, 8, 2, 18) times—45 (47, 47, 49, 49, 51, 51, 53) sts rem.

Work even until piece meas 17¾" (45 cm) from pick-up rnd.

Outer Hem

Purl 1 rnd. Knit 10 rnds.

Change to smaller dpn.

NEXT (TURNING) RND: Purl.

Inner Hem

Knit 10 rnds.

Turn piece with WS facing.

NEXT (JOINING) RND: Fold inner hem to the WS of sleeve at the turning rnd, *pick up 1 st from WS of sleeve with left needle tip, then knit it tog with next st on left needle; rep from * around while binding off.

Work second sleeve same as first.

Finishing

Weave in loose ends. Block to measurements.

Outer Hem

DEC RND: *P1-tbl, k1, [p2tog, k2, p2tog] to 1 st before m, k1, sl m; rep from * once more—142 (158, 174, 190, 206, 222, 238, 254) sts rem.

NEXT RND: *P1-tbl, knit to m, sl m; rep from * once more.

Purl 1 rnd. Knit 10 rnds.

Change to smaller cir needle.

NEXT (TURNING) RND: Purl.

Inner Hem

Knit 10 rnds.

Turn piece with WS facing.

NEXT (JOINING) RND: Fold inner hem to WS of body at turning rnd, *pick up 1 st from WS of body with left needle tip, then knit it tog with next st on left needle; rep from * around while binding off.

Sleeves

Return held 56 (58, 60, 62, 64, 66, 68, 70) sts for one sleeve to 3 larger dpn. With 4th dpn, beg at center of body underarm sts, pick up and knit 3 (4, 5, 6, 7, 8, 9, 10) sts along CO edge, knit sleeve sts, then pick up and knit 4

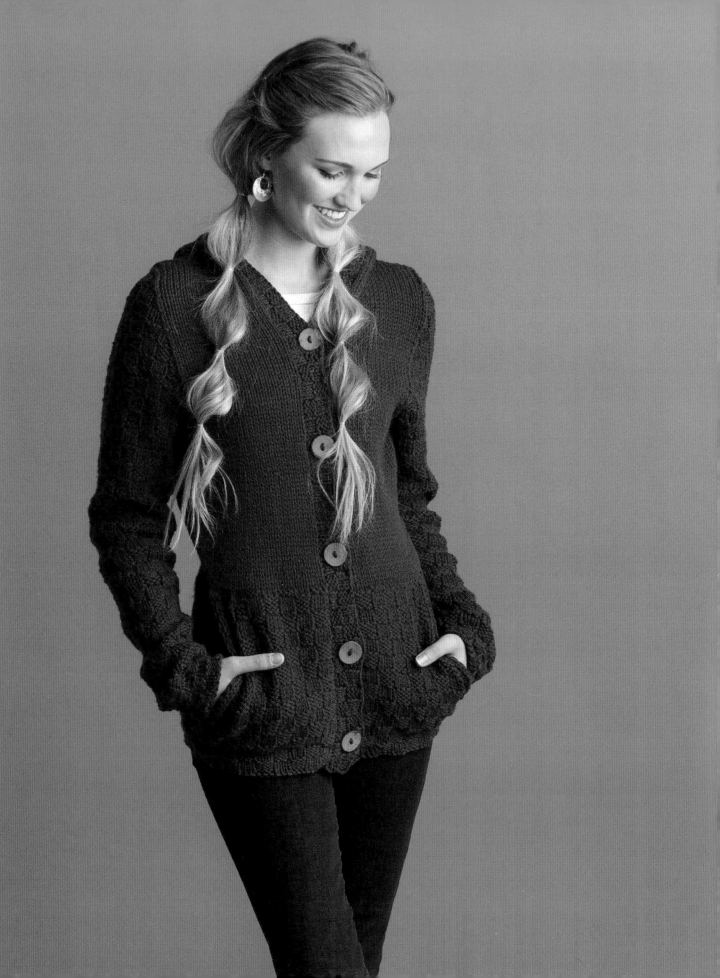

Merci HOODIE

Merci is the classic hoodie with pockets. The basketweave pattern detail gives this sweater a little pizzazz, and it may be swapped out with any of the other multiple of six stitches + two stitch patterns in this chapter! It would look great in the lattice pattern worked on the Majestic Tie Cardigan or the honeycomb pattern used in the Sunshine Pullover, with garter stitch for the buttonband.

Knit up some swatches, testing out different edgings for the lower edge and buttonband, to see what you like the best. (Read more about edgings on page 16). If you're not a pocket person, simply skip the row establishing the pocket, and jump ahead to the body, working 5 rows in stockinette stitch instead of 3. The Stockinette stitch body on this sweater lends itself to bust darts, too (see page 112).

Techniques

Circular knitting with dpns

Seamless pockets

Short-rows

Multiple stitch patterns at the same time

Buttonholes

Picking up stitches

Three-needle bind-off

Using a stitch holder or waste yarn

Lifted increases

Finished Size

About 30½ (33¾, 37, 40¼, 43½, 46½, 49¾, 53)" (77.5 [85.5, 94, 102, 110.5, 118, 126.5, 134.5] cm) bust circumference with 1¼" (3.2 cm) overlapping buttonband and 24¼ (24½, 25, 25½, 25½, 25¾, 26¼, 26¼)" (61.5 [62, 63.5, 65, 65, 65.5, 66.5, 66.5] cm) long.

Hoodie shown measures 33¾" (85.5 cm).

Yarn

Chunky weight (#5 Bulky).

Shown here: Quince & Co., Osprey (100% American wool, 170 yd [155 m]/100 g): #121 bark, 8 (8, 9, 10, 10, 11, 12, 12) skeins.

Needles

Size U.S. 11 (8 mm) needle: 32" (80 cm) circular (cir) needle and set of 4 or 5 double-pointed (dpn). *Adjust needle size if necessary to obtain the correct gauge.*

Notions

Markers (m); holders or waste yarn; tapestry needle; five 1¼" [32 mm] buttons.

Gauge

15 sts and 20 rows = 4" (10 cm) in St st; 15 sts and 20 rows/rnds = 4" (10 cm) in basketweave patt.

{ Adding a Seamless Pocket to Any Sweater }

A seamless pocket can be added to almost any sweater while in the process of knitting the sweater.

The Merci Hoodie is a cardigan with a pocket on each front and openings for the hands on the side edges of the pockets. Similarly, the Heroic Vest is a pullover with a single pocket on the front and openings for the hands on the sides. Both of these pockets can be added to any pullover or cardigan that's knit from the top down or bottom up.

If you've read through the pocket information in my book *Finish-Free Knits*, you'll see that the method I show here for the Heroic Vest is slightly different than the one in that book. Both techniques work and give the same results; however, this technique is a little more evolved and, in my opinion, a bit simpler.

The Wandering Hoodie is a Cardigan with a pocket on each front and openings for the hands on the top edge of the pockets. This pocket technique is a little simpler to do than the one above. It can be added to any sweater knit from the top down or bottom up. If you're knitting a sweater from side to side, this sort of pocket can still be added and will result in an opening on the side for the hand.

For your sweater, choose the technique that feels best to you and will give you the type of pocket you'll enjoy.

Cardigan Pocket with Opening on the Side (Merci Hoodie)

To establish the pockets, a right-side row is worked, doubling the

number of stitches on each front for the pockets using k1-f/b and/or p1-f/b to keep in the stitch pattern as it will appear on the pocket. If looking at the right side of stockinette-stitch fabric, you'll see that the second stitch from each of the k1-f/b stitches looks like a purl bump. This "increased" stitch will be kept to the wrong side for the body. The first stitch of the k1-f/b stitch is used for the pocket because it visibly maintains the stitch pattern. Knowing that, on the following wrong-side row, the pocket and body stitches are divided. With the working needle, work into all the "increased" stitches for the body while slipping the pocket stitches onto a double-pointed needle (or another circular needle) held to the back (right side) of the work for the pocket. Pause working on the body for the moment, and join a new ball of yarn to the pocket stitches and work the pocket to the desired length, adding some shaping along the opening if desired. Slip the pocket stitches onto a stitch holder and break the yarn. Go back to the body stitches and yarn and complete that row, separating the body and pocket stitches for the second pocket. Work the second pocket to the same length as the first.

When both pockets are complete, use the working yarn and needle to knit the body up to the same length as the pockets. Place the pocket stitches back onto a needle, hold the pocket and body needles parallel, and join them together by working through the stitches on both needles for each stitch across.

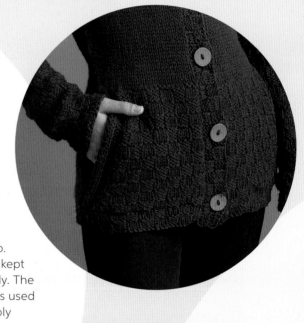

The final step for these pockets is to join the front edges of both pieces. When picking up stitches for the buttonbands, pick up through both the body and pocket fabrics. Voila!

Pullover Pocket with Opening on the Sides (Heroic Vest)

To establish the pocket, a right-side row is worked, doubling the number of stitches in the center of the front for the pocket using k1-f/b and/or p1-f/b to keep in the stitch pattern as it will appear on the pocket. If looking at the right side of stockinette-stitch fabric, you'll see that the second stitch from each of the k1-f/b stitches looks like a purl bump. This "increased" stitch will be kept to the wrong side for the body. The first stitch of the k1-f/b stitch is used for the pocket because it visibly maintains the stitch pattern. Knowing that, on the following wrong-side row, the pocket and body stitches are divided. With the working needle, work into all the "increased" stitches for the body while slipping the pocket stitches onto a double-pointed needle (or another circular needle) held to the back

(right side) of the work for the pocket. Pause working on the body for the moment and join a new ball of yarn to the pocket stitches and work the pocket to the desired length, adding some shaping along the side edges if desired. Slip the pocket stitches onto a stitch holder and break the yarn. Go back to the body stitches and knit the body up to the same length as the pocket. Place the pocket stitches back onto a needle, hold the pocket and body needles parallel, and join them together by working through the stitches on both needles for each stitch across. Voila!

Pocket with Opening on the Top (Tender Hoodie)

When you get to the row of your sweater where you would like the pocket opening to be, work to the part of that row where you want your pocket. Switch to a length of waste yarn and knit however many stitches you want for the pocket opening. Slip the stitches that were just knit with the waste yarn back to the left needle and use your working yarn to work across those stitches. Continue merrily on your way until the sweater is all finished.

With the right side facing, carefully ravel the waste yarn from your pocket opening to reveal live stitches at the top and bottom of the opening. Place the top and bottom stitches onto separate double-pointed needles as they are revealed. There will be 1 more stitch on the top (the knitting worked after placing the waste yarn) of your pocket than on the bottom (the knitting worked before placing the waste yarn). This is because there are technically 2 half stitches exposed to each side of the center stitches on the

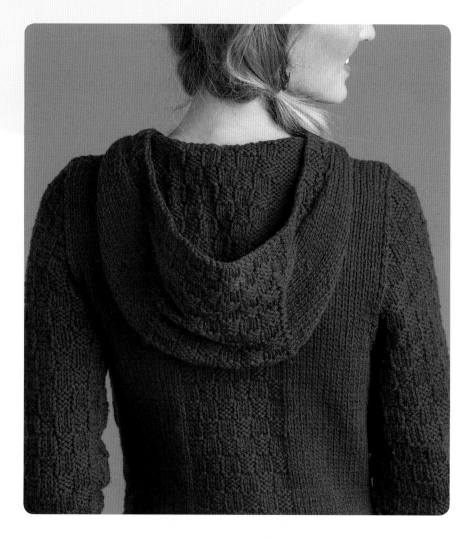

top, but both are picked up with the double-pointed needle.

Join the working yarn and pick up a stitch at one of the gaps between the two needles, knit across one needle, then pick up a stitch at the gap on the other side. Due to the extra stitch at the top, you will have an odd number of stitches. Place a marker for the beginning of the round and work in stockinette stitch (knitting every round) until the pocket is as deep as you'd like it.

On your last round, decrease 1 stitch so you have an even number of

stitches. Divide the stitches evenly onto two double-pointed needles so they are aligned with the top and bottom of the pocket opening, as they were after stitches were picked up. Carefully turn the pocket inside out, pulling your ball of yarn to the wrong side through the opening of the pocket. Join the stitches on both needles using the three-needle bind-off method (see Glossary). If desired, you may use the tail of yarn to tack the inside of the pocket to the wrong side of the sweater; that requires a little bit of sewing, so I don't usually bother.

Stitch Guide

Basketweave Pattern Worked Back and Forth:
(multiple of 6 sts + 2)

ROWS 1 AND 3: (RS) P1, *p3, k3; rep from * to last st, k1.

ROWS 2 AND 4: P1, *p3, k3; rep from * to last st, k1.

ROWS 5, 6, 7, AND 8: K1, *k3, p3; rep from * to last st, p1.

Rep Rows 1–8 for patt.

Basketweave Pattern Worked in Rounds:
(multiple of 6 sts)

RNDS 1–4: *P3, k3; rep from * around.

RNDS 5–8: *K3, p3; rep from * around.

Rep Rnds 1–8 for patt.

Note: Body and sleeves are worked separately to the underarm, where they are joined and worked at the same time to the shoulder, while working set-in sleeve shaping. The tops of the caps are completed by working short-rows, then the shoulders are joined with three-needle BO. The hood sts are picked up around the neck edge. The top of the hood is shaped with short-rows.

Lower Trim

With circular needle, CO 110 (122, 134, 146, 158, 170, 182, 194) sts. Do not join; work back and forth in rows.

Work in Rows 1–7 in basketweave patt.

NEXT ROW: (WS) Working in est patt, work 46 (52, 58, 64, 70, 76, 82, 88) sts, place marker (pm), work 18 sts, pm, work to end of row.

Begin Pockets

SET-UP ROW: (RS) P1-f/b, *[p1-f/b] 3 times, [k1-f/b] 3 times; rep from * 3 (4, 4, 5, 5, 6, 6, 6) times, pm for right pocket, work in St st (knit on RS, purl on WS) to back panel m, sl m, work 18 sts in basketweave patt as est, sl m, work in St st to last 25 (31, 31, 37, 37, 43, 43, 43) sts, pm for left pocket, [k1-f/b] 3 times, [p1-f/b] 3 times,

**[p1-f/b] 3 times, [k1-f/b] 3 times; rep from ** 2 (3, 3, 4, 4, 5, 5, 5) times, k1-f/b—160 (184, 196, 220, 232, 256, 268, 280) sts.

Left Pocket

DIVIDE POCKET FROM BODY: (WS) Slip next st to dpn at back for pocket, p1 for body, *[sl next st to dpn at back of work for pocket, p1 for body] 3 times, [sl next st to dpn at back of work for pocket, k1 for body] 3 times; rep from * 2 (3, 3, 4, 4, 5, 5, 5) times, [sl next st to dpn at back of work for pocket, k1 for body] 3 times, [sl next st to dpn at back of work for pocket, p1 for body] 3 times, remove left pocket marker—25 (31, 31, 37, 37, 43, 43, 43) sts on dpn for pocket. Drop working yarn and cir needle. Join a second ball of yarn to dpn to beg with a WS row. Continue working back and forth on dpn for left pocket as foll:

SET-UP ROW: (WS) P1, *p3, k3; rep from * to last 6 sts of pocket, pm, k3, p3.

DEC ROW: (RS) Sl 1 st purlwise with yarn in back (pwise wyb), k2, p3, sl m, k2tog (or p2tog to maintain patt; see Tip Box for the Noble Pullover, page 130), work in basketweave patt to end as est—1 st dec'd.

Work 7 rows even, maintaining the 6 sts at the side edge of pocket in k3, p3 ribbing and slipping the first st of each RS row.

Rep the last 8 rows 4 times, then work Dec row once more—19 (25,

25, 31, 31, 37, 37, 37) sts rem. Pocket should meas about 8½" (21.5 cm) from divide.

Sl sts onto holder and break yarn.

Right Pocket

DIVIDE POCKET FROM BODY: (WS) Cont working with cir needle and attached yarn as foll: work to right pocket m as est, sl m, *[p1 for body, slip next st to dpn at back of work for pocket] 3 times, [k1 for body, slip next st to dpn at back of work for pocket] 3 times; rep from * to last st, k1 for body, slip next st to dpn at back of work for pocket. Drop working yarn and cir needle. Join a second ball of yarn to dpn to beg with a WS row. Cont working back and forth on dpn for pocket as foll:

SET-UP ROW: (WS) Sl 1 st pwise with yarn in front (wyf), p2, k3, *p3, k3; rep from * to last st, k1.

DEC ROW: (RS) Work in basketweave patt to 2 sts before m, ssk (or ssp to maintain patt; see Tip Box for the Noble Pullover, page 130), sl m, p3, k3—1 st dec'd.

Work 7 rows even, maintaining the 6 sts at the side edge of pocket in k3, p3 ribbing and slipping the first st of each WS row.

Rep the last 8 rows 4 times, then work Dec row once more—19 (25, 25, 31, 31, 37, 37, 37) sts rem. Pocket

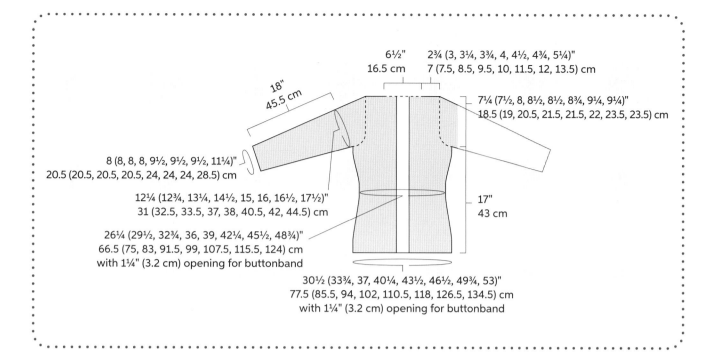

6½"
16.5 cm

2¾ (3, 3¼, 3¾, 4, 4½, 4¾, 5¼)"
7 (7.5, 8.5, 9.5, 10, 11.5, 12, 13.5) cm

18"
45.5 cm

7¼ (7½, 8, 8½, 8½, 8¾, 9¼, 9¼)"
18.5 (19, 20.5, 21.5, 21.5, 22, 23.5, 23.5) cm

8 (8, 8, 9½, 9½, 9½, 11¼)"
20.5 (20.5, 20.5, 20.5, 24, 24, 24, 28.5) cm

12¼ (12¾, 13¼, 14¼, 15, 16, 16½, 17½)"
31 (32.5, 33.5, 37, 38, 40.5, 42, 44.5) cm

17"
43 cm

26¼ (29½, 32¾, 36, 39, 42¼, 45½, 48¾)"
66.5 (75, 83, 91.5, 99, 107.5, 115.5, 124) cm
with 1¼" (3.2 cm) opening for buttonband

30½ (33¾, 37, 40¼, 43½, 46½, 49¾, 53)"
77.5 (85.5, 94, 102, 110.5, 118, 126.5, 134.5) cm
with 1¼" (3.2 cm) opening for buttonband

should meas about 8½" (21.5 cm) from divide.

Sl sts onto holder and break yarn.

Body

Cont working with cir needle and attached yarn across 110 (122, 134, 146, 158, 170, 182, 194) body sts as foll:

Beg with a RS row, work in est patt for 3 rows, ending with a RS row.

NEXT ROW: (WS) P26 (29, 32, 35, 38, 41, 44, 47), pm for side, work 58 (64, 70, 76, 82, 88, 94, 100) in est patt, pm for side, p26 (29, 32, 35, 38, 41, 44, 47).

Shape Waist

DEC ROW: (RS) *Work to 3 sts before side m, ssk, k1, sl m; k1, k2tog; rep from * once more, knit to end—4 sts dec'd.

Work 7 rows even.

Rep the last 8 rows 3 times—94 (106, 118, 130, 142, 154, 166, 178) sts rem.

Work even until body meas 8½" (21.5 cm) from divide, ending with a RS row.

JOIN BODY AND POCKETS: (WS) Return held left pocket sts to dpn and hold needles parallel, using right needle tip of cir needle, p2tog (1 st from pocket and 1 st from body) until all pocket sts are joined, work in est patt to last 19 (25, 25, 31, 31, 37, 37, 37) sts, return held right pocket sts to dpn and hold needles parallel, using right needle tip of cir needle, p2tog (1 st from pocket and 1 st from body) until all pocket sts are joined—94 (106, 118, 130, 142, 154, 166, 178) sts.

INC ROW: (RS) *Work to 1 st before side m, RLI, k1, sl m, k1, LLI; rep from * once more, knit to end—4 sts inc'd.

Work 5 rows even.

Rep the last 6 rows 3 times—110 (122, 134, 146, 158, 170, 182, 194) sts.

Cont even until piece meas 17" [43 cm] from beg, ending with a RS row.

DIVIDE BACK AND FRONTS: (WS) *Work to 4 (4, 4, 5, 5, 6, 6, 7) sts after side m, place the last 8 (8, 8, 10, 10, 12, 12, 14) sts worked onto holder or waste yarn for underarm, removing m; rep from * once more, purl to end—50 (56, 62, 66, 72, 76, 82, 86) sts rem for back, and 22 (25, 28, 30, 33, 35, 38, 40) sts rem for each front.

Set aside with yarn attached.

Sleeves

With dpn, CO 30 (30, 30, 30, 36, 36, 36, 42) sts. Divide sts evenly over 3 or 4 dpn. Pm and join for working in rnds.

Work in basketweave patt until piece meas 2" (5 cm) from beg.

Shape Sleeve

INC RND: M1 (or M1P to maintain patt; see Tip Box for Noble Pullover, page 130), work in est patt to end of rnd, M1 (or M1P to maintain patt)—2 sts inc'd.

Work 10 (9, 8, 7, 7, 6, 7) rnds even, working inc sts into basketweave patt.

Rep the last 11 (10, 9, 8, 8, 8, 7, 8) rnds 0 (0, 1, 0, 6, 0, 3, 0) more time(s)—32 (32, 34, 32, 50, 38, 44, 44) sts.

[Work Inc rnd, then work 8 (7, 6, 5, 5, 5, 4, 5) rnds even] 7 (8, 8, 11, 3, 11, 9, 11) times—46 (48, 50, 54, 56, 60, 62, 66) sts.

Cont even in est patt until piece meas 18" (45.5 cm) from beg, ending with an odd-numbered patt rnd.

DIVIDE FOR UNDERARM: Work 4 (4, 4, 5, 5, 6, 6, 7) sts, place the last 8 (8, 8, 10, 10, 12, 12, 14) sts worked onto holder or waste yarn for underarm, removing marker—38 (40, 42, 44, 46, 48, 50, 52) sts rem. Sl rem sts to separate holder or waste yarn. Break yarn and set aside.

Work second sleeve same as first, breaking yarn and keeping sts on dpn.

Yoke

Working with cir needle holding body sts, cont body and sleeves in est patt as foll:

NEXT (JOINING) ROW: (RS) Work to last st of right front, k2tog (last st of right front with first st of sleeve), pm for sleeve, work in est patt to last st of sleeve, pm for sleeve, ssk (last st of sleeve with first st of back), work to last st on back, return held sts from second sleeve to dpns and k2tog (last st of back with first st of sleeve), pm for sleeve, work in est patt to last sleeve st, pm for sleeve, ssk (last st of sleeve with first st of left front), work to end of left front—166 (182, 198, 210, 226, 238, 254, 266) sts rem; 22 (25, 28, 30, 33, 35, 38, 40) sts for each front, 36 (38, 40, 42, 44, 46, 48, 50) sts for each sleeve, and 50 (56, 62, 66, 72, 76, 82, 86) sts for back.

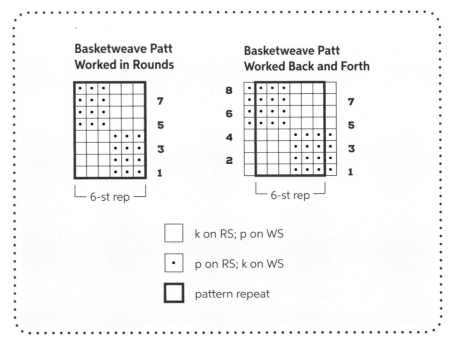

Basketweave Patt Worked in Rounds

6-st rep

Basketweave Patt Worked Back and Forth

6-st rep

☐ k on RS; p on WS

▪ p on RS; k on WS

☐ pattern repeat

Shape Armholes

DEC ROW 1: (WS) *Work to 2 sts before sleeve m, ssp, sl m, work to next sleeve m in est patt, sl m, p2tog; rep from * once more, work to end—4 body sts dec'd.

DEC ROW 2: (RS) *Work to 2 sts before sleeve m, k2tog, sl m, work to next sleeve m in est patt, sl m, ssk; rep from * once more, work to end—4 body sts dec'd.

Rep the last 2 rows 0 (1, 2, 2, 3, 3, 4, 4) more time(s)—158 (166, 174, 186, 194, 206, 214, 226) sts rem; 20 (21, 22, 24, 25, 27, 28, 30) sts for each front, 36 (38, 40, 42, 44, 46, 48, 50) sts for each sleeve, and 46 (48, 50, 54, 56, 60, 62, 66) sts for back.

Shape Sleeve Cap

CAP SET-UP ROW: (WS) *Work to 1 st before sleeve m, sl 1 st pwise, remove m, replace slipped st on left needle tip, replace m, work to next sleeve m, remove m, p1, replace m; rep from * once more, work to end—19 (20, 21, 23, 24, 26, 27, 29) sts for each front, 38 (40, 42, 44, 46, 48, 50, 52) sts for each sleeve, and 44 (46, 48, 52, 54, 58, 60, 64) sts for back.

DEC ROW: (RS) *Work to sleeve m, sl m, ssk, work in est patt to 2 sts before next sleeve m, k2tog, sl m; rep from * once more, work to end—2 sts dec'd for each sleeve.

Work 1 WS row even.

Rep the last 2 rows 9 (8, 7, 8, 5, 6, 5, 4) times—118 (130, 142, 150, 170, 178, 190, 206) sts rem; 19 (20, 21, 23, 24, 26, 27, 29) sts for each front, 18 (22, 26, 26, 34, 34, 38, 42) sts for each sleeve, and 44 (46, 48, 52, 54, 58, 60, 64) sts for back.

DEC ROW: (RS) *Work to sleeve m, sl m, ssk, work in est patt to 2 sts before next sleeve m, k2tog, sl m; rep from * once more, work to end—2 sts dec'd for each sleeve.

DEC ROW: (WS) *Work to sleeve m, sl m, p2tog, work in est patt to 2 sts before next sleeve m, ssp, sl m; rep from * once more, work to end—2 sts dec'd for each sleeve.

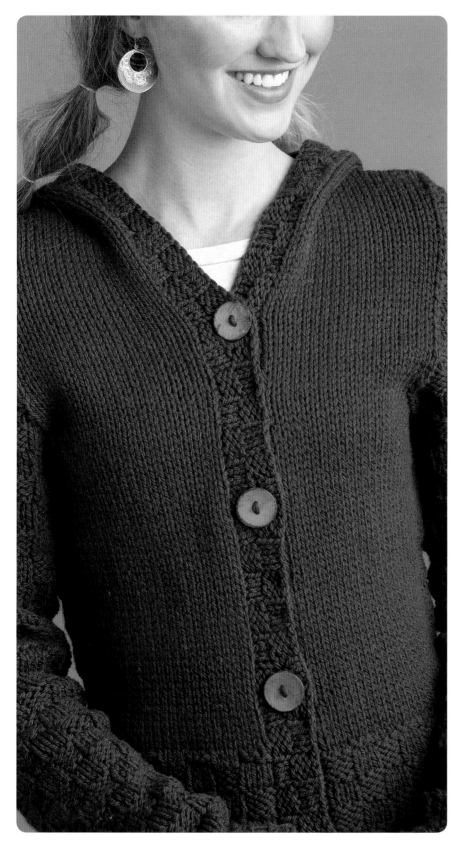

Rep last 2 rows 1 (2, 3, 3, 5, 5, 6, 7) more time(s)—102 (106, 110, 118, 122, 130, 134, 142) sts rem; 19 (20, 21, 23, 24, 26, 27, 29) sts for each front, 10 sts for each sleeve, and 44 (46, 48, 52, 54, 58, 60, 64) sts for back.

All sizes, shape top of right front sleeve cap using short-rows as foll:

Note: *Sts on sleeve are not wrapped when turning, but sts at the neck edge are wrapped.*

SHORT-ROW 1 (SEE GLOSSARY): (RS) Work to sleeve m, sl m, ssk, turn piece with WS facing; (WS) sl 1 pwise wyf, sl m, work to end—1 st dec'd on right sleeve.

Rep last short-row 2 times—7 sts rem for right sleeve.

Shape top of right back sleeve cap and neck using short-rows as foll:

SHORT-ROW 2: (RS) Work to sleeve m, remove m, ssk, work to 2 sts before next sleeve m, k2tog, sl m, work 13 (14, 15, 17, 18, 20, 21, 23) back sts, wrap next st and turn piece with WS facing; (WS) work to sleeve m, sl m, sl 2 sts pwise wyf, turn—5 right sleeve sts rem.

SHORT-ROW 3: (RS) K2tog, sl m, work 12 (13, 14, 16, 17, 19, 20, 22) back sts, wrap next st and turn piece with WS facing; (WS) work to sleeve m, sl m, sl 2 sts pwise wyf, turn piece with RS facing—4 right sleeve sts rem.

SHORT-ROW 4: (RS) K2tog, sl m, work 11 (12, 13, 15, 16, 18, 19, 20) back sts, wrap next st and turn piece with WS facing; (WS) work to sleeve m, sl m, sl 2 sts pwise wyf, turn—3 right sleeve sts rem.

Shape top of left back sleeve cap and neck using short-rows as foll:

SHORT-ROW 5: (RS) K2tog, sl m, work to next sleeve m hiding wraps as they appear, sl m, ssk, turn piece with WS facing; (WS) sl 1 pwise wyf, sl m, work 13 (14, 15, 17, 18, 20, 21, 23) back sts, wrap next st and turn piece with RS facing—2 right sleeve sts rem; 9 left sleeve sts rem.

SHORT-ROW 6: (RS) Work to sleeve m, sl m, ssk, turn piece with WS facing; (WS) sl 1 pwise wyf, sl m, work 12 (13, 14, 16, 17, 19, 20, 22) back sts, wrap next st and turn piece with RS facing—8 left sleeve sts rem.

SHORT-ROW 7: (RS) Work to sleeve m, sl m, ssk, turn piece with WS facing; (WS) sl 1 pwise wyf, sl m, work 11 (12, 13, 15, 16, 18, 19, 20) back sts, wrap next st and turn piece with RS facing—7 left sleeve sts rem.

Shape top of left front sleeve cap using short-rows as foll:

SHORT-ROW 8: (RS) Work to sleeve m, remove m, ssk, work to 2 sts before next sleeve m, k2tog, sl m, work to end—5 left sleeve sts rem

SHORT-ROW 9: (WS) Work to sleeve m, sl m, sl 2 sts pwise wyf, turn piece with RS facing; (RS) k2tog, sl m, work to end—1 left sleeve st dec'd.

Rep last short-row 2 times—2 left sleeve sts rem.

NEXT ROW: (WS) Work to sleeve m, remove m, sl 2 sleeve sts pwise wyf, sl m, work 10 (11, 12, 14, 15, 17, 18, 20) sts, BO center 24 sts for back neck hiding wraps as they appear and removing m for back panel, work to next m, remove m, sl 2 sleeve sts

pwise wyf, work to end—31 (33, 35, 39, 41, 45, 47, 51) sts rem for each side.

Join Shoulders

Keeping yarn attached at right front edge, sl 9 sts at each front edge onto holders or waste yarn. Divide rem 22 (24, 26, 30, 32, 36, 38, 42) sts for each shoulder evenly onto 2 larger dpns—11 (12, 13, 15, 16, 18, 19, 21) sts on each needle; 1 sleeve st and 10 (11, 12, 14, 15, 17, 18, 20) shoulder sts. Hold needles parallel so that RS face tog. Join yarn and use three-needle method (see Glossary) to BO sts tog.

Rep shoulder join with rem sts for left shoulder.

Finishing

JOIN UNDERARM STS: With WS facing, remove waste yarn from held underarm sts and place body and sleeve sts onto separate dpns, pick up 1 st in gap between sts at each end of dpns. Hold needles parallel so that RS face tog. Join yarn and use three-needle method to BO sts tog. Rep for second underarm.

Block to measurements.

Hood

Return 9 held right front sts to cir needle and knit across, pick up and knit 7 sts along neck edge to basketweave patt, pm, pick up and knit 18 sts across basketweave patt, pm, pick up and knit 7 sts along neck edge to held left front sts, return 9 held left front sts to left needle tip and knit across—50 sts.

SET-UP ROW: (WS) Work in St st to m, sl m, work in basketweave patt aligning patt with patt on body, sl m, work to end in St st.

Cont even until piece meas 1" (2.5 cm) from pick-up row, ending with a WS row.

Shape hood

INC ROW: (RS) K2, LLI, knit to 1 st before m, RLI, k1, sl m, work to next m, sl m, k1, LLI, knit to last 2 sts, RLI, k2—4 sts inc'd.

Work 5 rows even.

Rep Inc row every 6 rows 4 times—70 sts.

Shape back of hood with short-rows as foll:

SHORT-ROW 1: (RS) Work 34 sts, sl m, k1, wrap next st and turn piece with WS facing, work p1, sl m, work to next m, sl m, p1, wrap next st and turn piece with RS facing.

SHORT-ROW 2: (RS) Work to wrapped st, knit wrap together with the st it wraps, k4, wrap next st and turn piece with WS facing; work to wrapped st, purl wrap together with the st it wraps, p4, wrap next st and turn piece with RS facing.

Rep last short-row 3 more times.

NEXT 2 ROWS: Work to wrapped st, work wrap together with the st it wraps, work to end.

DEC ROW: (RS) Knit to 2 sts before m, ssk, sl m, work to next m, sl m, k2tog, knit to end—2 sts dec'd.

Work 1 WS row even as est.

Rep the last 2 rows 3 times—62 sts rem; 18 sts in the center; 22 sts to each side.

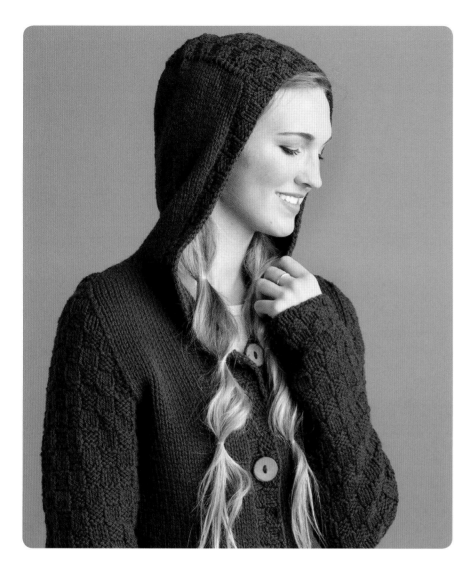

Buttonband

Note: *When picking up sts for the buttonband, align basketweave patt on band with the existing pocket and hood basketweave patt. It may be necessary to adjust the stitch counts picked up by 3 stitches more or less to maintain the stitch patterns on your sweater. See the Tip Box for the Vortex Pullover for more info.*

With circular needle and RS facing, beg at lower right front edge and picking up sts through both layers of fabric over the pockets, pick up and knit 37 sts evenly along right front pocket, 98 (98, 101, 101, 101, 104, 104, 104) sts along right front edge to held hood sts, place 20 held sts onto left needle tip and work across in est patt, pick up and knit 98 (98, 101, 101, 101, 104, 104, 104) sts along hood and body to pocket, then 37 sts along pocket to lower left front edge—290 (290, 296, 296, 296, 302, 302, 302) sts.

Work Rows 2–4 of basketweave patt.

NEXT (BUTTONHOLE) ROW: (RS) Working Row 5 of patt as est, work 6 sts, work one-row buttonhole (see Glossary) over 3 sts, *work in est patt until there are 15 sts on right needle tip after buttonhole, work one-row buttonhole over 3 sts; rep from * 3 times, work to end.

Work 2 more rows in est patt.

BO all sts in patt.

Sew buttons opposite buttonholes.

Weave in loose ends.

Shape top of hood with short-rows as foll:

SHORT-ROW 1: (RS) Knit to first m, sl m, work to second m, sl m, k2tog, turn (do not wrap) piece with WS facing; slip 1 st pwise wyf, sl m, work to next m, sl m, ssp, turn (do not wrap) piece with RS facing—1 st dec'd on each side of hood.

SHORT-ROW 2: (RS) Sl 1 st pwise wyb, sl m, work to m, sl m, k2tog, turn (do not wrap) piece with WS facing; slip 1 st pwise wyf, sl m, work to m, sl m, ssp, turn (do not wrap) piece with RS facing—1 st dec'd on each side of hood.

Rep last short-row 19 times—20 sts rem; 18 center panel sts and 1 st on each side.

Slip all sts onto holder. Break yarn and set aside.

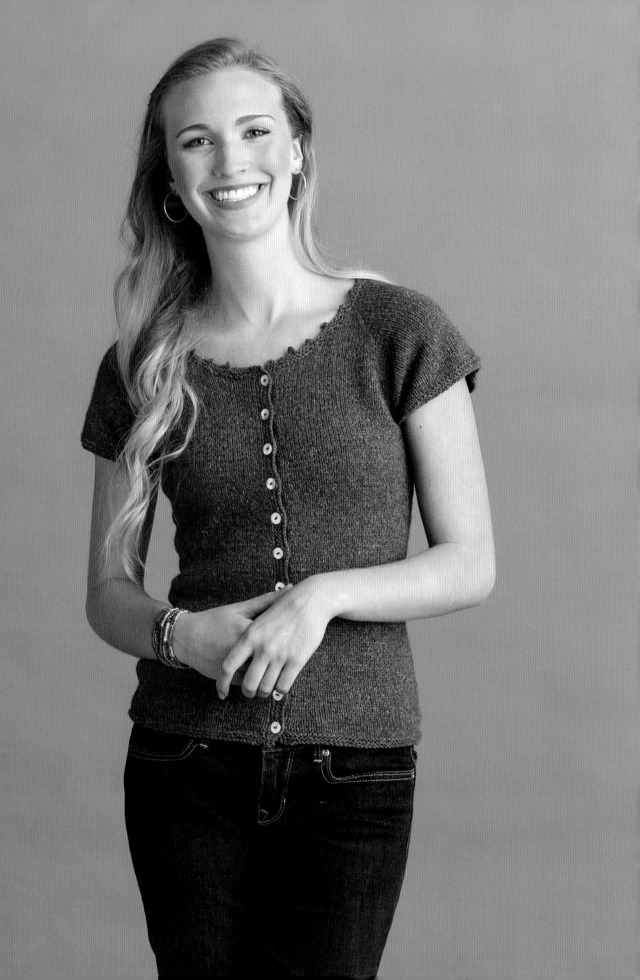

Lace

Chapter 3 features lacy stitch patterns. Lace can be a beautiful addition to a sweater's texture. A panel of lace can be added among a background of stockinette stitch, or a multiple of lace repeats can be worked as trim or even over the entirety of a sweater.

Whenever I use lace as an allover texture I let the lace take center stage and construct the sweater with minimal shaping.

Chapter 3 includes the Sensual Open Cardigan with lace edging; the Sensible Cardigan with a single panel of lace along the center back; and three sweaters with allover lace: The Enchanted Cardigan has a boxy shape, with all shaping occurring over the same number of stitches as the lace pattern to always keep the stitch pattern whole; the Moonlight Pullover and Wonder Tank have some shaping in the lace, but it's not done with increases or decreases. Instead you'll change the needle size, keeping the lace pattern repeats whole throughout all the shaping! Nice and easy!

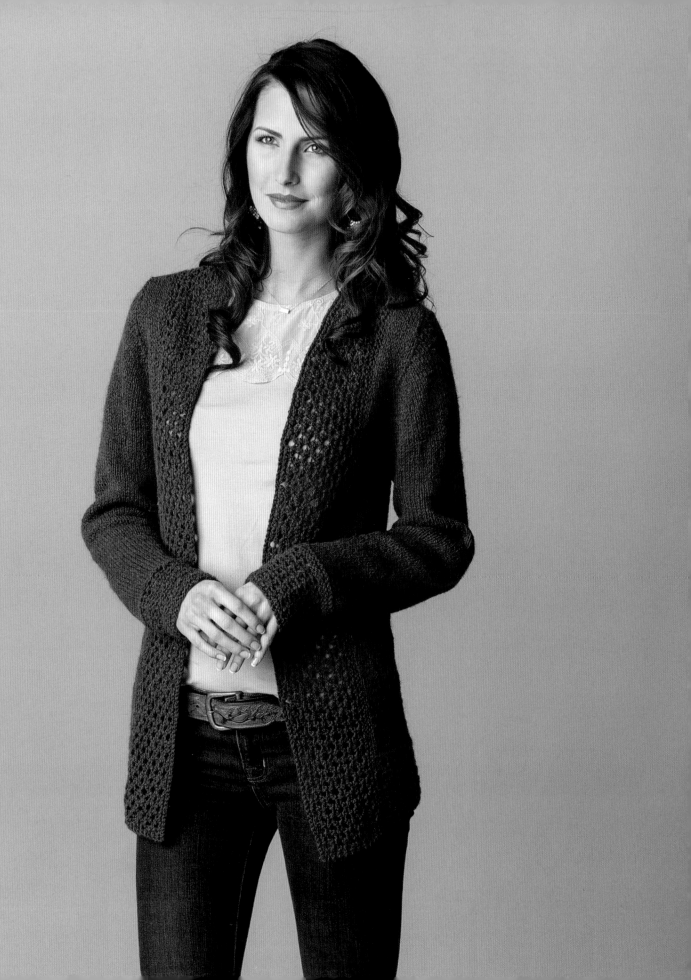

Sensual
OPEN CARDIGAN

The Sensual Open Cardigan is a great business-casual sweater, and it's really fun to knit. The body and sleeves are knit separately from the bottom up. They are joined at the underarms, and the yoke is worked with set-in sleeve shaping, decreasing stitches on the back and fronts first for the armholes, then decreasing sleeve stitches to the shoulders. The tops of the sleeves and shoulders are shaped with a few short-rows and are then joined with the three-needle bind-off. The collar stitches are picked up along the center front and back neck and worked in the lace pattern.

Finished Size
About 32 (35¾, 39½, 43½, 47¼, 51, 54¾)" (81.5 [91, 100.5, 110.5, 120, 129.5, 139] cm) bust circumference and 25¼ (25½, 25¾, 26¼, 26½, 26¾, 27¼)" (64 [65, 65.5, 66.5, 67.5, 68, 69] cm) long.

Cardigan shown measures 35¾" (91 cm).

Yarn
Worsted weight (#4 medium).

Shown here: Quince & Co., Owl (50% American wool, 50% American alpaca; 120 yd [110 m]/50 g): #314 rosebay, 9 (10, 10, 11, 13, 14, 15) skeins.

Needles
Size U.S. 8 (5 mm): 32" (80 cm) circular (cir) needle and set of 5 double-pointed (dpn). *Adjust needle size if necessary to obtain the correct gauge.*

Notions
Markers (m); holders or waste yarn; tapestry needle.

Gauge
17 sts and 24 rows/rnds = 4" (10 cm) in St st; 18 sts and 25 rows/rnds = 4" (10 cm) in lace patt.

{ The Joy of Lifelines }

Lifelines are like insurance. They're something you place ahead of time, so if a terribly confusing mistake occurs farther down the road, it's easy to fix. You can rip back to the lifeline and place the held stitches onto the knitting needle to continue. If there is no lifeline, it may be a bit of a headache to tink back to the mistake or to ravel down a few rows in the lace.

When working in an allover lace pattern, it's wise to place a lifeline every few inches (centimeters). To place a lifeline, thread a piece of smooth waste yarn onto a tapestry needle. Draw the tapestry needle through all the live stitches on the needle, keeping the stitches on the knitting needle. Continue knitting, being careful not to split the waste yarn as you work into the stitches. After another few inches (centimeters) have been worked, place another lifeline. If you feel confident about the work you did between the two lifelines, remove the first one, leaving just one lifeline in the project at a time.

Stitch Guide
Lace Pattern Worked in Rounds (multiple of 4 sts)

RND 1: K2, k2tog, [yo] twice, *ssk, k2tog, [yo] twice; rep from * to last 4 sts, ssk, k2.

RND 2: P4, p1-tbl, *p3, p1-tbl; rep from * to last 3 sts, p3.

RND 3: K2, yo, ssk, k2tog, *[yo] twice, ssk, k2tog; rep from * to last 2 sts, yo, k2.

RND 4: P5, *p1, p1-tbl, p2; rep from * to last 3 sts, p3.

Rep Rnds 1–4 for patt.

Lace Pattern Worked Back and Forth (multiple of 4 sts)

ROW 1: (RS) K2, k2tog, [yo] twice, *ssk, k2tog, [yo] twice; rep from * to last 4 sts, ssk, k2.

ROW 2: (WS) K3, *k1, k1-tbl, k2; rep from * to last st, k1.

ROW 3: K2, yo, ssk, k2tog, *[yo] twice, ssk, k2tog; rep from * to last 2 sts, yo, k2.

ROW 4: K3, *k3, k1-tbl; rep from * to last 5 sts, k5.

Rep Rows 1–4 for patt.

Notes

Circular needle is used to accommodate large number of sts. Do not join; work back and forth in rows.

Because there are separate sections for some sizes, and the placement of each size may be different in relationship to the (), I suggest using a pencil to circle the size that you are making throughout the pattern before you begin to knit.

Sleeves

With dpns and using the long-tail method (see Glossary), CO 40 (40, 40, 40, 44, 44, 44) sts. Divide sts evenly over 4 dpn. Place marker (pm) and join for working in rnds so purl ridge is on the RS (see Glossary).

Knit 1 rnd.

Purl 1 rnd.

Work in lace patt worked in rnds until piece meas 4" (10 cm) from beg, ending with an even-numbered rnd.

Knit 1 rnd. Purl 1 rnd.

Cont in St st (knit every rnd) until piece meas 5" (12.5 cm) from beg.

Shape Sleeve

INC RND: K1, RLI (see Glossary), knit to last st, LLI (see Glossary), k1—2 sts inc'd.

Knit 8 (6, 5, 4, 4, 3, 3) rnds.

Rep the last 9 (7, 6, 5, 5, 4, 4) rnds 6 (8, 10, 12, 12, 14, 16) times—54 (58, 62, 66, 70, 74, 78) sts.

Cont even until piece meas 18" (45.5 cm) from beg.

Divide for Underarms

NEXT RND: K2 (2, 3, 3, 4, 4, 5), slip the last 4 (4, 6, 6, 8, 8, 10) sts onto holder or waste yarn for underarm, knit to end—50 (54, 56, 60, 62, 66, 68) sts rem. Slip rem sts onto separate st holder or waste yarn for sleeve. Break yarn and set aside.

Make a second sleeve the same as the first.

Body

With longer cir and using the long-tail method, CO 96 (112, 128, 144, 160, 176, 192) sts. Do not join; work back and forth in rows.

Knit 2 rows, ending with a WS row.

Work in lace patt worked back and forth until piece meas 4" (10 cm) from beg, ending with a WS row.

Knit 2 rows, ending with a WS row.

Cont in St st (knit RS rows, purl WS rows) until piece meas 5" (12.5 cm) from beg, ending with a RS row.

NEXT ROW: (WS) P14 (18, 22, 26, 30, 34, 38), pm, p68 (76, 84, 92, 100, 108, 116), pm, purl to end.

Shape Waist

DEC ROW: (RS) *Knit to 3 sts before m, ssk, k1, sl m, k1, k2tog; rep from * once more, knit to end—4 sts dec'd.

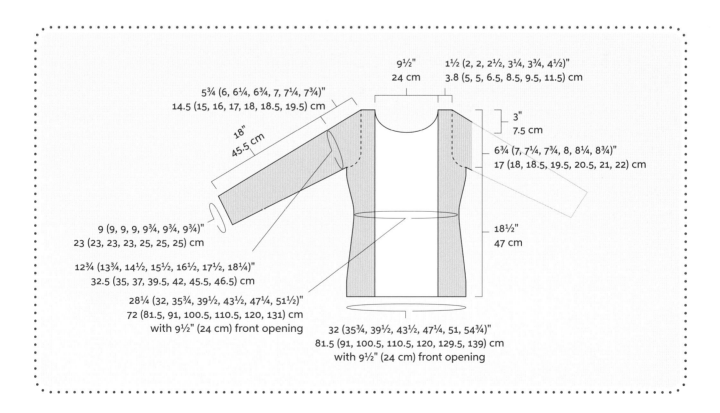

9½"
24 cm

1½ (2, 2, 2½, 3¼, 3¾, 4½)"
3.8 (5, 5, 6.5, 8.5, 9.5, 11.5) cm

5¾ (6, 6¼, 6¾, 7, 7¼, 7¾)"
14.5 (15, 16, 17, 18, 18.5, 19.5) cm

18"
45.5 cm

3"
7.5 cm

6¾ (7, 7¼, 7¾, 8, 8¼, 8¾)"
17 (18, 18.5, 19.5, 20.5, 21, 22) cm

9 (9, 9, 9, 9¾, 9¾, 9¾)"
23 (23, 23, 23, 25, 25, 25) cm

18½"
47 cm

12¾ (13¾, 14½, 15½, 16½, 17½, 18¼)"
32.5 (35, 37, 39.5, 42, 45.5, 46.5) cm

28¼ (32, 35¾, 39½, 43½, 47¼, 51½)"
72 (81.5, 91, 100.5, 110.5, 120, 131) cm
with 9½" (24 cm) front opening

32 (35¾, 39½, 43½, 47¼, 51, 54¾)"
81.5 (91, 100.5, 110.5, 120, 129.5, 139) cm
with 9½" (24 cm) front opening

Work 7 rows even, ending with a WS row.

Rep the last 8 rows 3 times—80 (96, 112, 128, 144, 160, 176) sts rem.

INC ROW: (RS) *Knit to 1 st before m, LLI (see Glossary), k1, sl m, k1, RLI (see Glossary); rep from * once more, knit to end—4 sts inc'd.

Work 7 rows even, ending with a WS row.

Rep the last 8 rows 3 times —96 (112, 128, 144, 160, 176, 192) sts.

Cont even until piece meas 18½" (47 cm) from beg, ending with a WS row.

Divide for Underarm

NEXT ROW: (RS) *Knit to side m, remove m, k2 (2, 3, 3, 4, 4, 5), place the last 4 (4, 6, 6, 8, 8, 10) sts onto holder or waste yarn for underarm; rep from * once more, knit to end— 12 (16, 19, 23, 26, 30, 33) sts for each front, and 64 (72, 78, 86, 92, 100, 106) sts for back.

Yoke

NEXT (JOINING) ROW: (WS) Using yarn and needle that are attached to the body, k12 (16, 19, 23, 26, 30, 33) left front sts, pm, place held 50 (54, 56, 60, 62, 66, 68) sts for one sleeve onto empty needle and knit, pm, k64 (72, 78, 86, 92, 100, 106) back sts, pm, place held 50 (54, 56, 60, 62, 66, 68) sts for second sleeve onto empty needle and knit, pm, k12 (16, 19, 23, 26, 30, 33) right front sts—188 (212, 228, 252, 268, 292, 308) sts.

Shape Armholes

DEC ROW: (RS) *Knit to 3 sts before m, ssk, k1, sl m, knit to next m, sl m, k1,

Lace Pattern Worked Back and Forth

Lace Pattern Worked in Rounds

4-st rep

k on RS; p on WS

p on RS; k on WS

k2tog

yo

sk

p1-tbl on RS, k1-tbl on WS

pattern repeat

k2tog; rep from * once more, knit to end—4 sts dec'd (1 st on each front, and 2 sts on back).

DEC ROW: (WS) *Purl to 3 sts before m, p2tog, p1, sl m, purl to next m, sl m, p1, ssp; rep from * once more, purl to end—4 sts dec'd (1 st on each front, and 2 sts on back).

Rep the last 2 rows 2 (3, 4, 5, 5, 6, 6) times—164 (180, 188, 204, 220, 236, 252) sts rem; 6 (8, 9, 11, 14, 16, 19) sts for each front, 50 (54, 56, 60, 62, 66, 68) sts for each sleeve, and 52 (56, 58, 62, 68, 72, 78) sts for back.

Shape Sleeve Caps

DEC ROW: (RS) *Knit to m, sl m, k1, k2tog, knit to 3 sts before next m, ssk, k1, sl m; rep from * once more, knit to end—4 sts dec'd (2 sts on each sleeve).

Purl 1 WS row even.

Rep the last 2 rows 7 (5, 4, 2, 3, 1, 2) time(s)—132 (156, 168, 192, 204, 228, 240) sts rem; 6 (8, 9, 11, 14, 16, 19) sts for each front, 34 (42, 46, 54, 54, 62, 62) sts for each sleeve, and 52 (56, 58, 62, 68, 72, 78) sts for back.

Sizes 35¾ (39½, 43½, 47¼, 51, 54¾)" only:

DEC ROW: (RS) *Knit to next m, sl m, k1, k2tog, knit to 3 sts before next m, ssk, k1, sl m; rep from * once more, knit to end—4 sts dec'd (2 sts on each sleeve).

DEC ROW: (WS) *Purl to next m, sl m, p1, ssp, purl to 3 sts before next m, p2tog, p1, sl m; rep from * once more, knit to end—4 sts dec'd (2 sts on each sleeve).

Rep the last 2 rows 1 (2, 4, 4, 6, 6) time(s)—140 (144, 152, 164, 172, 184) sts rem; 8 (9, 11, 14, 16, 19) sts for each front, 34 sts for each sleeve, and 56 (58, 62, 68, 72, 78) sts for back.

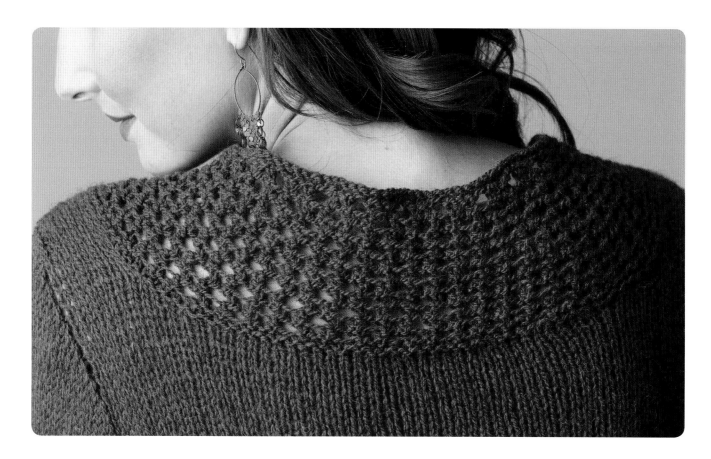

All sizes:
Shape Sleeve Cap and Back Neck

DEC ROW: (RS) Knit to next m, sl m, k1, k2tog, knit to 3 sts before next m, ssk, k1, sl m, k11 (13, 14, 16, 19, 21, 24), join a second ball of yarn and BO next 30 sts, knit to next m, sl m, k1, k2tog, knit to 3 sts before next m, ssk, k1, sl m, knit to end—49 (53, 55, 59, 65, 69, 75) sts rem for each side; 6 (8, 9, 11, 14, 16, 19) sts for each front, 32 sts for each sleeve, and 11 (13, 14, 16, 19, 21, 24) sts for each back.

Cont working both sides at the same time, using separate balls of yarn.

DEC ROW: (WS) Purl to m, sl m, p1, ssp, purl to 3 sts before next m, p2tog, p1, sl m, purl to neck edge; on other side, BO 3 sts, purl to m, sl m, p1, ssp, purl to 3 sts before next m, p2tog, p1, sl m, purl to end—7 sts dec'd.

DEC ROW: (RS) Knit to next m, sl m, k1, k2tog, knit to 3 sts before next m, ssk, k1, sl m, knit to neck edge; on other side, BO 3 sts, knit to next m, sl m, k1, k2tog, knit to 3 sts before next m, ssk, k1, sl m, knit to end—42 (46, 48, 52, 58, 62, 68) sts rem for each side; 6 (8, 9, 11, 14, 16, 19) sts for each front, 28 sts for each sleeve, 8 (10, 11, 13, 16, 18, 21) sts for each back.

DEC ROW: (WS) Purl to next m, sl m, p1, ssp, purl to 3 sts before next m, p2tog, p1, sl m, purl to neck edge; on other side, BO 2 sts, purl to next m, sl m, p1, ssp, purl to 3 sts before next m, p2tog, p1, sl m, purl to end—6 sts dec'd.

DEC ROW: (RS) Knit to next m, sl m, k1, k2tog, knit to 3 sts before next m, ssk, k1, sl m, knit to neck edge; on other side, BO 2 sts, knit to next m, sl m, k1, k2tog, knit to 3 sts before next m, ssk, k1, sl m, knit to end—36 (40, 42, 46, 52, 56, 62) sts rem for each side; 6 (8, 9, 11, 14, 16, 19) sts each for front and back, and 24 sts for each sleeve.

Shape Sleeve Caps

DEC ROW: (WS) Purl to m, sl m, p1, ssp, purl to 3 sts before next m, p2tog, p1, sl m, purl to neck edge; on other side, purl to m, sl m, p1, ssp, purl to 3 sts before next m, p2tog, p1, sl m, purl to end—4 sts dec'd (2 sts on each sleeve).

DEC ROW: (RS) Knit to m, sl m, k1, k2tog, knit to 3 sts before next m, ssk, k1, sl m, knit to neck edge; on other side, knit to m, sl m, k1, k2tog, knit to 3 sts before next m, ssk, k1, sl m, knit to end—4 sts dec'd (2 sts on each sleeve).

Rep the last 2 rows 2 times, then work WS Dec row once more—22 (26, 28, 32, 38, 42, 48) sts rem for each side; 6 (8, 9, 11, 14, 16, 19) sts each for front and back, and 10 sts for each sleeve.

Shape top of right front sleeve cap with short-rows as foll:

SHORT-ROW 1 (SEE GLOSSARY): With RS facing, knit to first m, sl m, ssk, turn piece with WS facing, sl 1 pwise wyf, sl m, purl to end—1 st dec'd.

Rep the last short-row 2 times—7 sts rem for right sleeve.

Shape top of right back sleeve cap using short-rows as foll:

DEC ROW: (RS) Knit to first m, remove m, ssk, knit to 2 sts before next m, k2tog, sl m, work to neck edge, turn piece with WS facing—5 sts rem for right sleeve.

SHORT-ROW 2: Purl to m, sl m, sl 2 sts pwise wyf, turn piece with RS facing, k2tog, sl m, knit to neck edge, turn piece with RS facing—1 st dec'd.

Rep the last short-row 2 times; do not turn after the last row—2 sts rem for right sleeve.

Shape top of left back sleeve cap using short-rows as foll:

SHORT-ROW 3: With RS facing and working on other side of neck edge, knit to m, sl m, ssk, turn piece with WS facing, sl 1 pwise wyf, sl m, purl to neck edge—1 st dec'd.

Rep the last short-row 2 times—7 sts rem for left sleeve.

Shape top of left front sleeve cap using short-rows as foll:

DEC ROW: (RS) Knit to m, remove m, ssk, knit to 2 sts before next m, k2tog, sl m, work to end, turn piece with WS facing—5 sts rem for left sleeve.

SHORT-ROW 4: Purl to m, sl m, sl 2 sts pwise wyf, turn piece with RS facing, k2tog, sl m, knit to end, turn piece with WS facing—1 st dec'd.

Rep the last short-row 2 times—14 (18, 20, 24, 30, 34, 40) sts rem for each side; 6 (8, 9, 11, 14, 16, 19) sts each for front and back, and 2 sts for each sleeve.

NEXT ROW: (WS) Purl to m, remove m, sl 2 sts pwise wyf, purl to neck edge; on other side, purl to m, remove m, sl 2 sts pwise wyf, purl to end.

JOIN SHOULDERS: Divide sts for each shoulder in half onto 2 larger dpn—7 (9, 10, 12, 15, 17, 20) sts on each dpn. Hold the needles parallel with RS facing tog and use the three-needle method (see Glossary) to BO sts tog.

Finishing

JOIN UNDERARMS: Slip held underarm sts onto dpns, picking up 1 additional st at each end of each needle—6 (6, 8, 8, 10, 10, 12) sts on each dpn. Hold the needles parallel with RS facing tog and use the three-needle method to BO sts tog. Rep for second underarm.

Block to measurements.

FRONT TRIM: With cir needle and RS facing, beg at lower edge of right front, pick up and knit 117 (119, 121, 123, 123, 125, 127) sts along right front to shoulder, 74 sts along back neck to left shoulder, then 117 (119, 121, 123, 123, 125, 127) sts along left front to bottom edge—308 (312, 316, 320, 320, 324, 328) sts.

Knit 3 rows, ending with a WS row.

Work in lace patt worked back and forth until piece meas 4" (10 cm) from pick-up row, ending with a RS row.

Knit 2 rows.

BO all sts kwise.

Weave in loose ends.

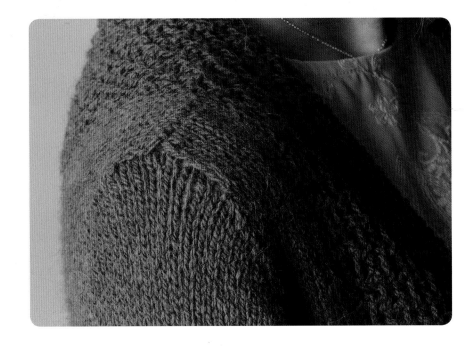

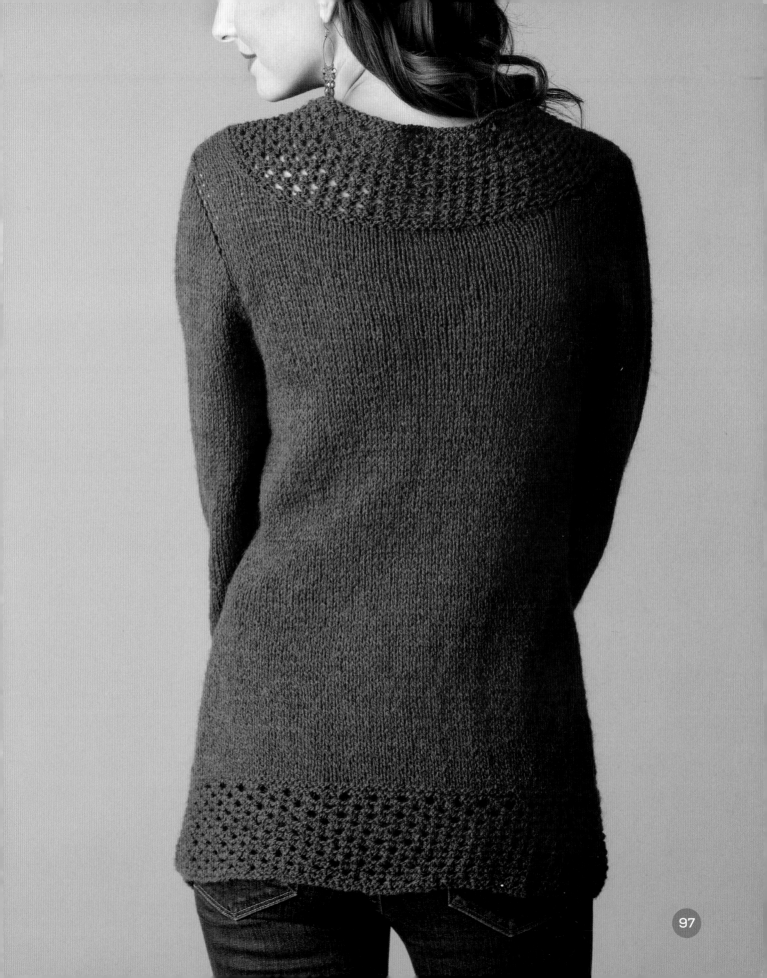

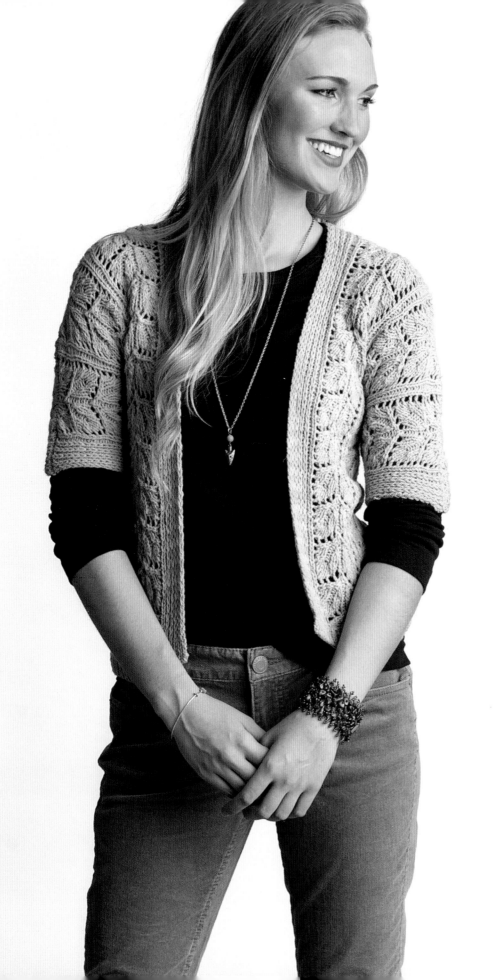

Enchanted
CARDIGAN

Beginning with a tubular cast-on at the lower edge creates a smooth and integrated edge for the ribbing. The body of Enchanted Cardigan is knit in one piece from the lower edge to the underarm. Stitches are cast on for the sleeves in the stitch multiple for the lace leaf pattern, so it's easy to maintain the pattern. The tops of the sleeves are joined front to back using a three-needle bind-off.

Techniques
. .
Tubular cast-on
Three-needle bind-off
Casting on stitches mid-row
Lace
Using a stitch holder
or waste yarn
Picking up stitches

Finished Size
About 26 (32½, 39, 45¾, 52¼, 58¾)" (66 [82.5, 99, 116, 132.5, 149] cm) bust circumference with 4¼" (11 cm) front opening and 21 (21½, 22, 22¾, 23½, 24¼)" (53.5 [54.5, 56, 58, 59.5, 61.5] cm) long.

Cardigan shown measures 32¾" (83 cm).

Yarn
DK weight (#3 Light).

Shown here: Bijou Basin Ranch, Bijou Bliss (50% pure yak, 50% American Cormo wool; 150 yd [137 m]/56 g): sky, 4 (5, 6, 7, 8, 9) skeins.

Needles
Size U.S. 6 (4 mm): two 32" (80 cm) circular (cir) needles. *Adjust needle size if necessary to obtain the correct gauge.*

Notions
Markers (m); holders or waste yarn; waste yarn for tubular CO; tapestry needle.

Gauge
16 sts (1 patt rep) = 3¼" [8.5 cm] and 22½ rows = 4" (10 cm) in lace leaf pattern.

{ Shaping Lace }

One of the challenging parts of working in lace patterns can be the shaping. When working in a stitch pattern that includes both increases and decreases for shaping, it can be difficult to maintain the correct stitch count if the increases and decreases worked at the side edges cut into the lace pattern. It's also not the most aesthetically pleasing way to shape lace.

When designing lace patterns, I keep in mind how the piece is going to be shaped and try to maintain the pattern repeat while working the shaping This saves the headache of trying to maintain the stitch count while adding or subtracting stitches along the edges. There are a few different ways that I like to do this.

The first is to design a boxy-shaped sweater, allowing the texture of the lacy fabric to take center stage and letting the shape of the sweater take the backseat. The Enchanted Cardigan is an example of this. The body is knit straight up from the cast-on edge to the sleeves without shaping. When the sleeves are cast on, the total stitch count of the leaf lace pattern remains a multiple of 16 stitches + 1, the same stitch count worked on the body. These sleeves could easily be lengthened or shortened by adding or subtracting multiples of 16 stitches when casting on the sleeve stitches.

Another way to shape in lace is to change the needle size, instead of the stitch count, to create curves. In the Majestic Pullover, the lace and cable pattern near the waist is knit on the smallest size needles for a tighter fabric and a narrower waist. As the pattern progresses toward the hip, larger needles are used to widen the lower edge. The larger needles also provide a more open stitch pattern and a more flowing drape.

Stitch Guide

Slipped Rib Pattern:
(multiple of 2 sts + 1)
ROW 1: (RS) Sl 1 pwise wyb, *p1, sl 1 pwise wyb; rep from *.

ROW 2: P1, *k1, p1; rep from *.

Rep Rows 1–2 for patt.

Lace Leaf Pattern:
(multiple of 16 sts + 1)
ROW 1: (RS) P1, *k1, yo, ssk, k1, [p1, k2] twice, p1, k1, k2tog, yo, k1, p1; rep from *.

ROW 2: K1, *p4, [k1, p2] twice, k1, p4, k1; rep from *.

ROW 3: P1, *[k1, yo] twice, ssk, p1, k2tog, p1, ssk, p1, k2tog, [yo, k1] twice, p1; rep from *.

ROW 4: K1, *p5, [k1, p1] twice, k1, p5, k1; rep from *.

ROW 5: P1, *k1, yo, k3, yo, sssk, p1, k3tog, yo, k3, yo, k1, p1; rep from *.

ROW 6: K1, *p7, k1; rep from *.

ROW 7: P1, *k1, yo, k5, yo, sssk, yo, k5, yo, k1, p1; rep from *—multiple of 18 sts + 1.

ROW 8: K1, *p17, k1; rep from *.

ROW 9: P1, *k1, yo, k1, ssk, p1, k2tog, k1, p1, k1, ssk, p1, k2tog, k1, yo, k1, p1; rep from *—multiple of 16 sts + 1.

ROW 10: Rep Row 2.

Rep Rows 1–10 for patt.

Note: *Circular needle is used to accommodate large number of stitches. Do not join; work back and forth in rows.*

Body

Using the tubular method (see Glossary), CO 115 (147, 179, 211, 243, 275) sts. Do not join; work back and forth in rows.

SET-UP ROW: (RS) Sl 1 purlwise with yarn in back (pwise wyb), *p1, k1; rep from *.

NEXT ROW: (WS) Sl 1 pwise with yarn in front (wyf), *k1, p1; rep from *.

Cont in est patt until piece meas 1" (2.5 cm) from beg, ending with a WS row.

EST PATT: (RS) Work Row 1 of slipped rib patt over 9 sts, place marker (pm), work Row 1 of lace leaf patt to last 9 sts, pm, work Row 1 of slipped rib patt over rem 9 sts.

Cont in est patt until piece meas 15½" (39.5 cm) from beg, ending with a WS row on Row 2, 4, or 10 of lace leaf patt.

Right Front
Divide Right Front

NEXT ROW: (RS) Work slipped rib patt to m, sl m, work 16 (24, 32, 40, 48, 56) sts in lace leaf patt, work into the next st but keep the st on the left needle (it is used for both the right front and the back), place that st and the rem 89 (113, 137, 161, 185, 209) sts onto holder or waste yarn for back and left front—26 (34, 42, 50, 58, 66) sts rem for right front. Cont on right front sts only as follows:

Shape Sleeve

Turn piece with WS facing and using the cable method (see Glossary), CO 25 (33, 25, 33, 25, 33) sts—51 (67, 67, 83, 83, 99) sts.

NEXT ROW: (WS) Work Row 2 of slipped rib patt over 9 sts, pm, work next row of lace leaf patt to next m, sl m, work Row 2 of slipped rib patt over rem 9 sts.

Cont in est patt until piece meas 5½ (6, 6½, 7¼, 8, 8¾)" (14 [15, 16.5, 18.5, 20.5, 22] cm) from sleeve CO, ending with a WS row on Row 2, 4, 6, or 10 of lace leaf patt. (Take note of the last row of lace leaf patt worked.)

Place sts onto holder or waste yarn. Break yarn and set aside.

Back

Return 65 (81, 97, 113, 129, 145) held sts from center of body onto cir needle for back. Keep the last st from the back on the holder with the rem 25 (33, 41, 49, 57, 65) sts for left front (this stitch is worked for the back and left front). With RS facing, beg at the right sleeve cuff, pick up and knit 25

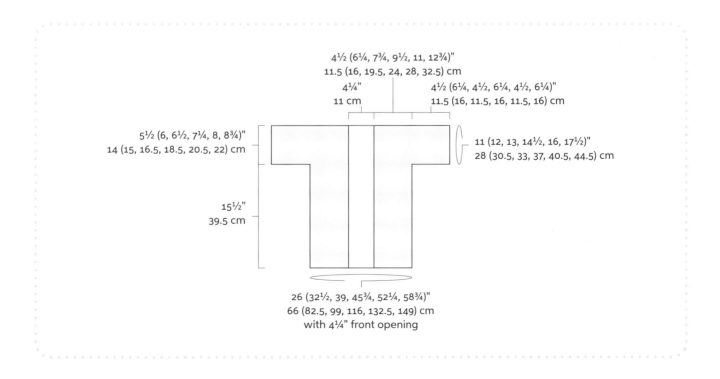

4½ (6¼, 7¾, 9½, 11, 12¾)"
11.5 (16, 19.5, 24, 28, 32.5) cm

4¼"
11 cm

4½ (6¼, 4½, 6¼, 4½, 6¼)"
11.5 (16, 11.5, 16, 11.5, 16) cm

5½ (6, 6½, 7¼, 8, 8¾)"
14 (15, 16.5, 18.5, 20.5, 22) cm

11 (12, 13, 14½, 16, 17½)"
28 (30.5, 33, 37, 40.5, 44.5) cm

15½"
39.5 cm

26 (32½, 39, 45¾, 52¼, 58¾)"
66 (82.5, 99, 116, 132.5, 149) cm
with 4¼" front opening

(33, 25, 33, 25, 33) sts evenly along CO edge of right sleeve (1 st in each CO st), work in est patt across back sts (including the last-back/first-left-front stitch), turn piece with WS facing, and using cable method, CO 25 (33, 25, 33, 25, 33) sts for left sleeve—115 (147, 147, 179, 179, 211) sts.

NEXT ROW: (WS) Work Row 2 of slipped rib patt over 9 sts, pm, work next row of lace leaf patt to last 9 sts, pm, work Row 2 of slipped rib patt over rem 9 sts.

Cont in est patt until piece meas 3½ (4, 4½, 5¼, 6, 6¾)" (9 [10, 11.5, 13.5, 15, 17] cm) from sleeve CO, ending with a WS row on Row 2, 4, 6, or 10 of lace leaf patt.

EST NECK PATT: (RS) Work in slipped rib patt to m, sl m, work 33 (49, 49, 65, 65, 81) sts in lace leaf patt, pm, work slipped rib patt over next 31 sts, pm, work 33 (49, 49, 65, 65, 81) sts in lace leaf patt to m, sl m, work in slipped rib patt to end.

Cont in est patt until piece meas 5½ (6, 6½, 7¼, 8, 8¾)" (14 [15, 16.5, 18.5, 20.5, 22] cm) from sleeve CO, ending with same WS row of lace leaf patt as right front

Place sts onto holder or waste yarn. Break yarn and set aside.

Left Front

Return held 26 (34, 42, 50, 58, 66) left front sts to cir needle. With RS facing, beg at left sleeve cuff, pick up and knit 25 (33, 25, 33, 25, 33) sts evenly along CO edge of sleeve (1 st in each

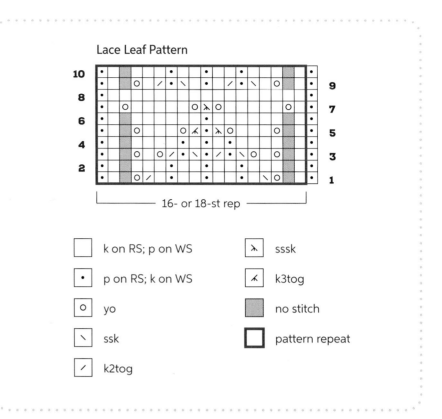

Lace Leaf Pattern

16- or 18-st rep

	k on RS; p on WS
::	::
•	p on RS; k on WS
O	yo
\	ssk
/	k2tog

⅄	sssk
::	::
⅄	k3tog
▨	no stitch
☐	pattern repeat

CO st), then work across left front sts in est patt—51 (67, 67, 83, 83, 99) sts.

NEXT ROW: (WS) Work Row 2 of slipped rib patt to m, sl m, work next row of lace leaf patt to last 9 sts, pm, work Row 2 of slipped rib patt over rem 9 sts.

Cont in est patt until piece meas 5½ (6, 6½, 7¼, 8, 8¾)" (14 [15, 16.5, 18.5, 20.5, 22] cm) from sleeve CO, ending with same WS row of lace leaf patt as right front.

Join Shoulders

Place held 51 (67, 67, 83, 83, 99) right front sts onto same cir needle as left

front, then place back sts onto a second cir needle. Hold needles parallel with RS of knitting facing tog and use the three-needle method (see Glossary) to BO left front and back sts tog, BO 13 back sts until there are 51 (67, 67, 83, 83, 99) sts rem for both back and right front, then use the three-needle method to BO right front and back sts tog.

Finishing

Weave in loose ends. Block to measurements.

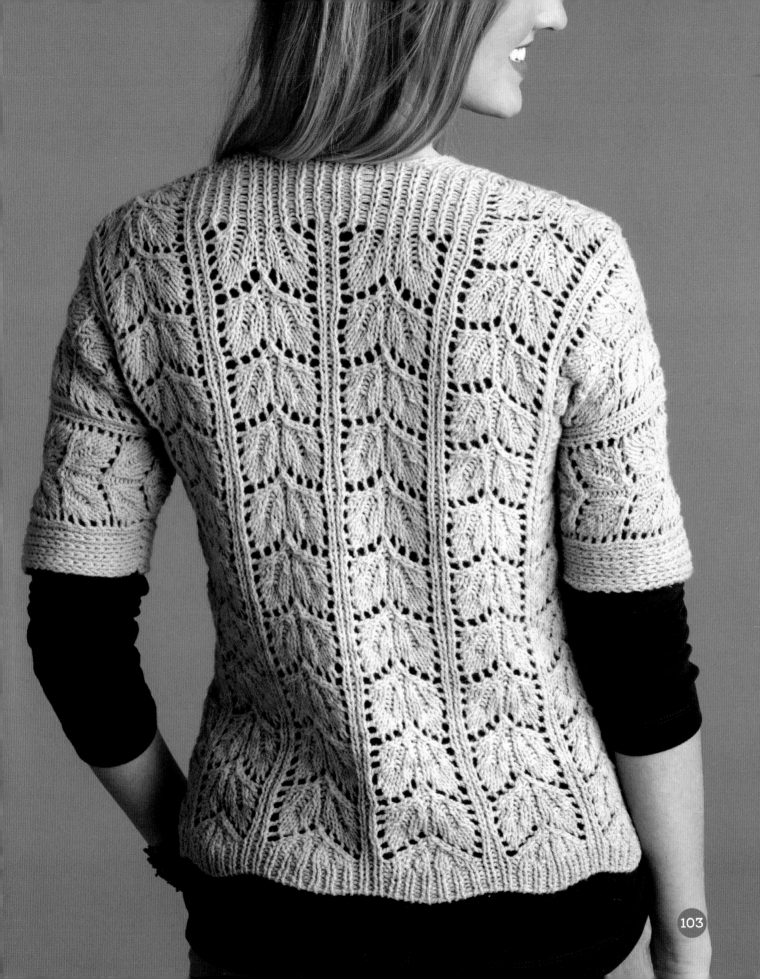

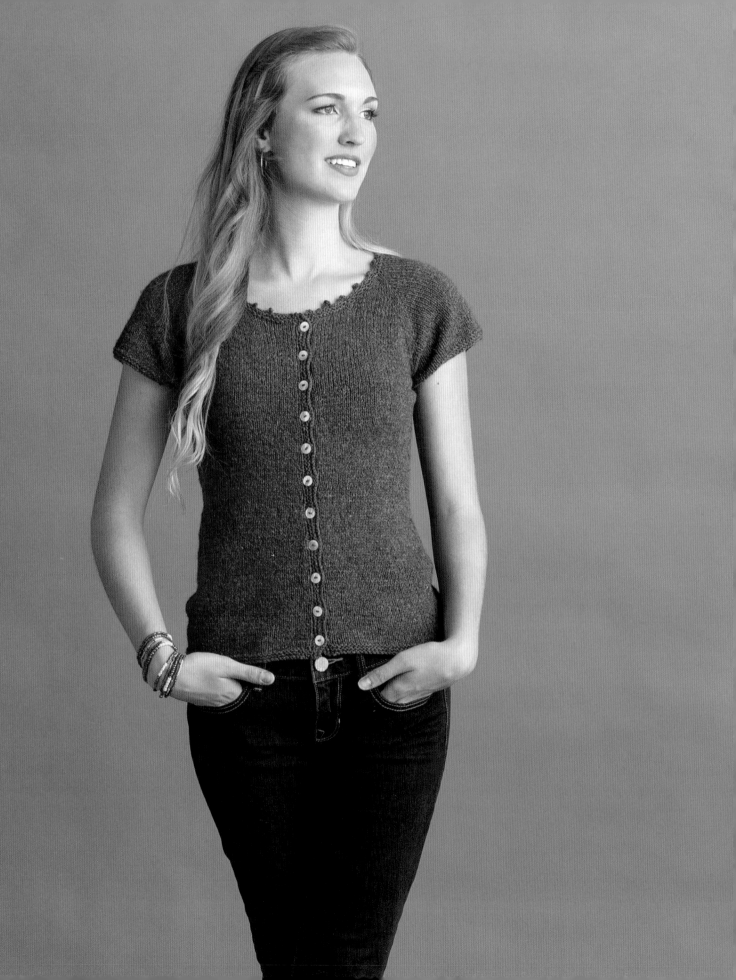

Sensible CARDIGAN

The Sensible Cardigan is knit from the top down, which means it's easy to try on and customize. An elegant lace pattern flows down the back of the sweater, and the rest is knitted in stockinette stitch. Keep your sleeves short, as shown here, or add some length (see page 54). Or if you're busty, this sweater is a great template for adding some bust dart shaping (see page 112), to be sure it's a perfect fit!

Techniques

Circular knitting with dpns
Buttonholes
Lace
Multiple stitch patterns
at the same time
Casting on stitches mid-row
Using a stitch holder
or waste yarn
Picking up stitches

Finished Size

About 29 (32¾, 36½, 40¼, 44¼, 48, 51¾, 55½, 59¼)" (73.5 [83, 92.5, 102, 112, 122.5, 131.5, 141, 150.5] cm) with ¾" (2 cm) over-lapping buttonband and 21½ (22¼, 23, 23¾, 24, 25, 25¼, 26, 26¼)" (54.5 [56.5, 58.5, 60.5, 61, 63.5, 64, 66, 66.5] cm) long.

Cardigan shown measures size 32¾ (83 cm).

Yarn

DK weight (#3 Light).

Shown here: Bijou Basin Ranch, Himalayan Trail (75% pure yak, 25% merino; (200 yd [183 m]/ 56 g]): natural brown, 3 (3, 4, 4, 5, 5, 6, 6, 7) skeins.

Needles

Size U.S. 2 (2.75 mm): 16" (40 cm) circular (cir) needle and set of 4 or 5 double-pointed (dpn).

Size U.S. 3 (3.25 mm): 32" (80 cm) circular (cir) needle and set of 4 or 5 double-pointed (dpn).

Adjust needle size if necessary to obtain the correct gauge.

Notions

Markers (m); holders or waste yarn; tapestry needle; eleven ¼" (6 mm) buttons.

Gauge

21 sts and 33 rnds = 4" (10 cm) in St st with larger needles; 19 sts in lace panel = 3" (7.5 cm) with larger needles.

Stitch Guide

Lace Panel:
(panel of 19 sts)

ROWS 1, 3, AND 5: (RS) P1, k2tog, yo, k1, yo, ssk, k7, k2tog, yo, k1, yo, ssk, p1.

ROW 2 AND ALL WS ROWS: K1, p17, k1.

ROW 7: P1, k2, yo, k1, yo, ssk, k2, s2kp, k2, k2tog, yo, k1, yo, k2, p1.

ROW 9: P1, k3, yo, k1, yo, ssk, k1, s2kp, k1, k2tog, yo, k1, yo, k3, p1.

ROW 11: P1, k4, yo, k1, yo, ssk, s2kp, k2tog, yo, k1, yo, k4, p1.

ROW 12: Rep Row 2.

Rep Rows 1–12 for patt.

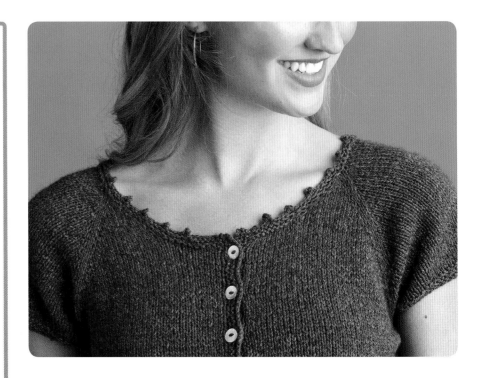

Notes

Sweater is worked from the top down.

Because there are separate sections for some sizes, and the placement of each size may be different in relationship to the (), I suggest using a pencil to circle the size you are making throughout the pattern before you begin to knit.

Yoke

Using larger cir needle, CO 85 (85, 87, 87, 87, 89, 93, 95, 95) sts. Do not join; work back and forth in rows.

SET-UP ROW: (WS) P2 for front, place marker (pm) for raglan, p21 (20, 21, 20, 19, 20, 21, 22, 21) for sleeve, pm for raglan, p10 (11, 11, 12, 13, 13, 14, 14, 15), pm for lace panel, k1, p17, k1, pm for lace panel, p10 (11, 11, 12, 13, 13, 14, 14, 15), pm for raglan, p21 (20, 21, 20, 19, 20, 21, 22, 21) for sleeve, pm for raglan, p2 for front.

Shape Raglan

Sizes 32¾ (36½, 40¼, 44¼, 48, 51¾, 55½, 59¼)" only:

INC BODY AND SLEEVES: (RS) [Work in St st to 1 st before m, M1, k1, sl m, k1, M1] twice, work in St st to lace panel m, sl m, work lace panel to next m, sl m, [work in St st to 1 st before next m, M1, k1, sl m, k1, M1] twice, work in St st to end—8 sts inc'd.

INC BODY AND SLEEVES: (WS) [Work in St st to 1 st before m, M1P, p1, sl m, p1, M1P] twice, work in St st to lace panel m, sl m, work lace panel to next m, sl m, [work in St st to 1 st before next m, M1P, p1, sl m, p1, M1P] twice, work in St st to end—8 sts inc'd.

Rep the last 2 rows 0 (1, 1, 2, 2, 3, 3, 4) time(s)—101 (119, 119, 135, 137, 157, 159, 175) sts; 4 (6, 6, 8, 8, 10, 10, 12) sts for each front, 24 (29, 28, 31, 32, 37, 38, 41) sts for each sleeve and 45 (49, 51, 57, 57, 63, 63, 69) sts for back.

Sizes 29 (32¾)" only:

INC BODY AND SLEEVES: (RS) [Work in St st to 1 st before m, M1, k1, sl m, k1, M1] twice, work in St st to lace panel m, sl m, work lace panel to next m, sl m, [work in St st to 1 st before next m, M1, k1, sl m, k1, M1] twice, work in St st to end—8 sts inc'd.

INC SLEEVES: (WS) Work in St st to m, sl m, p1, M1P, work in St st to 1 st before m, M1P, p1, sl m, work in St st to lace panel m, sl m, work lace panel

to next m, sl m, work in St st to next m, sl m, p1, M1P, work in St st to 1 st before m, M1P, p1, sl m, work in St st to end—4 sts inc'd (2 sts each sleeve).

Rep the last 2 rows 1 (0) time(s)—109 (113) sts; 4 (5) sts for each front, 29 (28) sts for each sleeve, and 43 (47) sts for back.

Sizes 36½ (40¼, 44¼, 48, 51¾, 55½, 59¼)" only:

INC BODY AND SLEEVES: (RS) [Work in St st to 1 st before m, M1, k1, sl m, k1, M1] twice, work in St st to next m, sl m, work lace panel to next m, sl m, [work in St st to 1 st before next m, M1, k1, sl m, k1, M1] twice, work in St st to end—8 sts inc'd.

INC BODY: (WS) Work in St st to 1 st before m, M1P, p1, sl m, work in St st to next m, sl m, p1, M1P, work in St st to lace panel m, sl m, work lace panel to next m, sl m, work in St st to 1 st before next m, M1P, p1, sl m, work in St st to next m, sl m, p1, M1P, work in St st to end—4 sts inc'd; 1 st for each front, and 2 sts for back.

Rep the last 2 rows 1 (2, 3, 6, 8, 11, 12) time(s)—143 (155, 183, 221, 265, 303, 331) sts; 10 (12, 16, 22, 28, 34, 38) sts for each front, 33 (34, 39, 46, 55, 62, 67) sts for each sleeve, and 57 (63, 73, 85, 99, 111, 121) sts for back.

All sizes:
Shape Raglan and Neck

INC NECK, BODY, AND SLEEVES: (RS) K1, M1, [work in St st to 1 st before m, M1, k1, sl m, k1, M1] twice, work in St st to next m, sl m, work lace panel to next m, sl m, [work in St st to 1 st before next m, M1, k1, sl m, k1, M1] twice, work in St st to last st, M1, k1—10 sts inc'd.

NEXT ROW: (RS) Work in St st to lace panel m, sl m, work lace panel to next m, sl m, work in St st to end.

Rep the last 2 rows 3 (4, 4, 5, 5, 5, 4, 4, 3) times—149 (163, 193, 215, 243, 281, 315, 353, 371) sts; 12 (15, 20, 24, 28, 34, 38, 44, 46) sts for each front, 37 (38, 43, 46, 51, 58, 65, 72, 75) sts for each sleeve, and 51 (57, 67, 75, 85, 97, 109, 121, 129) sts for back.

CAST-ON FOR NECK, INC BODY, AND SLEEVES: With WS facing, using the cable method (see Glossary), CO 10 (10, 10, 10, 11, 11, 13, 13, 15) sts. Turn piece with RS facing, [work in St st to 1 st before m, M1, k1, sl m, k1, M1] twice, work in St st to next m, sl m, work lace panel to next m, sl m, [work in St st to 1 st before next m, M1, k1, sl m, k1, M1] twice, work in St st to end, CO 10 (10, 10, 10, 11, 11, 13, 13, 15) sts—177 (191, 221, 243, 273, 311, 349, 387, 409) sts; 23 (26, 31, 35, 40, 46, 52, 58, 62) sts for each front, 39 (40, 45, 48, 53, 60, 67, 74, 77) sts for each sleeve, and 53 (59, 69, 77, 87, 99, 111, 123, 131) sts for back.

NEXT ROW: (WS) Work in St st to lace panel m, sl m, work lace panel to next m, sl m, work in St st to end.

29 (32¾, 36½, 40¼, 44¼, 48, 51¾, 55½, 59¼)"
73.5 (83, 92.5, 102, 112.5, 122, 131.5, 141, 150.5) cm
with ¾" (2 cm) opening for buttonband

24¼ (28¼, 32, 35¾, 39½, 43¼, 47¼, 51, 54¾)"
61.5 (71.5, 81.5, 91, 100.5, 110, 120, 129.5, 139) cm
with ¾" (2 cm) opening for buttonband

15 (15, 15½, 15½, 15½, 16, 16, 16½, 16½)"
38 (38, 39.5, 39.5, 39.5, 40.5, 40.5, 42, 42) cm

12½ (13¼, 14¼, 15¼, 16¼, 17¼, 18, 19, 20)"
32 (33.5, 36, 38.5, 41.5, 44, 45.5, 48.5, 51) cm

4½ (5¼, 5½, 6¼, 6¾, 7, 7¼, 7½, 7¾)"
11.5 (13.5, 14, 16, 17, 18, 18.5, 19, 19.5) cm

2 (2, 2, 1¾, 2, 2, 2, 2)"
5 (5, 5, 5, 4.5, 5, 5, 5, 5) cm

6¾ (7¼, 7¼, 7½, 8, 8, 8¼, 8¼, 8¾)"
17 (18.5, 18.5, 19, 20.5, 20.5, 21, 21, 22) cm

Shape Raglan

INC BODY AND SLEEVES: (RS) [Work in St st to 1 st before m, M1, k1, sl m, k1, M1] twice, work in St st to lace panel m, sl m, work lace panel to next m, sl m, [work in St st to 1 st before next m, M1, k1, sl m, k1, M1] twice, work in St st to end—8 sts inc'd.

NEXT ROW: (WS) Work even in est patt.

Rep the last 2 rows 10 (12, 11, 12, 12, 10, 9, 7, 8) times—265 (295, 317, 347, 377, 399, 429, 451, 481) sts; 34 (39, 43, 48, 53, 57, 62, 66, 71) sts for each front, 61 (66, 69, 74, 79, 82, 87, 90, 95) sts for each sleeve, and 75 (85, 93, 103, 113, 121, 131, 139, 149) sts for back.

DIVIDE SLEEVES FROM BODY: (RS) *Work in est patt to raglan m, remove m, slip 61 (66, 69, 74, 79, 82, 87, 90, 95) sleeve sts onto holder or waste yarn, remove marker, use the backward-loop method and CO 2 (2, 3, 3, 3, 4, 4, 5, 5) sts, pm for side, CO 2 (2, 3, 3, 3, 4, 4, 5, 5) sts; rep from * once more, work to end—151 (171, 191, 211, 231, 251, 271, 291, 311) sts.

Body

Cont even in est patt until piece meas 1 (1, 1, 1, 1, ½, ½, ½, ½)" (2.5 [2.5, 2.5, 2.5, 2.5, 1.3, 1.3, 1.3, 1.3] cm) from divide, ending with a WS row.

Shape Waist

DEC ROW: (RS) *Work in est patt to 3 sts before side m, ssk, k1, sl m, k1, k2tog; rep from * once more, work to end as est—4 sts dec'd.

Work 5 (5, 5, 5, 5, 7, 7, 7, 7) rows even as est.

Rep the last 6 (6, 6, 6, 6, 8, 8, 8, 8) rows 5 times—127 (147, 167, 187, 207, 227, 247, 267, 287) sts rem.

Work even until piece meas 6½ (6½, 7, 7, 7, 7¼, 7¼, 7½, 7½)" [16.5 (16.5,

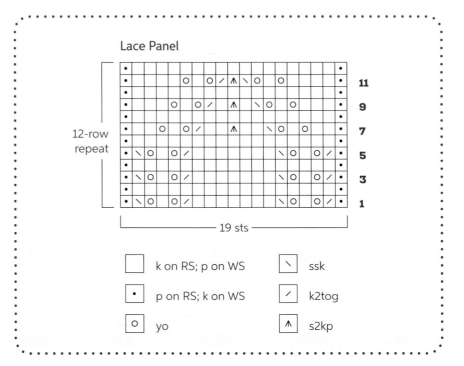

Lace Panel

12-row repeat

19 sts

☐ k on RS; p on WS

• p on RS; k on WS

○ yo

╲ ssk

╱ k2tog

⋀ s2pk

(rows labeled 11, 9, 7, 5, 3, 1)

18, 18, 18, 18.5, 18.5, 19, 19) cm] from divide, ending with a WS row.

INC ROW: (RS) *Work in est patt to 1 st before side m, M1, k1, sl m, k1, M1; rep from * once more, work to end as est—4 sts inc'd.

Work 7 (7, 7, 7, 9, 9, 9, 9) rows even as est.

Rep the last 8 (8, 8, 8, 8, 10, 10, 10, 10) rows 5 times—151 (171, 191, 211, 231, 251, 271, 291, 311) sts.

Cont even until piece meas 14½ (14½, 15, 15, 15, 15½, 15½, 16, 16)" (37 [37, 38, 38, 38, 39.5, 39.5, 40.5, 40.5] cm) from divide, ending with a RS row.

Change to smaller cir needle.

Knit 4 rows, ending with a WS row. BO all sts kwise.

Sleeves

Place held 61 (66, 69, 74, 79, 82, 87, 90, 95) sts from one sleeve onto larger dpn. With RS facing, beg at center

of underarm, pick up and knit 3 (3, 4, 4, 4, 5, 5, 6, 6) sts along CO edge, knit held sts, then pick up and knit 3 (3, 4, 4, 4, 5, 5, 6, 6) sts along rem CO edge—67 (72, 77, 82, 87, 92, 97, 102, 107) sts. Divide sts evenly over 3 or 4 dpn. Pm and join for working in rnds.

DEC RND: K2 (2, 3, 3, 3, 4, 4, 5, 5), k2tog, knit to last 4 (4, 5, 5, 5, 6, 6, 7, 7) sts, ssk, knit to end—65 (70, 75, 80, 85, 90, 95, 100, 105) sts rem.

Cont even in St st until piece meas 1" (2.5 cm) from pick-up rnd.

Change to smaller dpns.

[Purl 1 rnd. Knit 1 rnd.] twice.

BO all sts pwise.

Work second sleeve same as first.

Finishing

Block piece to measurements.

NECK TRIM: With smaller cir needle and RS facing, beg at right front

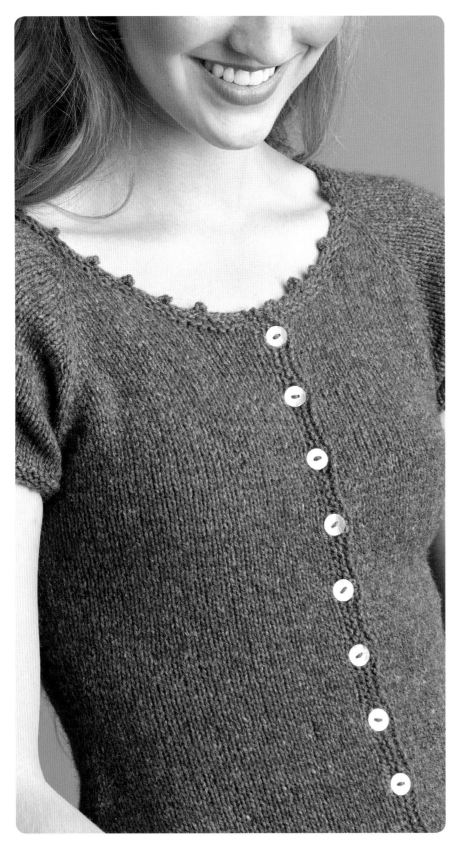

neck edge, pick up and knit 10 (10, 10, 10, 11, 11, 13, 13, 15) sts along front neck CO sts, 12 (12, 13, 15, 18, 19, 24, 26, 28) sts along right front edge, 85 (85, 87, 87, 87, 89, 93, 95, 95) sts along back and sleeve CO sts, 12 (12, 13, 15, 18, 19, 24, 26, 28) sts along left front edge, then 10 (10, 10, 10, 11, 11, 13, 13, 15) sts along left front neck CO sts—129 (129, 133, 137, 145, 149, 167, 173, 181) sts.

Knit 3 rows, ending with a WS row.

PICOT BO: BO 6 (6, 5, 7, 5, 7, 7, 7, 5) sts, *sl 1 st from right needle to left, use the cable method to CO 2 sts, BO 6 sts; rep from * to last 1 (1, 0, 2, 0, 2, 2, 2, 0) st(s), BO rem sts.

BUTTONBAND: With smaller cir needle and RS facing, beg at neck trim edge of left front, pick up and knit 108 (112, 114, 116, 116, 116, 114, 114, 116) sts evenly along left front edge. Knit 4 rows, ending with a RS row. BO all sts kwise.

BUTTONHOLE BAND: With smaller cir needle and RS facing, beg at lower edge of right front, pick up and knit 108 (112, 114, 116, 116, 116, 114, 114, 116) sts evenly along right front edge. Knit 1 WS row.

BUTTONHOLE ROW: (RS) K2 (4, 5, 6, 6, 6, 5, 5, 6), work one-row buttonhole (see Glossary) over next 3 sts, *knit until 7 sts are on right needle past buttonhole, work one-row button-hole over next 3 sts; rep from * to last 2 (4, 5, 6, 6, 6, 5, 5, 6) sts, knit to end.

Knit 2 rows. BO all sts kwise.

Sew buttons to buttonband opposite buttonholes.

Weave in loose ends.

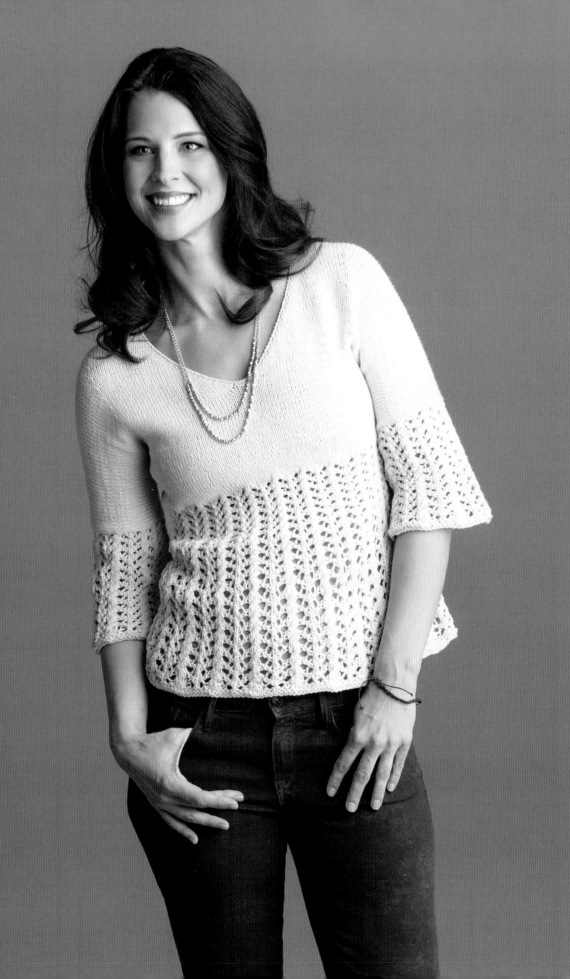

Moonlight
PULLOVER

Knit from the top down, Moonlight can be tried on as it's being knit and customized to fit you! Just after joining the underside of the sleeves with a three-needle bind-off, pop it on over your head to be sure it's comfortable. If you need a little more wiggle room, undo the three-needle bind-off and add some more length equally to the back and front. If you're a particularly busty gal, consider adding some short-rows for the bust (see page 112), beginning about 1" (2.5 cm) after joining the sleeves together. The length of the lace on the body and sleeves can also be adjusted to suit the vision you have for your sweater.

Techniques
.
Shoulder short-rows (optional)
Picking up stitches
Three-needle bind-off

Finished Size
About 31¼ (34¼, 37½, 40½, 43¾, 46¾, 50, 53, 56¼)" (79.5 [87, 95.5, 103, 111, 118.5, 127, 134.5, 143] cm) bust circumference and 20¼ (21, 21¾, 22¼, 23, 23¾, 24½, 25, 25½)" (51.5 [53.5, 55, 56.5, 58.5, 60.5, 62, 63.5, 65] cm) long.

Pullover shown measures 34¼" (87 cm).

Yarn
Sport weight (#2 Fine).

Shown here: Classic Elite Yarns, Canyon (85% pima cotton, 15% alpaca, 150 yd [137 m]/50 g): #3716 milkweed, 7 (7, 8, 8, 9, 10, 11, 11, 12) skeins.

Needles
Size U.S. 3 (3.25 mm): two 32" (80 cm) circular (cir) needle and set of 4 or 5 double-pointed (dpn).

Sizes U.S. 5 and 7 (3.75 and 4.5 mm): one each 32" (80 cm) circular (cir) needle and set of 4 or 5 double-pointed (dpn).

Adjust needle sizes if necessary to obtain the correct gauge.

Notions
Markers (m); holders or waste yarn; cable needle (cn); tapestry needle.

Gauge
23 sts and 31 rows/rnds = 4" (10 cm) in St st on smallest needle; 18 sts (2 pattern reps) = 3" (7.5 cm) in lace patt on smallest needle; 18 sts (2 pattern reps) = 3¾" (9.5 cm) in lace patt on largest needle.

{ Shape Bust Darts with Short-rows }

Bust shape is unique to each individual body shape. So, rather than give generic instructions for each size, I'm including instructions for you to customize the sweater to fit *you!*

It's commonly said that anyone with a cup size smaller than C does not need to add bust darts to her sweater. But don't let that stop you! No matter what size your cups are, if you've ever thought that a little extra shaping might be nice, I suggest giving this a try. I'll give my own measurements as an example.

Materials

Measuring tape; waste yarn; pencil; paper; and perhaps a friend.

Measure your back

Doing this yourself may be tricky, but it is possible. If you have a friend handy, though, ask for her help. Tie a piece of waste yarn around your waist. This will give you a consistent point to measure to. Place one end of the measuring tape at your shoulder and measure from the top of your shoulder to the yarn at your waist. If you have a friend helping, measure down your back for the most accurate measurement. If you're doing this by yourself, it may be easier to measure along the side of your body, in the front of your arm, beside your breast. Write down this measurement. My back measures 17½" (44.5 cm).

Measure your front

Hold one end of the measuring tape at your shoulder and measure over the highest part of your breast down to the yarn at your waist. Write down this measurement. My front measures 20½" (52 cm).

Determine how many short-rows are needed

Determine the difference between the back and front measurements.

The front will measure more than the back, so subtract the back measurement from the front to get the difference.

FOR EXAMPLE:
Front meas: 20½" (52 cm) minus back meas: 17½" (44.5 cm) = 3" (7.5 cm) difference.

The result is how much more fabric you need to add to the front of the sweater.

Next, figure out how many extra rows you'll need add to match this measurement.

Multiply the above number (3") by the number of rows per inch your pattern uses. The Moonlight Pullover uses 7¾ rows per inch: 7¾ × 3" = 23 rows.

This needs to be an even number, so round it to the nearest even number, if necessary. I could round my number up to 24 or down to 22. I'll make note of that and determine which one to use after I see how many stitches I have available to use.

Determine where to work the short-rows

In order to work the short-rows at the sides of the breast, and avoid any points in unsightly places, let's measure!

Measure horizontally across from the apex of one breast to the apex of the other. I measure 8" (20.5 cm). Add 2" (5 cm) to this measurement so it's 1" (2.5 cm) wider on each side. I have 10" (25.5 cm) here.

How many stitches is that?

The finished measurement of the sample garment is 36" (91.5 cm), and there are 99 stitches across the front half of the sweater: 198 sts total, divided by 2 to determine how many are in the front = 99.

Based on the stitch gauge, determine how many stitches are at the center and on each side. The stitch gauge for the Moonlight Pullover is 5½ stitches per inch. Multiply the gauge by the measurement from apex to apex (10" [25.5 cm]) to get the number of center stitches. I get 55 stitches:

5½ × 10" = 55. If your total number of stitches above is even, this number needs to be even, too; if your number above is odd, this number needs to be odd. Add one stitch, if necessary, to make them both even or both odd.

Subtract the number of center stitches from the total front stitches, then divide that number by two to determine how many stitches remain to either side.

In this example, 99 total stitches - 55 center stitches = 44 remaining stitches. 44 ÷ 2 = 22 stitches on each side.

I have 22 stitches on each side of the center available to use. Now I can decide whether to use 22 or 24 rows. I'll choose 22 because working 22 short-rows with 22 stitches available for wraps and turns makes things really easy!

When the number of stitches and rows match, then you can work 1 stitch in between each wrap and turn on each side. There is 1 wrap for each row, so I will have 11 wraps on each side.

If you have more rows than you have stitches

If you have more rows than you have stitches, some of your wraps will need to be right beside each other.

For example, say you have 22 rows and 18 stitches. Some of the wraps will have 1 stitch between them, and some will be right beside each other. Here is how to figure out how many of each:

Divide the number of rows in half. This tells you how many wraps will be worked on each side: 22 ÷ 2 = 11.

· Subtract the number of wraps on each side from the number of stitches: 18 stitches - 11 wraps = 7.

This tells you that 7 of the wraps will be worked with 1 knit stitch between them, and the rest of the wraps will be worked side-by-side.

Double-check it!

Before you start knitting, double-check your figures.

The number of wraps with 1 knit stitch between them is ___ (7) times.

Multiply that by 2 stitches (1 wrapped and 1 knit) uses a total of ___ (14) stitches.

There are ___ (11) wraps needed total, and ___ (7) used, so there are ___ (4) remaining.

These ___ (4) wraps are all worked right beside each other and use a total of ___ (4) stitches.

___ (14) stitches + ___ (4) stitches = ___ (18) stitches.

Does it work?

I often find that when it doesn't work for me it's because I've got the numbers backward; in this example, working the wraps with the knit stitch between them 4 times and the wraps right beside each other 7 times would result in only 15 stitches.

If you have more stitches than you have rows

If you have more stitches than you have rows, you have two options.

You could work some wraps with 1 knit stitch between them and some wraps with 2 stitches between them. Here's how to figure out how many of each.

For example, say you have 22 rows and 24 stitches.

Subtract the number of rows from the number of stitches: 24 stitches - 22 rows = 2.

This tells you to work the wraps with 2 stitches between them 2 times and the remaining 9 wraps with 1 stitch between them.

Be sure to double-check your work before starting to knit! Each wrap plus 2 stitches between them = 3 stitches, and each wrap plus 1 stitch between them = 2 stitches.

Two instances of wraps with 2 stitches between them (3 sts) + 9 instances of wraps with 1 stitch between them (2 sts) = 24 stitches! Yay! Phew.

Or, you could simplify it dramatically and knit (without wrapping) the stitches at the edges of the row so you're working over the same number of stitches as rows.

Now, we knit!

For my example of 22 sts and 22 rows, this is how I worked it on the sample:

Top Down

The Moonlight Pullover is worked from the top down. Work the short-rows after about 1" (2.5 cm) has been worked from the underarms. Beg the short-rows by working the shortest row, then make each following row longer than the previous row.

SHORT-ROW 1: (RS) Knit to last 22 sts, wrap next st and turn piece with WS facing; purl to last 22 sts, wrap next st and turn piece with RS facing.

SHORT-ROW 2: (RS) Knit to wrapped st, knit into wrapped st hiding the wrap, k1, wrap next st and turn piece with WS facing; purl to wrapped st, purl into wrapped st hiding the wrap, p1, wrap next st and turn piece with WS facing.

Rep the last short-row 9 more times (for a total of 11 short-rows that each consist of 2 rows).

NEXT ROW: (RS) Knit to end, hiding the wrap as it appears.

Work next full row or round, hiding the remaining wraps as they appear.

Bottom Up

If you're modifying a bottom-up sweater, work the short-rows when the body measures about 1" (2.5 cm) from the total measurement to the underarms.

Work the short-rows so that each row is shorter than the previous row, as follows:

SHORT-ROW 1: (RS) Knit to 1 st before m, wrap next st and turn piece with WS facing; purl to 1 st before m, wrap next st and turn piece with RS facing.

SHORT-ROW 2: (RS) Knit to 2 sts before wrapped st (this means there is 1 knit stitch between the wraps), wrap next st and turn piece with WS facing; purl to 2 sts before wrapped st, wrap next st and turn piece with RS facing.

Rep the last short-row 9 more times (for a total of 11 short-rows that each consist of 2 rows).

NEXT ROW: (RS) Knit to end, hiding wraps as they appear.

Work next full row or round, hiding the remaining wraps as they appear.

Stitch Guide

C4B (CABLE 4 BACK): Sl 2 sts onto cn and hold in back, k2, k2 from cn.

Cable and Lace Pattern:
(multiple of 9 sts)

RND 1: *Yo, ssk, k1, k2tog, yo, C4B; rep from *.

RNDS 2 AND 4: Knit.

RND 3: *K1, yo, s2kp, yo, k5; rep from *.

Rep Rnds 1–4 for patt.

Edging Pattern:
(multiple of 9 sts)

RND 1: *Yo, ssk, k1, k2tog, yo, C4B; rep from *.

RND 2: *P2, k1, p2, k4; rep from *.

RND 3: *K1, yo, s2kp, yo, k5; rep from *.

RND 4: *P5, k4; rep from *.

RND 5: *K5, C4B; rep from *.

RND 6: Purl.

Notes

Because of the loose gauge, I suggest using wooden dpns for the medium and largest sizes. The texture of the wood will help the stitches stay on the needles better than smooth metal.

Because there are separate sections for some sizes, and the placement of each size may be different in relationship to the (), I suggest using a pencil to circle the size that you are making throughout the pattern before you begin to knit.

Left Back Shoulder

With smallest cir needle, CO 52 (56, 61, 65, 70, 74, 79, 83, 88) sts. Do not join; work back and forth in rows.

OPTIONAL:
Shape Shoulder with Short-rows

SHORT-ROW 1: (WS) P4 (5, 5, 6, 6, 7, 7, 8, 8), wrap next st and turn piece with RS facing, knit to end.

SHORT-ROW 2: (RS) Purl to wrapped st from previous row, purl wrap together with the stitch it wraps, p4 (3, 5, 4, 5, 5, 7, 6, 7) more sts, wrap next st and turn piece with RS facing, knit to end.

(END OPTIONAL SHORT-ROWS)

NEXT ROW: (WS) Purl to end, hiding the wrap from the last short-row as it appears.

Shape Neck

INC ROW: (RS) Knit to last st, M1L, k1—53 (57, 62, 66, 71, 75, 80, 84, 89) sts.

Slide sts away from needle tip and keep them on the needle. Break yarn.

Right Back Shoulder

Using the same needle tip that was in the right hand when you ended the Left Back Shoulder, CO 52 (56, 61, 65, 70, 74, 79, 83, 88) sts. Do not join; work back and forth in rows.

Purl 1 WS row.

OPTIONAL:
Shape Shoulder with Short-rows

SHORT-ROW 1: (RS) K4 (5, 5, 6, 6, 7, 7, 8, 8), wrap next st and turn piece with WS facing, purl to end.

SHORT-ROW 2: (RS) K9 (9, 11, 11, 12, 13, 15, 15, 16), hiding the wrap from the previous row as it appears, wrap next st and turn piece with WS facing, purl to end.

(END OPTIONAL SHORT-ROWS)

Shape Neck

INC ROW: (RS) K1, M1R, knit to end, hiding wrap from the last short-row as it appears—53 (57, 62, 66, 71, 75, 80, 84, 89) sts.

(**Note:** Left Back Shoulder and Right Back Shoulder should be aligned on the needle so the neck edges for each shoulder are at the center. If they are not, slip one set of stitches onto a st holder or waste yarn, then return them to the needle in the correct position.)

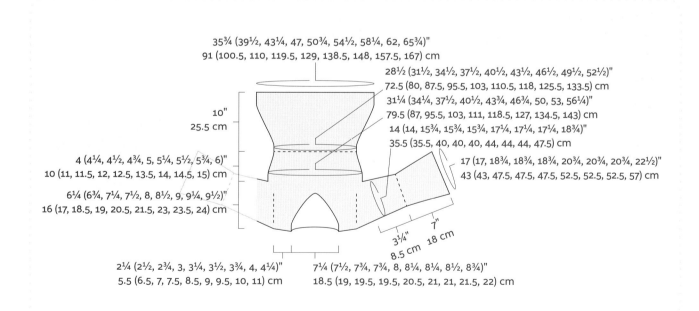

35¾ (39½, 43¼, 47, 50¾, 54½, 58¼, 62, 65¾)"
91 (100.5, 110, 119.5, 129, 138.5, 148, 157.5, 167) cm

28½ (31½, 34½, 37½, 40½, 43½, 46½, 49½, 52½)"
72.5 (80, 87.5, 95.5, 103, 110.5, 118, 125.5, 133.5) cm

31¼ (34¼, 37½, 40½, 43¾, 46¾, 50, 53, 56¼)"
79.5 (87, 95.5, 103, 111, 118.5, 127, 134.5, 143) cm

14 (14, 15¾, 15¾, 15¾, 17¼, 17¼, 17¼, 18¾)"
35.5 (35.5, 40, 40, 40, 44, 44, 44, 47.5) cm

10"
25.5 cm

4 (4¼, 4½, 4¾, 5, 5¼, 5½, 5¾, 6)"
10 (11, 11.5, 12, 12.5, 13.5, 14, 14.5, 15) cm

6¼ (6¾, 7¼, 7½, 8, 8½, 9, 9¼, 9½)"
16 (17, 18.5, 19, 20.5, 21.5, 23, 23.5, 24) cm

17 (17, 18¾, 18¾, 18¾, 20¾, 20¾, 20¾, 22½)"
43 (43, 47.5, 47.5, 47.5, 52.5, 52.5, 52.5, 57) cm

3¼"
8.5 cm

7"
18 cm

2¼ (2½, 2¾, 3, 3¼, 3½, 3¾, 4, 4¼)"
5.5 (6.5, 7, 7.5, 8.5, 9, 9.5, 10, 11) cm

7¼ (7½, 7¾, 7¾, 8, 8¼, 8¼, 8½, 8¾)"
18.5 (19, 19.5, 19.5, 20.5, 21, 21, 21.5, 22) cm

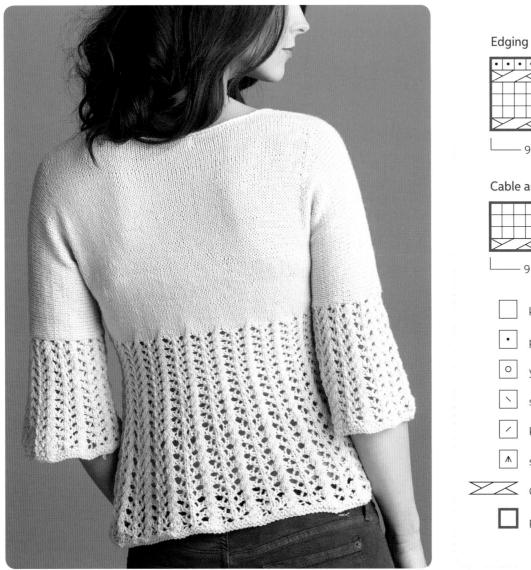

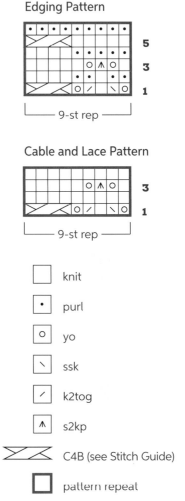

Edging Pattern

9-st rep

Cable and Lace Pattern

9-st rep

□	knit
•	purl
○	yo
\	ssk
/	k2tog
∧	s2kp
⧅	C4B (see Stitch Guide)
□	pattern repeat

Back

With WS facing, cont working on sts from right back shoulder as follows:

CAST-ON FOR NECK: (WS) Purl to last st, M1P, p1, turn piece with RS facing and use the cable method (see Glossary) to CO 38 (39, 40, 41, 42, 43, 44, 45, 46) sts for back neck, turn piece with WS facing and purl 1 left back shoulder st, M1P, purl to end—146 (155, 166, 175, 186, 195, 206, 215, 226) sts.

Work even in St st for 5 (7, 9, 11, 5, 7, 7, 9, 9) rows, ending with a RS row.

PLACE MARKERS FOR SLEEVE CAPS: (WS) P39 (42, 45, 48, 52, 54, 57, 60, 64), place marker (pm), p68 (71, 76, 79, 82, 87, 92, 95, 98), pm, p39 (42, 45, 48, 52, 54, 57, 60, 64).

Shape Sleeve Caps

DEC ROW: (RS) Knit to 2 sts before m, ssk, sl m, knit to next m, sl m, k2tog, knit to end—2 sts dec'd.

Work 3 rows even.

Rep the last 4 rows 8 (8, 9, 9, 10, 10, 11, 11, 12) times—128 (137, 146, 155, 164, 173, 182, 191, 200) sts rem; 68 (71, 76, 79, 82, 87, 92, 95, 98) sts for back, and 30 (33, 35, 38, 41, 43, 45, 48, 51) sts for each sleeve. Remove markers.

Cont even in St st until armholes meas 6¼ (6¾, 7¼, 7½, 8, 8½, 9, 9¼, 9½)" (16 [17, 18.5, 19, 20.5, 21.5, 23, 23.5, 24] cm) from CO along side edges, ending with a WS row.

Keep all sts on cir needle. Break yarn and set aside.

Left Front

With second smallest cir needle and RS facing, beg at neck edge, pick up and knit 1 st in each CO st along left back shoulder—52 (56, 61, 65, 70, 74, 79, 83, 88) sts.

PLACE MARKER FOR SLEEVE CAP: (WS) P39 (42, 45, 48, 52, 54, 57, 60, 64) sts, pm for sleeve cap, purl to end.

OPTIONAL: Shape Shoulder with Short-rows

SHORT-ROW 1: (RS) K4 (5, 5, 6, 6, 7, 7, 8, 8), wrap next st and turn piece with WS facing, purl to end.

SHORT-ROW 2: (RS) K9 (9, 11, 11, 12, 13, 15, 15, 16), hiding the wrap from the previous row as it appears, wrap next st and turn piece with WS facing, purl to end.

(END OPTIONAL SHORT-ROWS)

Work 0 (2, 6, 8, 4, 6, 8, 10, 10) rows even in St st, hiding the wrap from the previous short-row as it appears on the first row, ending with a WS row.

Sizes 31¼ (34¼, 37½, 40½, 43¾, 46¾)" only: Shape Neck

INC ROW: (RS) K1, M1R, knit to end—1 st inc'd.

Purl 1 WS row.

Rep the last 2 rows 2 (2, 1, 1, 0, 0) time(s)—55 (59, 63, 67, 71, 75) sts.

All sizes: Shape Neck and Sleeve Caps

INC NECK, DEC SLEEVE CAP: (RS) K1, M1R, knit to m, sl m, k2tog, knit to end.

Purl 1 WS row.

INC NECK: (RS) K1, M1R, knit to end—1 st inc'd.

Purl 1 WS row.

Rep the last 4 rows 8 (8, 9, 9, 10, 10, 11, 11, 11) times—64 (68, 73, 77, 82, 86, 91, 95, 100) sts; 34 (35, 38, 39, 41, 43, 46, 47, 48) sts for front, and 30 (33, 35, 38, 41, 43, 45, 48, 52) sts for sleeve.

Size 56¼" (143 cm) only:

INC NECK, DEC SLEEVE CAP: (RS) K1, M1R, knit to m, sl m, k2tog, knit to end—100 sts; 49 sts for front, and 51 sts for sleeve.

Purl 1 WS row.

All sizes:

Remove marker. Place sts onto holder or waste yarn and break yarn.

Right Front

With RS facing, pick up and knit 1 st in each CO st along right back shoulder—52 (56, 61, 65, 70, 74, 79, 83, 88) sts.

OPTIONAL: Shape Shoulder with Short-rows

SHORT-ROW 1: (WS) P4 (5, 5, 6, 6, 7, 7, 8, 8), wrap next st and turn piece with RS facing, knit to end.

SHORT-ROW 2: (WS) P9 (9, 11, 11, 12, 13, 15, 15, 16), hiding the wrap from the previous row as it appears, wrap next st and turn piece with RS facing, knit to end.

(END OPTIONAL SHORT-ROWS)

PLACE MARKER FOR SLEEVE CAP: (WS) P13 (14, 16, 17, 18, 20, 22, 23, 24) sts, hiding the wrap from the last short-row as it appears, pm for sleeve cap, purl to end.

Work 0 (2, 6, 8, 4, 6, 8, 10, 10) rows even in St st, ending with a WS row.

Sizes 31¼ (34¼, 37½, 40½, 43¾, 46¾)" only: Shape Neck

INC ROW: (RS) Knit to last st, M1L, k1—1 st inc'd.

Purl 1 WS row.

Rep the last 2 rows 2 (2, 1, 1, 0, 0) time(s)—55 (59, 63, 67, 71, 75) sts.

All sizes: Shape Neck and Sleeve Caps

INC NECK, DEC SLEEVE CAP: (RS) Knit to 2 sts before m, ssk, sl m, knit to last st, M1L, k1.

Purl 1 WS row.

INC NECK: (RS) Knit to last st, M1, k1—1 st inc'd.

Purl 1 WS row.

Rep the last 4 rows 8 (8, 9, 9, 10, 10, 11, 11, 11) times—64 (68, 73, 77, 82, 86, 91, 95, 100) sts; 34 (35, 38, 39, 41, 43, 46, 47, 48) sts for fronts, and 30 (33, 35, 38, 41, 43, 45, 48, 52) sts for sleeve.

Size 56¼" (143 cm) only:

INC NECK, DEC SLEEVE CAP: (RS) Knit to 2 sts before m, ssk, sl m, knit to last st, M1L, k1—100 sts; 49 sts for front, and 51 sts for sleeve.

Purl 1 WS row.

All sizes:
Remove markers.

Front

Join neck for your size as follows:

Sizes 31¼ (37½, 43¾, 50, 56¼)" only:
JOINING ROW: (RS) Knit to last st of right front sts, slip last st to right needle, place left front sts onto empty needle, return last right front st to left needle and knit it together with the first st of the left front—127 (145, 163, 181, 199) sts.

Sizes 34¼ (40½, 46¾, 53)" only:
JOINING ROW: (RS) Knit to end of right front sts, place left front sts onto empty needle, then knit across—136 (154, 172, 190) sts.

All sizes:
Cont even in St st until piece meas 6¼ (6¾, 7¼, 7½, 8, 8½, 9, 9¼, 9½)" (16 [17, 18.5, 19, 20.5, 21.5, 23, 23.5, 24] cm) from CO along side edges, ending with a WS row.

Body
Join Sleeves

*Hold cir needles for front and back parallel with RS of knitting facing tog and use the three-needle method (see Glossary) to BO 19 sleeve sts tog, then BO 1 st from the back needle, slip the rem st from right needle to back left needle. * Break yarn. Join yarn to other sleeve and rep from * to * once more—179 (197, 215, 233, 251, 269, 287, 305, 323) sts rem for body.

Turn piece with RS facing. Pm and join for working in rnds.

CLOSE GAPS AT UNDERARMS: With RS facing, sl 1 st, knit to 1 st before gap at other sleeve, M1L, pm for side, sl 1 st kwise wyb, pick up and knit 1 st and place it onto left needle tip, k3tog, psso, M1R, knit to 1 st before beg-of-rnd m, M1L, sl 1, remove beg-of-rnd m, pick up and knit 1 st and place it onto left needle tip, k2tog, psso, slip st just made onto left needle tip and replace beg-of-rnd m, then return last st to right needle tip.

Work even in St st until piece meas 1" (2.5 cm) from underarm.

Shape Sides

DEC RND: K1, k2tog, knit to 3 sts before next m, ssk, k1, sm; rep from * once more—4 sts dec'd.

Work 10 (11, 12, 13, 14, 15, 16, 17, 18) rnds even.

Rep Dec rnd—171 (189, 207, 225, 243, 261, 279, 297, 315) sts.

Work even until piece meas 4 (4¼, 4½, 4¾, 5, 5¼, 5½, 5¾, 6)" (10 [11, 11.5, 12, 12.5, 13.5, 14, 14.5, 15] cm) from underarm. Remove side m, keeping beg-of-rnd m on needle.

Work Rnds 1–4 of cable and lace patt 6 times.

Change to middle size needle and work Rnds 1–4 of cable and lace patt 4 times.

Change to largest needle and work cable and lace patt until piece meas about 9¼" (23.5 cm) from beg of cable and lace patt, ending with Rnd 4 of patt.

Work Rnds 1–6 of edging patt. BO loosely pwise, using a larger size needle if necessary to prevent the BO from being too tight.

Sleeve Cuffs

With RS facing and smallest dpns, beg at three-needle BO on one sleeve cuff, pick up and knit 81 (81, 90, 90, 90, 99, 99, 99, 108) sts evenly around sleeve cuff edge. Pm and join for working in rnds.

Work Rnds 1–4 of cable and lace patt 9 times.

Change to medium dpns and work Rnds 1–4 of cable and lace patt until piece meas about 6¼" (16 cm) from pick-up rnd, ending with Rnd 4 of patt.

Change to largest dpns and work Rnds 1–6 of edging patt. BO all sts loosely pwise, using a larger size needle if necessary.

Work second sleeve cuff same as first.

Finishing

Block to measurements.

NECK TRIM: With smallest dpns, beg at right shoulder "seam," pick up and knit 42 (43, 44, 45, 46, 47, 48, 49, 50) sts evenly along back neck, 43 (45, 51, 53, 51, 53, 57, 59, 61) sts along left front, 1 st at center of V, then 43 (45, 51, 53, 51, 53, 57, 59, 61) sts evenly along right front—129 (134, 147, 152, 149, 154, 163, 168, 173) sts. Pm and join for working in rnds. BO all sts pwise.

Weave in loose ends.

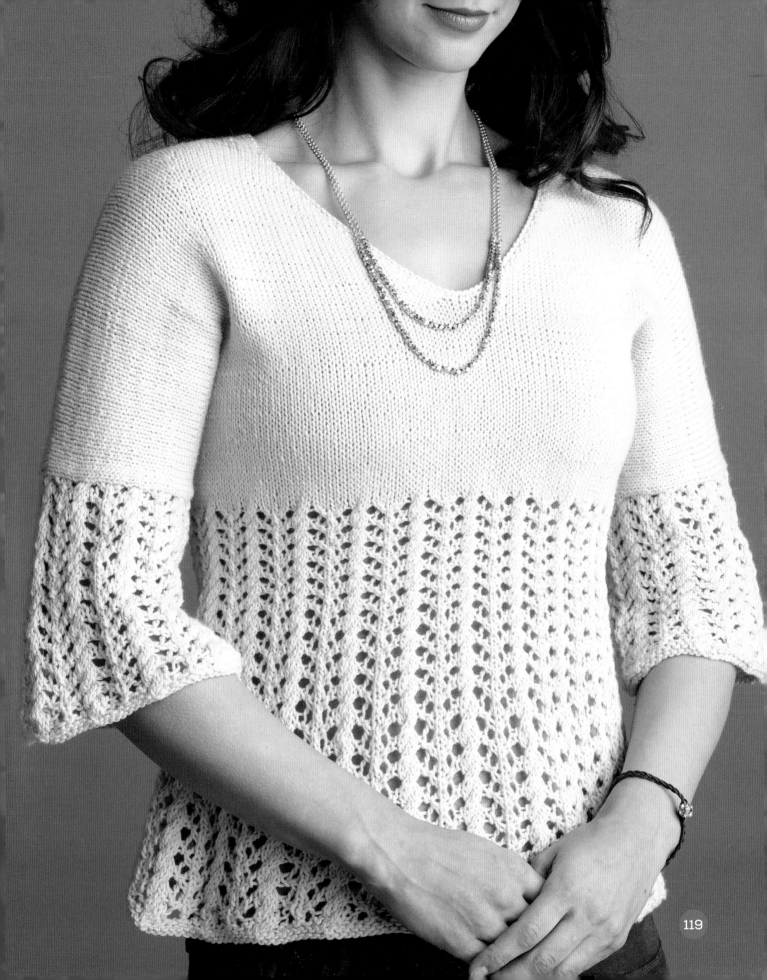

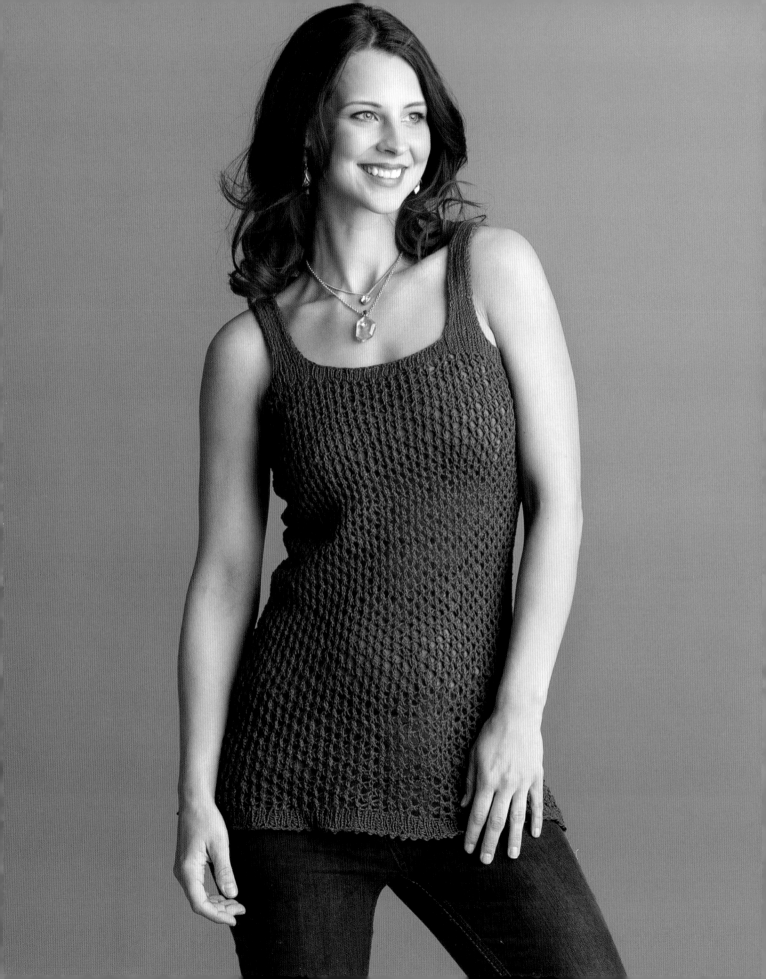

Wonder TANK

Beginning at the tops of the shoulders with a provisional cast-on, the straps for the Wonder Tank are knit out from the center and set aside. Beginning at the right underarm, stitches for the body are cast on and the held strap stitches are joined. The body is worked in an openwork lace pattern from the top down, changing needle sizes to give a little shaping to the waist and hips.

Techniques
. .
Circular knitting with circular needles
Provisional cast-on
Lace
Casting on stitches mid-row
Using a stitch holder or waste yarn

Finished Size
About 29¾ (34¼, 38¾, 43½, 48, 52½, 57¼)" [75.5 (87, 98.5, 110.5, 122, 133.5, 145.5 cm] bust circumference and 26½ (27, 27½, 28, 28¼, 28¾, 29¼)" (67.5 [68.5, 70, 71, 72, 73, 74.5] cm) long.

Tank shown measures 34¼" (87 cm).

Yarn
Fingering weight (#1 Super Fine).

Shown here: Lanaknits, Allhemp3 (100% long fiber hemp; 165 yd [150 m]/50 g): #016 deep sea, 4 (5, 5, 6, 6, 7, 8) skeins.

Needles
Size U.S. 3 (3.25 mm): 24" (60 cm) circular (cir) needle. Sizes U.S. 2 and 5 (2.75 and 3.75 mm): 24" (60 cm) circular (cir) needles.

Adjust needle size if necessary to obtain the correct gauge.

Notions
Markers (m); holders or waste yarn; waste yarn for provisional CO and lifeline; tapestry needle.

Gauge
21 sts and 34 rnds = 4" (10 cm) in lace pattern, worked in rnds on U.S. 3 (3.25 mm) needles.

{ The Joy of Faux Side Seams }

When working in the round, there are many different stitch patterns that could benefit from a faux side seam at each side of the body, aligned with the underarm. Here are a few examples:

• If your stitch pattern uses double decreases at the edges of a repeat, such as sk2p, s2kp, sssk, or k3tog, to maintain the pattern all the way around, stitches may need to be "borrowed" from the beginning of the round to complete the decrease stitch at the end of the round. That can get pretty confusing and complicated.

Placing faux side seams at each side of the body can simplify this kind of stitch pattern because it allows the stitch pattern to be worked like rows with an edge stitch at each marker.

• When working a Fair Isle pattern that has a large stitch repeat, it may not be possible to get the garment to measure the size you want if you use the multiple of stitches in the pattern repeat. If there is a 20-stitch repeat, you would be limited to working multiples of 20 stitches, and that may not be ideal at your gauge. Adding a faux side seam at each edge of the body divides the body into a back and front. Now each can be worked identically, so they mirror each other at the side "seam," instead of flowing consistently all the way around the sweater. The faux side seam also allows for shaping to be worked in the pattern, which would not be aesthetically pleasing if the Fair Isle pattern was worked consistently all the way around the body.

• A faux side seam can also assist in adding stability to the body of a sweater. A common concern of seamless knitting is there are no seams for stability. Faux side seams can be twisted and/or slipped every other row, which will assist in keeping the length of your garment from growing too far from the intended length.

Making a faux side seam is as simple as working a single reverse stockinette rib (p1) to one side of the side body marker on every round. To make the stitch a little less obvious, you can twist it by purling through the back loop; this tightens it up a bit so the gap from the rib is not as wide as if it were purled through the front loop.

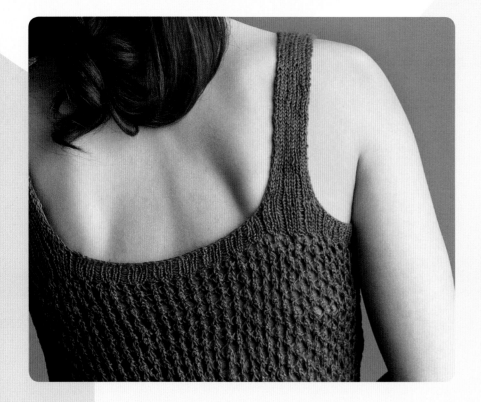

Stitch Guide

Lace Pattern:
(multiple of 4 sts + 5)

RND 1: *K1, yo, s2kp, yo; rep from * to last st, k1.

RNDS 2 AND 4: Knit.

RND 3: Ssk, yo, k1, yo, *s2kp, yo, k1, yo; rep from * to last 2 sts, k2tog.

Rep Rnds 1–4 for patt.

Notes

When working the lace pattern, the yo tends to wrap itself over the knit stitch, and they could easily be worked in the wrong order. When working the knit rnd (Rnds 2 and 4 of patt), be sure you're working into a yo on every other stitch.

It is recommended to occasionally place a lifeline into this lace pattern (see page 92, the Tip Box for the Sensual Open Cardigan for more on lifelines).

Front Strap

With middle size needle (U.S. 3 [3.25 mm]) and using a provisional method (see Glossary), CO 13 sts.

Knit 1 RS row.

SET-UP ROW: (WS) Sl 1 purlwise with yarn in front (pwise wyf,) p3, [k1, p3] twice, p1.

NEXT ROW: (RS) Sl 1 pwise with yarn in back (wyb), k3, [p1, k3] twice, k1.

Cont in est patt until piece meas 6½ (7, 7½, 8, 8¼, 8¾, 9¼)" [16.5 (18, 19, 20.5, 21, 22, 23.5) cm] from CO edge, ending with a WS row.

Place sts onto holder or waste yarn. Break yarn and set aside.

Make second front strap same as first.

Back Strap

Carefully remove waste yarn from provisional CO sts of one front strap and place sts on middle size needle. Join yarn with WS facing. Work back strap same as front strap. Piece meas 13 (14, 15, 16, 16½, 17½, 18½)" (33 [35.5, 38, 40.5, 42, 44.5, 47] cm) from front holder. Place sts onto holder or waste yarn.

Make second back strap same as first.

Body

(**Note:** *While working the following, be careful not to twist the straps or stitches.*)

With middle size needle, use the cable method (see Glossary) to *CO 13 (17, 21, 25, 29, 33, 37) sts, turn piece with RS facing, place held 13 front strap sts onto empty end of needle and [p1, k3] 3 times, p1, turn piece with WS facing, CO 27 (31, 35, 39, 43, 47, 51) sts, turn piece with RS facing, place second set of held 13 front strap sts onto empty end of needle and [p1, k3] 3 times, p1, turn piece with WS facing, CO 12 (16, 20, 24, 28, 32, 36) sts, place marker (pm) for side; rep from * once more for back, working across held back strap sts; second marker indicates beg of rnd—156 (180, 204, 228, 252, 276, 300) sts. Join for working in rnds.

SET-UP RND: [P1-tbl (faux side seam), p1, *k3, p1; rep from * to next m, sl m] twice.

Cont in est patt until piece meas 1" (2.5 cm) from body CO rnd.

LACE SET-UP RND: *P1-tbl (faux side seam), work Rnd 1 of lace patt to next m, sl m; rep from * once more.

Cont in est patt until piece meas 6" (15 cm) from body CO rnd.

Change to smallest size needle, and work even until piece meas 12" (30.5 cm) from body CO rnd.

Change to middle size needle, and work even until piece meas 15½" (39.5 cm) from body CO rnd.

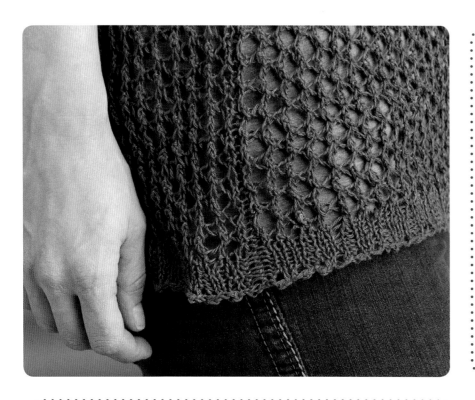

Lace Pattern

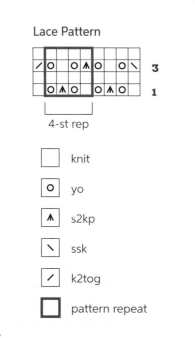

/	o		o	∧	o		o	\\|**3**		
	o	∧	o			o	∧	o		**1**

4-st rep

□	knit
○	yo
∧	s2kp
\\	ssk
/	k2tog
□	pattern repeat

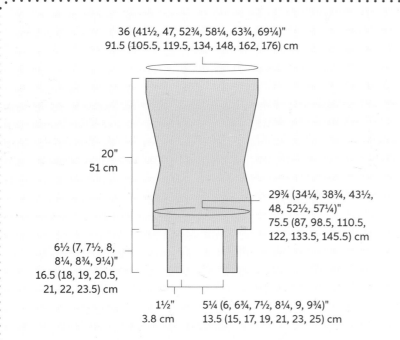

36 (41½, 47, 52¾, 58¼, 63¾, 69¼)"
91.5 (105.5, 119.5, 134, 148, 162, 176) cm

20"
51 cm

29¾ (34¼, 38¾, 43½, 48, 52½, 57¼)"
75.5 (87, 98.5, 110.5, 122, 133.5, 145.5) cm

6½ (7, 7½, 8, 8¼, 8¾, 9¼)"
16.5 (18, 19, 20.5, 21, 22, 23.5) cm

1½"
3.8 cm

5¼ (6, 6¾, 7½, 8¼, 9, 9¾)"
13.5 (15, 17, 19, 21, 23, 25) cm

Change to largest size needle, and work even until piece meas 19" (48.5 cm) from body CO rnd, ending with Rnd 2 or 4 of patt.

NEXT RND: [P1-tbl (faux side seam), p1, *k3, p1; rep from * to next m, sl m] twice.

Cont in est ribbing for 1" (2.5 cm).

PICOT BO: BO 1 knitting tbl, *use backward-loop method (see Glossary) to CO 1, BO 3 sts knitting tbl; rep from * to last st, BO last st, CO 1, BO 2 knitting tbl.

Finishing

Weave in loose ends. Block to measurements.

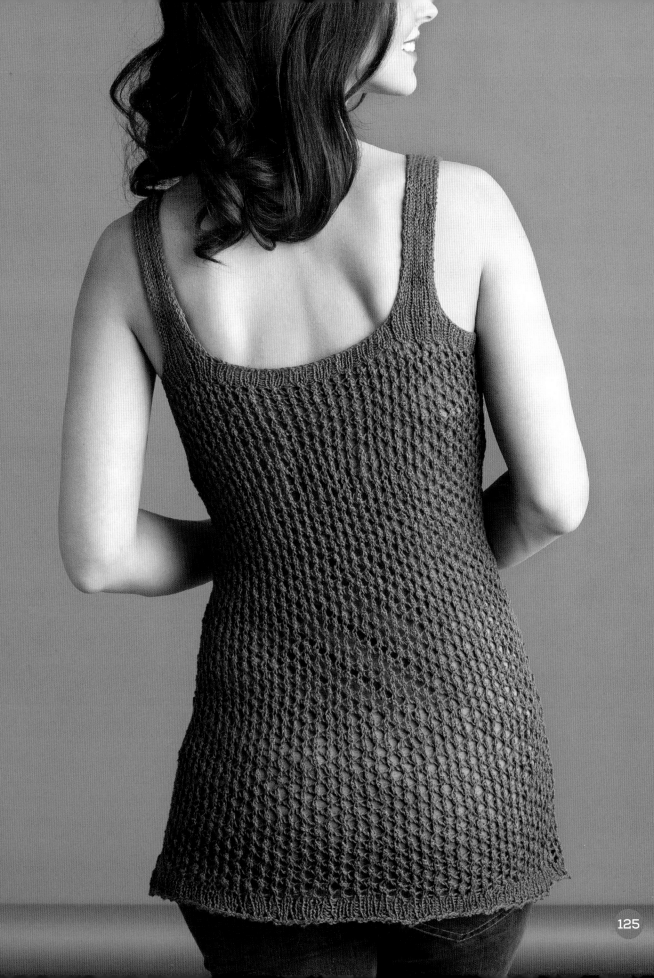

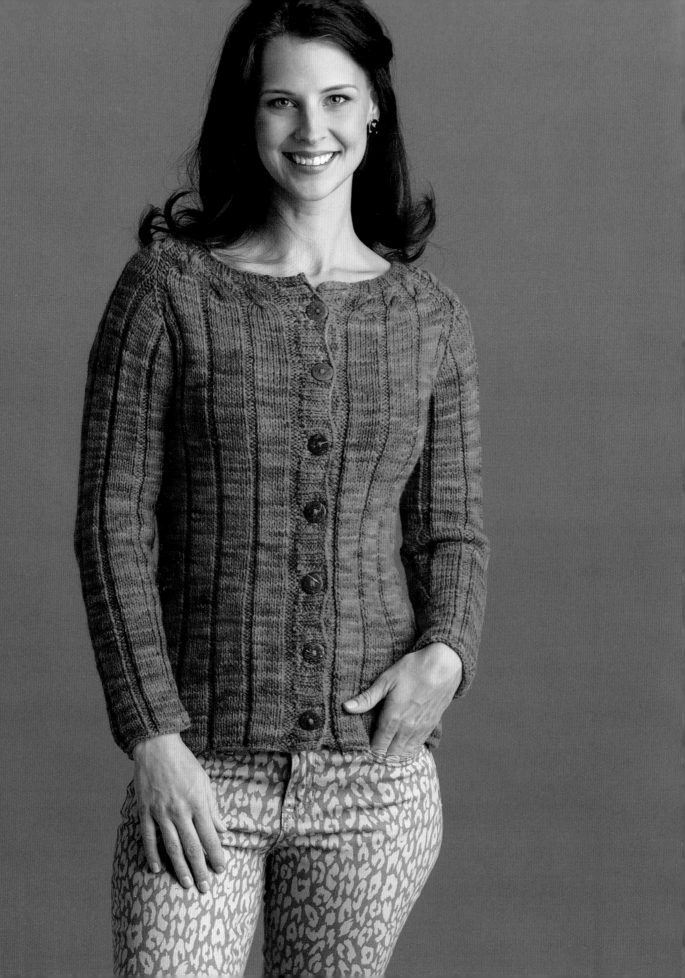

Cables

Chapter 4 features cables! I love the extra bit of coziness that is added to a sweater by including cables. Each of these sweater designs includes a cable panel(s) placed strategically on the sweater. The Rejoice Tunic has a single large cable running vertically along the front; the Paradise Cardigan has one on the back; the Vortex Pullover and Forest Cardigan also have cables on the sleeves; and the Noble Pullover has cable panels worked along the raglan lines, then the insides of the sleeves and sides of the body.

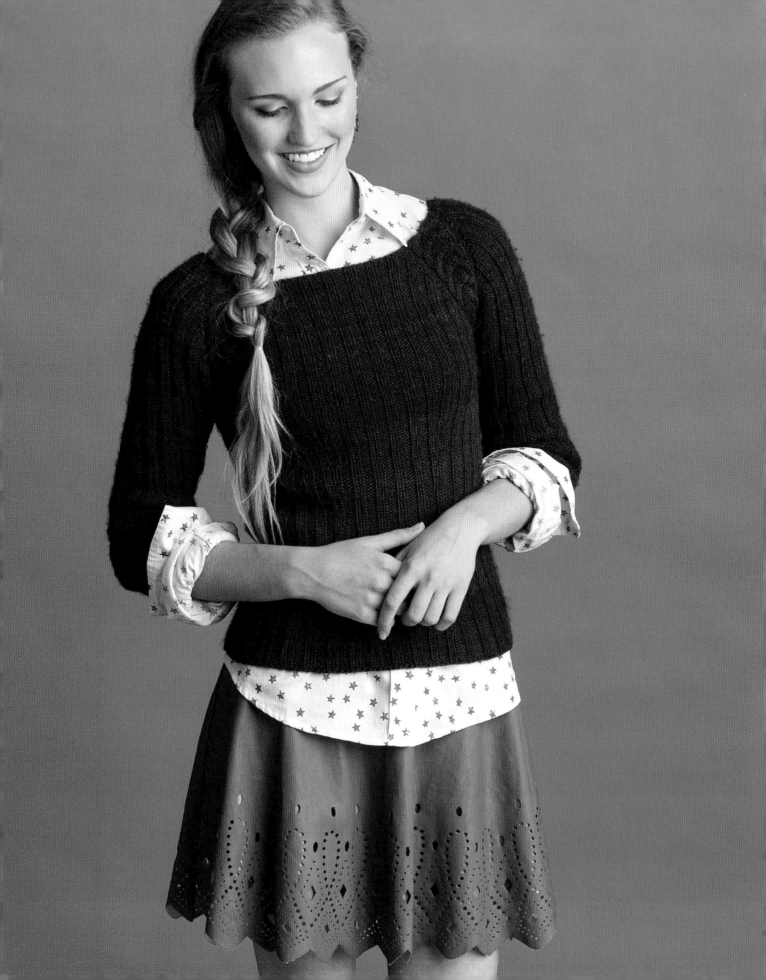

Noble PULLOVER

The Noble Pullover is knit from the top down with cable details along each raglan line. The cable continues to flow along the side edges of the body and inside edges of the sleeves. The waist is shaped in the centers of the front and back, creating subtle hourglass shaping to draw in the waist. Check out the tip box (page 144) for more information on how to increase and decrease while maintaining the ribbing pattern. Or, for an easy-to-knit pattern, the waist shaping could be omitted from your sweater allowing the natural gathering of the rib to custom form to your body.

Techniques

Circular knitting with circular needles and dpns

Increasing and decreasing in pattern

Cables

Multiple stitch patterns at the same time

Using a stitch holder or waste yarn

Finished Size

About 27½ (30¾, 33¾, 36¾, 39¾, 42¾, 46, 49, 52)" (70 [78, 85.5, 93.5, 101, 108.5, 117, 124.5, 132] cm) bust circumference and 21½ (22, 23, 22¾, 23, 22¾, 23, 23¾, 24)" (54.5 [56, 58.5, 58, 58.5, 58, 58.5, 60.5, 61] cm) long.

Pullover shown measures 27½" (70 cm).

Yarn

Worsted weight (#4 Medium).

Shown here: Fibre Company, Organik (70% organic merino, 15% baby alpaca, 15% silk; 98 yd [90 m]/50 g): #906 desert rose, 11 (12, 13, 14, 15, 16, 16, 18, 18) skeins.

Needles

Size U.S. 7 (4.5 mm): 16" (40 cm) and 32" (80 cm) circular (cir) and set of 4 or 5 double-pointed (dpn). *Adjust needle size if necessary to obtain the correct gauge.*

Notions

Markers (s); cable needle (cn); tapestry needle.

Gauge

21 sts and 31 rnds = 4" (10 cm) in k2, p2 ribbing, blocked so ribbing lays flat.

14-st cable panel = 2" (5 cm) wide.

{ Keeping in Pattern While Increasing }

In the Noble Pullover pattern, and in many other patterns you will come across as a knitter, you may see this phrase or one similar: M1 or M1P, keeping in pattern. This means that as the stitches are being increased they are to be worked into the existing pattern; you are to choose the appropriate knit (M1, M1R or M1L) or purl (M1P) stitch to maintain the pattern.

Often, stitch patterns are multiples of more than one stitch. So, when increasing one stitch at a time, you will need to work part of the pattern repeat over the available number of stitches until all the stitches in the repeat are available.

When increasing beside a marker, choose the knit or purl increase to maintain the stitch pattern on that side of the marker. Chances are that for a while (until the total number of stitches in the pattern repeat have been increased) the patterns to each side of the marker will not line up.

For example, the Noble Pullover pattern begins with 2 purl stitches on one side of the marker and 2 knit stitches on the other side. The increases for the raglan are worked on the side of the marker with the 2 knit stitches. To maintain the ribbing pattern on that side of the marker,

a purl stitch would need to be the first increased stitch. That means there will be 3 purl stitches together (2 on one side of the marker, and 1 on the other). The following stitch will be another purl stitch, resulting in 4 purl stitches beside each other. The next stitch is a knit stitch, then the following stitch completes the 4 stitches needed for the pattern repeat, bringing us back to having 2 purl stitches on one side and 2 knit stitches on the other.

Keeping in Pattern While Decreasing

You may also see this phrase, or one similar, in a pattern: k2tog or p2tog. This means to choose the appropriate knit (k2tog or ssk) or purl (p2tog or ssp) stitch to maintain the stitch pattern.

As when keeping in pattern while increasing, you want to maintain the stitch pattern to the same side of the marker where the decrease is being worked, and it may not align with the stitches on the other side of the marker.

The first stitch beside the marker will be hidden during decrease, so it doesn't matter if it's knit or

purl. The second stitch beside the marker will be the stitch on top after the decrease; this is the determining stitch. If that second stitch is a purl stitch, decrease purlwise; if it's a knit stitch, decrease knitwise.

When continuing to work the stitch pattern, work that stitch in the manner that you choose to decrease it. So, if you worked a purl decrease, continue to work that stitch as a purl stitch; if you worked a knit decrease, work the stitch as a knit stitch.

Yoke

With shorter cir needle, CO 112 (104, 112, 104, 112, 104, 112, 104, 112) sts. Place marker (pm) and join for working in rnds.

SET-UP RND: *[K2, p2] 5 times, k2 for body, pm, work Row 1 of cable panel over next 14 sts for raglan, pm, [k2, p2] 1 (0, 1, 0, 1, 0, 1, 0, 1) time, k2 for sleeve, pm, work Row 1 of cable panel over next 14 sts for raglan, pm; rep from * once more.

Shape Raglan

(**Note:** *Change to progressively longer cir needles when sts no longer fit comfortably on dpn.*)

Sizes 39¾ (42¾, 46, 49, 52)" only:

BODY AND SLEEVES INC RND: *M1r (or M1P to maintain ribbing; see Tip Box, page 144), work in est ribbing to next m, M1L (or M1P to maintain ribbing), sl m, work next row of cable panel to next m, sl m; rep from * 3 times—8 sts inc'd.

Rep the last rnd 3 (7, 7, 11, 11) times—144 (168, 176, 200, 208) sts; 30 (38, 38, 46, 46) sts each for back and front, 14 (18, 22, 26, 30) sts for each sleeve, and 14 sts between markers for each cable panel.

Sizes 33¾ (36¾, 39¾, 42¾, 46, 49, 52)" only:

BODY AND SLEEVES INC RND: *M1r (or M1P to maintain ribbing; see Tip Box, page 144), work in est ribbing to next m, M1L (or M1P to maintain ribbing), sl m, work next row of cable panel to next m, sl m; rep from * 3 times—8 sts inc'd.

BODY INC RND: *M1r (or M1P to maintain ribbing), work in est ribbing to next m, M1L (or M1P to maintain ribbing), sl m, work in est patt to next m, sl m, work in est ribbing to next m, sl m, work in est patt to next m, sl m; rep from * once more—4 sts inc'd.

Rep the last 2 rnds 3 (3, 7, 7, 11, 11, 15) times—160 (152, 240, 264, 320, 344, 400) sts; 38 (38, 62, 70, 86, 94, 110) sts each for back and front, 14 (10, 30, 34, 46, 50, 62) sts for each sleeve, and 14 sts between markers for each cable panel.

All sizes:

BODY AND SLEEVES INC RND: *M1r (or M1P to maintain ribbing; see Tip Box, page 144), work in est ribbing to next m, M1L (or M1P to maintain ribbing), sl m, work in est patt to next m, sl m; rep from * 3 times—8 sts inc'd.

Work 1 rnd even as est.

Rep the last 2 rnds 17 (23, 17, 23, 15, 15, 11, 11, 7) times—256 (296, 304, 344, 368, 392, 416, 440, 464) sts; 58 (70, 74, 86, 94, 102, 110, 118, 126) sts each for back and front, 42 (50, 50, 58, 62, 66, 70, 74, 78) sts for each sleeve, and 14 sts between markers for each cable panel.

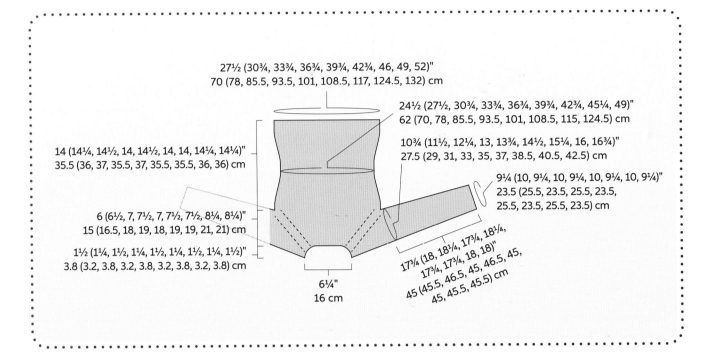

27½ (30¾, 33¾, 36¾, 39¾, 42¾, 46, 49, 52)"
70 (78, 85.5, 93.5, 101, 108.5, 117, 124.5, 132) cm

24½ (27½, 30¾, 33¾, 36¾, 39¾, 42¾, 45¼, 49)"
62 (70, 78, 85.5, 93.5, 101, 108.5, 115, 124.5) cm

10¾ (11½, 12¼, 13, 13¾, 14½, 15¼, 16, 16¾)"
27.5 (29, 31, 33, 35, 37, 38.5, 40.5, 42.5) cm

9¼ (10, 9¼, 10, 9¼, 10, 9¼, 10, 9¼)"
23.5 (25.5, 23.5, 25.5, 23.5, 25.5, 23.5, 25.5, 23.5) cm

14 (14¼, 14½, 14, 14½, 14, 14, 14¼, 14¼)"
35.5 (36, 37, 35.5, 37, 35.5, 35.5, 36, 36) cm

6 (6½, 7, 7½, 7, 7½, 7½, 8¼, 8¼)"
15 (16.5, 18, 19, 18, 19, 19, 21, 21) cm

1½ (1¼, 1½, 1¼, 1½, 1¼, 1½, 1¼, 1½)"
3.8 (3.2, 3.8, 3.2, 3.8, 3.2, 3.8, 3.2, 3.8) cm

17¾ (18, 18¼, 17¾, 18¼,
17¾, 17¾, 18, 18)"
45 (45.5, 46.5, 45, 46.5, 45,
45, 45.5, 45.5) cm

6¼"
16 cm

Size 27½ (33¾)" only:

[Work Body and Sleeves inc rnd, then work 3 rnds even] 2 times—272 (320) sts; 62 (78) sts each for back and front, 46 (54) sts for each sleeve, and 14 sts between markers for each cable panel.

All sizes:

Work 1 rnd even, ending after an even-numbered rnd of the cable panel.

Divide Body and Sleeves

*Work 62 (70, 78, 86, 94, 102, 110, 118, 126) sts in est patt to next m for body, sl m, p2, k5, keeping m with sleeve sts, sl next 7 cable panel sts, 46 (50, 54, 58, 62, 66, 70, 74, 78) sleeve sts, then first 7 cable panel sts onto holder or waste yarn, k5, p2, sl m; rep from * once more—152 (168, 184, 200, 216, 232, 248, 264, 280) sts rem for body, and 60 (64, 68, 72, 76, 80, 84, 92) sts held for each sleeve.

Body

Cont in est patt until piece meas 1" (2.5 cm) from underarm.

NEXT RND: *Work 18 (22, 22, 26, 26, 30, 30, 34, 34) sts, pm for dart, work 26 (26, 34, 34, 42, 42, 50, 50, 58) sts, pm for dart, work 18 (22, 22, 26, 26, 30, 30, 34, 34) sts, sl m for cable panel, work to next m, sl m; rep from * once more.

Shape Waist

DEC RND: *Work in est patt to dart m, sl m, k2tog (or p2tog to maintain patt; see Tip Box, page 144), work to 2 sts before next dart m, ssk (or ssp to maintain patt), sl m; rep from * once more, work to end—4 sts dec'd.

Work 9 rnds even as est.

Rep the last 10 rnds 3 times —136 (152, 168, 184, 200, 216, 232, 244, 264) sts rem.

Work 9 rnds even.

INC RND: *Work in est patt to dart m, sl m, M1R (or M1P to maintain patt), work to next dart m, M1L (or M1P to maintain patt), sl m; rep from * once more, work to end—4 sts inc'd.

Work 11 rnds even as est.

Rep the last 12 rnds 3 times—152 (168, 184, 200, 216, 232, 248, 264, 280) sts.

Cont even in est patt until piece meas about 14 (14¼, 14½, 14, 14½, 14, 14, 14¼, 14¼)" (35.5 [36, 37, 35.5, 37, 35.5, 35.5, 36, 36] cm) from divide, ending with Rnd 5 of cable panel. BO all sts in patt.

Sleeves

Return held 60 (64, 68, 72, 76, 80, 84, 88, 92) sleeve sts to dpn. Pick up and knit 2 sts in gap at underarm, slip first 7 sts with yarn loosely held in back, sl m (this is the beg-of-rnd m), work in est ribbing to next m, sl m, p2, k4, ssk, k2tog, k4, p2—60 (64, 68, 72, 76, 80, 84, 88, 92) sts.

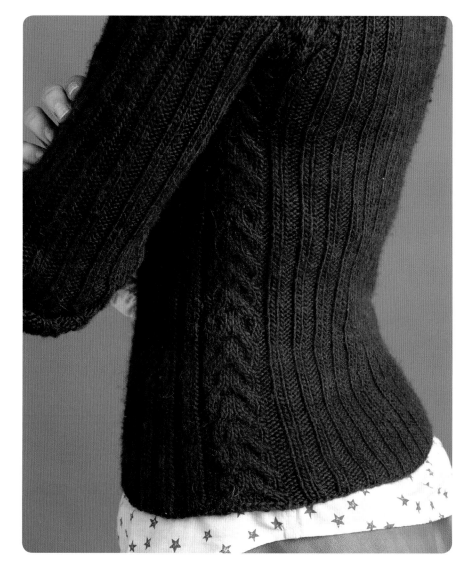

Cont in k2, p2 ribbing and cable panel until piece meas 1" (2.5 cm) from underarm.

Shape Sleeve

DEC RND: K2, k2tog (or p2tog to maintain patt), work in est patt to 4 sts before next m, ssk (or ssp to maintain patt), sl m, work to end—2 sts dec'd.

Rep Dec rnd every 24 (24, 12, 12, 8, 8, 6, 6, 6) rnds 3 (3, 7, 7, 11, 11, 15, 15, 19) times—52 (56, 52, 56, 52, 56, 52, 56, 52) sts rem.

Cont even in est patt until piece meas about 17¾ (18, 18¼, 17¾, 18¼, 17¾, 17¾, 18, 18)" (45 [45.5, 46.5, 45, 46.5, 45, 45, 45.5, 45.5] cm) from underarm, ending with Rnd 5 of cable panel. BO all sts in patt.

Work second sleeve same as first.

Finishing

Weave in loose ends. Block to measurements.

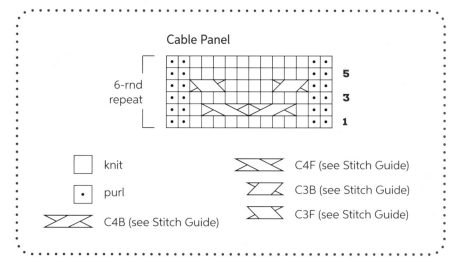

Cable Panel

6-rnd repeat

5

3

1

	knit		C4F (see Stitch Guide)
•	purl		C3B (see Stitch Guide)
	C4B (see Stitch Guide)		C3F (see Stitch Guide)

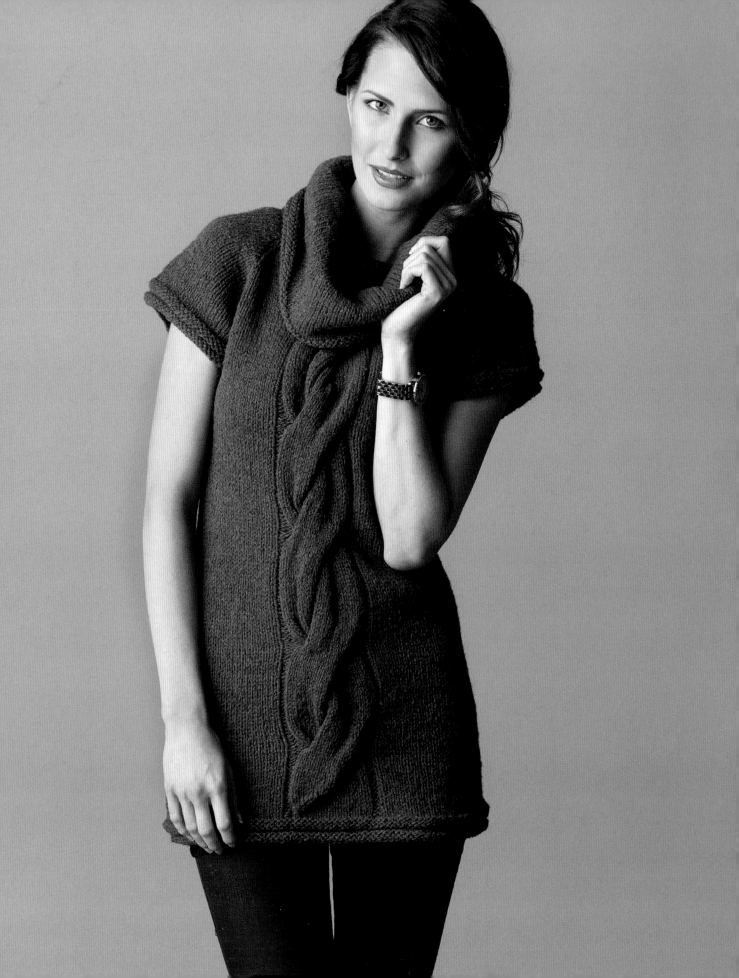

Rejoice TUNIC

Knitted from the top down requires stitches to be increased as the yoke is shaped. My favorite type of increase is the lifted increase, and this pattern has a plethora of these—in the raglan shaping, at the beginning of the cable panel, and in the waist shaping. I personally find them fun and easy to make, and the result is aesthetically pleasing.

If you have a favorite method of increasing, this pattern can easily be made using a variety of increases. See page 136 for more information on different types of increases and pick any of them to use in this sweater! The only thing I wouldn't suggest is an increase with yo's in the cable panel.

This design could also benefit from a pocket (see page 80), or if you're well endowed, consider adding some bust darts following the instructions on page 112.

Techniques

Cables
Casting on stitches mid-row
Lifted increases
Picking up stitches

Finished Size

About 33 (37, 41¼, 45¼, 49½, 53½, 57¾)" (84 [94, 105, 115, 125.5, 136, 146.5] cm) bust circumference and 29¾ (29¾, 29¾, 29¾, 29¾, 29½, 29½)" (75.5 [75.5, 75.5, 75.5, 75.5, 75, 75] cm) long.

Tunic shown measures 36½" (92.5 cm).

Yarn

Worsted weight (#4 Medium).

Shown here: Green Mountain Spinnery, Weekend Wool (100% American wool; 140 yd [128 m]/60 g): #7765 deep lake, 9 (10, 11, 11, 12, 13, 14) skeins.

Needles

Size U.S. 8 (5 mm): 16" (40 cm) and 32" (80 cm) circular (cir) and set of 4 or 5 double-pointed (dpn). *Adjust needle size if necessary to obtain the correct gauge.*

Notions

Markers (m); cable needle (cn); holders or waste yarn; tapestry needle.

Gauge

15½ sts and 22 rnds = 4" (10 cm) in St st; 34-st cable panel = 4" (10 cm) at widest point.

{ What Are the Different Types of Increases? }

Throughout this book, a variety of increases have been used. Most of these may easily be substituted with another type of increase. Learn a little about each of these increase methods below.

Right- and left-slanting M1 stitches and lifted increases are useful in places where there are increases on two edges that mirror each other, such as when shaping the sleeves, waist, or a raglan. Take a look at the increases below to determine which would be best suited for your project.

M1L and M1R

RS ROWS: M1L, k2, M1R.

WS ROWS: M1RP, p2, M1LP.

M1R and M1L

RS ROWS: M1R, k2, M1L.

WS ROWS: M1LP, p2, M1RP.

Lifted increases every other row

RS ROWS: LLI, k2, RLI.

It's commonly said that lifted increases cannot be worked on every row. When working the lifted increases in this order, it's true because a lifted increase cannot be worked into a lifted increase stitch from the previous row.

Take a look at Diagram A. The third row from the bottom works an LLI, k2 then RLI. The green arrows indicate the stitch in the rows below where the increase is worked.

On the following row, when working the LLPI, p2, RLPI, the stitch to work into would end up being the same stitch as the previous row. As you continue to work each row with the increases worked in this manner, every row would work into that same stitch on the first row. This won't work out well.

If you wish to work lifted increases on every row, you need to work them in an order where the lifted increase will be worked into a non-increased stitch on each row. As you can see in Diagram B, the green, orange, and black arrows each point to stitches in different rows and, therefore, will work successfully to shape every row.

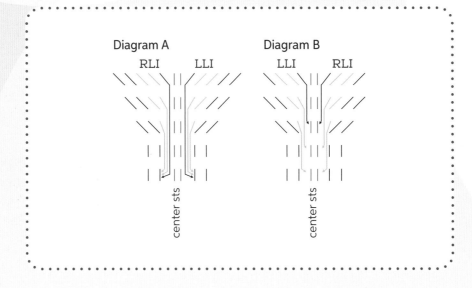

Diagram A

RLI LLI

center sts

Diagram B

LLI RLI

center sts

Lifted increases

RS ROWS: RLI, k2, LLI.

WS ROWS: LLPI, p2, RLPI.

Yo increases

RS ROWS: Yo, k2, yo.

WS ROWS: Yo, p2, yo.

Bar increases

RS ROWS: K1f&b, k1, slip marker, k1f&b.

WS ROWS: P1f&b, p1, slip marker, p1f&b.

When working bar increases, knitting (or purling) into the front and back of the stitch, the first stitch (the one that is knit or purled through the front loop) creates a stitch that looks knit with the RS facing. The second stitch (the one that is knit or purled through the back loop) looks like a purl stitch with the RS facing. Because of this, the marker is oriented 1 stitch after the first bar increase, just before the second bar increase. This will create 2 knit-looking stitches—1 on either side of the marker—because the first half of the bar increase after the marker matches the stitch on the other side of the marker.

Notes

When placing markers, use different colored markers for the beginning of round, cable panel, raglan, and sides to easily tell them apart. After working the cable panel to the point where the pattern is visibly obvious, you may remove the cable panel markers.

When working the cable panel chart, work Rnds 1–17 once, then repeat Rnds 18–45 until instructed to work Rnds 46–62.

Because there are separate sections for some sizes, and the placement of each size may be different in relationship to the (), I suggest using a pencil to circle the size that you are making throughout the pattern before you begin to knit.

Yoke

With shorter cir needle, CO 80 (82, 84, 84, 90, 92, 94) sts. Place marker (pm) and join for working in rnds.

SET-UP RND: K28 (30, 30, 30, 34, 36, 38) sts for back, pm for raglan, k12 (11, 12, 12, 11, 10, 9) sts for sleeve, pm for raglan, k5 (6, 6, 6, 8, 9, 10) sts for right front, pm, work Rnd 1 of cable panel over next 18 sts, pm, k5 (6, 6, 6, 8, 9, 10) sts for left front, pm for raglan, k12 (11, 12, 12, 11, 10, 9) sts for sleeve—81 (83, 85, 85, 91, 93, 95) sts; 12 (11, 12, 12, 11, 10, 9) sts for each sleeve, 28 (30, 30, 30, 34, 36, 38) sts for back, and 29 (31, 31, 31, 35, 37, 39) sts for front.

Shape Raglan

(**Notes:** *Stitches are increased on the cable panel between Rnds 2 and 16. These increased sts are incorporated into the stitch counts listed below. All sts increased for the raglan shaping are worked in St st once they've been increased. Change to longer cir needle when sts no longer fit comfortably on shorter cir needle.*)

BODY AND SLEEVE INC RND: *K1, LLI (see Glossary), work in est patt to 1 st before next raglan m, RLI (see Glossary), k1, sl m; rep from * 3 times—8 sts inc'd for raglan, and 1 st inc'd in cable panel.

Rep the last rnd 0 (4, 7, 10, 11, 13, 13) times—90 (128, 157, 184, 199, 219, 221) sts; 14 (21, 28, 34, 35, 38, 37) sts for each sleeve, 30 (40, 46, 52, 58, 64, 66) sts for back, and 32 (46, 55, 64, 71, 79, 81) sts for front.

Sizes 32½ (36½)" (82.5 [92.5] cm) only:

Rep Body and Sleeve inc rnd—8 sts inc'd for raglan, and 1 st inc'd in cable panel.

SLEEVE INC RND: *Work in est patt to next raglan m, sl m, k1, LLI, knit to 1 st before next raglan m, RLI, k1, sl m; rep from * once more—4 sts inc'd on sleeves, and 1 st inc'd in cable panel.

Rep the last 2 rnds 2 (1) time(s)—132 (156) sts; 26 (29) sts for each sleeve, 36 (44) sts for back, and 44 (54) sts for front.

Sizes 40¾ (44¾, 49, 53, 57¼)" (103.5 [113.5, 124.5, 134.5, 145.5] cm) only:

Rep Body and Sleeve Inc rnd—8 sts inc'd for raglan, and 1 st inc'd in cable panel until Rnd 16 is completed.

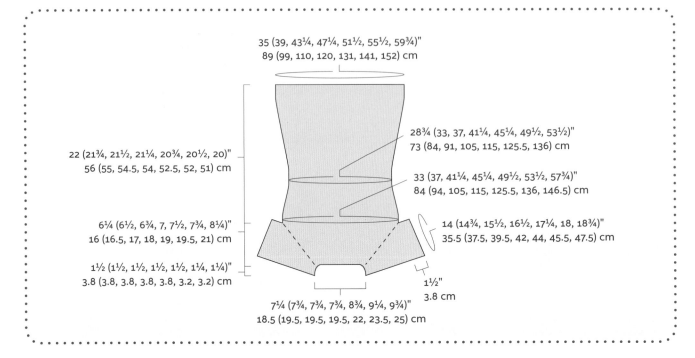

35 (39, 43¼, 47¼, 51½, 55½, 59¾)"
89 (99, 110, 120, 131, 141, 152) cm

28¾ (33, 37, 41¼, 45¼, 49½, 53½)"
73 (84, 91, 105, 115, 125.5, 136) cm

22 (21¾, 21½, 21¼, 20¾, 20½, 20)"
56 (55, 54.5, 54, 52.5, 52, 51) cm

33 (37, 41¼, 45¼, 49½, 53½, 57¾)"
84 (94, 105, 115, 125.5, 136, 146.5) cm

6¼ (6½, 6¾, 7, 7½, 7¾, 8¼)"
16 (16.5, 17, 18, 19, 19.5, 21) cm

14 (14¾, 15½, 16½, 17¼, 18, 18¾)"
35.5 (37.5, 39.5, 42, 44, 45.5, 47.5) cm

1½ (1½, 1½, 1½, 1½, 1¼, 1¼)"
3.8 (3.8, 3.8, 3.8, 3.8, 3.2, 3.2) cm

1½"
3.8 cm

7¼ (7¾, 7¾, 7¾, 8¾, 9¼, 9¾)"
18.5 (19.5, 19.5, 19.5, 22, 23.5, 25) cm

BODY INC RND: *K1, LLI, work in est patt to 1 st before next raglan m, RLI, k1, sl m, knit to next raglan m, sl m; rep from * once more—4 sts inc'd on body, and 1 (1, 1, 0, 0) st inc'd in cable panel until Rnd 16 is completed.

Rep the last 2 rnds 0 (2, 2, 3, 4) times—171 (224, 238, 268, 282) sts; 30 (40, 41, 46, 47) sts for each sleeve, 50 (64, 70, 80, 86) sts for back, and 61 (80, 86, 96, 102) sts for front.

All sizes:
[Rep Body and Sleeve inc rnd, then work 1 rnd even] 13 (13, 13, 10, 11, 10, 10) times—244 (266, 280, 304, 326, 348, 362) sts; 52 (55, 56, 60, 63, 66, 67) sts for each sleeve, 62 (70, 76, 84, 92, 100, 106) sts for back, and 78 (86, 92, 100, 108, 116, 122) sts for front.

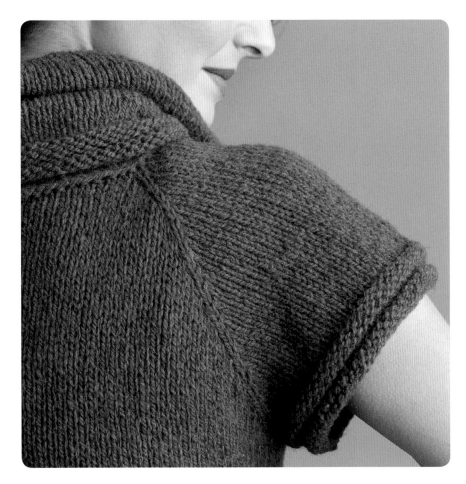

Cable Panel

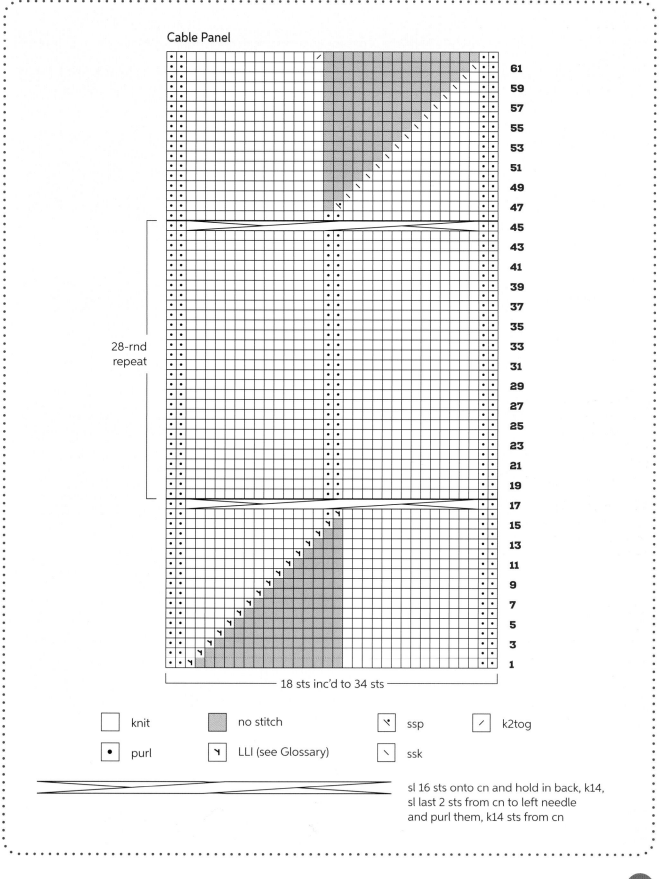

28-rnd repeat

61
59
57
55
53
51
49
47
45
43
41
39
37
35
33
31
29
27
25
23
21
19
17
15
13
11
9
7
5
3
1

18 sts inc'd to 34 sts

| | knit | | no stitch | | ssp | | k2tog |
| | purl | | LLI (see Glossary) | | ssk |

sl 16 sts onto cn and hold in back, k14, sl last 2 sts from cn to left needle and purl them, k14 sts from cn

Divide Body and Sleeves

Knit 62 (70, 76, 84, 92, 100, 106) back sts, remove m, sl 52 (55, 56, 60, 63, 66, 67) sleeve sts onto holder or waste yarn, remove m, use backward-loop method (see Glossary) and CO 1 (1, 2, 2, 2, 2, 3) st(s), pm for side, CO 1 (1, 2, 2, 2, 2, 3) st(s), work 78 (86, 92, 100, 108, 116, 122) front sts in est patt, remove m, sl 52 (55, 56, 60, 63, 66, 67) sleeve sts onto holder or waste yarn, remove m, use backward-loop method and CO 1 (1, 2, 2, 2, 2, 3) st(s), pm for new beg of rnd, CO 1 (1, 2, 2, 2, 2, 3) st(s)—144 (160, 176, 192, 208, 224, 240) sts; 64 (72, 80, 88, 96, 104, 112) sts for back, and 80 (88, 96, 104, 112, 120, 128) sts for front.

Body

Work 5 rnds even.

Shape Waist

DEC RND: *K3, k2tog, work in est patt to 5 sts before next side m, ssk, k3, sl m; rep from * once more—4 sts dec'd.

Work 6 rnds even.

Rep the last 7 rnds 3 times —128 (144, 160, 176, 192, 208, 224) sts rem; 56 (64, 72, 80, 88, 96, 104) sts for back, and 72 (80, 88, 96, 104, 112, 120) sts for front.

Work 9 rnds even.

INC RND: *K3, LLI, knit to 3 sts before next m, RLI, k3; rep from * once more—4 sts inc'd.

Work 6 rnds even.

Rep the last 7 rnds 5 times —152 (168, 184, 200, 216, 232, 248) sts; 68 (76, 84, 92, 100, 108, 116) sts for back, and 84 (92, 100, 108, 116, 124, 132) sts for front.

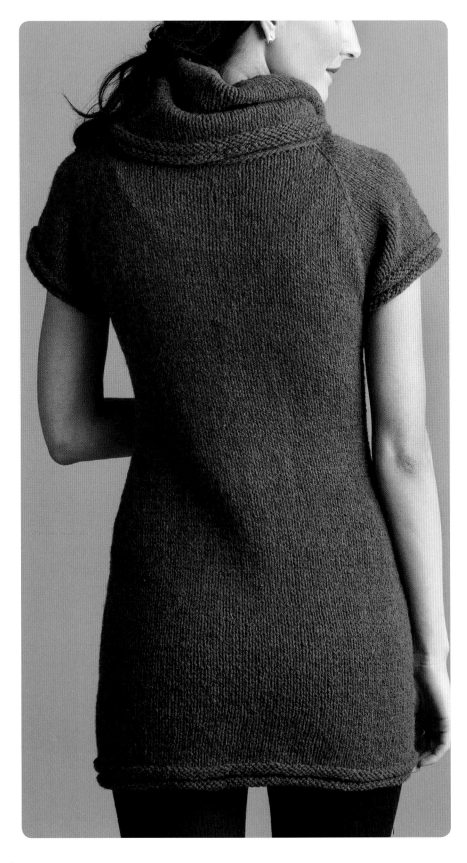

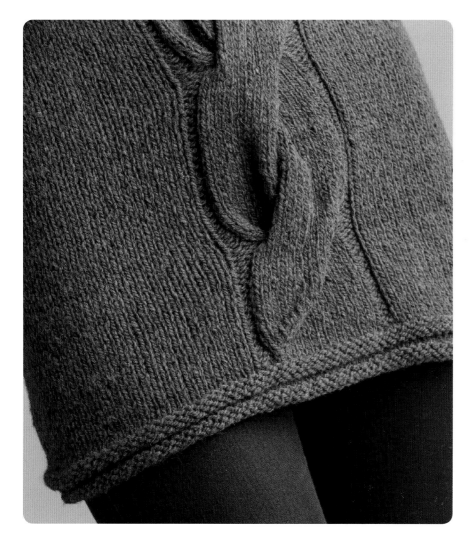

Cont even until Rnd 45 cable panel has been completed.

Work Rnds 46–62 of cable panel—136 (152, 168, 184, 200, 216, 232) sts rem; 68 (76, 84, 92, 100, 108, 116) sts each for back and front. Remove all markers except beg-of-rnd m.

Knit 1 rnd.

Purl 3 rnds.

Knit 3 rnds.

Purl 2 rnds. BO all sts pwise.

Sleeve

Place held 52 (55, 56, 60, 63, 66, 67) sleeve sts onto dpn. With RS facing and an empty dpn, beg at center of underarm CO sts, pick up and knit 1 (1, 2, 2, 2, 2, 3) st(s), knit sleeve sts, then pick up and knit 1 (1, 2, 2, 2, 2, 3) st(s) to center of underarm—54 (57, 60, 64, 67, 70, 73) sts. Distribute sts evenly over 3 or 4 dpn. Pm and join for working in rnds.

Knit 1 rnd.

Purl 3 rnds.

Knit 3 rnds.

Purl 2 rnds. BO all sts pwise.

Work second sleeve same as first.

Finishing

Block to measurements.

COWL: With shorter cir needle and WS facing, beg at center of back neck, pick up and knit 1 st in each CO st along neck edge—80 (82, 84, 84, 90, 92, 94) sts. Pm and join for working in rnds.

INC RND: Knit and inc 0 (2, 0, 0, 2, 0, 2) sts evenly around—80 (84, 84, 84, 92, 92, 96) sts.

SET-UP RND: *K2, p2; rep from * around.

Work in est ribbing until piece meas 4" (10 cm) from pick-up rnd.

INC RND: *K4, RLI; rep from * around—100 (105, 105, 105, 115, 115, 120) sts.

Work in St st (knit every rnd), until piece meas 12" (30.5 cm) from pick-up rnd.

Purl 3 rnds.

Knit 3 rnds.

Purl 2 rnds.

BO all sts loosely pwise.

Weave in loose ends.

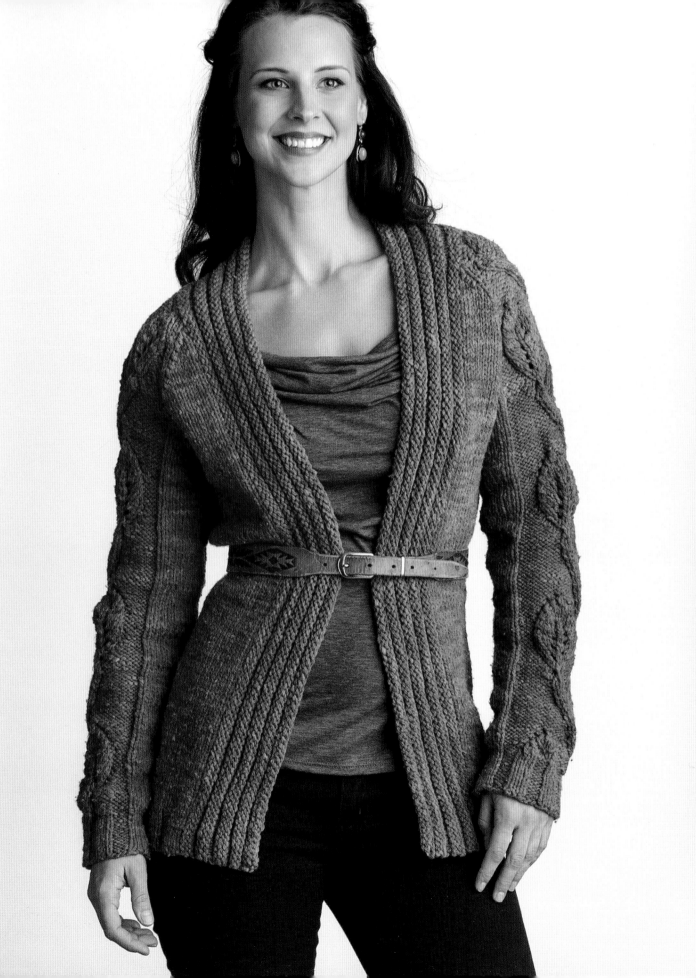

Forest CARDIGAN

The cable patterns in this cardigan remind me of the foliage of the forest, growing from the ground up toward the sky. In the same way, the sweater is worked from the bottom up. The body and sleeves are worked separately to the underarms, where they are joined, then worked together to the neck edge while decreasing along the raglan. A welt-like collar is added around the front opening. I chose to keep this as an unfastened sweater, but if you'd prefer to add one button or more, make the collar a little longer and work some three-stitch one-row buttonholes (see Glossary) along the center row of the collar or add some I-cords to tie the fronts closed (as in the Majestic Tie Cardigan).

Techniques

Circular knitting with dpns
Cables
Decreasing in pattern
Picking up stitches
Using a stitch holder
or waste yarn
Lifted increases

Finished Size

About 32 (35¼, 38½, 42, 45¼, 48½, 51¾, 55)" [81.5 (89.5, 98, 106.5, 115, 123, 131.5, 139.5) cm] bust circumference and 27½ (28, 28¾, 28¾, 29¼, 29¾, 30, 30½)" (70 [71, 73, 73, 74.5, 75.5, 76, 77.5] cm) long.

Cardigan shown measures 35" (89 cm).

Yarn

Chunky weight (#5 Bulky).

Shown here: Mountain Meadow Wools, Sheridan (100% Mountain Merino, 96 yd [88 m]/100 g): sorrel, 8 (9, 10, 11, 12, 13, 14, 15) skeins.

Needles

Body—Size U.S. 10½ (6.5 mm): 32" (80 cm) circular (cir) and set of 4 or 5 double-pointed (dpn).

Ribbing and Neckband—Size U.S. 9 (5.5 mm): 32" (80 cm) circular (cir) and set of 4 or 5 double-pointed (dpn).

Adjust needle sizes if necessary to obtain the correct gauge.

Notions

Markers (m); cable needle (cn); holders or waste yarn; tapestry needle.

Gauge

14½ sts and 22 rows = 4" (10 cm) in St st with larger needles; 56 sts = 11½" (29 cm) in back cable panel; 38 sts = 8" (20.5 cm) in sleeve cable panel.

{ Decreasing Stitches in Pattern While Maintaining the Correct Stitch Count }

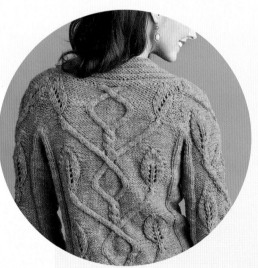

Whenever possible I try to avoid shaping in a stitch pattern that has increase and decrease stitches. However, in some cases, as in the Forest Cardigan, it's not easily avoidable.

When decreasing in a stitch pattern, it's important to maintain an equal number of increases and decreases throughout the stitch pattern; otherwise there may be stitches added or subtracted from the stitch count accidentally. The ease of identifying if there are an equal number of increases and decreases varies depending on the stitch pattern. When working the two cable panel charts in the Forest Cardigan, you should be able to tell rather easily. I've charted an example for the back cable panel below.

As you can see in the top chart, the red lines indicate the raglan shaping that will cut through the chart. Keep in mind this is hypothetical raglan shaping; for each size of the Forest Cardigan, the place in the chart at which you begin the raglan shaping will vary. The yellow highlighted stitches are the increase and decrease stitches affected by the raglan shaping.

On Rows 25, 27, and 29, the M1P stitch outside the red raglan line is an increase stitch that will not be included in that row. Therefore, the decrease stitch that corresponds with that increase stitch should not be worked; if it is, an extra stitch will be decreased on each edge of the chart.

On Row 31, there is an M1P stitch outside the red raglan line. Inside the red raglan line there is a double decrease and another M1P stitch. This double decrease stitch corresponds with both of the M1P stitches (2 stitches decreased for 2 stitches increased). Because one of the M1P stitches will not be worked, the double decrease will need to change to a single decrease so it still corresponds with the M1P stitch that will be worked. Whether you change the double decrease into a left- or right-slanting single decrease is up to you.

The lower chart shows how I would edit the chart to maintain the correct stitch count while working the raglan shaping. Note that the raglan shaping stitches are not included in the charts; they would be worked just outside the red raglan lines.

Stitch Guide

3/1 LCP (3 OVER 1 LEFT CROSS PURL): Sl 3 sts onto cn and hold in front, p1, k3 from cn.

3/1 RCP (3 OVER 1 RIGHT CROSS PURL): Sl 1 st onto cn and hold in back, k3, p1 from cn.

3/2 LCP (3 OVER 2 LEFT CROSS PURL): Sl 3 sts onto cn and hold in front, p2, k3 from cn.

3/2 RCP (3 OVER 2 RIGHT CROSS PURL): Sl 2 sts onto cn and hold in back, k3, p2 from cn.

3/3 LC (3 OVER 3 LEFT CROSS): Sl 3 sts onto cn and hold in front, k3, k3 from cn.

3/3 RC (3 OVER 3 RIGHT CROSS): Sl 3 sts onto cn and hold in back, k3, k3 from cn.

3/3 LCP (3 OVER 3 LEFT CROSS PURL): Sl 3 sts onto cn and hold in front, p3, k3 from cn.

3/3 RCP (3 OVER 3 RIGHT CROSS PURL): Sl 3 sts onto cn and hold in back, k3, p3 form cn.

Which stitches are affected during shaping?

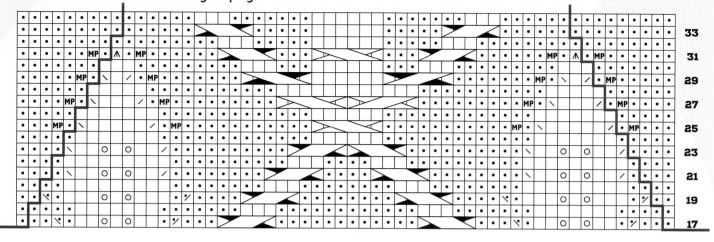

How those stitches are edited to maintain the stitch count:

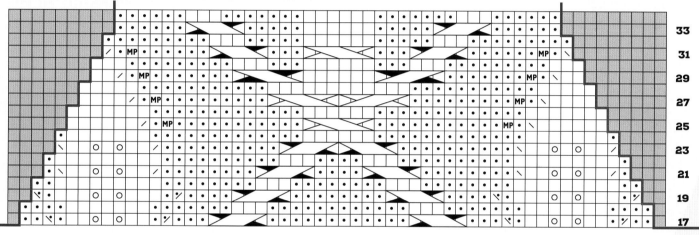

Notes

In the yoke shaping, there are separate sections for some sizes, and the placement of each size may be different in relationship to the () than in the rest of the pattern. I suggest using a pencil to circle the size that you are making throughout the pattern before you begin to knit.

Circular needle is used to accommodate large number of sts. Do not join; work back and forth in rows.

Sleeves

With smaller dpn, CO 37 (37, 37, 49, 49, 49, 49) sts. Divide sts evenly over 3 or 4 dpn. Place marker (pm) and join for working in rnds.

SET-UP RND: K2, *p3, k3; rep from * to last 5 sts, p3, k2.

Cont even in est ribbing until piece meas 2" (5 cm) from beg.

Change to larger dpn.

INC RND: K2, [p3, k3] 0 (0, 0, 0, 1, 1, 1) time, pm for sleeve cable panel, p3, k3, p3, M1, k2, M1, k1, p1, M1P, p2, k3, p3, k1, M1, k2, p3, k2, M1, k1, p3, pm for sleeve cable panel, [k3, p3] 0 (0, 0, 0, 1, 1, 1) time, k2—42 (42, 42, 42, 54, 54, 54, 54) sts.

SET-UP RND: Knit to sleeve cable panel m, sl m, work Row 1 of sleeve cable panel to next m, sl m, knit to end.

Work 1 rnd even in est patt.

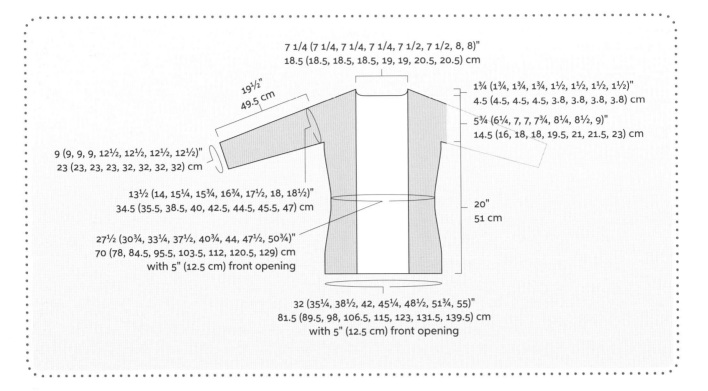

7 1/4 (7 1/4, 7 1/4, 7 1/4, 7 1/2, 7 1/2, 8, 8)"
18.5 (18.5, 18.5, 18.5, 19, 19, 20.5, 20.5) cm

19½"
49.5 cm

1¾ (1¾, 1¾, 1¾, 1½, 1½, 1½, 1½)"
4.5 (4.5, 4.5, 4.5, 3.8, 3.8, 3.8, 3.8) cm

5¾ (6¼, 7, 7, 7¾, 8¼, 8½, 9)"
14.5 (16, 18, 18, 19.5, 21, 21.5, 23) cm

9 (9, 9, 9, 12½, 12½, 12½, 12½)"
23 (23, 23, 23, 32, 32, 32, 32) cm

13½ (14, 15¼, 15¾, 16¾, 17½, 18, 18½)"
34.5 (35.5, 38.5, 40, 42.5, 44.5, 45.5, 47) cm

20"
51 cm

27½ (30¾, 33¼, 37½, 40¾, 44, 47½, 50¾)"
70 (78, 84.5, 95.5, 103.5, 112, 120.5, 129) cm
with 5" (12.5 cm) front opening

32 (35¼, 38½, 42, 45¼, 48½, 51¾, 55)"
81.5 (89.5, 98, 106.5, 115, 123, 131.5, 139.5) cm
with 5" (12.5 cm) front opening

Shape Sleeve

INC RND: K1, RLI (see Glossary), work to last st, LLI (see Glossary), k1—2 sts inc'd.

Work 11 (9, 7, 7, 11, 9, 9, 7) rnds even as est.

Rep the last 12 (10, 8, 8, 12, 10, 10, 8) rnds 2 (6, 9, 6, 2, 6, 2, 9) times—48 (56, 62, 56, 60, 68, 60, 74) sts.

[Rep Inc Rnd, then work , 9 (7, 5, 5, 9, 7, 7, 5) rnds even] 5 (2, 1, 5, 5, 2, 7, 1) time(s)—58 (60, 64, 66, 70, 72, 74, 76) sts.

Cont even until piece meas 19½" (49.5 cm) from beg, ending with an odd-numbered rnd.

Divide for Underarms

NEXT RND: K3 (3, 4, 4, 5, 5, 6, 6), place the last 6 (6, 8, 8, 10, 10, 12, 12) sts onto holder or waste yarn for underarm and remove m, work to end—52 (54, 56, 58, 60, 62, 62, 64) sts rem. Break yarn. Place rem sts onto separate holder or waste yarn.

Make second sleeve same as first.

Body

With smaller cir needle, CO 107 (119, 131, 143, 155, 167, 179, 191) sts. Do not join; work back and forth in rows.

SET-UP ROW: (WS) P4, *k3, p3; rep from * to last st, p1.

NEXT ROW: (RS) K4, *p3, k3; rep from * to last st, k1.

Cont even until piece meas 2" (5 cm) from beg, ending with a RS row.

Change to larger cir needle.

INC ROW: (WS) P20 (23, 26, 29, 32, 35, 38, 41), pm for side, p8 (11, 14, 17, 20, 23, 26, 29), pm for back cable panel, k13, M1P, p3, M1P, k7, p2, M1P, p3, k7, M1P, p3, M1P, k13, pm for back cable panel, p8 (11, 14, 17, 20, 23, 26, 29), pm for side, purl to end—112 (124, 136, 148, 160, 172, 184, 196) sts; 20 (23, 26, 29, 32, 35, 38, 41) sts for each front, and 72 (78, 84, 90, 96, 102, 108, 114) sts for back.

SET-UP ROW: (RS) Work in St st (knit on RS, purl on WS) to back cable panel m, sl m, work Row 1 of back cable panel to next m, sl m, work in St st to end.

Work 1 row even in est patt.

Shape Waist

DEC ROW: (RS) *Work to 3 sts before side m, ssk, k1, sl m, k1, k2tog; rep from * once more, work to end—4 sts dec'd.

Work 11 rows even, ending with a WS row.

Rep the last 12 rows 3 times—96 (108, 120, 132, 144, 156, 168, 180) sts rem.

INC ROW: (RS) *Work to 1 st before side m, LLI, k1, sl m, k1, RLI; rep from * once more, work to end—4 sts inc'd.

Work 9 rows even, ending after a WS row.

Rep the last 10 rows 3 times—112 (124, 136, 148, 160, 172, 184, 196) sts.

Cont even until piece meas 20" (51 cm) from beg, ending with a RS row.

Divide for Underarms

NEXT ROW: (WS) Purl to side m, remove m, p3 (3, 4, 4, 5, 5, 6, 6), place the last 6 (6, 8, 8, 10, 10, 12, 12) sts onto holder or waste yarn for underarm, work to side m in est patt, remove m, p3 (3, 4, 4, 5, 5, 6, 6), place the last 6 (6, 8, 8, 10, 10, 12, 12) sts onto holder or waste yarn for underarm, purl to end—17 (20, 22, 25, 27, 30, 32, 35) sts rem for each front, and 66 (72, 76, 82, 86, 92, 96, 102) sts for back.

Yoke

JOINING ROW: (RS) Work 17 (20, 22, 25, 27, 30, 32, 35) right front sts, pm for raglan, place held 52 (54, 56, 58, 60, 62, 62, 64) sleeve sts onto dpn and work in est patt, pm for raglan, work 66 (72, 76, 82, 86, 92, 96, 102) back sts, pm for raglan, place held 52 (54, 56, 58, 60, 62, 62, 64) sleeve sts onto dpn and work in est patt, pm for raglan, work 17 (20, 22, 25, 27, 30, 32, 35) left front sts—204 (220, 232, 248, 260, 276, 284, 300) sts.

Shape Raglan

(**Note:** When shaping the cable panels, be sure to work corresponding inc's and dec's together to maintain the correct st count. When there are not enough sts to work as charted, knit the knit sts and purl the purl sts as they face you.)

Work 1 WS row even.

BODY AND SLEEVE DEC ROW: (RS) *Work in est patt to 3 sts before raglan m, ssk, k1, sl m, k1, k2tog; rep from * 3 times, work to end—8 sts dec'd.

Rep the last 2 rows 11 (14, 17, 14, 17, 16, 17, 16) times—108 (100, 88, 128, 116, 140, 140, 164) sts rem; 5 (5, 4, 10, 9, 13, 14, 18) sts for each front, 28 (24, 20, 28, 24, 28, 26, 30) sts for each sleeve, and 42 (42, 40, 52, 50, 58, 60, 68) sts for back.

Sizes 32 (35¼)" only:
SLEEVE DEC ROW: (WS) *Work in est patt to raglan m, sl m, p1, ssp, work to 3 sts before next raglan m, p2tog, p1, sl m; rep from * once more, work to end—4 sts dec'd.

BODY AND SLEEVE DEC ROW: (RS) *Work in est patt to 3 sts before raglan m, ssk, k1, sl m, k1, k2tog; rep from * 3 times, work to end—8 sts dec'd.

Rep the last 2 rows 2 (0) times—72 (88) sts rem; 2 (4) sts for each front, 16 (20) sts for each sleeve, and 36 (40) sts for back.

Sizes 42 (45¼, 48½, 51¾, 55)" only:
BODY DEC ROW: (WS) *Work in est patt to 3 sts before raglan m, p2tog, p1, sl m, work to next raglan m, sl m, p1, ssp; rep from * once more, work to end—4 sts dec'd.

BODY AND SLEEVE DEC ROW: (RS) *Work in est patt to 3 sts before raglan m, ssk, k1, sl m, k1, k2tog; rep from * 3 times, work to end—8 sts dec'd.

Rep the last 2 rows 1 (0, 2, 3, 5) time(s)—104 (104, 104, 92, 92) sts rem; 6 (7, 7, 6, 6) sts for each front, 24 (22, 22, 18, 18) sts for each sleeve, and 44 (46, 46, 44, 44) sts for back.

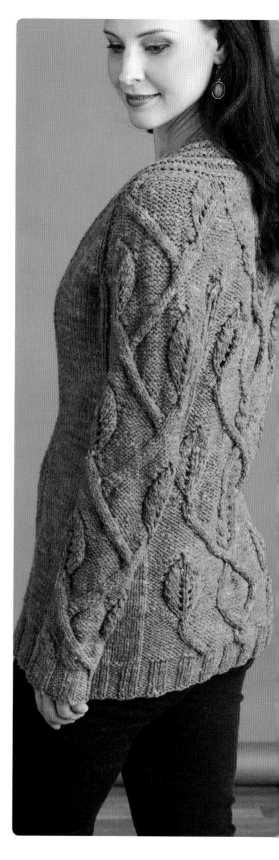

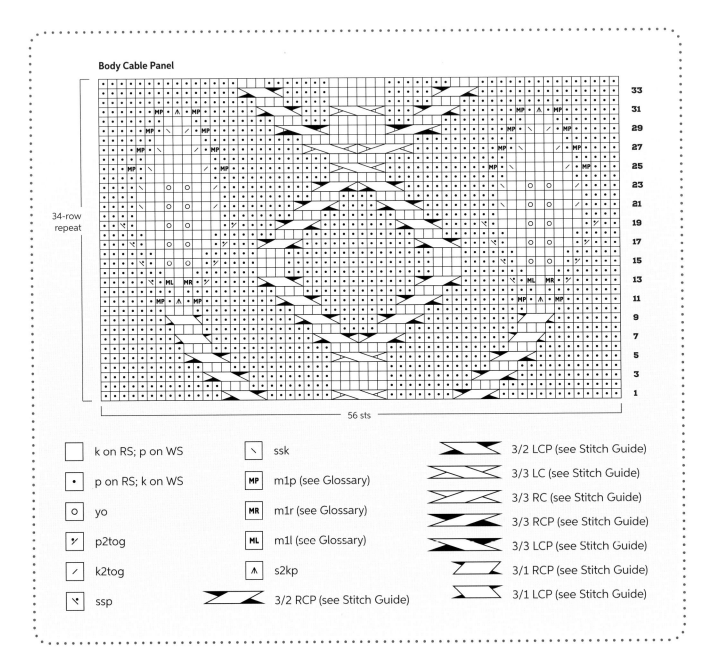

Body Cable Panel

34-row repeat

56 sts

Row numbers (right side): 33, 31, 29, 27, 25, 23, 21, 19, 17, 15, 13, 11, 9, 7, 5, 3, 1

Legend:

☐ k on RS; p on WS	＼ ssk	◤◢ 3/2 LCP (see Stitch Guide)
• p on RS; k on WS	MP m1p (see Glossary)	◢◤ 3/3 LC (see Stitch Guide)
○ yo	MR m1r (see Glossary)	◥◣ 3/3 RC (see Stitch Guide)
⅄ p2tog	ML m1l (see Glossary)	◢◤ 3/3 RCP (see Stitch Guide)
／ k2tog	⋀ s2kp	◤◢ 3/3 LCP (see Stitch Guide)
↘ ssp	◥◤ 3/2 RCP (see Stitch Guide)	◥◣ 3/1 RCP (see Stitch Guide)
		◢◤ 3/1 LCP (see Stitch Guide)

Sizes 35¼ (38½, 42, 45¼, 48½, 51¾, 55)" only:

BODY AND SLEEVE DEC ROW: (WS) *Work in est patt to 3 sts before raglan m, p2tog, p1, sl m, p1, ssp; rep from * 3 times, work to end—8 sts dec'd.

BODY AND SLEEVE DEC ROW: (RS) *Work in est patt to 3 sts before raglan m, ssk, k1, sl m, k1, k2tog; rep from * 3 times, work to end—8 sts dec'd.

Rep the last 2 rows 0 (0, 1, 1, 1, 0, 0) time(s)—72 (72, 72, 72, 72, 76, 76) sts rem; 2 (2, 2, 3, 3, 4, 4) sts for each front, 16 (16, 16, 14, 14, 14, 14) sts for each sleeve, and 36 (36, 36, 38, 38, 40, 40) for back.

All sizes:
BO all sts.

Finishing

Block to measurements.

Collar

With smaller cir needle and RS facing, beg at lower right front edge, pick up and knit 77 (80, 82, 82, 84, 85, 86, 87) sts evenly along right front edge, 56 (56, 56, 56, 56, 56, 60, 60) sts

Sleeve Cable Panel

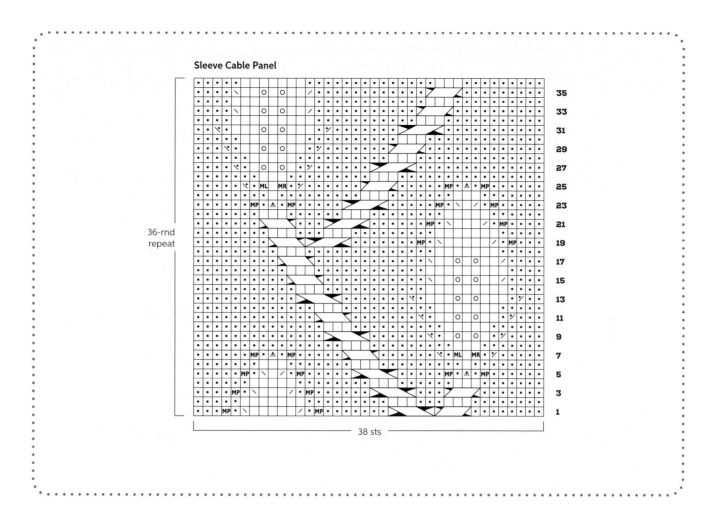

36-rnd repeat

38 sts

along BO edge skipping cable sts that are toward the back of the work, then 77 (80, 82, 82, 84, 85, 86, 87) sts along left front edge—210 (216, 220, 220, 224, 226, 232, 234) sts. Do not join; work back and forth in rows.

ROW 1: (WS) Knit.

ROW 2: Purl.

ROWS 3 AND 4: Knit.

ROW 5: Purl.

ROW 6: Knit.

Rep the last 6 rows 3 times, then work Rows 1–2 once more.

BO all sts kwise.

Join Underarms

Return held 6 (6, 8, 8, 10, 10, 12, 12) sts from sleeve and body of one underarm to larger dpns, then pick up 1 additional st at each end of each needle—8 (8, 10, 10, 12, 12, 14, 14) sts on each needle. Turn piece with WS facing. Hold needles parallel with RS of knitting facing tog and use the three-needle method (see Glossary) to BO sts tog.

Rep for second underarm.

Weave in loose ends.

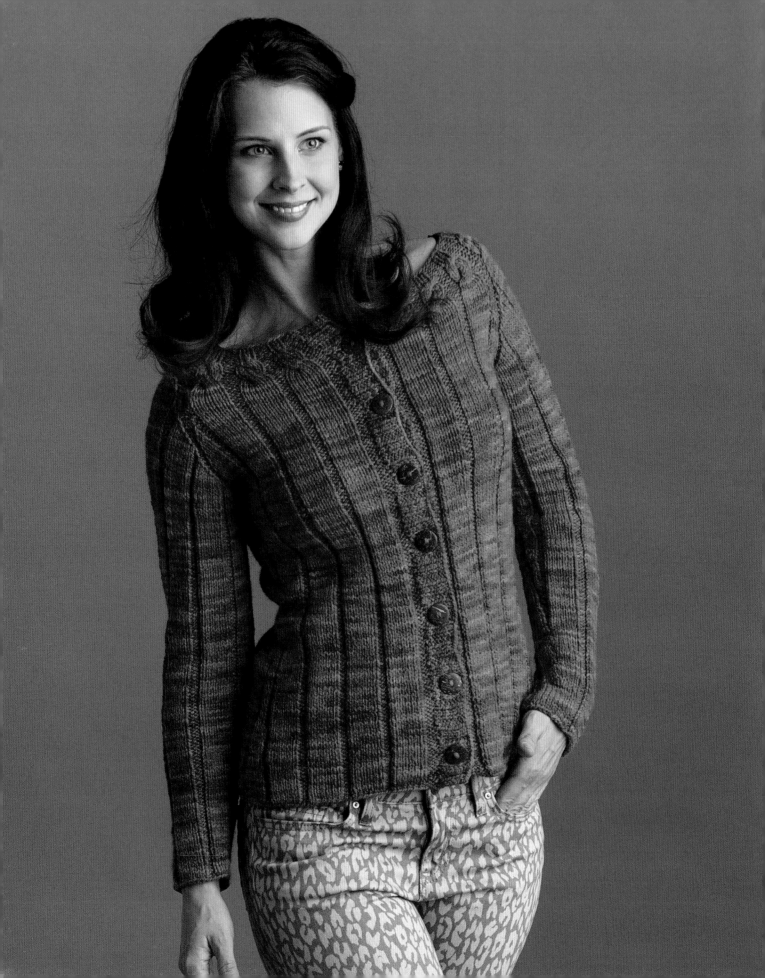

Paradise CARDIGAN

I'm so in love with huge cables right now, especially ones with lots of texture. The Paradise Cardigan has a nice combination of ribbing and cables. It's knit from the top down, making it easy to try it on and adjust the length if needed. To be sure the ribbing pattern is increasing in pattern, check out the tips on page 144. And, if you're graced with a lofty upper body, maybe try adding some bust dart shaping, keeping your wraps and turns in the knitted sections of the ribbing to hide them best.

the tips on page 144.

Techniques
Circular knitting with dpns

Cables

Using a stitch holder or waste yarn

Increasing and decreasing in pattern

Multiple stitch patterns at the same time

Lifted increases

Picking up stitches

Buttonholes

Finished Size
About 33 (36½, 40, 43½, 47, 50¾, 54¼)" (84 [92.5, 101.5, 110.5, 119.5, 129, 138] cm) bust circumference, buttoned with 1" (2.5 cm) overlapping buttonband, and 23¼ (23½, 24, 24¼, 24½, 24¾, 25¼)" (59 [59.5, 61, 61.5, 62, 63, 64] cm) long.

Cardigan shown measures 36½" (92.5 cm).

Yarn
Worsted weight (#4 Medium).

Shown here: Good Karma Farm, Worsted weight (60% wool, 40% alpaca; 210 yd [192 m]/110 g): January thaw, 5 (6, 6, 7, 7, 8, 8) skeins.

Needles
Size U.S. 7 (4.5 mm): 32" (80 cm) circular (cir) and double-pointed (dpn).

Adjust needle size if necessary to obtain gauge.

Notions
Markers (m); holders or waste yarn; 2 cable needles (cn); seven 1" (25 mm) buttons; tapestry needle.

Gauge
18 sts and 25 rows = 4" (10 cm) in k6, p2 ribbing; 26-st large cable chart = 3" (7.5 cm) wide.

{ Alternating Skeins of Hand-Dyed Yarns }

When using multiple skeins of hand-dyed yarns, there is a possibility the colors will be slightly different from one skein to the next even if they were all dyed in the same lot. To prevent an obvious color shift when you change skeins, I recommend knitting with two skeins of yarn at once.

To do this, begin with the first skein of yarn and work 2 rows (or rounds). Keep that skein of yarn attached and join a second skein to knit the following 2 rows/rounds. As you continue to knit, alternate between the two skeins every 2 rows. Keep them both attached and carry the unused skein of yarn along the selvedge edge of the work.

The extra strands of yarn at the selvedge edge will be hidden when stitches are picked up along that edge, making it invisible from the RS.

If there are no stitches being picked up along either selvedge edge, make the color change a few stitches in from the selvedge edge or an inconspicuous place such as the side body, and wrap the 2 skeins of yarn as if knitting intarsia. To do this, bring the strand of yarn you're done using over the top of the new strand of yarn, then pick up the new strand of yarn to the right of the old one to wrap them. Continue knitting the row/round with your new strand of yarn.

Stitch Guide

3/3 RC (3 OVER 3 RIGHT CROSS):
Sl 3 sts onto cn and hold in back, k3, k3 from cn.

3/3 LC (3 OVER 3 LEFT CROSS):
Sl 3 sts onto cn and hold in front, k3, k3 from cn.

Notes
Circular needle is used to accommodate large number of sts. Do not join; work back and forth in rows.

Because there are separate sections for some sizes, and the placement of each size may be different in relationship to the (),

I suggest using a pencil to circle the size that you are making throughout the pattern before you begin to knit.

If using a hand-dyed yarn, alternate skeins every 2 rows (see Tip Box).

Yoke

With cir needle, CO 64 (80, 88, 88, 96, 96, 104) sts. Do not join; work back and forth in rows.

SET-UP ROW: (WS) K1, *k2, p2; rep from * to last 3 sts, k3.

NEXT ROW: (RS) P1, *p2, k2; rep from * to last 3 sts, p3.

Work 3 more rows in est patt, ending with a WS row.

Shape Yoke

INC ROW 1: (RS) P1, *p2, [RLI (see Glossary), k1] twice; rep from * 5 (7, 8, 8, 9, 9, 10) times, place marker (pm), work Row 1 of large cable chart over next 14 sts, pm, **[k1, LLI (see Glossary)] twice, p2; rep from ** 5 (7, 8, 8, 9, 9, 10) times, p1—89 (113, 125, 125, 137, 137, 149) sts.

INC ROW 2: (WS) K1, [k2, p1, RLPI (see Glossary), p2, RLPI, p1] 6 (8, 9, 9, 10, 10, 11) times, sl m, work Row 2 of large cable to next m, sl m, [p1, LLPI (see Glossary), p2, LLPI, p1, k2] 6 (8, 9, 9, 10, 10, 11) times, k1—114 (146, 162, 162, 178, 178, 194) sts.

CABLE ROW: (RS) P1, [p2, 3/3 RC] 6 (8, 9, 9, 10, 10, 11) times, sl m, work next row of large cable to next m, sl m, [3/3 LC, p2] 6 (8, 9, 9, 10, 10, 11) times, p1—1 st inc'd.

Large Cable

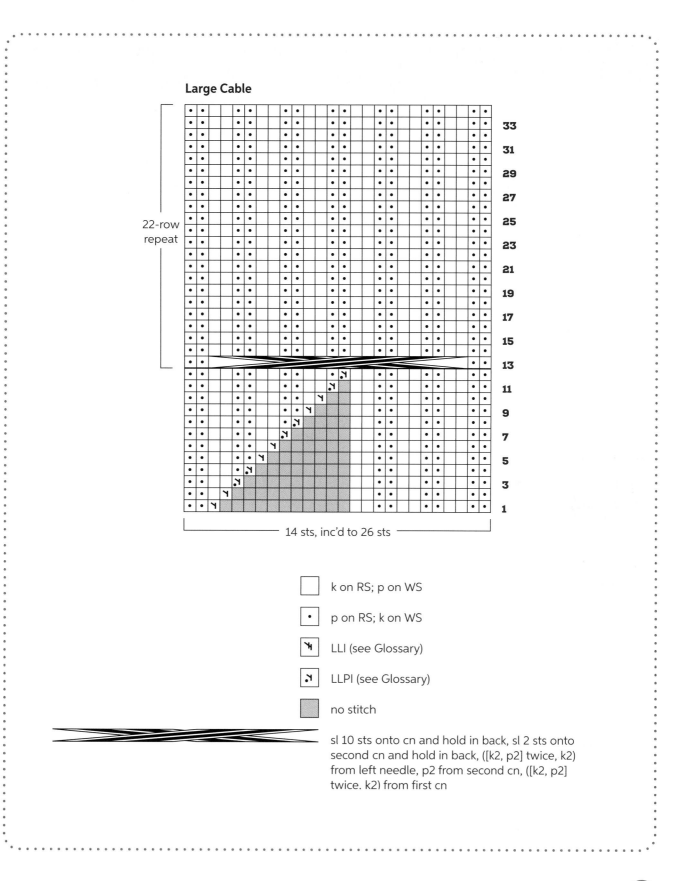

22-row repeat

33
31
29
27
25
23
21
19
17
15
13
11
9
7
5
3
1

14 sts, inc'd to 26 sts

☐ k on RS; p on WS

• p on RS; k on WS

⅄ LLI (see Glossary)

↗ LLPI (see Glossary)

▨ no stitch

sl 10 sts onto cn and hold in back, sl 2 sts onto second cn and hold in back, ([k2, p2] twice, k2) from left needle, p2 from second cn, ([k2, p2] twice. k2) from first cn

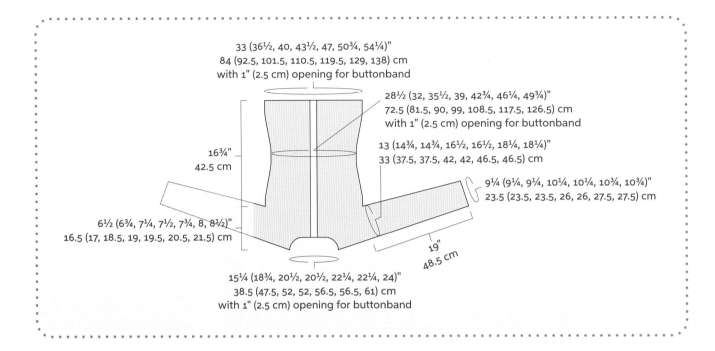

33 (36½, 40, 43½, 47, 50¾, 54¼)"
84 (92.5, 101.5, 110.5, 119.5, 129, 138) cm
with 1" (2.5 cm) opening for buttonband

28½ (32, 35½, 39, 42¾, 46¼, 49¾)"
72.5 (81.5, 90, 99, 108.5, 117.5, 126.5) cm
with 1" (2.5 cm) opening for buttonband

13 (14¾, 14¾, 16½, 16½, 18¼, 18¼)"
33 (37.5, 37.5, 42, 42, 46.5, 46.5) cm

16¾"
42.5 cm

9¼ (9¼, 9¼, 10¼, 10¼, 10¾, 10¾)"
23.5 (23.5, 23.5, 26, 26, 27.5, 27.5) cm

6½ (6¾, 7¼, 7½, 7¾, 8, 8½)"
16.5 (17, 18.5, 19, 19.5, 20.5, 21.5) cm

19"
48.5 cm

15¼ (18¾, 20½, 20½, 22¼, 22¼, 24)"
38.5 (47.5, 52, 52, 56.5, 56.5, 61) cm
with 1" (2.5 cm) opening for buttonband

NEXT ROW: (WS) K1, [k2, p6] 6 (8, 9, 9, 10, 10, 11) times, sl m, work next row of large cable to next m, sl m, [p6, k2] 6 (8, 9, 9, 10, 10, 11) times, k1—1 st inc'd.

NEXT ROW: (RS) P1, [p2, k6] 6 (8, 9, 9, 10, 10, 11) times, sl m, work next row of large cable to next m, sl m, [k6, p2] 6 (8, 9, 9, 10, 10, 11) times, p1—1 st inc'd.

Rep last 2 rows once more, then rep WS row once more—120 (152, 168, 168, 184, 184, 200) sts.

Rep Cable row—121 (153, 169, 169, 185, 185, 201) sts.

Work 3 rows in est patt; Row 12 of large cable has been completed—124 (156, 172, 172, 188, 188, 204) sts.

Cont in k6, p2 ribbing as est and rep Rows 13–34 of large cable chart while working as follows:

Work 1 RS row even.

NEXT ROW: (WS) Work 18 (26, 26, 26, 34, 34, 34) sts in est ribbing for left front,

pm for raglan, work 16 (16, 24, 24, 16, 16, 24) sts for sleeve, pm for raglan, work 56 (72, 72, 72, 88, 88, 88) sts for back, pm for raglan, work 16 (16, 24, 24, 16, 16, 24) sts for sleeve, pm for raglan, work to end for right front.

Shape Raglan
Sizes 33 (40, 43½, 47, 50¾, 54¼)" only:
BODY AND SLEEVE INC ROW: (RS) *Work in est patt to 1 st before m, M1 (or M1P to maintain patt), work 1 st, sl m, work 1 st, M1 (or M1P to maintain patt); rep from * 3 times, work to end—8 sts inc'd.

BODY AND SLEEVE INC ROW: (WS) *Work in est patt to 1 st before m, M1 (or M1P to maintain patt); rep from * 3 times, work to end—8 sts inc'd.

Rep last 2 rows 4 (2, 5, 0, 3, 6) times—204 (220, 268, 204, 252, 316) sts; 28 (32, 38, 36, 42, 48) sts for each front, 36 (36, 48, 20, 32, 52) sts for each sleeve, and 76 (84, 96, 92, 104, 116) sts for back.

All sizes:
BODY AND SLEEVE INC ROW: (RS) *Work in est patt to 1 st before m, M1 (or M1P to maintain patt), work 1 st, sl m, work 1 st, M1 (or M1P to maintain patt); rep from * 3 times, work to end—8 sts inc'd.

SLEEVE INC ROW: (WS) *Work in est patt to m, sl m, work 1 st, M1 (or M1P to maintain patt), work to 1 st before next m, M1 (or M1P to maintain patt), work 1 st, sl m; rep from * once more, work to end—4 sts inc'd.

Rep last 2 rows 3 (11, 3, 3, 11, 11, 3) times—252 (300, 268, 316, 348, 396, 364) sts; 32 (38, 36, 42, 48, 54, 52) sts for each front, 52 (64, 52, 64, 68, 80, 68) sts for each sleeve, and 84 (96, 92, 104, 116, 128, 124) sts for back.

Sizes 33 (40, 43½, 47, 54¼)" only:
BODY AND SLEEVE INC ROW: (RS) *Work in est patt to 1 st before m, M1 (or M1P to maintain patt), work 1 st, sl m, work 1 st, M1 (or M1P to maintain

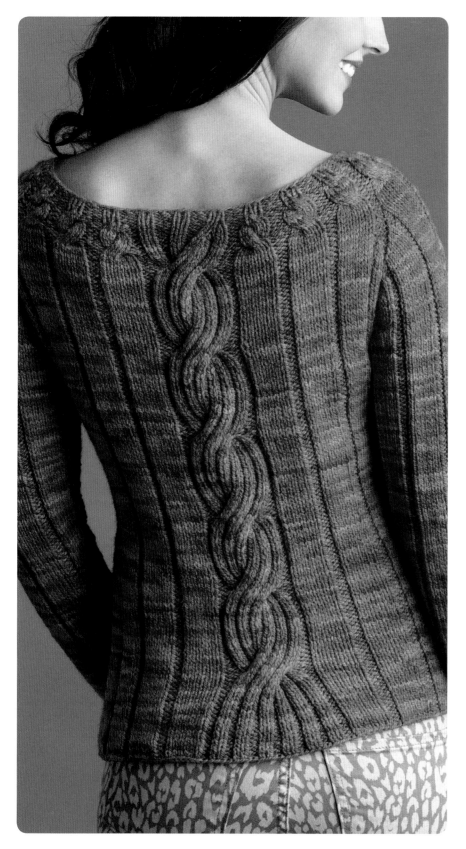

patt); rep from * 3 times, work to end—8 sts inc'd.

Work 1 WS row even.

Rep the last 2 rows 1 (5, 3, 1, 5) time(s)—268 (316, 348, 364, 412) sts; 34 (42, 46, 50, 58) sts for each front, 56 (64, 72, 72, 80) sts for each sleeve, and 88 (104, 112, 120, 136) sts for back.

All sizes:
Divide Body and Sleeves

NEXT ROW: (RS) Work 34 (38, 42, 46, 50, 54, 58) sts in est patt for left front, place next 56 (64, 64, 72, 72, 80, 80) sts onto holder or waste yarn for sleeve, pm for side, work 88 (96, 104, 112, 120, 128, 136) back sts, place next 56 (64, 64, 72, 72, 80, 80) sts onto holder or waste yarn for sleeve, pm for side, work rem 34 (38, 42, 46, 50, 54, 58) sts for right front—156 (172, 188, 204, 220, 236, 252) sts rem.

Body

Work even in est patt until piece meas 1" (2.5 cm) from divide, ending with a WS row.

Shape Waist

DEC ROW: (RS) *Work in est patt to 3 sts before side m, ssk (or ssp to maintain patt), work 1 st, sl m, work 1 st, k2tog (or p2tog to maintain patt); rep from * once more, work to end—4 sts dec'd.

Work 7 rows even, ending with a WS row.

Rep the last 8 rows 4 times—136 (152, 168, 184, 200, 216, 232) sts rem.

INC ROW: (RS) *Work in est patt to 1 st before side m, LLI (or LLPI to maintain patt), work 1 st, sl m, work 1 st, RLI (or RLPI to maintain patt); rep

from * once more, work to end—4 sts inc'd.

Work 9 rows even as est, ending after a WS row.

Rep the last 10 rows 4 times, working inc'd sts into ribbing—156 (172, 188, 204, 220, 236, 252) sts.

Cont working even until piece meas about 16¾" (42.5 cm) from divide, ending with any WS row except Row 14, 16, or 34 of large cable chart.

BO all sts in patt.

Sleeves

Return held 56 (64, 64, 72, 72, 80, 80) sleeve sts to dpn. Pick up and knit 1 st at underarm gap, work to end in patt, then pick up and knit 1 st at underarm gap—58 (66, 66, 74, 74, 82, 82) sts. Pm and join for working in rnds.

Shape Sleeve

DEC RND: K2tog (or p2tog to maintain patt), work in est ribbing to last 2 sts, ssk (or ssp to maintain patt)—2 sts dec'd.

Work 13 (9, 9, 7, 7, 7, 7) rnds even.

Rep the last 14 (10, 10, 8, 8, 8, 8) rnds 4 (4, 4, 10, 10, 1, 1) time(s)—48 (56, 56, 52, 52, 78, 78) sts rem.

[Work dec rnd, then work 11 (7, 7, 5, 5, 5, 5) rnds even] 3 (7, 7, 3, 3, 15, 15) times—42 (42, 42, 46, 46, 48, 48) sts rem.

Cont even in est ribbing until piece meas 19" (48.5 cm) from underarm.

BO all sts in patt.

Work second sleeve same as first.

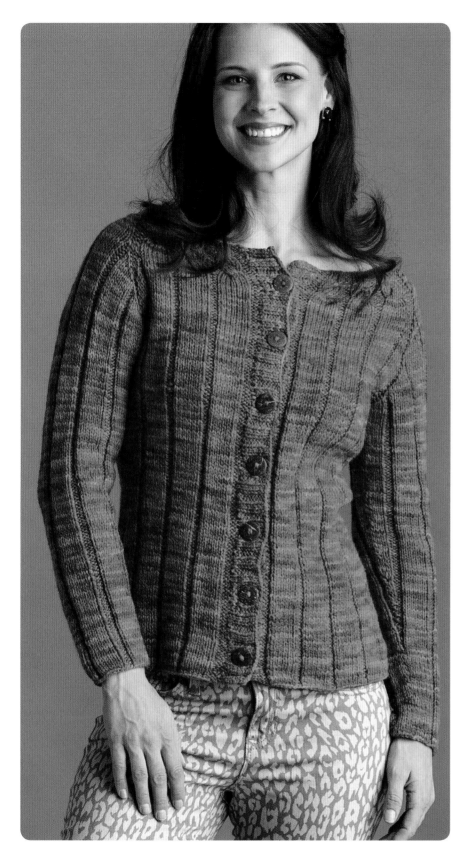

Finishing

Block piece to measurements.

Buttonband

With cir needle and RS facing, beg at left neck edge, pick up and knit 102 (102, 102, 106, 106, 106, 110) sts evenly along left front edge.

SET-UP ROW: (WS) P2, *k2, p2; rep from *.

NEXT ROW: (RS) K2, *p2, k2; rep from *.

Work 5 more rows in est ribbing, ending with a WS row. BO all sts in rib.

Buttonhole Band

With cir needle and RS facing, beg at lower right edge, pick up and knit 102 (102, 102, 106, 106, 106, 110) sts evenly along right front edge.

Work 2 rows of ribbing same as for buttonband.

BUTTONHOLE ROW: (WS) Work 10 (10, 10, 10, 10, 10, 14) sts, *[yo] twice, ssk (or ssp to maintain patt), work 12 sts; rep from * 5 times, [yo] twice, ssk (or ssp to maintain patt), work to end—7 buttonholes.

NEXT ROW: (RS) *Work in est ribbing to double yo, k1 (or p1 to maintain patt) in double yo, dropping extra wrap; rep from * 6 times, work to end.

NEXT ROW: (WS) *Work in est patt to st above yo, k1-b (or p1-b to maintain patt); rep from * 6 times, work to end.

Work 2 rows in est ribbing. BO all sts in rib.

Sew buttons to buttonband opposite buttonholes. Weave in loose ends.

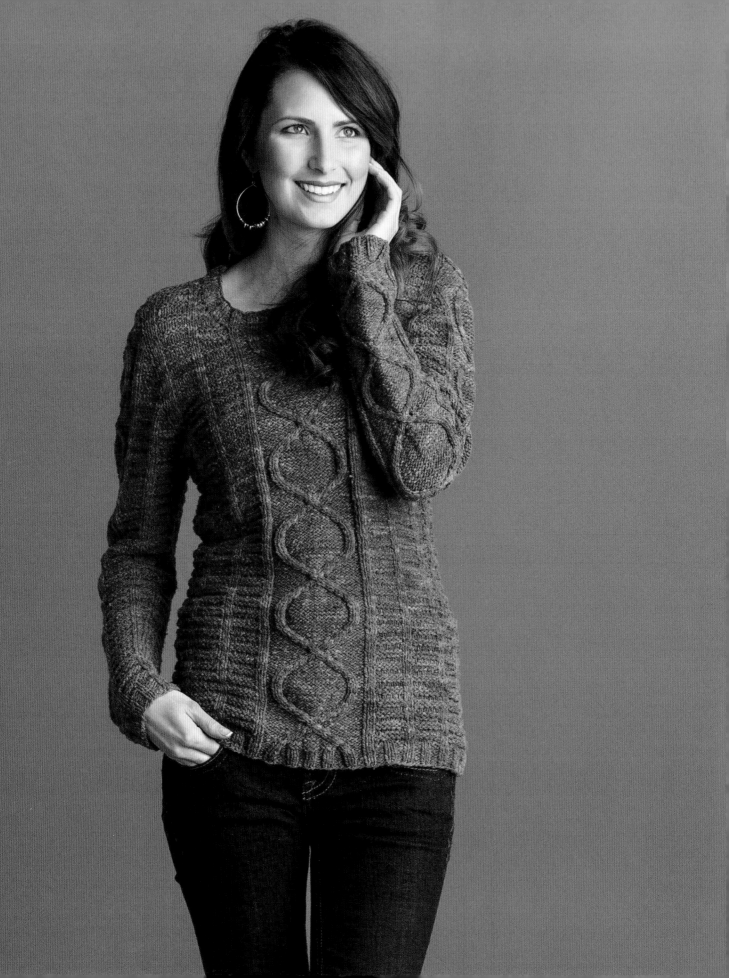

Vortex PULLOVER

The body and sleeves of the Vortex Pullover are worked separately from the lower edge to the underarm, where they are joined and worked together while working set-in shaping to the shoulders. A few short-rows are worked at the shoulders to decrease the remaining sleeve cap stitches and to shape the slanted shoulders and the back neck. When you're working the body, you have the option to add a pouch pocket that is not shown on the sample. I just love pockets and would put them on everything if I could, but I wanted to show some sweaters without them. Of course, since I thought of it, I wanted you to have the option, so I've included instructions for both!

Techniques

Circular knitting with circular needles and dpns

Cables

Short-rows

Multiple stitch patterns at the same time

Picking up stitches

Three needle bind-off

Using a stitch holder or waste yarn

Increasing and decreasing in pattern

Finished Size

About 30¾ (34½, 38, 41½, 45, 48½, 52¼, 55¾)" (78 [87.5, 96.5, 105.5, 114.5, 123, 132.5, 141.5] cm) bust circumference and 26 (26¼, 26½, 26¾, 27, 27½, 27¾, 28¼)" (66 [66.5, 67.5, 68, 68.5, 70, 70.5, 72] cm) long.

Pullover shown measures 34½" (87.5 cm).

Yarn

Worsted weight (#4 Medium).

Shown here: Mountain Meadow Wools, Cheyenne (100% Mountain Merino, 190 yd [174 m]/100 g): moss, 7 (7, 8, 9, 9, 10, 11, 11) skeins.

Needles

Size U.S. 8 (5 mm): 16" (40 cm) and 32" (80 cm) circular (cir) and double-pointed (dpn). *Adjust needle sizes if necessary to obtain the correct gauge.*

Notions

Markers (m); cable needle (cn); holders or waste yarn; tapestry needle.

Gauge

18 sts and 27 rnds = 4" (10 cm) in ridged rib pattern.

26-st cable panel = 4¾" (12 cm).

{ Picking Up Stitches to Maintain a Stitch Pattern }

When the body of a sweater is worked in a pattern similar to the neck trim, it's nice if the neck trim pattern can align closely to the stitch pattern as it appears on the body of the sweater.

The best way I've found to do this is to be aware of the neck trim stitch pattern as the stitches are being picked up around the neck edge and pick up in the appropriate place for whatever that stitch is.

For example, on the Vortex Pullover, the neck trim is worked in a k2, p2 ribbing, and I chose to align the knit stitches of the cable and broken rib patterns with the knit stitches in the ribbing. To do this, I looked ahead to how the ribbing would be established, then beginning at one of

the shoulders, I determined I would need either 2 stitches (p2) or a multiple of 4 stitches plus 2 ([p2, k2] repeated, p2) to go from the shoulder to the first set of knit stitches. I could pick up 2 stitches in the knit stitches and maintain the pattern. I continued picking up in this manner all the way around, occasionally going back to the beginning and counting the stitches as if I was working in the ribbing to be sure they aligned the way I wanted them. When finished picking up the stitches, the first round of the ribbing should align as intended with the body.

Stitch Guide

2/1 LCP (2 OVER 1 LEFT CROSS PURL):
Sl 2 sts onto cn and hold in front, p1, k2 from cn.

2/1 RCP (2 OVER 1 RIGHT CROSS PURL):
Sl 1 st onto cn and hold in back, k2, p1 from cn.

2/2 LC (2 OVER 2 LEFT CROSS): Sl 2 sts onto cn and hold in front, k2, k2 from cn.

2/2 LCP (2 OVER 2 LEFT CROSS PURL):
Sl 2 sts onto cn and hold in front, p2, k2 from cn.

2/2 RCP (2 OVER 2 RIGHT CROSS PURL):
Sl 2 sts onto cn and hold in back, k2, p2 from cn.

2/3 LCP (2 OVER 3 LEFT CROSS PURL):
Sl 2 sts onto cn and hold in front, p3, k2 from cn.

2/3 RCP (2 OVER 3 RIGHT CROSS PURL):
Sl 3 sts onto cn and hold in back, k2, p3 from cn.

Broken Ribbing:
(multiple of 8 sts)

RNDS 1 AND 2: Knit.

RNDS 3 AND 4: *K1, p6, k1; rep from *.

Rep Rnds 1–4 for patt.

Notes

On the sides, between the front and back cable panels, sizes 30¾ (38, 45, 52¼)" have an even number of Broken Rib pattern repeats, and sizes 34½ (41½, 48½, 55¾)" have an odd number of repeats. The sizes with the even number of repeats work the waist shaping between the 2 center repeats—these sizes have 1 "side" marker and 1 beg-of-rnd marker. The sizes with the odd number of repeats work the waist shaping on either side of the center repeat—these sizes have 3 "side" markers and 1 beg-of-rnd marker. The sample size has an odd number of repeats.

Because there are separate sections for some sizes, and the placement of each size may be different in relationship to the (), I suggest using a pencil to circle the size that you are making throughout the pattern before you begin to knit.

Use different colored markers for the beg-of-rnd, side, and cable panels, to easily tell them apart.

Body

With longer cir needle, CO 148 (164, 180, 196, 212, 228, 244, 260) sts. Place marker (pm) for beg-of-rnd and join for working in rnds.

SET-UP RND: *K1, [p2, k2] 7 (9, 9, 11, 11, 13, 13, 15) times, pm, p3, k2, [p2, k2] twice, p3, pm, [k2, p2] 7 (7, 9, 9, 11, 11, 13, 13) times, k1, pm for side; rep from * once more.

Cont in est ribbing until piece meas 1" (2.5 cm) from beg, on the last rnd remove all markers except the beg-of-rnd and side markers.

Sizes 30¾ (38, 45, 52¼)" (78 [96.5, 114.5, 132.5] cm) only:

SET-UP RND: Work 24 (32, 40, 48) sts in Broken Ribbing, pm for cable panel, work Rnd 1 of cable panel over next 26 sts, pm for cable panel, work 24 (32, 40, 48) sts in Broken Ribbing, sl m for side; rep from * once more.

Cont in est patt until piece meas 2" (5 cm) from beg.

Shape Waist

DEC RND: *Sl m, k1, k2tog (or p2tog to maintain patt; see Tip Box for Noble Pullover), work in est patt to 3 sts before side m, ssk (or ssp to maintain patt; see Tip Box for Noble Pullover), k1; rep from * once more—4 sts dec'd.

Work 13 rnds even.

Rep the last 14 rnds 3 times—132 (164, 196, 228) sts rem.

INC RND: *Sl m, k1, M1 (or M1P to maintain patt; see Tip Box for Noble Pullover), work in est patt to 1 st before side m, M1 (or M1P to maintain patt; see Tip Box for Noble Pullover), k1; rep from * once more—4 sts inc'd.

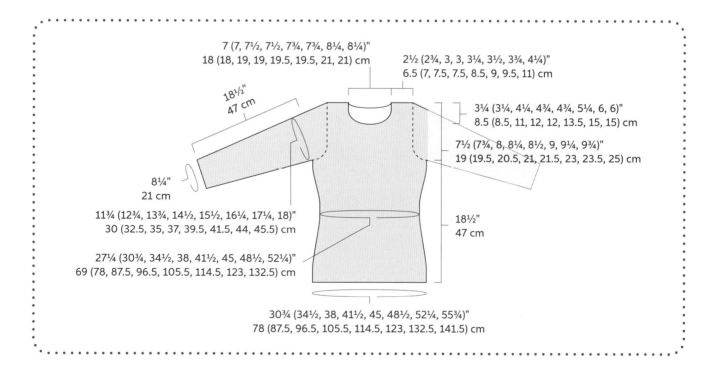

7 (7, 7½, 7½, 7¾, 7¾, 8¼, 8¼)"
18 (18, 19, 19, 19.5, 19.5, 21, 21) cm

2½ (2¾, 3, 3, 3¼, 3½, 3¾, 4¼)"
6.5 (7, 7.5, 7.5, 8.5, 9, 9.5, 11) cm

18½"
47 cm

3¼ (3¼, 4¼, 4¾, 4¾, 5¼, 6, 6)"
8.5 (8.5, 11, 12, 12, 13.5, 15, 15) cm

7½ (7¾, 8, 8¼, 8½, 9, 9¼, 9¾)"
19 (19.5, 20.5, 21, 21.5, 23, 23.5, 25) cm

8¼"
21 cm

11¾ (12¾, 13¾, 14½, 15½, 16¼, 17¼, 18)"
30 (32.5, 35, 37, 39.5, 41.5, 44, 45.5) cm

18½"
47 cm

27¼ (30¾, 34½, 38, 41½, 45, 48½, 52¼)"
69 (78, 87.5, 96.5, 105.5, 114.5, 123, 132.5) cm

30¾ (34½, 38, 41½, 45, 48½, 52¼, 55¾)"
78 (87.5, 96.5, 105.5, 114.5, 123, 132.5, 141.5) cm

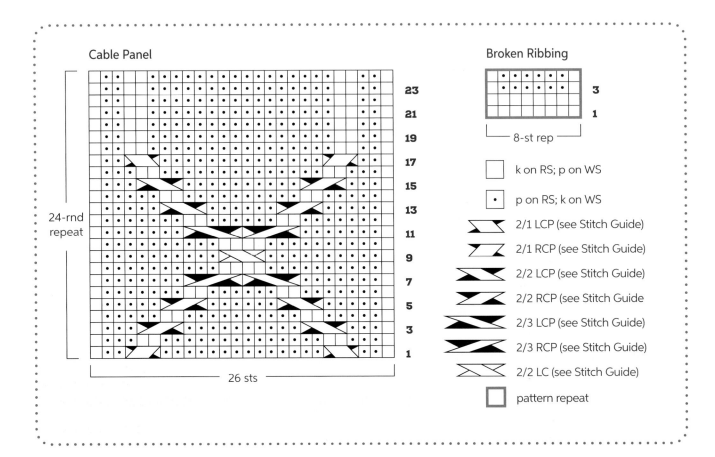

Cable Panel

23
21
19
17
15
13
11
9
7
5
3
1

24-rnd repeat

26 sts

Broken Ribbing

3
1

8-st rep

☐ k on RS; p on WS

• p on RS; k on WS

2/1 LCP (see Stitch Guide)

2/1 RCP (see Stitch Guide)

2/2 LCP (see Stitch Guide)

2/2 RCP (see Stitch Guide

2/3 LCP (see Stitch Guide)

2/3 RCP (see Stitch Guide)

2/2 LC (see Stitch Guide)

☐ pattern repeat

Sizes 34½ (41½, 48½, 55¾)" (87.5 [105.5, 123, 141.5] cm) only:

SET-UP RND: *Work 8 sts in Broken Ribbing, pm for side, work 24 (32, 40, 48) sts in Broken Ribbing, pm for cable panel, work Rnd 1 of cable panel over next 26 sts, pm for cable panel, work 24 (32, 40, 48) sts in Broken Ribbing, sl m for side; rep from * once more.

Cont in est patt until piece meas 2" (5 cm) from beg.

DEC RND: *Sl m, work 8 sts as est, sl m, k1, k2tog (or p2tog to maintain patt), work in est patt to 3 sts before next side m, ssk (or ssp to maintain patt), k1; rep from * once more—4 sts dec'd.

Work 13 rnds even.

Rep the last 14 rnds 3 times—148 (180, 212, 244) sts rem.

INC RND: *Sl m, work 8 sts as est, sl m, k1, M1 or M1P keeping in patt, work as est to 1 st before next side m, M1 or M1P keeping in patt, k1; rep from * once more—4 sts inc'd.

All sizes:
Work 11 rnds even.

Rep the last 12 rnds 3 times —148 (164, 180, 196, 212, 228, 244, 260) sts rem.

Cont even in est patt until piece meas 18½" (47 cm) from beg (measure along the cable panel), ending after working an odd- (odd-, odd-, even-, odd-, even-, even-, odd-) numbered

rnd, and ending last rnd 3 (0, 4, 0, 5, 1, 5, 2) st(s) before end of rnd.

(**Note:** *Take note of which rnd of the cable panel you worked last. You will end after the same rnd on the sleeves.*)

DIVIDE FOR UNDERARMS: Work 6 (8, 8, 8, 10, 10, 10, 12) sts removing side m, and place these sts onto holder or waste yarn for underarm, work in est patt to 3 (0, 4, 0, 5, 1, 5, 2) st(s) before next side m, work next 6 (8, 8, 8, 10, 10, 10, 12) sts removing side m, and place these sts onto holder or waste yarn for underarm, work to end—68 (74, 82, 90, 96, 104, 112, 118) sts rem each for front and back. Keep all sts on larger cir needle and set aside. Do not break yarn.

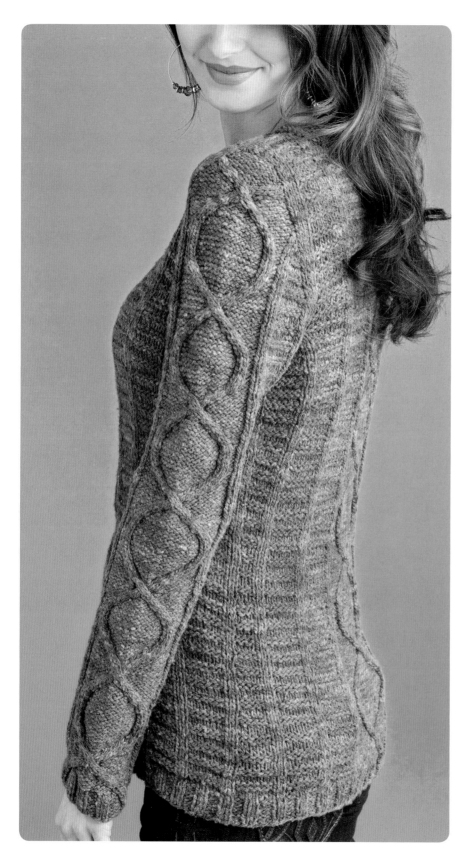

Sleeves

With dpn, CO 42 sts. Distribute sts evenly over 3 or 4 dpn. Pm and join for working in rnds.

SET-UP RND: K1, [p2, k2] 3 times, p3, k2, [p2, k2] twice, p3, [k2, p2] 3 times, k1.

Cont in est ribbing until piece meas 1" (2.5 cm) from beg.

SET-UP RND: Work 8 sts in broken ribbing, pm for cable panel, work Rnd 1 of cable panel over next 26 sts, pm for cable panel, then work rem 8 sts in broken ribbing.

Cont in est patt until piece meas 2" (5 cm) from beg.

Shape Sleeve

INC RND: K1, M1 (or M1P to maintain patt), work in est patt to last st, M1 (or M1P to maintain patt), k1—2 sts inc'd.

Work 13 (9, 9, 7, 7, 5, 5) rnds even.

Rep last 14 (10, 10, 8, 8, 6, 6, 6) rnds 0 (8, 0, 6, 0, 12, 8, 4) times—44 (60, 44, 56, 44, 68, 60, 52) sts.

[Rep Inc rnd, then work 11 (7, 7, 5, 5, 3, 3, 3) rnds even] 7 (1, 11, 7, 15, 5, 11, 17) times—58 (62, 66, 70, 74, 78, 82, 86) sts.

Cont in est patt until piece meas 18½" (47 cm) from beg, ending with same rnd of patt as for body, ending last rnd 3 (4, 4, 4, 5, 5, 5, 6) sts before end of rnd.

DIVIDE FOR UNDERARM: Work 6 (8, 8, 8, 10, 10, 10, 12) sts removing m, and place these sts onto holder or waste yarn for underarm, work to end—52 (54, 58, 62, 64, 68, 72, 74) sts rem.

Place rem sts onto separate piece of waste yarn. Break yarn and set aside.

Make second sleeve same as first, keep sts on dpn, and break yarn.

Yoke

JOINING RND: With longer cir needle and RS facing, hold needle with back sts on right needle, pm for beg of rnd, work next rnd of est patt over 52 (54, 58, 62, 64, 68, 72, 74) sleeve sts, pm, work in est patt over 68 (74, 82, 90, 96, 104, 112, 118) front sts, pm, place held 52 (54, 58, 62, 64, 68, 72, 74) sleeve sts onto empty needle and work in est patt, pm, work in est patt over 68 (74, 82, 90, 96, 104, 112, 118) back sts—240 (256, 280, 304, 320, 344, 368, 384) sts.

Keep 1 st to each side of armhole markers in St st (knit when working in the round, and knit on RS rows, purl on WS rows when working back and forth) throughout while working as foll:

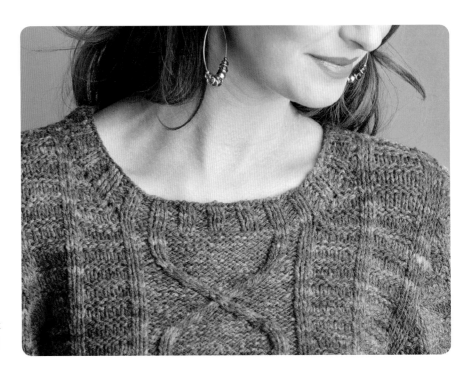

Shape Armholes

DEC RND: *K1, work in est patt to last sleeve st, k1, sl m, k1, k2tog (or p2tog to maintain patt), work to 3 sts before next m, ssk (or ssp to maintain patt), k1, sl m; rep from * once more—4 sts dec'd.

Rep the last rnd 4 (6, 8, 11, 12, 15, 17, 18) times, ending after an even numbered rnd of patts—220 (228, 244, 256, 268, 280, 296, 308) sts; 58 (60, 64, 66, 70, 72, 76, 80) sts each for front and back, and 52 (54, 58, 62, 64, 68, 72, 74) sts for each sleeve.

Shape Sleeve Caps

(**Note:** *When decreasing into the cable panel, if there are not enough sts to work a cable, work the sts as they appear, knitting the knit sts and purling the purl sts.*)

DEC RND: *K1, k2tog (or p2tog to maintain patt), work in est patt to 3 sts before next m, ssk (or ssp to maintain patt), k1, sl m, k1, work in est patt to 1

st before next m, k1, sl m; rep from * once more—4 sts dec'd.

Work 1 rnd even.

Rep last 2 rnds 9 (9, 6, 3, 4, 2, 0, 1) more time(s)—180 (188, 216, 240, 248, 268, 292, 300) sts; 58 (60, 64, 66, 70, 72, 76, 80) sts each for front and back, and 32 (34, 44, 54, 54, 62, 70, 70) sts for each sleeve.

Shape Sleeve Cap and Front Neck

DEC RND: (RS) K1, k2tog (or p2tog to maintain patt), work in est patt to 3 sts before next m, ssk (or ssp to maintain patt), k1, sl m, k1, work next 16 (16, 18, 18, 19, 20, 21, 23) sts in est patt, BO next 24 (26, 26, 28, 30, 30, 32, 32) sts for front neck, work to 1 st before next m, k1, sl m, k1, k2tog (or p2tog to maintain patt), work to 3 sts before next m, ssk (or ssp to maintain patt), k1, sl m, k1, work to 1 st before next m, k1, sl m—152 (158, 186, 208, 214, 234, 256, 264) sts; 17 (17, 19, 19, 20, 21,

22, 24) sts for each front, 30 (32, 42, 52, 52, 60, 68, 68) sts for each sleeve, and 58 (60, 64, 66, 70, 72, 76, 80) sts for back.

Break yarn. Slip all sts from the left needle to the right needle so needle tips are at the front neck BO sts. Cont working back and forth in rows. Join yarn at left front neck edge, preparing to work a WS row.

Work 1 WS row even.

DEC ROW: (RS) K1, k2tog (or p2tog to maintain patt), *work in est patt to 1 st before m, k1, sl m, k1, k2tog (or p2tog to maintain patt), work to 3 sts before next m, ssk (or ssp to maintain patt), k1, sl m; rep from * once more, work to last 3 sts, ssk (or ssp to maintain patt), k1—6 sts dec'd.

Rep the last 2 rows 5 (4, 5, 4, 4, 4, 4, 4) times—116 (128, 150, 178, 184, 204, 226, 234) sts; 11 (12, 13, 14, 15, 16, 17, 19) sts for each front, 18 (22, 30, 42, 42, 50, 58, 58) sts for each sleeve, and 58 (60, 64, 66, 70, 72, 76, 80) sts for back.

Shape Sleeve Cap

DEC ROW: (WS) *Work in est patt to 1 st before m, p1, sl m, p1, ssk (or ssp to maintain patt), work to 3 sts before next m, k2tog (or p2tog to maintain patt), p1, sl m; rep from * once more, work to end—4 sts dec'd.

DEC ROW: (RS) *Work in est patt to 1 st before m, k1, sl m, k1, k2tog (or p2tog to maintain patt), work to 3 sts before next m, ssk (or ssp to maintain patt), k1, sl m; rep from * once more, work to end—4 sts dec'd.

Rep last 2 rows 1 (2, 4, 7, 7, 9, 11, 11) time(s), then work WS Dec row once more—96 (100, 106, 110, 116, 120, 126, 134) sts; 11 (12, 13, 14, 15, 16, 17, 19) sts for each front, 8 sts for each sleeve, and 58 (60, 64, 66, 70, 72, 76, 80) sts for back.

Shape top of right front sleeve cap with short-rows as foll:

(**Note:** Sts on sleeves are not wrapped when turning, but sts at the neck edges are wrapped.)

SHORT-ROW 1: With RS facing, work in est patt to 1 st before m, k1, sl m, ssk, turn piece with WS facing, sl 1 pwise wyf, sl m, work to end—1 st dec'd.

Rep Short-row 1 once more—6 sts rem for right sleeve.

Shape top of right back sleeve cap and neck using short-rows as foll:

SHORT-ROW 2: With RS facing, work to 1 st before m, k1, remove m, ssk, work to 2 sts before next m, k2tog, sl m, work next 16 (17, 19, 20, 22, 23, 25, 27) back sts, wrap next st, turn piece with WS facing, work to m, sl m, sl 2 sts pwise wyf, turn piece with RS facing—4 sts rem for right sleeve.

SHORT-ROW 3: With RS facing, k2tog, sl m, work next 14 (15, 17, 18, 19, 20, 22, 24) back sts, wrap next st and turn piece with WS facing, work to m, sl m, sl 2 sts pwise wyf, turn work—3 sts rem for right sleeve.

Shape top of left back sleeve cap and neck using short-rows as foll:

SHORT-ROW 4: With RS facing, k2tog, sl m, work to next m hiding wraps as they appear, sl m, ssk, turn piece with WS facing, sl 1 pwise wyf, sl m, work next 16 (17, 19, 20, 22, 23, 25, 27) back sts, wrap next st, turn piece with RS facing—2 sts rem for right sleeve, and 7 sts rem for left sleeve.

SHORT-ROW 5: With RS facing, work to m, sl m, ssk, turn piece with WS facing, sl 1 pwise wyf, sl m, work next 14 (15, 17, 18, 19, 20, 22, 24) back sts, wrap next st, turn piece with RS facing—6 sts rem for left sleeve.

Shape top of left front sleeve cap using short-rows as foll:

SHORT-ROW 6: With RS facing, work to m, remove m, ssk, work to 2 sts before next m, k2tog, sl m, work to end—4 sts rem for left sleeve.

SHORT-ROW 7: With WS facing, work to m, sl m, sl 2 sts pwise wyf, turn piece with RS facing, k2tog, sl m, work to end—3 sts rem for left sleeve.

Rep the last short-row once more—84 (88, 94, 98, 104, 108, 114, 122) sts rem; 11 (12, 13, 14, 15, 16, 17, 19) sts for each front, 2 sts for each sleeve and 58 (60, 64, 66, 70, 72, 76, 80) sts for back.

NEXT ROW: (WS) Work to m, remove m, sl 2 sts pwise wyf, sl m, work 11 (12, 13, 14, 15, 16, 17, 19) sts, BO next 36 (36, 38, 38, 40, 40, 42, 42) sts for back neck hiding wraps as they appear, work to next m, remove m, sl 2 sts pwise wyf, work to end—24 (26, 28, 30, 32, 34, 36, 40) sts rem each side for shoulders.

Divide rem 24 (26, 28, 30, 32, 34, 36, 40) sts for each shoulder evenly onto 2 dpn—12 (13, 14, 15, 16, 17, 18, 20) sts on each needle. Hold needles parallel so that RS face tog. Join yarn and use three-needle method (see Glossary) to BO sts tog.

Finishing

JOIN UNDERARMS: With WS facing, place held underarm sts onto 2 dpn, picking up 1 additional st at each end of each needle—8 (10, 10, 10, 12, 12, 12, 14) sts on each dpn. Hold needles parallel so that RS face tog. Join yarn and use three-needle method to BO sts tog. Rep for second underarm.

Block to measurements.

NECKBAND: With shorter cir needle and RS facing, pick up and knit 96 (96, 104, 112, 120, 128, 136, 136) sts around neck edge. (See Tip box for more information on how to align the ribbing with the existing stitch pattern on the body.) Pm and join for working in rnds.

RND 1: *P2, k2; rep from * around.

Rep the last rnd until neckband meas 1" (2.5 cm) from pick-up rnd. BO all sts in patt.

Weave in loose ends.

Abbreviations

beg(s)	begin(s); beginning	**kwise**	knitwise, as if to knit	**sl st**	slip st (slip stitch purlwise unless otherwise indicated)	
BO	bind off	**m**	marker(s)			
cir	circular	**mm**	millimeter(s)	**ssk**	slip, slip, knit (decrease)	
cm	centimeter(s)	**M1**	make one (increase)	**st(s)**	stitch(es)	
cn	cable needle	**oz**	ounce	**St st**	stockinette stitch	
CO	cast on	**p**	purl	**tbl**	through back loop	
cont	continue(s); continuing	**p1f&b**	purl into front and back of same stitch	**tog**	together	
dec(s)('d)	decrease(s); decreasing; decreased			**WS**	wrong side	
		p2tog	purl 2 stitches together	**wyb**	with yarn in back	
dpn	double-pointed needles	**patt(s)**	pattern(s)	**wyf**	with yarn in front	
foll(s)	follow(s); following	**pm**	place marker	**yd**	yard(s)	
g	gram(s)	**psso**	pass slipped stitch over	**yo**	yarnover	
inc(s)('d)	increase(s); increasing; increase(d)	**pwise**	purlwise; as if to purl	*****	repeat starting point	
		rem	remain(s); remaining	******	repeat all instructions between asterisks	
k	knit	**rep**	repeat(s); repeating			
k1f&b	knit into the front and back of same stitch	**Rev St st**	reverse stockinette stitch	**()**	alternate measurements and/or instructions	
		rnd(s)	round(s)			
k2tog	knit 2 stitches together	**RS**	right side	**[]**	work instructions as a group a specified number of times	
k3tog	knit 3 stitches together	**sl**	slip			

Glossary

Blocking

Steam Blocking

Pin the pieces to be blocked to a blocking surface. Hold an iron set on the steam setting ½" (1.3 cm) above the knitted surface and direct the steam over the entire surface (except ribbing). You can get similar results by lapping wet cheesecloth on top of the knitted surface and touching it lightly with a dry iron. Lift and set down the iron gently; do not use a pushing motion.

Wet-Towel Blocking

Run a large bath or beach towel (or two towels for larger projects) through the rinse/spin cycle of a washing machine. Roll the knitted pieces in the wet towel(s), place the roll in a plastic bag, and leave overnight so that the knitted pieces become uniformly damp. Pin the damp pieces to a blocking surface and let air-dry thoroughly.

Buttons

To attach buttons, place a removable stitch marker in the fabric at each button location. Thread an 8" (20.5 cm) length of yarn onto a tapestry needle. Secure one end of the yarn to the wrong side of the fabric, beginning a few stitches away from the marked button position and working toward the marker. Remove the marker, *bring the tapestry needle from the wrong side to the right side of the fabric, through one hole in the button, then back through another hole in the button, and into

the fabric one or two stitches away from where it entered. Repeat from * two or three times. To finish, secure the remaining yarn on the wrong side of the fabric.

Cast-Ons

Backward-Loop Cast-On

*Loop working yarn and place it on needle backward so that it doesn't unwind. Repeat from *.

Cable Cast-On

If there are no stitches on the needles, make a slipknot of working yarn and place it on the left needle, then use the knitted method to cast-on one more stitch—two stitches on needle. When there are at least two stitches on the left needle, hold needle with working yarn in your left hand. *Insert right needle between the first two stitches on left needle (**Figure 1**), wrap yarn around needle as if to knit, draw yarn through (**Figure 2**), and place new loop on left needle (**Figure 3**) to form a new stitch. Repeat from * for the desired number of stitches, always working between the first two stitches on the left needle.

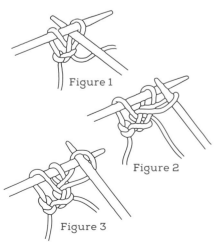

Figure 1

Figure 2

Figure 3

Circular Tubular Cast-On for K1, P1 Rib

With waste yarn and circular or double-pointed needles, use desired method to cast on half the desired number of stitches. Join for working in rounds, being careful not to twist the stitches. Knit two rounds even. Change to working yarn and knit four more rounds.

NEXT RND: (RS) K1, *holding the yarn in front, use a needle tip to pick up the lowermost working yarn loop (forms a "dashed" line below the last round of waste yarn stitches) between the first two stitches (**Figure 1**), place this loop on the left needle tip, and purl it (**Figure 2**). Repeat from * to the end of the round. After working a few rounds in ribbing, cut out waste yarn.

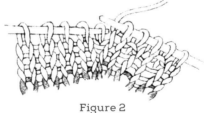

Figure 1

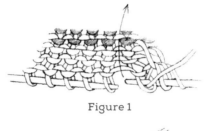

Figure 2

Crochet Provisional Cast-On

With waste yarn and crochet hook, make a loose crochet chain (see page 173) about four stitches more than you need to cast on. With knitting needle, working yarn, and beginning two stitches from end of chain, pick up and knit one stitch through the back loop of each crochet chain (**Figure 1**) for desired number of stitches. When you're

ready to work in the opposite direction, pull out the crochet chain to expose live stitches (**Figure 2**).

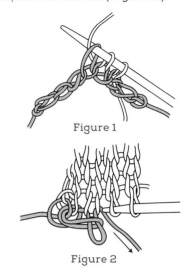

Figure 1

Figure 2

Knitted Cast-On

If there are no stitches on the needles, make a slipknot of working yarn and place it on the left needle. When there is at least one stitch on the left needle, *use the right needle to knit the first stitch (or slipknot) on left needle (**Figure 1**) and place new loop onto left needle to form a new stitch (**Figure 2**). Repeat from * for the desired number of stitches, always working into the last stitch made.

Figure 1

Figure 2

Glossary 167

Long-Tail (Continental) Cast-On

Leaving a long tail (about ½" [1.3 cm] for each stitch to be cast on), make a slipknot and place on right needle. Place thumb and index finger of your left hand between the yarn ends so that working yarn is around your index finger and tail end is around your thumb and secure the yarn ends with your other fingers. Hold your palm upward, making a V of yarn (**Figure 1**). *Bring needle up through loop on thumb (**Figure 2**), catch first strand around index finger, and go back down through loop on thumb (**Figure 3**). Drop loop off thumb and, placing thumb back in V configuration, tighten resulting stitch on needle (**Figure 4**). Repeat from * for the desired number of stitches.

Figure 1

Figure 2

Figure 3

Figure 4

Bind-Offs
Standard Bind-Off

Knit the first stitch, *knit the next stitch (two stitches on right needle), insert left needle tip into first stitch on right needle (**Figure 1**) and lift this stitch up and over the second stitch (**Figure 2**) and off the needle (**Figure 3**). Repeat from * for the desired number of stitches.

Figure 1

Figure 2

Figure 3

Three-Needle Bind-Off

Place the stitches to be joined onto two separate needles and hold the needles parallel so that the right sides of knitting face together. Insert a third needle into the first stitch on each of two needles (**Figure 1**) and knit them together as one stitch (**Figure 2**), *knit the next stitch on each needle the same way, then use

the left needle tip to lift the first stitch over the second and off the needle (**Figure 3**). Repeat from * until no stitches remain on first two needles. Cut yarn and pull tail through last stitch to secure.

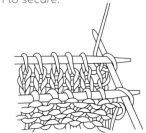

Figure 1

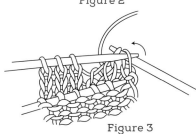

Figure 2

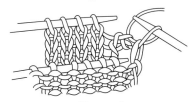

Figure 3

Decreases
Knit 2 Together (k2tog)

Knit two stitches together as if they were a single stitch.

Knit 3 Together (k3tog)

Knit three stitches together as if they were a single stitch.

Purl 2 Together (p2tog)

Purl two stitches together as if they were a single stitch.

Purl 3 Together (p3tog)

Purl three stitches together as if they were a single stitch.

Slip, Slip, Knit (ssk)

Slip two stitches individually knitwise (**Figure 1**), insert left needle tip into the front of these two slipped stitches, and use the right needle to knit them together through their back loops (**Figure 2**).

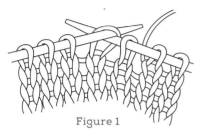

Figure 1

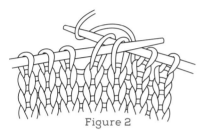

Figure 2

Slip, Slip, Slip, Knit (sssk)

Slip three stitches individually knitwise, insert left needle tip into the front of these three slipped stitches, and use the right needle to knit them together through their back loops.

Slip, Slip, Purl (ssp)

Holding yarn in front, slip two stitches individually knitwise (**Figure 1**), then slip these two stitches back onto left needle (they will be twisted on the needle), and purl them together through their back loops (**Figure 2**).

Figure 1

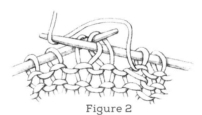

Figure 2

Joining for Working in Rounds

For projects that begin with ribbing or stockinette stitch, simply arrange the stitches for working in rounds, then knit the first stitch that was cast-on to form a tube.

For projects that begin with seed, garter, or reverse stockinette stitch arrange the needle so that the yarn tail is at the left needle tip. Holding the yarn in back, slip the first stitch from the right needle onto the left needle (**Figure 1**), bring the yarn to the front between the two needles, and slip the first two stitches from the left tip to the right tip (**Figure 2**), then bring the yarn to the back between the two needles and slip the first stitch from the right tip to the left tip (**Figure 3**).

Figure 1

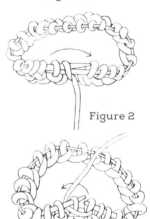

Figure 2

Figure 3

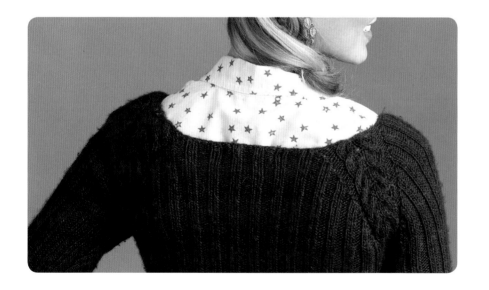

Gauge

Measuring Gauge

Knit a swatch at least 4" (10 cm) square. Remove the stitches from the needles or bind them off loosely and lay the swatch on a flat surface. Place a ruler over the swatch and count the number of stitches across and number of rows down (including fractions of stitches and rows) in 4" (10 cm) and divide this number by four to get the number of stitches (including fractions of stitches) in one inch. Repeat two or three times on different areas of the swatch to confirm the measurements. If you have more stitches and rows than called for in the instructions, knit another swatch with larger needles; if you have fewer stitches and rows, knit another swatch with smaller needles.

I-Cord (also called Knit-Cord)

This is worked with two double-pointed needles. Cast on the desired number of stitches (usually three to four). Knit across these stitches, then *without turning the needle, slide stitches to other end of needle, pull the yarn around the back, and knit the stitches as usual. Repeat from * for desired length.

Increases

Bar Increase

Knitwise (k1f&b)

Knit into a stitch but leave the stitch on the left needle (**Figure 1**), then knit through the back loop of the same stitch (**Figure 2**) and slip the original stitch off the needle (**Figure 3**).

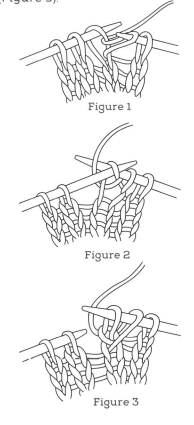

Figure 1

Figure 2

Figure 3

Purlwise (p1f&b)

Work as for a knitwise bar increase, but purl into the front and back of the same stitch.

Raised Make-One (M1) Increase

Note: *Use the left slant if no direction of slant is specified.*

Left Slant (M1L)

With left needle tip, lift the strand between the last knitted stitch and the first stitch on the left needle from front to back (**Figure 1**), then knit the lifted loop through the back (**Figure 2**).

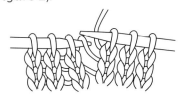

Figure 1

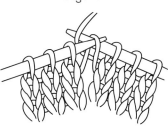

Figure 2

Right Slant (M1R)

With left needle lip, lift the strand between the needles from back to front (**Figure 1**). Knit the lifted loop through the front (**Figure 2**).

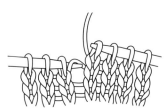

Figure 1

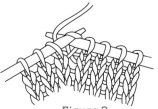

Figure 2

Purlwise (M1P)

With left needle tip, lift the strand between the needles from front to back (**Figure 1**), then purl the lifted loop through the back (**Figure 2**).

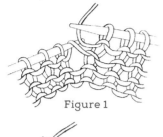

Figure 1

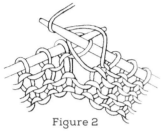

Figure 2

Magic-Loop Technique

Using a 32" or 40" (80 or 100 cm) circular needle, cast on the desired number of stitches. Slide the stitches to the center of the cable, then fold the cable and half of the stitches at the midpoint, then pull a loop of the cable between the stitches. Half of the stitches will be on one needle tip and the other half will be on the other tip (**Figure 1**). Hold the needle tips parallel so that the working yarn comes out of the right-hand edge of the back needle. *Pull the back needle tip out to expose about 6" (15 cm) of cable and use that needle to knit the stitches on the front needle (**Figure 2**). At the end of those stitches, pull the cable so that the two sets of stitches are at the ends of their respective needle tips, turn the work around and repeat from * to complete one round of knitting.

Figure 1 Figure 2

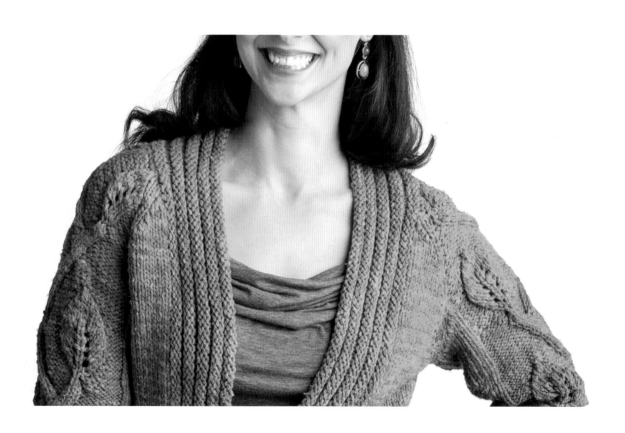

One-Row Buttonhole

With RS facing, bring yarn to front, slip the next stitch purlwise, return yarn to the back, *slip the next stitch purlwise, pass the first slipped stitch over the second slipped stitch and off the needle; repeat from * two more times (**Figure 1**). Slip the last stitch on the right needle tip to the left needle tip and turn the work so that the wrong side is facing. **With yarn in back, insert right needle tip between the first two stitches on the left needle tip (**Figure 2**), draw through a loop and place it on the left needle]; rep from ** three more times, then turn the work so the right side is facing. With yarn in back, slip the first stitch and lift the extra cast-on stitch over the slipped stitch (**Figure 3**) and off the needle to complete the buttonhole.

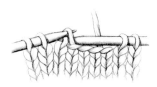

Figure 1

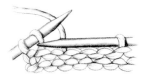

Figure 2

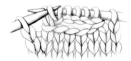

Figure 3

Pick Up and Knit
Along CO or BO Edge

With right side facing and working from right to left, insert the tip of the needle into the center of the stitch below the bind-off or cast-on edge (**Figure 1**), wrap yarn around needle, and pull through a loop (**Figure 2**). Pick up one stitch for every existing stitch.

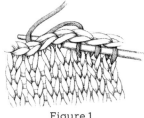

Figure 1

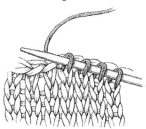

Figure 2

Along Shaped Edge

With right side facing and working from right to left, insert tip of needle between last and second-to-last stitches, wrap yarn around needle, and pull through a loop. Pick up and knit about three stitches for every four rows, adjusting as necessary so that picked-up edge lays flat.

Short-Rows
Knit Side

Work to turning point, slip next stitch purlwise (**Figure 1**), bring the yarn to the front, then slip the same stitch back to the left needle (**Figure 2**), turn the work around and bring the yarn in position for the next stitch— one stitch has been wrapped, and the yarn is correctly positioned to work the next stitch. When you come to a wrapped stitch on a subsequent row, hide the wrap by working it together with the wrapped stitch as follows: Insert right needle tip under the wrap (from the front if wrapped stitch is a knit stitch; from the back if wrapped stitch is a purl stitch; **Figure 3**), then into the stitch on the needle, and work the stitch and its wrap together as a single stitch.

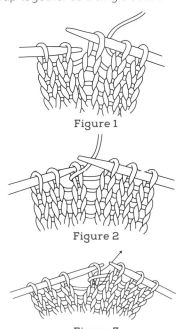

Figure 1

Figure 2

Figure 3

Purl Side

Work to the turning point, slip the next stitch purlwise to the right needle, bring the yarn to the back of the work (**Figure 1**), return the slipped stitch to the left needle, bring the yarn to the front between the needles (**Figure 2**), and turn the work so that the knit side is facing—one stitch has been wrapped, and the yarn is correctly positioned to knit the next stitch. To hide the wrap on a subsequent purl row, work to the wrapped stitch, use the tip of the right needle to pick up the wrap from the back, place it on the left needle (**Figure 3**), then purl it together with the wrapped stitch.

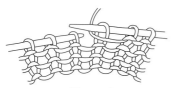

Figure 1

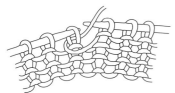

Figure 2

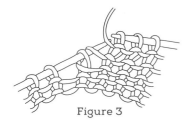

Figure 3

Weave in Loose Ends

Thread the ends on a tapestry needle and trace the path of a row of stitches (**Figure 1**) or work on the diagonal, catching the back side of the stitches (**Figure 2**). To reduce bulk, do not weave two ends in the same area. To keep color changes sharp, work the ends into areas of the same color.

Figure 1

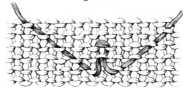

Figure 2

Crochet Chain (ch)

Make a slipknot and place on crochet hook. *Yarn over hook and draw through a loop on the hook. Repeat from * for the desired number of stitches. To fasten off, cut yarn and draw end through last loop formed.

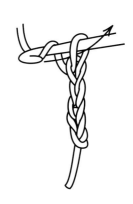

Sources for Yarns

Bijou Basin Ranch
PO Box 154
Elbert, CO 80106
bijoubasinranch.com

Blue Sky Alpacas
PO Box 88
Cedar, MN 55011
blueskyalpacas.com

Cascade
PO Box 58168
1224 Andover Park E.
Tukwila, WA 98188
cascadeyarns.com

Classic Elite Yarns
16 Esquire Rd., Unit 2
North Billerica, MA 01862-2500
classiceliteyarns.com

**Fairmount Fibers/
Manos del Uruguay**
PO Box 2082
915 N. 28th St.
Philadelphia, PA 19130
fairmountfibers.com

The Fibre Company
2000 Manor Rd.
Conshohocken, PA 19428
thefibreco.com

Good Karma Farm
67 Perkins Rd.
Belfast, ME 04915
goodkarmafarm.com

Green Mountain Spinnery
PO Box 568
7 Brickyard Ln.
Putney, VT 05326
spinnery.com

Imperial Stock Ranch
92462 Hinton Rd.
Maupin, OR 97037
imperialyarn.com

Lanaknits Hemp for Knitting
320 Vernon St., Ste. 3B
Nelson, British Columbia
Canada, V1L4E4
lanaknits.com

Mountain Meadow Wools
22 Plains Dr.
Buffalo, WY 82834
mountainmeadowwool.com

O-Wool
915 N. 28th St.
Philadelphia, PA 19130
o-wool.com

Peace Fleece
475 Porterfield Rd.
Porter, ME 04068
peacefleece.com

Quince & Co
85 York St.
Portland, ME 04101
quinceandco.com

Swans Island
231 Atlantic Hwy. (U.S. Rte. 1)
Northport, ME 04849
swansislandcompany.com

Index

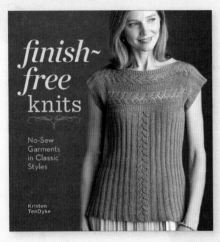